Retrographic

History's Most Exciting Images Transformed Into Living Colour

Michael D. Carroll

Retrographic

History's Most Exciting Images Transformed Into Living Colour

A catalogue record for this book is available from the British Library.

First Edition 2017
First published in Great Britain in 2017 by Carpet Bombing Culture.
An imprint of Pro-actif Communications
www.carpetbombingculture.co.uk
Email: books@carpetbombingculture.co.uk
©Carpet Bombing Culture. Pro-actif Communications

Cover image courtesy of Getty, colourised by Sanna Dullaway
Curated and authored by Michael D. Carroll
To my girls: Amrita, Freya and Anoushka

ISBN: 978-1908211-50-7

www.carpetbombingculture.co.uk

CONTENTS

Forward 4
Introduction 6
1854: American Revolutionary 14
1857: Napoleonic Veterans 16
1861: Medal of Honor 18
1862: General Custer 20
1863: A Harvest of Death 22
1865: Lincoln Assassins 24
1877: The Free Cheyenne 32
1880: Age of the Lumberjacks 34
1882: Oscar Wilde 36
1888: The Cowboy 38
1890: Irish Famine 40
1894: Butch Cassidy and the Wild Bunch 42
1895: Calamity Jane and Deadwood 44
1899: The Last Hunters 46
1900: Feudal Japan 48
1900: Street Life 50
1900: The First Supermodel 54
1903: One Times Square 56
1903: First Flight 60
1904: Helen Keller 62
1904: Going Underground 64
1906: Mata Hari 66
1907: Tattooed Lady 68
1908: Spear Fishing 70
1910: Ellis Island 72
1910: Paul von Hindenburg 74
1913: Father of Biometrics 76
1913: Prussian Soldiers 78
1916: Charlie Chaplin 80
1916: Lost Tommies 82
1917: Generation Shellshock 84
1917: Anzac Spirit 88
1918: Tarred and Feathered 90
1920: Razer Gangs 92
1922: Prohibition 94
1924: The Last Whalers 96
1930: Al Capone 98

1931: Mahatma Gandhi 100
1931: Aviation Pioneers 102
1933: American Zeppelin 104
1936: Migrant Mother 106
1937: Hindenburg Disaster 110
1939: The World Fair 112
1940: Blitz Kids 114
1941: Airmen of Colour 116
1941: Prosperity 118
1941: Nazi Power 120
1942: Night Witches 122
1943: War in the Desert 124
1944: Female Pilots of WW2 126
1944: Churchill's Tank 128
1944: D-Day at Times Square 130
1944: War in the Pacific 132
1945: Raising the Flag at Iwo Jima 136
1945: Fall of the Reichstag 138
1945: General Patton 140
1945: VJ Day Kiss 142
1946: Atomic 144
1946: Sarah Vaughan 146
1953: The Royal Coronation 148
1954: Marilyn Monroe 152
1958: Escape from Alcatraz 154
1963: Monk Self-Immolation 160
1963: Lee Harvey Oswald 162
1964: Ali meets the Beatles 164
1967: Batman 166
1967: Pops Stars of Liverpool 168
1967: The Monkees 170
1967: Twiggy 172
1967: Jimmi Hendrix 174
1970: Apollo 13 176
1971: David Bowie 178
1972: Bloody Sunday 180
1972: Napalm Girl 184
1974: Nixon and Watergate 186
Biographies 188

FOREWORD

By Jeff Vickers MBE HonsFRPS Fenton Medal Ambassador to The Royal Photographic Society

There are a precious few moments in life that one can remember, and think to ones-self, "that was magical". However, when I first saw colourised historical images, I knew I had felt one of those moments. I was reading the *Daily Telegraph* newspaper, when I was struck by a series of photographic ghosts from the past: veterans of Emperor Napoleon's *Grande Armée*, taken in Paris over 160-years ago and which can be seen later in this book. I had never seen anything like the images of these ancient soldiers before, and I was fascinated by their colourful uniforms, glinting metallic weapons, and stern faces. I called the Telegraph and spoke to the editor on duty to find out how this series of images had been sourced. I was told, the colourised collection had been supplied by press agency Media Drum World, based in Birmingham. I contacted the agency, and the company director and author of this book, Michael D. Carroll, briefed me on the wonderful transformation of historical photography occurring now, I explained that seeing the Napoleonic images had given me that magical feeling of déjà vu. From this initial encounter with colourisation, I was transported back in time to my first moment of photographic magic, when at the age of 15, in a red-lit darkroom I watched my first bromide black and white print appear.

Each page of this ground-breaking book, *Retrographic*, has the power to give rise to this same sense of magic, if one is open to the experience. Ghosts from the past have been brought to life in true colour, through a combination of new technology, artistic craftsmanship, and the age-old method of undertaking historical research. From the history scholar, to the photo-enthusiast who wants to see a collection of the world's finest vintage photography made modern, anyone with an appreciation for photography can gain inspiration, and see the past from a new perspective through the added power of colour. In short, *Retrographic* has something for everyone. Some will even have lived through the historical events represented in the images published here, and would have felt the impact of the original images when they were first published as live news

events. Presenting these history-making images in true colour, allows older readers to experience the emotions of these important moments for a second time, from a refreshed perspective. However, many of these images are so iconic they are instantly familiar to everyone, and we can all enjoy seeing famous images in this new format. Importantly, we can now witness these events as they would have appeared to the photographer who was there taking the picture in the moment, rather than in black and white. In addition, *Retrographic* has the strong potential to connect the younger generation with historical images. Through the added layers of true colour onto the originals, the people and scenes from the past appear to come to life. History itself is made more robust through being interesting to those who come after us. If families of different generations were to sit down together and read this book, a grandparent and a grandchild for example; what an interesting sharing of knowledge would be experienced.

Once the concept of *Retrographic* was fully explained to me, as a photographer who has always been at the forefront of the industry over the past six decades, I was fascinated. I instinctively knew the transformative power of colourisation. In partnership with Ilford Photo, my company ChromaCopy launched the reproduction of colour copy print images made outside of a darkroom but on photographic paper, globally in the 1980's. I later pioneered the digital imaging scene when I subsequently founded Genix Imaging. From my recent exposure to the colourisation technique, as one of the founding fathers of the digital scene, I felt as if my life in photography had come full circle. More importantly, the potential historical value of this process to museums, galleries, private collections is enormous, and needs to be emphasised and an entire historical epoch that was black and white, is now being faithfully reproduced in colour through collaboration across the fledgling colourisation community. In that sense, *Retrographic* is one milestone along a new chapter in the world of photography that is perhaps just beginning, and one I am honoured to be a part of.

INTRODUCTION

What is probably the most famous image of all time, found on the cover of *Retrographic,* is the kissing scene known as, *V-J Day in Times Square*. This evocative and spontaneous capture is a perfect example of how iconic images like this imprint on our psyches in a powerful way, and it is the nature of the photographic medium that this impact is immediate. Without us necessarily knowing the couple were complete strangers celebrating the end of the Second World War, when we gaze on the image we feel the passion of their embrace. The appreciation of the context, once known, only serves to give the image that much more resonance. Through this celebratory image, the author takes pleasure in welcoming the reader to *Retrographic*, where you will find an eclectic selection of the world's most iconic images, transformed from black and white, into living colour. As with *V-J Day in Times Square*, many of these photographs are so famous, they are already indelibly inscribed into our minds, even if we are unfamiliar with the exact context under which they were taken. In fact, we may know nothing of them except the impression they have given us of the scene from the past. However, it would not be an exaggeration to say many of these photographs are so iconic, they are imprinted in our modern collective minds as indelibly as hand-drawn symbols were for the people of ancient cultures.

On the pages of *Retrographic*, the reader will also witness, for perhaps the first time, some of the most striking, but little-known scenes from the past, given the full effect that colour images provide. What both known, and unknown images deliver, is a glimpse as to what the photographers themselves would have seen as they placed their eye against the viewfinder, and decided to take the shot. We are transported backward in time to what photographic master, Cartier-Bresson called the "decisive moment", and by so doing we have the privilege of perhaps not standing on, but rather peering over, the shoulders of giants. The debt owed by those who come afterwards, to these photographers of the past, cannot be overstated. Many present-day photographers, photo-enthusiasts, academics, and readers have a justified love of black and white photography, which is shared by the author, and all the colourisers he has ever worked with. This preference is understandable, because there is an element of seduction in the simplicity of black and white. By presenting the image in a greyscale, the complexity, and distraction, of colour has been stripped back, and the eye is allowed to rest purely on the subject.

The period of history from the invention of photography in the 1820's, to the end of black and white as the leading medium to the early 1970's, is what *Retrographic* refers to as the First Age of Photography. What the author will call the Second Age is the period when colour analogue film photography was the dominant medium from the 1970's to the 2000's, which is not to be confused with early attempts at replicating colour stills through skilled hand-painting onto black and white prints. The author will refer to the epoch we are living in now as, The Third Age of Photography, where digital images taken by camera, smart phones and video stills are the most frequently produced images. Images today are usually shared digitally online, or through SMS text, and other messaging services on our mobile devices, rather than via physical photo-albums, sleeves or having simply being collected in boxes and drawers, as happened more frequently in the past two photographic ages. A crucial point that should be noted from the onset, is that *Retrographic*, and colourisation as an art, is not "at war" with black and white of the First Age. On the contrary, it is wholly dependent on the medium, having only been born as an artform through the love of the originals, and the desire to see them, literally, in a new light. Therefore, instead of being in conflict with black and white, colourisation can be viewed as a bridge spanning from the Third Age, and reaching into the First, perhaps taking inspiration from the colourful Second Age along the way.

We can justify the colourisation by recognising that we share the photographic moment more authentically with the photographer, and the subject, when we view it in colour. Many people express a preference towards black and white for aesthetic reasons, and indeed people, objects, and scenes look excellent when viewed through black and white photography. However, as one of our contributors, Matt Loughrey argues, authentic colour imagery brings us closer to the, "truth", as far as any historical record can be said to recreate the past. Aesthetics is not entirely irrelevant to history, but it is certainly subservient to accuracy, in terms of what the witnesses to history would have seen when the image was taken. War photography, in particular, benefits from colourisation. Uniforms, signals, medals, paintwork all have meaning to combatants during the time of fighting, and we spectators of the present can also profit, if we have the knowledge to decipher these messages from the past. A person's eyes have been famously equated to being, "the gateway to the soul", and eye-colour returns the humanising element. As creatures that see in the colour spectrum, we are hardwired to interpret the world in this most natural of ways. It is in this sense that black and white can be viewed as an artificial filter, that we have gotten comfortable with, and which has layers of psychological baggage attached, being linked with the past, and the sense of what is "vintage", or "retro". We can see this vintage/retro effect immediately through the application of a simple analogue black and white lens filter, or digital post-production filter, over the colour version. Sadly, many people refuse to view black and white movies for precisely this reason, associating them with being old-fashioned, vintage, and therefore unwatchable.

To contemporary eyes, particularly the new generation of digital millennials who have not been raised with colour analogue photography, let alone black and white, the original versions of historical images, no matter how iconic, are more distant, and therefore less accessible. Yet the ever-widening gulf between the post-moderns of digital colour, and the moderns of analogue black and white, has not reduced the capacity of this new generation to recognise the importance of the past, and the photographic legacy of those that went before. In fact, this problem of distance has spawned an answer, by virtue of what is probably the most important cultural phenomenon in history: The Information Revolution, as experienced by humanity now, through the use of the internet. As analogue, that is to say, physical photographic prints, have been digitised and uploaded online, the capacity for these images to be shared across platforms worldwide is dramatically and exponentially increased. Individual web-users have been crucial in the dissemination of digital images; however, institutions have been impressively quick at making their catalogues available to view by the public, which has in turn fuelled informal sharing by bloggers and other web publishers. Not only can we all now consume images at the touch of a keyboard, but we can also manipulate them as never-before through computer applications such as, Adobe Photoshop. Image manipulation software can be used for myriad purposes, from airbrushing the imperfections from the face of a model, to creating fantastical otherworldly vistas that would otherwise exist only in the human imagination. What this software can also be used for is the application of diligent historical research into what a black and white scene would have looked like at the time the image was taken. A disparate, but assiduous, online community dedicated to this aim has sprung up over the past few years, thanks to these technological and cultural breakthroughs.

Retrographic's contributing colourisation artists fall into two camps. The professional colourisers have carved out a living working on the restoration, and colourisation of vintage images for some of the world's most famous galleries, museums, publishers, television networks, as-well-as private individuals. The skilled-hobbyists have plumbed the depths of public museums, libraries, photo-collections, to curate some of the rarest and most eye-opening scenes from the past. Many have come together through the efforts of celebrated British colourist

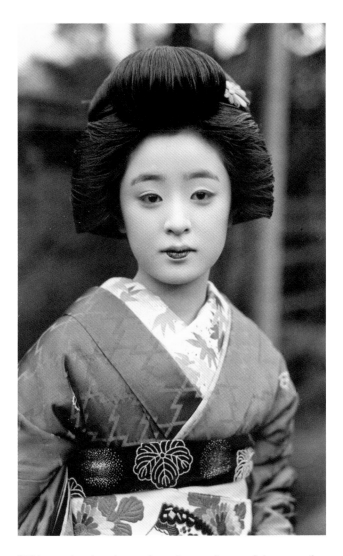 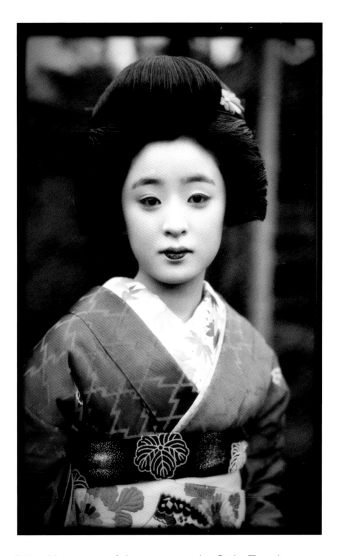

"This resplendent image from Japan of one of the most famous traditional hostesses of this nation, geisha Geiko Tomeko, shows the transformative impact colour provides to the original black and white."

Photograph courtesy of an anonymous private collector, c.1930's

Colourised by Frederic Duriez

Doug Banks, who administers a facebook group called *Colourising History*, where the community shares techniques, and members peer-review each other's work. Here, in additional to providing support, and sharing best practice, the community has a role in ensuring colours are accurate, potential pitfalls are avoided, and debates are hosted around the authenticity, or not, of various subjects. What both professional and hobbyist colourisers share, is a dedicated passion for historical photography, respect for the black and white originals, sympathy where possible for their subjects, and the skill and knowledge to do justice to the, often momentous, material they have worked on, and presented, in a transformative way. One of the contributing colourisers to this publication, the skilled Brazilian artist Marina Amaral, describes this effect eloquently, but succinctly, when she calls colourisation the, "second perspective".

Methods for colourising images vary from artist-to-artist. Each has their own style, approach, and interest that makes them stand out from their peers. Ability, experience, and the sheer time that any group of people can devote to a given work, or pastime, will impact on the quality of what they produce. That being said, there are common processes that are followed by most in the colourisation community. The first step is to choose the image to be colourised. For professionals working on a commission, this part is fairly easy: they want to support their work, so they will colourise what they have been given on behalf of their paying client. This commission could be a family photograph of a long-dead ancestor, or a treasured photo-memory from the past, such as a wedding. Alternatively, the commission could be for a large television network to advertise their latest hit series, or it could be for a museum to give publicity to a new exhibition. For non-commissioned pieces, when pitching feature ideas, "on-spec", to newspapers for example, a careful assessment of the image quality is necessary, both in terms of the sharpness, depth of field, and detail of the original and the resolution of the digital version, which should

not pixilate when "blown up", or zoomed into. A compelling image which speaks to the viewer is almost universally chosen above others, and of course, it is iconic, world famous shots that are the most sought after by many. Some colourists, such as the American *Retrographic* contributor, Patty Allison, are fascinated with transportation and street scenes. Others like Briton Tom Marshall, are on a quest to discover previously uncoloured, but historically important images. Once the image has been chosen, if it is only available in analogue print, then it must be digitally scanned. Most colourisers will then open the black and white digital image on their computer with Adobe Photoshop. They will "paint" colours onto the digital black and white using a mouse on a desktop like any other office-based worker, or by standing with a tablet mounted on a stand with a stylus pen acting as a brush, like a traditional artist. Different layers of colour are applied to the image; many start with the skin of the subjects, and the foreground, and work towards the background, which is generally left for last. The depth of field of the original can therefore be critical in ensuring the colourisation brings out the composition of the image. Many colourists describe glass plate images from the early 1900's as being the best to work with, because of the large size of the glass and long exposure times, which produced highly detailed black and white images with excellent depth of field. Interestingly, colourists report that the skin tones of human subjects have hardly any difference in the Photoshop colour setting between people of difference racial groups. During the colourisation process, a fair white male will, for example, have their skin painted in much the same colour as a black female, or a child from the Far East. It is the original tone of the black and white photograph that makes their skin look different in the resulting colourised image. Perhaps therefore, "skin tone", rather than "skin colour", is a more accurate description of the differences of appearance in the organ that human bodies are wrapped up inside.

So, the colourisation artist has picked their image, decided how to add colour, but how do they know which colours are

correct? How does the colouriser know the Ferrari found in a racing image is red? Should they assume this, and make a choice based on their preference for red sports cars? Or should they use some other method to find out the true colour? The traditional method for reaching authenticity is that which has been honed by generations of researchers: looking at the primary historical sources for evidence. We know, for example, that if we are colourising an image of the Russian, "Mad Monk" Rasputin of the Romanov Tsar's court, we can quickly learn his eyes are blue, and they were said by those who met him to have had a hypnotic quality. Choosing the colour blue is therefore straightforward, but we will need to match the colours to the available light in the scene, and we would spend some extra time ensuring his eyes were suitably mesmerising. However, if we are colourising the paintwork of a Second World War Sherman Tank of the British Eight Army deployed in North Africa in 1941, we should ideally consult regimental records to ensure the colours of the various insignia are correct, because each signal means something different in the military context under which the photograph was taken, and which cannot have been conveyed in the original black and white. The author has been told, a reliable shortcut would be to consult a plastic kit model of the tank in question, where the stickers have been fastidiously researched by the manufacturer to exactly replicate the original WW2 colours. Apparently, BBC television period dramas are also reliable for cross-checking the correct historical colours, because costume staff will have already carefully researched the correct dyes of both civilian and military dress. A contrasting, high-tech method, developed by Ireland-based contributor Matt Loughrey, has been to produce a computer algorithmic code which "learns" the correct colours based on the tonality of the black and white original, and which has been rigorously tested against known image colours for reliability. The "pallet" this algorithm produces is then used as a guide for the colouriser, who will know the "red" Ferrari can be reliably painted red.

In additional to the colourisation technique, the curation process for "second perspective" images we have been able to include in *Retrographic,* deserves some explanation. Because of the way in which photography as a technology was invented in Europe, at a time when European and then Western culture dominated the planet, nearly all the images we see from the "First Age of the Photograph" were taken by Westerners (i.e. mostly, but not all, being men, from Europe, North America and occasionally Oceania). In addition, because of the nationality of the author (British), combined with America's status as the Twentieth Century's sole surviving superpower to date, and the USA's open system for making most publicly-owned images free for use worldwide, the prevalence of English as the modern language of global communication, and the interplay of shared English-speaking culture, in particular that between Britain and America through the ages, has all conspired to pull *Retrographic* towards the Anglo-American sphere of influence. There are simply more iconic and history-making moments from the English-speaking world available for the colourisation community to work with, and the author to carefully curate. That being said, Russian contributor, Olga Shirnina, has pioneered the colourisation of the breath-taking and hugely significant photographic history of her nation, both in the pre-revolutionary Tsarist period, and through to the Communist period of the Soviet Union. French contributor, Frederic Duriez has represented his nation, which pioneered the development of photographic techniques from its earliest stages, through his outstanding colourisation of French First World War scenes. It should also be pointed out that *Anglo-American*, does not equate to *Anglo-Saxon*, as the story of both Britain and America during Photography's First Age was one of rapid social and cultural change. By transformation through warfare, science, technology, economics, and migration, "The West", is no longer a group of homogenous racially white societies, and the seeds of this change lay in the period *Retrographic* is concerned with. The photographic records we discuss is informed by this change.

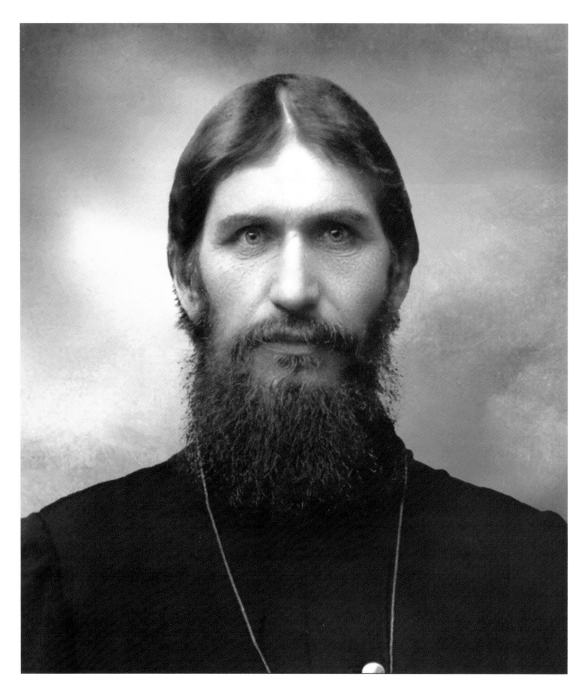

"Rasputin, known as the "Mad Monk", was a mystic, healer, and confident to the Tsar's of Russia, the Romanov family. Rasputin was said to have had a sinister hold over the Romanov's, and was widely blamed for much of the misfortune Russia experienced during the final years of their rule. On December 30th 1916, he was poisoned, shot, thrown from a building, and drowned by a group of angry nobles."

Image c.1910, courtesy of the Moscow Museum of Modern Art

Colourised by Olga Shirnina

Because of the momentous sweep of subjects and events, which *Retrographic* speaks of through colourised photography, when providing a narrative of the images that have been chosen, the author is mindful of the depth of historical analysis that has gone before. The aim of *Retrographic* is not to replicate, or even necessarily move forward this breadth of scholarship, through the medium of words, for the important historical periods we see in this book. Instead we will attempt to move forward though pictures. Learned historians across the decades have devoted their entire careers to discussing the causes of the First World War for example, or examining the impact of the Great Depression on the rise of Nazism in Germany. A cannon of historical text could be pulled up on both these subjects, and like much historiography, a good deal of the arguments presented say as much about the political, social and cultural fixations of the historians themselves, as they do about the events under examination. The author does not claim to be presenting history outside the preoccupations of his particular moment; on the contrary, *Retrographic* unashamedly presents history through the prism of the Twenty First Century culture that has produced it. The author stumbled upon the colourisation movement in his role as an agency journalist, and had he been alive in the 1890's, he might have been working with the hand-painting colourists of that period to produce a very different, Victorian, colour photography tome. Like the captioning system pioneered in the 1930's by documentary photographer Dorothea Lange, and now standard in editorial photography, what the narrative does provide is a context for the images, to allow them to speak for themselves, but also to present them in the most interesting way the author could devise. This means the most appealing facts have been presented, without taking for granted knowledge beyond the basic on the part of the reader in any given subject, and hopefully even providing the knowledgeable historian with some interesting facts to take away, or reconsider in a new light. Because of the unrelated selection of images, the narrative could be regarded as a group of extended picture captions threaded together chronologically across the age. What *Retrographic* is not, is a systematic pictorial survey of the past. The author has avoided jumping forward in history over a set period, with one image per decade for example, or even attempting to arbitrarily address every theme or issue he feels is worthy. Instead, it is the impact of the images themselves that has determined the final selection. The progression of images is chronological, but eclectic: in place of the predictable path through the ages that the systematic approach might have produced, we are transported from moment-to-moment and place-to-place, with each turn of the page providing a fresh surprise.

There are many outstanding images that have been colourised, but have not been possible to include in *Retrographic* for copyright, aesthetic and technical reasons. The project has been dependent on the goodwill, cooperation, and responsiveness of the contributors who have agreed to take part out of a love of history, photography, and a shared desire to inform and inspire. Many beautiful and important images have sadly fallen by the wayside during the process of curating *Retrographic*. Like a botanist on a journey into a newly discovered forest, sometimes the specimens the author could collect, preserve, and transport home, are just a sample of those he encountered along the way. Despite this shortfall, it is hoped that both the iconic and the rare colourised images from the past will inspire and inform the reader. Our journey begins generations ago, with a man who can be said to have *made* American democracy, and ends in the 1970's with a very different man who is remembered for having *unmade* this legacy. What lies between is an image selection of people and moments resurrected, with sympathy, into living colour.

Michael D. Carroll

THE LAST AMERICAN REVOLUTIONARY POSES FOR A PICTURE BEFORE DYING AT THE AGE OF NINETY-NINE

"Capt. Simeon Hicks (1755-1855) Revolutionary War Soldier"

Photographed by James Irving at Sunderland, Vermont, August 16, 1854, image courtesy of the Bauman Family Collection, Salt Lake City

Colourised by Matt Loughrey

The man we see in the image opposite is the most ancient we will be introduced to, having been born 262-years prior to the publication of this book, on August 22nd 1755, in Rehoboth, Massachusetts. This US state, was then one of the Thirteen British Colonies of North America. When we look at the proud face of Simeon Hicks, who was ninety-nine years-old when the image was taken, we are immediately struck by the clarity, and hint of defiance, in his eyes, which witnessed terrifying fighting between his fellow-rebel American militiamen, and the feared British Redcoats. Most notably, he was at the decisive Battle of Bennington on August 16th 1777, exactly seventy-seven years to-the-day that his portrait was captured. When he was tracked down by the photographer James Irving in 1854, Simeon Hicks was probably the oldest, and certainly one of the last American Revolutionary Patriots alive.

Thanks to the thirty-years of investigative research conducted by journalist Joe Bauman and compiled into his book *Don't Tread on Me: Photos and Stories of American Revolutionaries*, we know a good deal about Hicks' exploits. Just months after the famous December 1773 Boston Tea Party protest against British taxation, Hicks joined-up as a minuteman. By so doing, he became one of the men of the colonial militia units that were so well-drilled, they were named for being able to assemble, "at a minute's notice". Once the armed colonial rebellion against British rule began in April 1775, Hicks' first action was to join the rebel forces who were laying siege to the British-occupied city of Boston; the first major engagement of the Revolutionary War. The siege ended with the British having to retreat from the city after suffering artillery bombardment from the emplacement Hicks was stationed at, Dorchester Heights. So impressed was the British Commander, General Howe by the improvised fortification of this position, that he was said to have exclaimed, "My God, these fellows have done more work in one night that I could make my army do in three months".

In addition to meeting the Redcoat invasion of Rhode Island in December 1776, the next significant engagement Hicks took part in was one of the most important for the rebels, the 1777 Battle of Bennington, mentioned above. While on a raiding mission, a "Tory" (loyalist) coalition force of around one thousand five hundred British, Canadian, American loyalists,

Iroquois Native Americans and hired German mercenaries, led by Lieutenant Colonel Friedrich Baum, stumbled upon two thousand rebels under General John Stark. Believing Bennington to be lightly defended, Baum's men were taken by surprise and lost over nine hundred, killed and captured, compared to just seventy killed and wounded on the rebel side. Hicks was personally involved in an action that resulted in the capture of ten men on the Tory side, including one officer. The British Army, which was largely respected as a disciplined fighting force, was discredited for the first time. This boosted support for the rebel cause and played a key role in France intervening against the British on the side of the rebels. Many historians believe American independence would not have been achieved without the support of France. At the time this image was taken, Hicks was the last person left alive to have taken part in this game-changing battle.

After the final American victory over the British in September 1783, the United States soon declared independence, and Hicks settled in Sunderland, Vermont. He became something of a local celebrity. While in service of the militia, Hicks never rose above the rank of Private, so it appears the title "Capt" found in the picture caption was a term of endearment by those who knew him. He married Molly Barney in May 1778, had several children, and lived as a farmer and businessman.

By the 1840's the earliest commercially successful photographs, called *daguerreotypes* (named after French inventor Louis-Jacques-Mandé Daguerre) were made publicly available. The lengthy and expensive process required to produce the final image gave an otherworldly quality that is quite beautiful, as we see in the example opposite. Joe Bauman unearthed the Hicks daguerreotype along with a collection of seven other American Revolutionary images. Bauman was inspired by the work of the Reverend E. B. Hillard, who travelled America after the Hicks image was taken in 1864. Hillard's mission was to capture and interview the last Revolutionary Patriots before they died. The other photographed "Last Men of the Revolution" that have been collected are: Daniel Spencer, Dr Eneas Munson, Peter Mackintosh, James Head, Reverend Levi Hayes, Jonathan Smith and George Fishley.

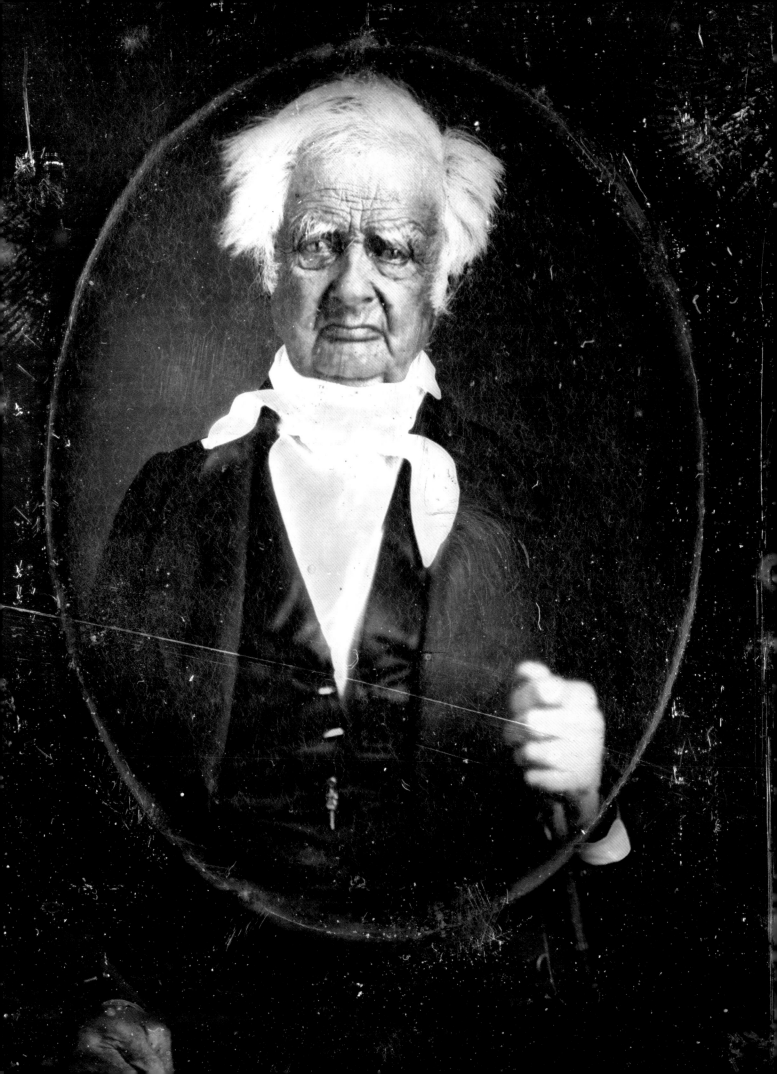

THE LAST NAPOLEONIC SOLDIERS WEAR AUTHENTIC UNIFORMS AS THEY PAY HOMAGE TO THEIR BELOVED EMPEROR

Photographs of Napoleon's Veterans c.1857

Photographs courtesy of Anne S.K. Brown Military Collection, Brown University Library

Colourised by Frederic Duriez

These rare images let us look in the eyes of men who would be notable because they were born two-hundred and thirty years-ago in the 1790's, during the French Revolution, and around the time when the United States became an independent nation. However, in addition, these old men in their antiquated uniforms were veterans who fought alongside one of history's most famous military leaders, Napoleon Bonaparte. This handful of Napoleonic soldiers survived long enough to see photography invented and pose for the camera before they passed away. We therefore have sight of the only known images of Napoleonic soldiers bearing the original arms and wearing the authentic uniforms of the wars they fought in on behalf of their Emperor.

We see elaborately-dressed and moustached Monsieur Maire, who served from 1809 to 1815 in the 7th Hussars, a cavalry regiment that fought the final Waterloo campaign, and the goateed Monsieur Moret sitting with his sabre across his lap, who was with the 2nd Regiment from 1814 to 1815. Quartermaster Fabry of the 1st Hassars stands with sabre drawn. Sergeant Taria, of the Imperial "Old Guard" Grenadiere de la Guard, from 1809 to 1815, will have stood as a personal guard with Napoleon during all his most decisive battles.

The exotically-dressed Monsieur Ducel cuts the most striking figure. He was one of two thousand Greek, Turkish and Armenian mercenaries Napoleon purchased from Syrian merchants, many of whom served as a special foreign corps in his Egyptian campaigns. They were armed for close quarters combat with a pair of pistols, a curved sabre, dagger, mace and battle axe. Sergeant Lefebre was with the 2nd Regiment of Engineers in 1815.

Napoleon is considered one of history's greatest military geniuses. He rose up the military echelons during the campaigns of the French Revolutionary wars, and became Emperor of France from 1804 to 1814. During the Napoleonic Wars of this decade, France fought five wars, with conflicts that raged across Europe, the Americas, Africa and Asia, most of which were decisively won by his forces. He was opposed by a shifting coalition of Prussian, Russian and other European powers headed by Britain. While he was eventually defeated by a British Armada, led by Lord Admiral Nelson at the Battle of Waterloo, where Nelson was killed, Napoleon's legacy preserved the French Empire for over a century. His leadership lead to the collapse of the Spanish Empire, bolstered the embryonic American nation, spread liberalism and French culture across the planet, saw Prussia rise as a military power, and allowed the British Empire to consolidate its grip on global trade and expand territorially into the 20th Century.

Probably taken in Paris on the anniversary of Napoleon's death on May 5th of 1857 or '58, these images were acquired by Baltimore military memorabilia collector Anne S.K. Brown in 1945. They show men who embody the French *espirit de corps* (military spirit) of honour, valour and self-sacrifice. Each year during the first half of the Nineteenth Century, a dwindling number of Napoleonic soldiers made a pilgrimage to pay homage to their beloved General and Emperor of France. The men we see pictured were celebrated as heroes of France, in a similar way to the manner in which the last of the Allied Second World War veterans are venerated today in the press, and esteemed in the popular imagination.

It has been verified by the Brown Military Collection, that the uniforms being worn are authentic, but have been tailored in places to achieve a mid-19th Century cut. It is also noted that the men must have been at least seventy or eighty years old, and from the blurred aspect of some of the portraits, are likely to have had difficulty in standing still for the time that it took for the image to affix itself to the photographic plate. We learn of the men's name, by handwritten pencil notes, on the reverse side of each of the original twelve-by-ten inch card mounts for the photographs.

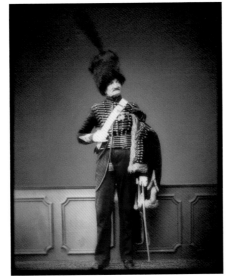
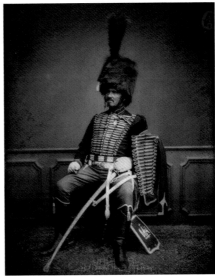

The reason why we would place the images from 1857 onwards, is that all the veterans pictured were wearing France's first campaign medal, the Saint Helene Medal, established on that year by Napoleon's nephew, Emperor Napoleon III, to recognise the men of his uncle's *Grande Armée*. It was named after the island of St Helena, the British-controlled Atlantic island off the coast of Africa, where Napoleon was exiled after his defeat, and where he died in 1821, aged 52. The reverse of the medal is an inscription in French, which reads: *"A ses compagnons de gloire sa derniere pensee St Helene 5 Mai 1821"*, which translates as: "To his companions in glory his last thought St Helena 5 May 1821."

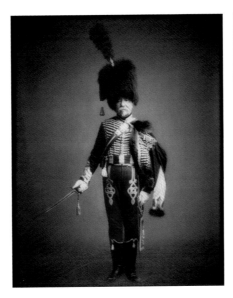
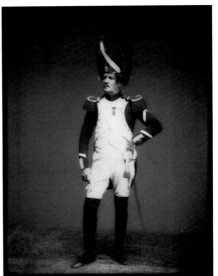

From top left to bottom right: Monsieur Maire - 7th Hussars, Monsieur Moret - 2nd Regiment, Quartermaster Fabry - 1st Hussars, Sergeant Taria - Grenadiere de la Garde, Monsieur Ducel -Mameluke de la Garde, Sergeant Lefebre - 2nd Regiment of Engineers.

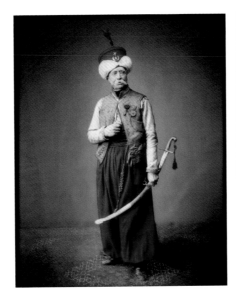
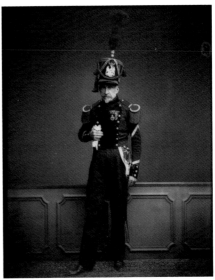

MEET THE MAN WHO CONDUCTED THE FIRST ACTION TO MERIT AMERICA'S HIGHEST MILITARY AWARD: THE MEDAL OF HONOR

"Private F. E. Brownell, 11th New York Infantry, 'Ellsworth's Avenger'"

Photographer unknown, taken in 1861, image courtesy of Library of Congress

Colourised by Mads Madsen

Standing with a bayonet fixed to his rifle, hand resting gently on his scabbard and posed while standing on what is possibly an enemy Confederate flag, this picture shows the impressively uniformed man credited with conducting the first action in history to merit America's highest military award, the Medal of Honour.

When America descended into Civil War in April 1861, Francis Brownell enlisted in the Union's 11th New York Volunteers, known as the "Fire Zouaves". Modelled on French units of North Africa, the American *Zouave* units borrowed the Algerian tribal dress of their French counterparts, which is why Brownell's uniform looks so impressively exotic, with its open jacket and baggy pantaloons. The red cap and collars which strikingly contrast with the blue Union colours provide the element of "Fire" to the *Zouaves* uniform and honoured the origins of volunteers: they were recruited from the ranks of New York's firemen.

Brownell was under the command of Colonel Elmer Ellsworth, a popular military figure and friend of President Lincoln. The *Zouares* were stationed in Washington when on May 23rd 1861, Virginia seceded from the Union and a state of a war therefore existed between that state and the North. Only the Potomac River separated Ellsworth from Virginia, and on the morning of the following day he led his men across into what had become enemy territory.

The *New York Times* reported how the *Zouaves* landed in good order, with each company assembling on the street facing the river. Colonel Ellsworth and his detachment proceeded in double quick time up the street. They marched three blocks, when Ellsworth spotted a large Confederate flag flying from an inn called the Marshall House, which was kept by a J. W. Jackson. It was reported that Ellsworth entered the hotel, and seeing a man in the hall asked, "Who put that flag up?" The man answered, "I don't know; I am a boarder here." Ellsworth, along with the chaplain of the regiment, Lieutenant Winser, a volunteer aide called Mr. House, and the four privates, including Brownell went up to the roof. Ellsworth cut down the flag.

As the party of soldiers left the attic of the house, the man who had said he was a boarder, but later turned out to be the landlord, Jackson, appeared in the hallway. He carried a double-barrelled gun, which he pointed at Brownell. Brownell apparently "struck up the gun with his musket", at the very moment Jackson pulled both triggers. The shots struck Ellsworth, between the third and fifth ribs, as he was in the process of rolling up the flag. He had time to exclaim "My God", before he fell forward on the floor of the hall and died. The account from the New York Times paints Brownell's response as both swift and decisive: *"Private Brownell, with the quickness of lightning, leveled his musket at Jackson and fired. The ball struck Jackson on the bridge of the nose, and crashed through his skull, killing him instantly. As he fell Brownell followed his shot by a thrust of his bayonet which went through Jackson's body."*

It is possible that what Brownell is pictured standing on with his left foot, is the actual Confederate flag his unit was ordered to remove from the flagpole of the Marshall House Inn, which led to the death of his commanding officer and his subsequent action and award. Ellsworth had the dubious honour of becoming the first man to be killed on the Union side during the American Civil War. Brownell, now affectionately known as, "Ellsworth's Avenger", won an officer's commission to first lieutenant, but was not immediately promoted.

In fact, the decoration we now know as Army Medal of Honor was not approved by Congress until the following year, so Brownell missed out, and had to appeal on three occasions to have his action awarded. On the third attempt his request was granted. After the war Brownell retired from the Army and worked at the Pension Office in Washington DC. He died on March 15th 1894 aged 54.

Brownell's Medal of Honor citation reads:
"Rank and organization: Private, Company A, 11th New York Infantry. Place and date: Alexandria, Va., May 24, 1861. Entered service at: Troy, N.Y. Birth: New York. Date of issue: January 26, 1877. Killed the southern sympathizer who shot Colonel Elmer E. Ellsworth at the Marshall House Alexandria, Va., after that state had declared its secession from the Union."

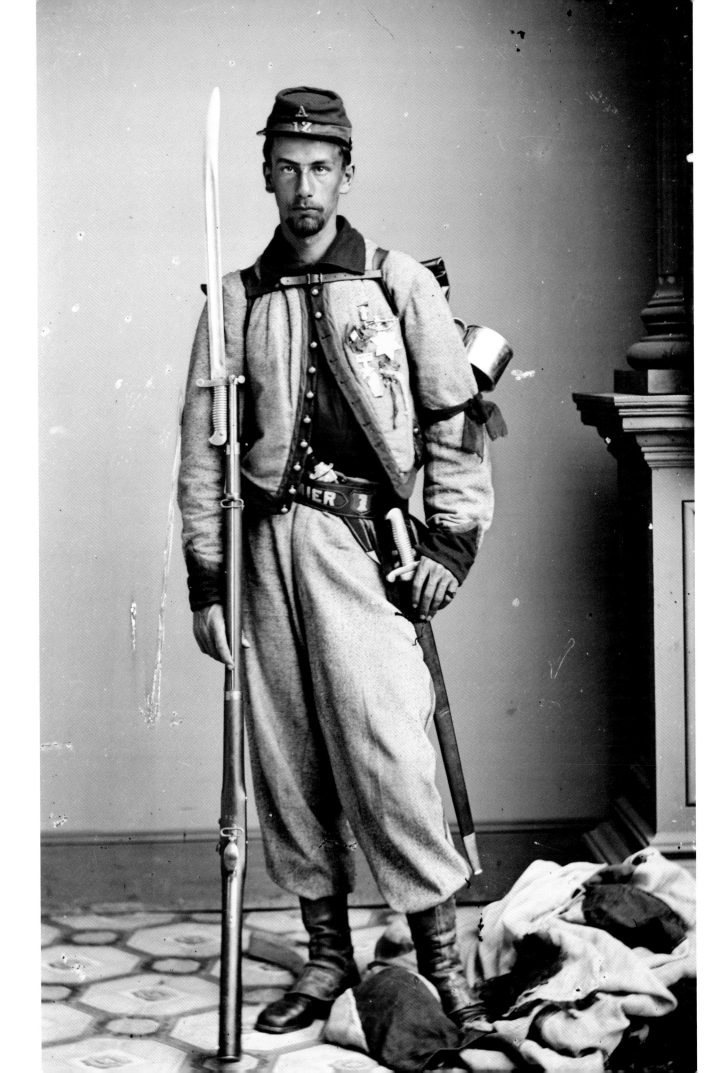

CUSTER'S FAMOUSLY GLORIFIED "LAST STAND" IS ACTUALLY A STRAIGHTFORWARD SLAUGHTER

"The Peninsula, Va. The staff of Gen. Fitz-John Porter; Lts. William G. Jones and George A. Custer reclining"

Photographed by James F. Gibson on May 20th 1862, image courtesy of Library of Congress

Colourised by Mads Madsen

In keeping with the Nineteenth-Century requirement to stand to attention for the camera to accommodate the time needed to create a photograph, here we see pictured the stern staff soldiers of Union general, Fitz John Porter, including a young then-Lieutenant George Armstrong Custer, pictured next to what looks like a fell terrier. The image was taken at the beginning of the career of the American military giant, Custer, whose, "Last Stand", was so famous it came to completely overshadow what was otherwise a celebrated record of military achievements. Custer fought during the Civil War against the Southern Confederate States, and the "Indian Wars", as the battles between Native American tribes and the US Army was generally known. At the time of his death, Custer was lionised as a patriotic martyr who sacrificed himself, to defend civilised settlers against the savage warriors who were trying to kill them. Even today, the myth of how Custer rallied his severely outnumbered troops in the face of certain death, has made this war leader the epitome of American military courage under adversity.

Born in Rumey, Ohio, Custer entered the military academy, West Point at the age of eighteen, and after serving with distinction as a cavalry officer, by the age of twenty-three, he was the youngest brevet (specially promoted) brigadier general in the Union Army. By the end of the Civil War, he was returned to the rank of Captain, and was deployed in the Great Plains to support US settlers who were in a state of hostilities with the native tribes of that region. A courageous soldier, and a maverick to say the least, the controversial Custer had been disciplined for leaving his unit to see his wife, without having located an army scouting party that was later found dead. By 1874, he violated treaties with the Lakotah, prohibiting the prospecting for gold in South Dakota's Black Hills, which were sacred to the tribes. The gold rush that ensued antagonised the local Lakotah warbands, and when they clashed with settlers, US punishment for the reprisals led to Native Americans being restricted to their reservations by lethal force. A state of open warfare soon existed between the two parties.

General Custer's nemesis, the Lakota spiritual leader and warrior, Sitting Bull had attended the Sun Dance, a gathering of tribes, where he had a series of visions, which included "soldiers falling into his camp like grasshoppers from the sky". This was interpreted as a prediction of a great military victory over the United States. Sitting Bull met Custer's forces at Little Bighorn on June 25th 1876. Custer had six hundred and forty-seven men under his command, and Sitting Bull had a cross-tribal alliance of up to two thousand five hundred men, although accounts of the Native American strength varies widely. Despite reports in the press of their bravery, Custer and his men were slaughtered. The public outcry was so intense, and the US government response so harsh, that the military was able to decisively suppress any future armed resistance by the tribes.

An Arapahoe warrior called Waterman, gave his eyewitness account of Custer's death to a Colonel Tim McCoy in 1920, which is in total contrast to the mythology that surrounds Custer's last moments:

"The soldiers were on the high ground, and in one of the first charges we made a Cheyenne Chief named White Man Cripple [AKA Lame White Man] was killed. Two Moon then took command of the Cheyennes and led them all during the fight. During the earlier part of the fight, I was with some Indians in a small gulch below the hill where the soldiers were, but later we moved up the hill and closed in on the soldiers. There was a great deal of noise and confusion. The air was heavy with powder smoke, and the Indians were all yelling. Crazy Horse, the Sioux Chief, was the bravest man I ever saw. He rode closest to the soldiers, yelling to his warriors. All the soldiers were shooting at him, but he was never hit. The Indians on horseback had shields and rode on the sides of their horses so the soldiers could not hit them. The soldiers were entirely surrounded, and the whole country was alive with Indians. There were thousands of them. A few soldiers tried to get away and reach the river, but they were all killed. A few did get down to the river, but were killed by some Indians there. The Indians were running all around shooting and yelling, and we were all very excited. I only know of one soldier that I killed. It was just at the last of the fight when we rushed to the top of the hill and finished all that were still alive. I killed him with my gun, but did not scalp him because the Arapahoes do not scalp a man with short hair, only long hair.

"When I reached the top of the hill I saw Custer. He was dressed in buckskin, coat and pants, and was on his hands and knees. He

had been shot through the side and there was blood coming from his mouth. He seemed to be watching the Indians moving around him. Four soldiers were sitting up around him, but they were all badly wounded. All the other soldiers were down. Then the Indians closed in around him, and I did not see any more. Most of the dead soldiers had been killed by arrows, as they had arrows sticking in them. The next time I saw Custer he was dead, and some Indians were taking his buckskin clothes. … I saw many soldiers who were scalped, but do not know whether Custer was scalped or not, because I went back across the river to camp after the fight was over.…

"The white people believe that there were a great many Indians killed in this fight. I only know of six Cheyennes and six Sioux who were killed. There were many wounded. That night we stayed in the Sioux camp, but the next night, after it was dark, Yellow Eagle, Yellow Fly, Well-Knowing One [Sage], Left Hand and I crawled out under the side of our wickiup, mounted ponies, slipped out of camp and rode on around the foot of the mountains back to Fort Robinson.

"That was many moons ago, and since then great changes have come upon us. The buffalo are all gone, and the Indians who once roamed these plains and were happy, are now held on reservations as wards of the government. My people are very poor, and sometimes have not enough to eat. Of the five Arapahoes who were in the battle of the Little Bighorn, only Left Hand and I, Waterman, are now alive. We are old men now, and soon we too must pass over to the great mystery. That is why I have told you this story."

THE FIRST PHOTOGRAPH TO IMPACTFULLY DOCUMENT THE HORROR OF WAR IS TAKEN

"Plate 36. Incidents of the War. A Harvest of Death"

Photographed by Timothy H. O'Sullivan, July 1863, image courtesy of Library of Congress

Colourised by Mads Madsen

Uniformed bodies splayed out under an unforgiving sky, limbs twisted unnaturally, with the contorted faces of the fallen soldiers testament to their agonising final moments, the *Harvest of Death* is regarded as the first significant image to depict the full horror of war. Details such as the way the bodies are spread out in clusters show how they were mown down by enemy action, a cavalryman in the distance who resembles a Horseman of the Apocalypse appears to be standing guard, yet the bare feet of the dead soldiers indicate the bodies had nevertheless been looted by members of the victorious side.

Captured by Irish-American photographer Timothy H. O'Sullivan at what historians describe as the turning point of the American Civil War, the Battle of Gettysburg saw a previously unknown level of carnage. Bitter fighting with swords, guns and artillery causing both sides to sufferer up to fifty thousand casualties, with ten generals killed. An estimated twenty-eight percent of Union Army of the Pontomac led by George G. Mead, and thirty-seven percent of Confederate Army of North Virginia, under General Robert E. Lee, were recorded as wounded, captured, killed or missing.

O'Sullivan's Gettysburg image, and others he and fellow photographers took during the conflict were compiled into the book by the Scottish-American Alexander Gardner, which became the seminal visual record of the Civil War. His 1865-66 *Gardner's Photographic Sketch Book of the War* was the first publication of its kind in the world.

Gardner was at pains to impress on the reader the futility of war, but from a pro-Union perspective, as shown by his text, which accompanied the *Harvest of Death* image:

"Slowly, over the misty fields of Gettysburg -- as all reluctant to expose their ghastly horrors to the light -- came the sunless morn, after the retreat by Lee's broken army. Through the shadowy vapors, it was, indeed, a "harvest of death" that was presented; hundreds and thousands of torn Union and rebel soldiers -- although many of the former were already interred -- strewed the now quiet fighting ground, soaked by the rain, which for two days had drenched the country with its fitful showers.

"A battle has been often the subject of elaborate description; but it can be described in one simple word, devilish! and the distorted dead recall the ancient legends of men torn in pieces by the savage wantonness of fiends. Swept down without preparation, the shattered bodies fall in all conceivable positions. The rebels represented in the photograph are without shoes. These were always removed from the feet of the dead on account of the pressing need of the survivors. The pockets turned inside out also show that appropriation did not cease with the coverings of the feet. Around is scattered the litter of the battle-field, accoutrements, ammunition, rags, cups and canteens, crackers, haversacks, &c., and letters that may tell the name of the owner, although the majority will surely be buried unknown by strangers, and in a strange land. Killed in the frantic efforts to break the steady lines of an army of patriots, whose heroism only excelled theirs in motive, they paid with life the price of their treason, and when the wicked strife was finished, found nameless graves, far from home and kindred.

"Such a picture conveys a useful moral: It shows the blank horror and reality of war, in opposition to its pageantry. Here are the dreadful details! Let them aid in preventing such another calamity falling upon the nation."

Gardner represents the Confederate soldiers he says feature in the images as having died fruitless and tragic deaths that was "the price of their treason". However, an inspection of the colourised image opposite shows the colourist has made the uniforms of the dead soldiers Union blue as opposed to Confederate grey. Later analysis of the image by historians has pointed to the diamond shaped badges, worn in fact by Union soldiers and bear close similarities with O'Sullivan's Plate 37. Gardner describes these as Union soldiers, but from the placement of their limbs and the bodies positions compared to each other, these men are now regarded as the very same soldiers we see in Plate 36, but are described as Confederate, captured from the opposite angle.

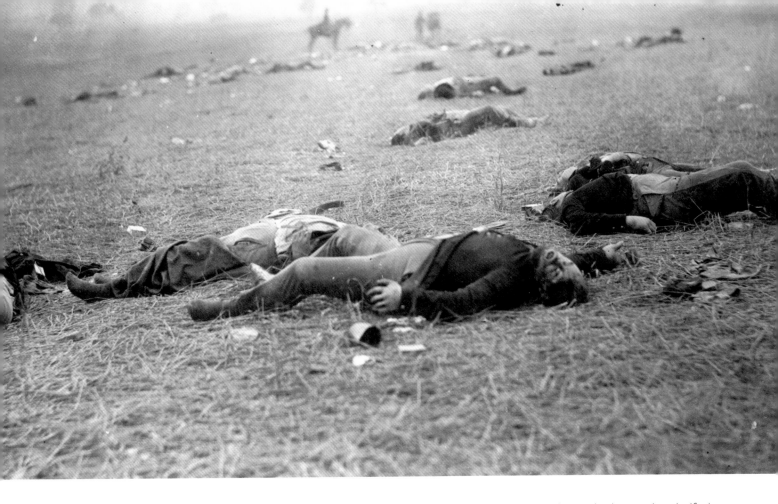

Here is Gardner's interpretation of this second image, which, given the true subjects of the photograph, would be more fittingly applied to the Harvest of Death image:

"The dead shown in the photograph were our own men. The picture represents only a single spot on the long line of killed, which after the fight extended across the fields. Some of the dead presented an aspect which showed that they had suffered severely just previous to dissolution, but these were few in number compared with those who wore a calm and resigned expression, as though they had passed away in the act of prayer. Others had a smile on their faces, and looked as if they were in the act of speaking. Some lay stretched on their backs, as if friendly hands had prepared them for burial. Some were still resting on one knee, their hands grasping their muskets. In some instances the cartridge remained between the teeth, or the musket was held in one hand, and the other was uplifted as though to ward a blow, or appealing to heaven. The faces of all were pale, as though cut in marble, and as the wind swept across the battle-field it waved the hair, and gave the bodies such an appearance of life that a spectator could hardly help thinking they were about to rise to continue the fight."

Gardner's pioneering use of photographs for war propaganda is not unexpected and the technique of employing photography as propaganda flourishes to the present day. He was documenting war, but as a Yankee entrepreneur publishing shortly after the war was won by the North, Gardner's primary motivation will have been to sell as many copies of his *Sketch* as possible. A patriotic message will certainly have equipped the

American public, who were used to seeing images that glorified combatants, a means to process a shocking image of death. Gardner's morality message will have protected him against accusations that the *Harvest of Death* was not gratuitous, but instead he could argue the image was one that all should look upon and consider.

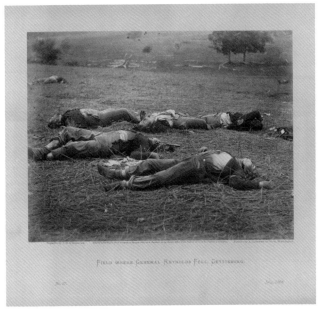

FIELD WHERE GENERAL REYNOLDS FELL, GETTYSBURG.

AFTER A FAILED PLOT TO DESTROY THE UNITED STATES OF AMERICA -THESE ENEMIES OF THE STATE FACE THE HANGMAN'S NOOSE

"Conspirators Lewis Payne, David E. Herold, Edman Spangler seated and manacled, Samuel Arnold un-manacled, April 1865, Washington Navy Yard, District of Columbia, USA."

Photographed by Alexander Gardner, image courtesy of Library of Congress

Colourised by Mads Madsen

Looking pensive and haunted, these prisoners were facing trial for the ultimate crime against the state: joining the conspiracy to assassinate its leader. We can only imagine the thoughts that were running through the minds of these Southern agents as they contemplated the trial that lay ahead. The ultimate sanction was death by hanging should they be found guilty by a jury made up of military officers from the enemy Northern side of the American Civil War. Cutting a dashing figure despite his perilous situation, we see "Lewis Payne" (real name Lewis Powell, which he shall be henceforth referred to as), a Southern veteran of Gettysburg, Confederate Secret Serviceman, and would-be assassin. His pose looks incredibly modern, at odds with the wooden stance most Nineteenth Century subjects took. The other three conspirators look understandably anxious. With metallic sheeting in the background, it is likely these images were captured while the prisoners were confined in the ships *U.S.S Montauk* and *Saugus*.

After four-years of leading the Union forces during the American Civil War, by April 14th 1865, President Abraham Lincoln was on the cusp of having successfully preserved the United States as a single nation. Just five days previously, General Robert E. Lee had finally surrendered the last significant Confederate force, the Army of North Virginia, to Lt General Ulysses S. Grant at the Battle of Appomattox Court House. Victory was assured and Lincoln was already lauded as the man who had led America through its most challenging chapter since Independence from Great Britain. Yet, according to his friend and Marshall of the District of Columbia, Ward Hill Lamon, the President had been a troubled man. Lamon recorded a conversation three-days earlier, where Lincoln described how he was being haunted in his dreams by a fearful premonition of encountering a dead body with its face covered, surrounded by guards and a throng of weeping mourners. "Who is dead in the White House?" Demanded the dreaming Lincoln of one of the soldiers, "The President," answered the soldier, "he was killed by an assassin." Then came a loud burst of grief from the crowd, which woke Lincoln from his dream. The President apparently slept no more that night and described how he was, "strangely annoyed by (the dream)."

What Lincoln perhaps suspected, but could not have known for a fact, was that the group that would conspire to assassinate him had been formed months ago. They were diehard Confederates, including the ringleader who was a man Lincoln personally admired and had invited to visit him at the White House on several occasions. Nationally famous stage actor John Wilkes Booth from Maryland was a proud Southerner and Confederate supporter, who assembled the group of conspirators. It was Lincoln's orders to halt prisoner exchanges between the two warring sides, which was intended to hit the manpower-starved South the hardest of the two, that galvanised Booth into taking his desperate conspiracy forward.

Booth's original intention was to kidnap Lincoln, and ransom him back to the Union in exchange for the prisoner swaps to be re-imposed. However, with Lee's surrender, it was obvious further exchanges would be fruitless in furthering the Confederate cause. The kidnap was the only stage conspirator Samuel Arnold (pictured) was involved in – he dropped out of the conspiracy after this time. Booth, however, believed the continuity of the United States would be irreparably damaged by killing the three most senior Union politicians, Lincoln, Secretary of State William H. Seward and Vice President Andrew Johnson.

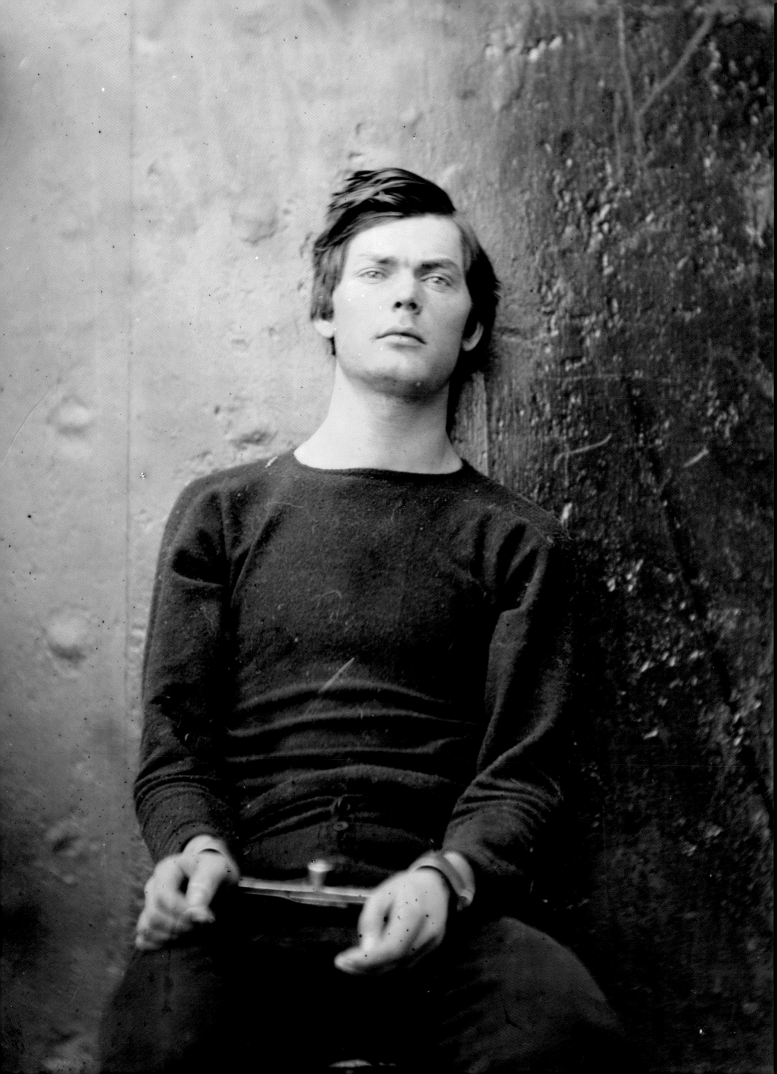

On the morning of Good Friday April 14th, Lincoln, according to his wife and other sources, woke up in uncharacteristically good spirits, and decided to celebrate the end of largescale fighting by attended a comedy *Our American Cousin,* which was playing at Washington DC's Ford Theatre that evening. General Grant was also due to attend the play and was included in the list of targets, however his last-minute change of plans at the insistence of his wife kept him out of the firing line. Others in Lincoln's inner circle, including his own wife and his bodyguard, warned him against attending, but the President insisted.

Meanwhile that morning, Booth, who had a mailbox at the Ford Theatre, heard from the owner John Ford that the Lincolns would be attending. The actor, who had performed in the theatre on numerous occasions and knew the layout well, immediately put his plans for killing the President into effect, with the assistance of local boarding lady Mary Surratt, who may or may not have known that the weapons and ammunition she was harbouring on behalf of Booth was to be used for the assassination. Actor William Henry Hawk was on stage that evening. His statement of what he witnessed after the third act was recorded just a few hours after the event. Hawk described how he was on the stage at the time of the shooting, with his back towards the Presidents box, when he, *"heard something tear and somebody fell and as I looked towards him he came in the direction in which I was standing and I believe to the best of my knowledge that it was John Wilkes Booth."*

Booth had entered the Presidential balcony, raised his Derringer pistol to the back of Lincoln's head and fired one round. Accounts of what Booth said vary, some claiming he cried *"Sic Semper Tyrannis!"* (Thus always to tyrants!), "The South is Avenged!", "Revenge for the South!" or "I have done it!". Major Rathbone, who was sharing the Presidential balcony along with his wife, jumped up and attempted to tackle Booth. However, the assassin produced a dagger and slashed Rathbone across the arm, before Booth caught his spur on a curtain and injured his shin. The round Booth fired, entered Lincoln's skull behind his left ear. The President received medical care immediately from a young army doctor called Charles A. Leale, who inserted his finger into the bullet wound where he found the round had entered the brain. He determined the wound was a mortal one. Lincoln was taken to a nearby boarding house and survived several hours before dying in agony at twenty-two minutes past seven in the morning of the following day.

Booth escaped, possibly with the assistance of stage hand Edmund Spangler who we also see pictured, and spent the next twelve days on the run. His co-conspirators were not so successful. Powell was guided by David E. Herold, to the home of his target, Secretary of State Seward, who was bedridden while recovering with a broken jaw and arm caused by an accident in his carriage. Armed with a Whitney revolver and bowie knife, Powell talked his way past the family butler with a story about delivering medicine for Seward. Powell was met on the stairs to the bedroom by Seward's son, Assistant Secretary of State Frederick W. Seward, who was suspicious and tried to convince Powell to leave. However, Seward's daughter, Fanny Seward opened the door to the bedroom and said, "Fred, Father is awake now." Powell made as if to leave, before turning and placing his pistol to Frederick Seward's head and pulling the trigger. The weapon misfired, so Powell bludgeoned him across the head until Frederick Seward was unconscious. Drawing his knife, Powell entered the darkened room, threw Fanny Seward to the floor and began slashing his target, the Secretary of State about the face and neck. Another son of Seward, Augustus, had also been in the room asleep, and along with a guard, Sergeant Robinson, they all attempted to overpower Powell, but he resisted and stabbed each of them. Powell eventually fled after Augustus pulled out a pistol. As he left the household, Powell stabbed a messenger who had just arrived in the back, paralysing him, before shouting "I'm mad, I'm mad" and riding off on the horse that had been left behind by Herold, who had already fled the scene to meet with Booth.

The third failed assassin, George Atzerodt, was tasked to kill his quarry, Vice President Johnson at his room at the Kirkwood House in Washington. Instead Atzerodt seems to have waited at the bar, had a few drinks before losing his nerve. He wondered the streets of Washington into the early hours before reaching a boarding house and falling asleep. The alarm was soon raised, and one of the largest manhunts in US history was mounted to find the assassins. This involved over ten thousand troops and rewards of $10,000 (equivalent to over $1.5million in 2017) for the capture of the Confederate attackers. Despite having crossed the Potomac River into what had previously been Confederate territory, after two days Booth and Herold were surrounded by Union soldiers at the barn they had been sleeping in. Herold surrendered after the solders threated to set fire to the barn, Booth refused, declaring, "I would not be taken alive", before attempting to escape the rear of the barn armed with a rifle and pistol. Sergeant Boston Corbett spotted him and fired one shot into the back of Booth's head, just an inch below the spot where the assassin had shot Lincoln. He was laid onto his back by the soldiers, and said, "Tell my mother I die for my country."

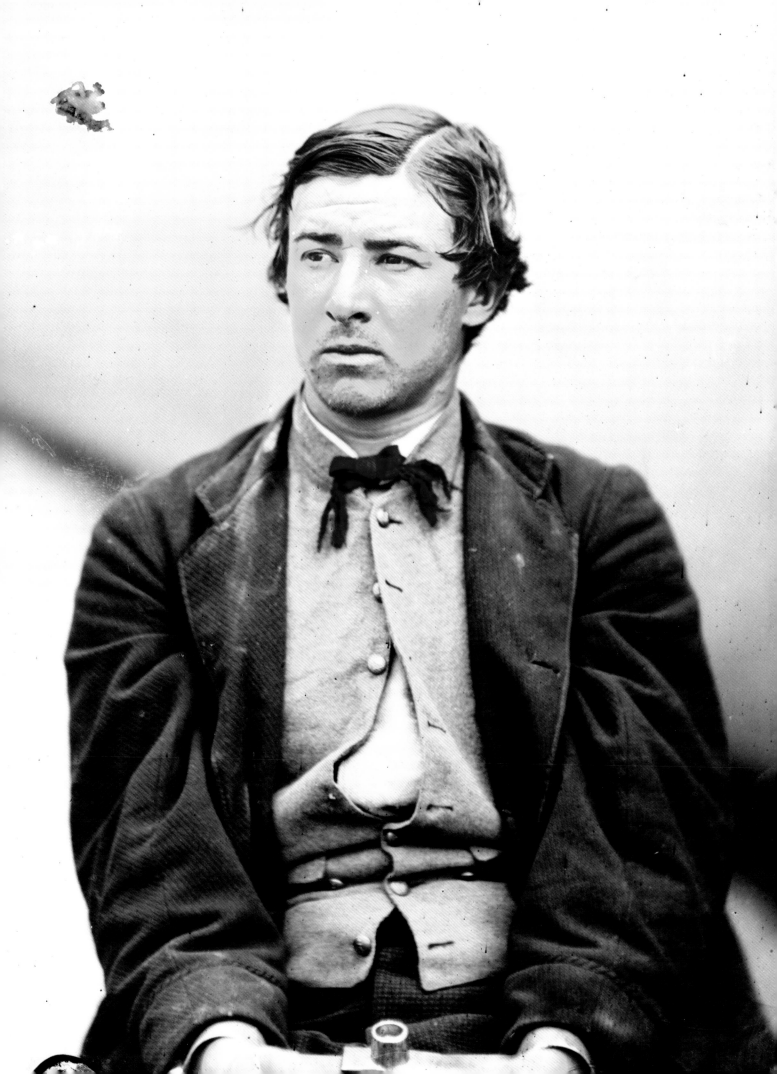

Powell, who had been abandoned by his guide, Herold, was left to wonder the city for three days before he eventually found his way back to Mary Surratt's house, where he was arrested. Surratt's son and Confederate courier-spy John Surratt Jnr managed to flee the country. George Atzerodt was arrested at his cousin's farm on April 20th. The majority of the conspirators were held on naval ships to prevent rescue attempts. Of the press, only renowned Civil War photographer Alexander Gardner (who also published the famous *Harvest of Death* image mentioned previously) was permitted to visit the prisoners. During Powell's captivity, it was reported by some that he appeared to have been suicidal and was possibly insane, while other accounts held that he was "manly and stoic". As the most central surviving conspirator, the authorities relentlessly questioned him about his role and other crimes he may have been part of or had knowledge of.

This image opposite shows, from left to right, Mary Surratt (sitting in the traditional "place of honour" for a hanging), Lewis Powell, George Atzerodt, and David Herold being taken to the scaffold on July 7th 1865. They were led by Captain Christian Rath, who we see adjusting the ropes in his white jacket and light hat. The condemned had endured three-months of captivity which saw them each manacled, chained to an iron ball, with heads covered by heavy leather suicide-proof hoods, before their seven-week trial, with the bitter news at the end that they were sentenced to death by hanging. In particular, an appeal for clemency on behalf of Mary Surratt was raised by her fellow conspirators, who maintained that she was wholly ignorant of her role in the assassination. The wider public joined these calls for clemency, as-well-as, interestingly, the jurors who had sentenced her to hang. The appeal was sent to President Johnson, but he declined to halt the execution. Surratt would become the first woman to be hanged by the courts of the United States.

The trial, under military jurisdiction, was controversial in that the defence for the accused was not given time to prepare, the accused were forbidden from testifying in their own defence, a lower level of proof was required to convict than in civilian courts, and only a majority verdict among jurors was required for the death sentence to be imposed. The Southern states accused the North of imposing a military trial to avoid the opportunity for civilian jurors to show clemency towards the accused. Samuel Arnold was given a life sentence, and Edmund Spangler received six years, insisting throughout his life he was innocent except for having been asked to hold Booth's horse on the fateful night of Lincoln's death. Powell's last actions centred around drafting statements for President Johnson on the innocence of Surratt and Atzerodt, and offering regret at having been part of the conspiracy, while maintaining that he had acted as a soldier.

Gardner's photograph shows how the four doomed conspirators were watched by dozens of Union soldiers and officers at the Old Arsenal Penitentiary, which lies as the Potomac and Anacostia Rivers meet. Outside the frame of the shot, around one thousand onlookers attended. As the condemned stood atop the twelve-foot-high gallows that had been specially constructed for them, the day reached an uncomfortable thirty-eight degrees Celsius. Their hands and feet were bound and white hoods were placed over each of their heads. Surratt's family, who were present, still held out hope that her sentence would be commuted at the last minute. General Hartranft read the death warrant, before each of the condemned asked a minister to step forward, who spoke on their behalf, offering thankfulness for their care and forgiveness to their executioners. Powell was reported to have said, "Mrs Surratt is innocent. She doesn't deserve to die with the rest of us." After the hood was put over his head, Powell was the first of the group to have a noose placed around his neck. He asked that it was firm under his chin. Captain Roth said to him, "I want you to die quick, Payne", to which Powell replied, "You know best Captain." His last words, which he whispered to Roth were, "I thank you, goodbye."

The night before his execution, Powell informed Reverand Abram Gillette that his favourite hymn was *The Convert's Farewell*. Perhaps he remembered the words of the hymn in his final moments:

> *Farewell, farewell to all be-low*
> *The Saviour calls, and I must go*
> *I launch my boat up on the sea*
> *This land is not the land for me*

The prisoners stood for ten seconds, before Roth clapped his hands and four soldiers below the scaffold knocked out the supports for the platform the condemned were standing on. They dropped, with Surratt's rope snapping cleanly, with no movement reported after this. Atzerodt heaved before falling still, but Herold and Powell, the chief conspirators, were strangled for five minutes before they died. Powell struggled wildly, pulling his legs up in towards his chest several times, before he was eventually still.

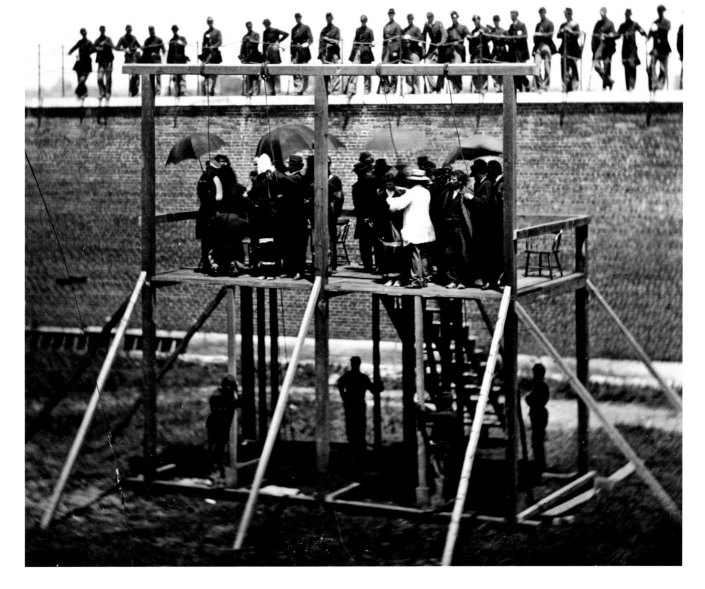

Washington, D.C. Adjusting the ropes for hanging the conspirators, July 7th 1865

Photographed by Alexander Gardner image courtesy of Library of Congress

Colourised by Mads Madsen

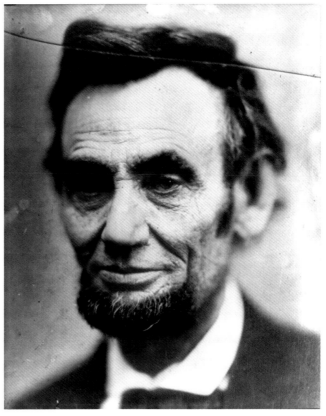

Abraham Lincoln, head-and-shoulders portrait, traditionally called "last photograph of Lincoln from life"

Image courtesy of the Library of Congress

Colourised by Mads Madsen

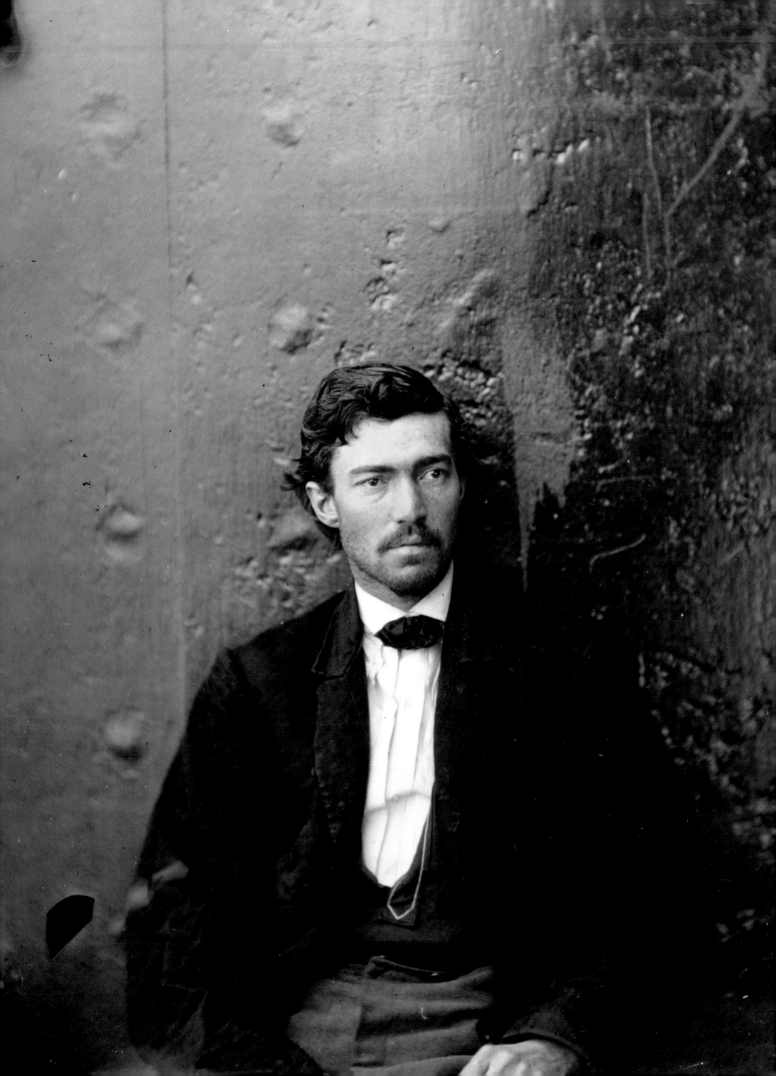

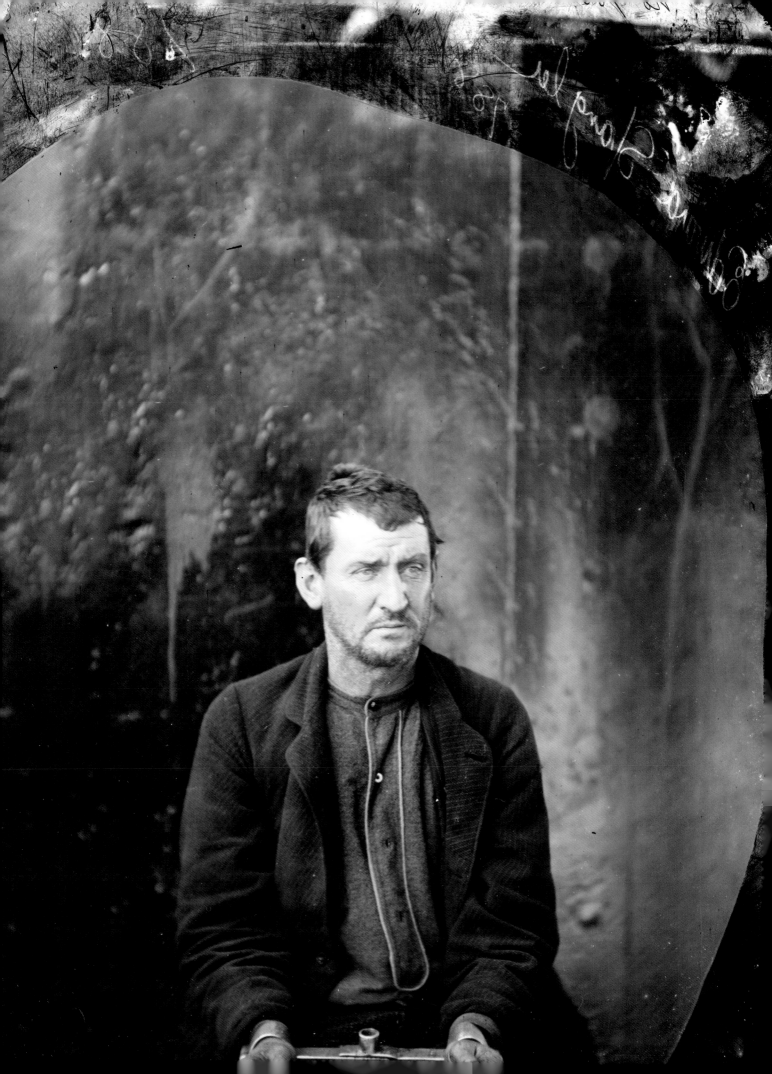

DEFIANT IN DEFEAT: ONE OF THE LAST FREE CHEYENNE LEADERS SITS FOR A PHOTOGRAPH BEFORE BEING FORCIBLY EXILED FROM HIS HOMELAND

"Half length Cheyenne portrait (Not identified)"

Photographed around 1877 courtesy of the Smithsonian Institution via National Archives Catalogue

Colourised by Matthew Loughrey

Sitting with quiet and proud composition, with the light of the photographer's flash shining from his tomahawk, this high-ranking Cheyenne warrior cuts a striking and dignified figure. However, at the time this image was taken, the Great Plains Native American tribes were past the height of the prowess they enjoyed at Little Bighorn, and were enduring the process of being dispersed and contained into reservations by the US Government.

The man pictures would either have been the chief of his band, or at least a man of high standing in the community, as signified by the prominent crucifix around his neck. He could well have been one of the "old man chiefs", or Cheyenne Council of Forty Four chiefs, who made all the major decisions on behalf of their people. The flattened-type cross this possible chief had resting on his chest was made from copper or silver, which were expensive and therefore a sign of high social status, rather than being an indication that the wearer was necessarily a Christian. The cross symbol has an origin in both the ancient Mississippian Mound Builder's culture, where it represented the underworld, earth and the heavens, as-well-as from the more widely spread Native American cosmic cross, which symbolised the four points of the compass. Many native tribespeople, however, were converted to Christianity during the Nineteenth Century, and would have worn smaller European-style crosses as a show of their faith. Sitting Bull is an example of a prominent Native American leader who was baptized by a Jesuit missionary into the Catholic faith, and who did wear a small crucifix with the image of Christ on the Cross.

While this proud member of the tribal elite looks with straightforward confidence into the lens of the camera, by 1877 when this image was taken, the Cheyenne people had lost their last major fight with the US Army, the Dull Knife Fight or Battle on the Red Fork of November 25th 1876. The Cheyenne force of about four hundred warriors, under Chief Dull Knife, was severely outnumbered by one thousand soldiers under General Crook. The native force were forced to abandon the Shoshone village of two hundred lodges, along with their seven hundred head of cattle. Despite a brave rear-guard action, this decisive defeat effectively ended the Cheyenne ability to resist the government by military means.

The tribe split into two factions, the southern and northern Cheyenne. The southern group settled in the reservation the government had ordered them into, and the northern Cheyenne returned with Dull Knife, and his fellow Chief Little Wolf, to live within the Sioux territories of Wyoming. Colonel Mackenzie of the Fourth Cavalry was assigned with the task of removing this group, which he did with brutal efficiency, defeating resistors, burning lodges and confiscating horses. Without food or shelter, by November 1876, the villagers had little option but to join the southern Cheyenne reservation.

Finding food supplies to be inadequate on arrival and conditions unsanitary, by September 1878, Dull Knife eventually led a group of his people back to the north. Many died in the infamous Fort Robinson Tragedy, where Dull Knife, his family and the rest of his band were incarcerated for four days without food, water or heat and were then fired upon while escaping. However, a group of northern Cheyenne did manage to settle outside Fort Keogh in Montana, and by 1884 the government agreed to the establishment of the 371,200 acre Northern Cheyenne Indian Reservation. Crucially the Cheyenne had access to the Black Hills, which are still sacred to them and key in preserving their religious and cultural practices.

Now in total there are over twenty-thousand members of the Cheyenne. Prominent people with Cheyenne ancestry include; Senator and lobbyist Ben Nighthorse Campbell, musician Jimmy Carl Black, Smithsonian Founding Director W. Richard West Jr and leading forensic artist Harvey Pratt.

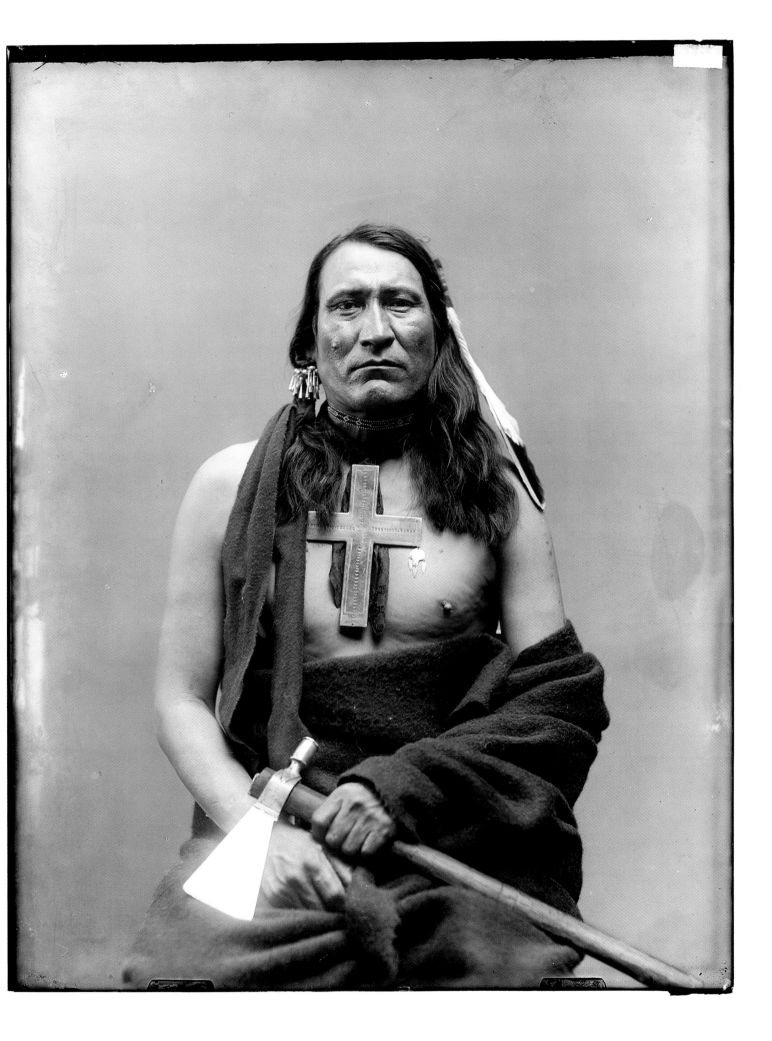

THE LOGGING WAY OF LIFE IS CRITICAL TO AMERICAN DEVELOPMENT - BUT THE ENVIRONMENTAL COST IS HUGE

"Logging a big load, North Woods, Michigan"

Photographed c.1880 by the Detroit Publishing Co, courtesy of the Library of Congress

Colourised by Patty Allison

Here, we see the teamsters and loggers of the great North Woods; the vast forests which stretches five thousand miles from Alaska in the west, to Cape Cod in the east. In an incredible physical feat demonstrating the sheer power of animal muscle, the team was transporting their "big load" of fifty-six trees, which weighed up to twenty tonnes, using a basic sled pulled across the snow by two stoic draft horses. Before the invention of the combustion engine, from passenger transport to goods, construction and industrial labour, nearly every task that vehicles do today was once the job of working horses such as these. By 1900 in the US alone there were over twenty-one million horses and the population peaked at over twenty-six million by the 1920's. The work of supplying this key building material was critical to the growth of the US economy and population. Over its history, wood was used to build nearly all new settlements, transport and industrial facilities, and it was the likes of the men pictured who had performed the role of sourcing timber for generations.

Traditional river loggers, like the team pictured, would begin work in September by clearing the twenty-five-foot-wide road they would need to transport the timber, once it had been cut. Streams would also need to be forded and bogs crossed by spanning them with log corduroys. At regular intervals clearings would be made for log piles to be stored for later transportation along the route. Loggers would tend to choose easier slopes near rivers to begin with, and expand into the interior and uplands with each season. Once the cutting started, trails were created, called "travoy roads", or "skid trails", which would lead to the main "skidway", like the one we see pictured.

The mission of the team in the photograph, would have been to painstakingly inch their way to one of the main rivers, such as the Manistee. Upon reaching it, over a painstaking period of weeks, the logs would be piled up on the banks of the river, and then driven into the water. Logs could travel up to one hundred-miles downstream to the nearest sawmill for processing into wood. However, rivers themselves had to be kept clear of obstruction, and logjams of thousands of logs could clog the river completely. In this situation, loggers would have to either identify the "key logs" and free them by hand to release the jam, or in severe cases, dynamite was used to simply blast a hole in the logjam.

Each log was branded on its end with the mark of the lumber company that had cut it (the "endmark"). Where work for these companies was plentiful, people from across the world arrived, and settled. Mill towns such as Grayling, Cadillac and Roscommon were established and boomed. Lumber barons, such as Michigan's Charles Hackley, became extremely wealthy from such operations. Upon his death, Hackley had provided around twelve million dollars-worth of infrastructure to his home city of Muskegon, including a school, library, hospital, art gallery, park and athletic field.

There was, however, a dark side to the lumber industry. The prosperity it brought came at a great human and environmental cost, with deforestation causing wildlife such as bears, wolves, eagles and mountain lions to become rare or die out in various districts. Loggers and settlers also frequently clashed with Native Americans over access to trails, rivers and other resources, and such conflicts caused the US Army to become involved in forcing the tribes into reservations.

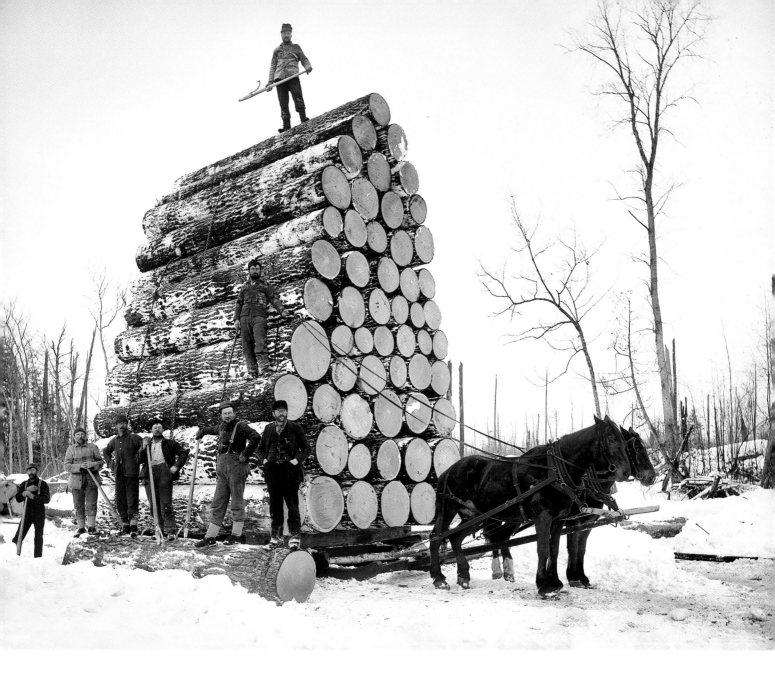

With deforestation came the end of the majority of sawmills. Hackley's mill opened in 1854 and after trees became scarce and the land bare around Muskegon, by 1894 his mill closed. Some communities diversified and survived, others became ghost towns. As modern transport and construction methods developed into the Twentieth Century, horses were no longer used for transport and the logging way of life became industrialised, requiring far less man-power. With modern construction materials now available, demand for wood has declined considerably. Today, North America is experiencing a period of reforestation, with the 949,750 acres of trees lost each year between 1990 and 2010 offset by planting and natural growth of 18,995,000 acres. This has meant the doubling of forest sizes in some eastern states in the last century.

THE WORLD'S GREATEST LITERARY STAR DESTROYS HIMSELF

"Photograph shows Oscar Wilde, three-quarter length portrait, facing front, seated, leaning forward, left elbow resting on knee, hand to chin, holding walking stick in right hand, wearing coat."

Photographed by Napoleon Sarony, New York, 1882, image courtesy of the Library of Congress

Colourised by Mads Madsen

The poet and playwright Oscar Wilde was the tragic rock-and-roll star of his day. Aged 27 or 28 in this picture, Wilde's poetic, literary and classical accomplishments were notable, however this confident young Anglo-Irishman had not yet experienced the personal glory that was to come. His only novel, *The Portrait of Dorian Gray*, and his most famous play, *The Importance of Being Ernest* were not yet published. During his time studying Classics at Trinity College Dublin and Greats at Magdalan College, Oxford, Wilde was exposed to Greek thought, and emerged at the centre of the rising *Aesthetic* movement; the inheritors of Romantic legacy of literary masters Keats, Byron and Shelley.

"We are all in the gutter, but some of us are looking at the stars."

Against the backdrop of Victorian conservatism and staunchly Christian faith, the Aesthetics' dress and manner was flamboyant and their lifestyles decadent. Through his poetry and lectures, Wilde toured Europe and then America, his advocacy of pleasure over utilitarian ethics, led to him being both celebrated by audiences, and condemned in the press. In 1884, Wilde married Constance Lloyd in an Anglican Ceremony and the couple had two sons, Cyril and Vyvyan. He had embarked on a career in journalism, when seventeen year-old Robert Ross entered his life.

"I can resist everything except temptation."

Ross seduced Wilde, who was to have many male lovers and experimented in derivatives of opium. Wilde's intense lifestyle did not hamper his work, in fact it seemed to fuel it, with a prodigious number of poems, articles, essays and plays produced from 1886 to 1895. He moved to Paris and wrote comedies, and his ground breaking biblical drama, *Salome*. He returned to England and was introduced to Lord Alfred Douglas, who was then a 21-year-old undergraduate at Oxford University. The pair became lovers, and Douglas, introduced him to the underworld of male prostitutes. Wilde's indulgent lifestyle was turned on its head by the intervention of Douglas' father, the formidable Marquess of Queensbury, who wrote the modern "Queensbury" rules of boxing. After hearing of his son's relationship with the older Wilde, Queensbury called on Wilde at his home and threatened

to "thrash him" if the pair were spotted in public again. According to Wilde his reply was:"I don't know what the Queensbury rules are, but the Wilde rule is to shoot on sight". It was a confrontation that would come to ruin Wilde.

"Always forgive your enemies - nothing annoys them so much."

Queensbury left a calling card at Wilde's club, which read "For Oscar Wilde, posing somdomite [sic]". Homosexuality was illegal in Britain until 1967 and interpreting this note as a public libel against his character, Wilde decided, against the advice of his friends and egged on by Douglas, to bring a private prosecution against Queensbury. To defend himself, Queensbury had to prove that Wilde was an active homosexual and that it was in the public interest to expose him. He enlisted private detectives who took statements from criminals, prostitutes and brothel owners and brought witnesses to court, with details of Wilde's sexual activity, that would lead to his reputation being destroyed. Wilde was not only left with his opponent's legal bill, which bankrupted him, but sufficient evidence was found by the Crown to criminally prosecute him for gross indecency. Wilde was convicted and sentenced to two years of hard labour. He was sent to the harsh regimes of Pentonville and Wandsworth prisons, until a fall and injury to his ear left him in the infirmary for two months. He was transferred to Reading Gaol and the crowd that gathered at Reading train station jeered and spat on him. After his release he left for Paris, where he lived in squalor, seeking solace in Christian spirituality and alcohol. From letters sent to friends, Wilde appeared to have forgiven Douglas for his role in his downfall.

"My wallpaper and I are fighting a duel to the death. One of us has got to go"

On November 30th 1900, shortly after receiving a baptism into the Catholic Church, Wilde died of cerebral meningitis. In January 2017, Wilde, along with WW2 code-breaker Alan Turing and 50,000 other British men convicted of homosexuality, were posthumously pardoned by the Queen of England Elizabeth II.

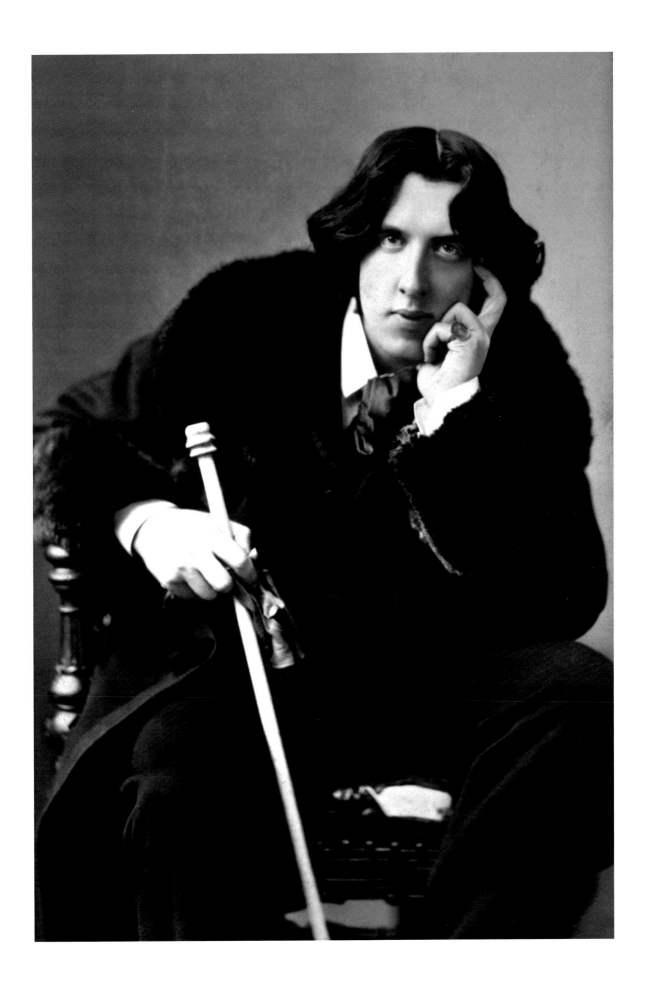

THIS CLASSIC IMAGE OF THE COWBOY COMES TO REPRESENT THE AMERICAN FRONTIER IN THE POPULAR IMAGINATION

"The Cow Boy"

Photographed by John C.H. Grabill in 1888 image courtesy of US Library of Congress

Colourised by Mads Madsen

This image of a cowboy on horseback staring into the distance is one of the most iconic photographs of the American Frontier. From the quintessential wide brimmed hat on his head, to the holstered pistol on his belt and spurred boots on his feet, this rider and his steed perfectly embody the Old West spirit of adventure. The photograph, by successful mine-prospector and travelling photographer, John C.H. Grabill, was part of a treasure-trove of images taken of the American nation as it was being born, as settlers, miners, engineers and drovers travelled west in search of a better life. Despite being an under-recognised artist, Grabill's images of Deadwood, South Dakota would come to define the era of gunslingers, madams and cattle rustlers that we now know through the genre of Wild West movies. He captured powerful photographs of historical events, most notably the aftermath of the infamous Massacre at Wounded Knee, where up to three-hundred Native American men, women and children were killed by the US Army. Grabill also documented the traditions, ceremonies, clothes, and way of life of the indigenous peoples who were displaced by this momentous influx of people. Grabill's work with tribal people was so well-respected, he was commissioned to take part in the ground-breaking *Columbian Exposition* by Frederic Ward Putnam and Franz Boas, who are credited with having founded the discipline of American Anthropology.

This particular image was so successful at capturing this essence of the Wild West that it was the subject of a copyright dispute between Grabill and the legendary scout and entertainer Buffalo Bill (real name William Frederick Cody) of the world-famous *Wild West Show*. Grabill had made his fortune as a miner in Colorado who branched out into the new and fashionable photography trade. He eventually opened a series of photographic studios in Buena Vista, Sturgis, Deadwood, Lead City, Hot Springs and Chicago. However, Grabill appears to have overextended his photography business, was unable to pay his debts and was forced to liquidate his studios to pay off his debtors. Down on his luck already, Grabill could have only been further incensed when he learned that his images were being reproduced without permission or payment, by one of the subjects of his photographs, Buffalo Bill, in order to promote this famous entertainer's already highly successful show.

According to the *Chicago Tribune* report of 1893, Grabill brought legal action against Buffalo Bill Cody, *"Grabill alleges that in 1890 he took a number of photographs of Indian scenes at Pine Ridge and South Dakota and he charges that this year Buffalo Bill has caused pictures to be made and distributed which are copies of the copyrighted photographs named."*

Without the financial resources necessary to protect his images from infringement, it seems that Grabill found a radical and clever way to do this free-of-charge. He donated nearly two-hundred images to the United States, whose rise he had so fastidiously recorded over a seven-year period. The summary from the Library of Congress website on the *Grabill Collection* states: *"The one hundred and eighty-eight photographs sent by John C.H. Grabill to the Library of Congress for copyright protection between 1887 and 1892 are thought to be the largest surviving collection of this gifted, early Western photographer's work. Grabill's remarkably well-crafted, sepia-toned images capture the forces of western settlement in South Dakota and Wyoming and document its effects on the area's indigenous communities."* Hardy any record of Grabill's life after his photographic donation remains, although secondary sources point to his profession as teamster and janitor for a moving company, as recorded upon his death in 1934 in Peoria, Illinois.

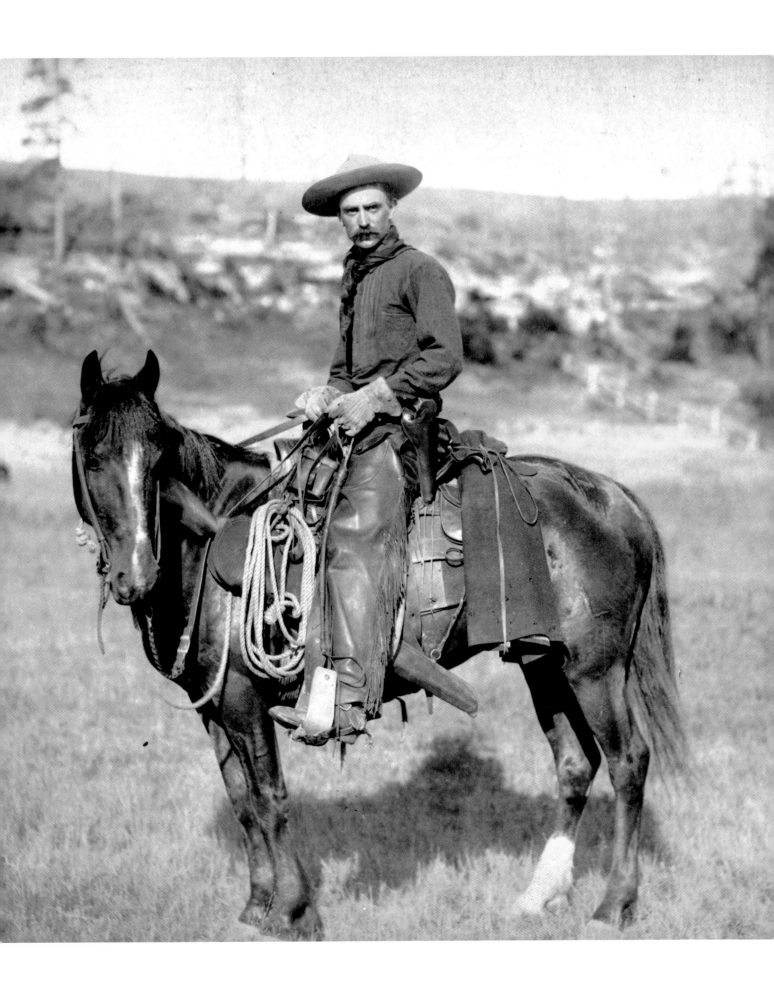

GREAT FAMINE OF IRELAND SURVIVORS DISPLAY THEIR BALLAD OF REMEMBRANCE

"Mother & Son. Lisdoonvarna 6813 W.L"

Photographed by Robert French (Lawrence Collection), County Clare, Ireland c.1890 courtesy of the Library of Ireland

Colourised by Frederic Duriez

The drawn yet vigorous faces of this mother and son tell a tale of deprivation, hardship and closeness to death, that most Europeans today would have difficulty in comprehending. Their bond is evident in their close body language; mother supports herself with a cane in her left hand and she grips a handkerchief in the other, which hints at ill-health. Her son, who is so wizened himself he could pass for her husband, sits proudly displaying a paper, which reads "Lines on the Scenery round St. Bridget's Well in the County Clare." The son is a ballad singer, who would appear, from the pointed way this image was captioned, to have been well-known at least locally.

From the age of the pair by the time this image was captured, they will both have been born prior to, and therefore survived, the catastrophic famine that struck Ireland from 1845 to 1852. Known as the Irish Potato Famine outside Ireland, and within Ireland, The Great Famine or *Gorta Mor* ("Great Hunger" in Irish), this potato blight destroyed what was a staple crop for the population, killing one out of eight people by starvation. The land was under a belligerent British rule at the time. The government in London declined to assist the starving Irish in any meaningful way (although troops were deployed to protect the food that was shipped and sold at famine prices to the starving), leaving a death toll of one million people and forcing a further million to flee the country to survive. As society broke down, so did the economy. Evictions due to failed rent payments and crime both soared. Increasing numbers of survivors were transported to Australia as punishment for offences ranging from stealing food to cattle rustling. Those that lived, but were left behind to rebuild the country, carried bitter memories of this apocalyptic time. In 1847, artist James Mahoney from Cork was commissioned by the *Illustrated London News* to report on the sights he saw while travelling the local countryside by coach. This is an excerpt of his report of entering nearby Bridgetown: *"I saw the dying, the living, and the dead, lying indiscriminately upon the same floor, without anything between them and the cold earth, save a few miserable rags upon them."*

Because of the pictured mother and son's status as famine survivors, special significance can be attributed to reference in the title of our son's ballad, to "St. Bridgitt's Well" or Saint Brigid's

Well, as this holy site is more commonly known. According to Irish Christian tradition, St Brigid was a fifth century Irish nun remembered for turning water into milk, for healing the sick and injured, and caring for the most accursed in medieval society, those suffering from the disfiguring nerve and skin condition, leprosy. In earlier pagan folklore she was a Goddess of higher learning and spirituality, being the patron deity of the mysterious and ancient Celtic priest-caste, the druids.

Today, the well is located under a stone well house, where visitors can descend to pay homage and leave offerings to Saint Brigid. A modern painted statue of the Saint marks the main prayer spot. Above the well, visitors can follow a winding path towards the upper sanctuary, where through the trees they will find a cemetery containing a mausoleum to one Cornelius O'Brien. Famous for building the iconic stone observation tower at the Cliffs of Moher, O'Brien was a Protestant, local landowner and member of Parliament in London from 1832 to his death in 1857.

Despite his difference of religion from the majority Catholic population he represented, O'Brien was a supporter of the repeal of the Union between Great Britain and Ireland, and could therefore be regarded as an early Irish Nationalist. During O'Brien's time in politics, Ireland was poor and Brigid's Well was in a dilapidated state. When O'Brien became ill, he nevertheless took water from the well, the holiness of which he attributed to his full recovery. He decided to restore the well and open it up to pilgrims during the Great Famine. He was also active in attempting to provide relief and galvanise support for the victims. The well he lovingly restored became a powerful symbol of hope among the starving people of the county.

Our mother pictured here must certainly have been an adult during this period and would have navigated her children through what must have been a frightening and horrific ordeal. Her son may have been a child or young adult, and will have been shaped indelibly with the experience. Despite their dark history, it is comforting to imagine the life of our son, here pictured as a much older and careworn man, travelling from village-to-village, singing his ballad of faith and remembrance of Saint Brigid's Well to his fellow survivors and their offspring.

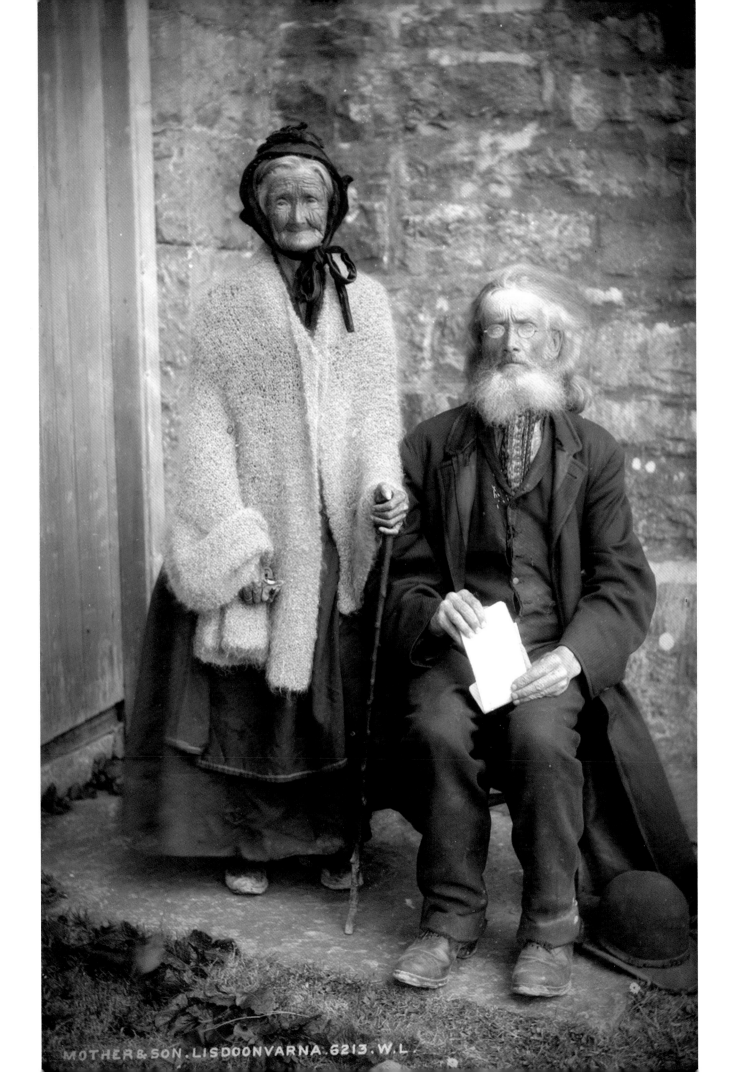

MOTHER & SON. LISDOONVARNA. 6213. W.L.

THE OLD WEST'S MOST LEGENDARY BANDIT BRINGS THE "COWBOY" ERA TO A CLOSE

"Butch Cassidy at Wyoming State Penitentiary in Lamamie, WY - a mugshot" 1894

Photographed by Unknown

Colourised by Mads Madsen

Staring wearily and defiantly at something beyond the photographer's lens, with a low brow, eyes set close together but with a firm jaw and scarred lower lip, this prison mugshot of the bandit Butch Cassidy captures the face of the man that would come to optimise the classic outlaw of Western legend. Taken by the Wyoming Prison authority at the beginning of his two-year sentence for cattle rustling, this spell in jail was Cassidy's first and only incarceration. He was a little-known criminal at the time, convicted for buying a stolen horse for five dollars. Although he was reportedly a model prisoner, while behind bars, Cassidy was perceived as a significant threat to law and order in the state because of the leadership he exerted over fellow-criminals. History would come to confirm these fears.

Born Robert Leroy Parker in Beaver, Utah, 1866, he was brought up as one of thirteen children by his Mormon British-born parents. Parker left home in his early teens, and while working in a dairy farm he fell in with a cowboy and rustler called Mike Cassidy, who was to become his mentor and namesake. After working as a butcher, Parker acquired the nickname "Butch" and just as he embarked on the beginning of his criminal career, he renamed himself Butch Cassidy in honour of his friend.

Cassidy's first recorded crime was to enter a shop after dark, and steal some jeans and a piece of pie. Despite having written his name on the IOU note he left behind, the store holder decided to press charges. Cassidy was acquitted, but his passion for crime only increased. After his release from jail in Wyoming in 1896 for the above-mentioned cattle rustling charge, he quickly formed the Cassidy Gang or "Wild Bunch", which eventually came to include Cassidy's chief partner-in-crime, Harry "The Sundance Kid" Longabaugh. Along with Longabaugh's girlfriend, Etta Place, the friendship would be immortalised in the 1969 Academy Award winning movie *Butch Cassidy and the Sundance Kid* with Hollywood star Robert Redford playing Longabaugh, Katherine Ross as Place and screen icon Paul Newman as Cassidy. The movie was sympathetic to "Butch and the Kid", romantically portraying them as charismatic rogues, motivated by a thirst for fancy-living and high-jinks.

This reputation did have some basis on fact – it was recorded that Cassidy would give money he stole from banks and trains to local farmers and he did certainly cultivate and acquire a Robin Hood reputation in the West, for taking from the rich to give to the poor. However, it is also likely he ran protection rackets among the ranchers of Wyoming, which would have necessitated, at bare minimum, the threat of force against the ranchers if they did not pay him.

The Wild Bunch stole tens of thousands of dollars in the five years they were active. While Cassidy insisted on never having personally killed anyone, his success came at a high human cost, with over a dozen lawmen killed by his gang members as-well-as numerous civilians, who either intervened or were unlucky enough to have been accidentally shot in the gunfights the Wild Bunch took part in. Throughout his career, Cassidy was hunted by agents of the Pinkerton detective agency, then the largest private security company in the world, who from 1850 to the 1900's hired bounty hunters to kill wanted men like the Wild Bunch.

The gang's greatest single crime was the Wilcox Train Robbery of 1899 where they stole up to $50,000 worth of gold bullion from the Pacific Express Company. Mail clerk Robert Lawson described events shortly after the westbound Union Pacific Overland Flyer No. 1 stopped for two men holding lanterns as the train approached. Thinking the men were flagging down the engine because the nearby bridge could have been flooded overnight, the engineer stopped the train. The men threatened to blow up the entire locomotive, fired into various carriages when staff and passengers failed to cooperate, and they used explosives to blow up carriage doors and access the safe. A posse of over one hundred men formed, and a $18,000 bounty was offered for the outlaws "dead or alive" ($3,000 for each of the six who took part in the robbery).

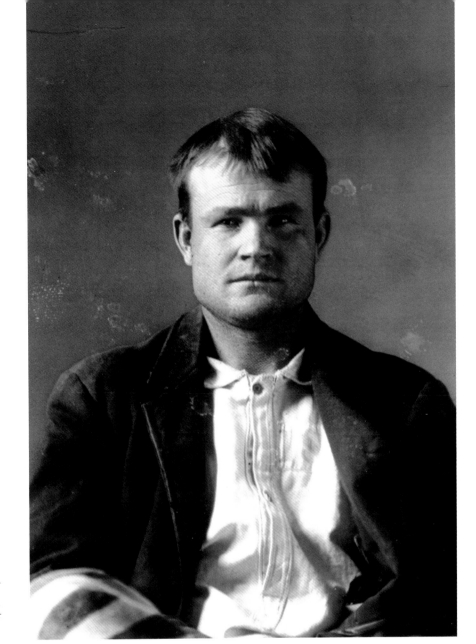

With several of their inner circle killed and Pinkerton agents closing in, in 1901 Cassidy, Longabaugh and Etta Place fled to New York where they took a steamer to Buenos Aires in Argentina, South America. The pair soon fell back to robbing, and after Place tired of life on the run and returned to the US, Cassidy and Longabaugh crossed the border into Bolivia. The pair most likely shot themselves, after being wounded and pinned down in a farmhouse by local police and soldiers. Other accounts and rumours allege that they were not involved in this incident and in fact survived in South America, and even returned to America. Whatever Cassidy's eventual fate, with the advent of urbanisation and industrialisation of the West, this last great outlaw came to symbolise the end of the American frontier, and the cowboy way of life.

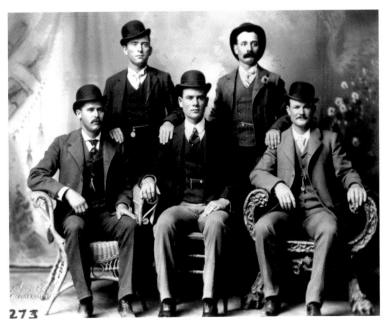

Butch Cassidy's Wild Bunch, from left to right: Harry Longabaugh, Bill Carver, Ben Kilpatrick, Harvey Logan and Butch Cassidy.

Photographed by Napoleon Sarony at Fort Worth, Texas c.1899

Colourised by Mads Madsen

CALAMITY JANE WAS A SINGLE MOTHER PLAGUED WITH ALCOHOLISM WHO NEVERTHELESS BECAME THE WILD WEST'S MOST FAMOUS FEMALE GUNSLINGER

"Calamity Jane, Gen. Crook's Scout"

Photographed by H.R. Locke, 1895 image courtesy of the Library of Congress

Colourised by Matt Loughrey

This image shows the legendary female gunslinger known as Calamity Jane, dressed little differently from many male frontiersmen of the time, with open eye-contact suggesting her no-nonsense attitude, right hand firmly gripping her rifle, ammunition belt slung around her waist. Despite her masculine attire, she does, however, have her legs crossed as a woman would have been expected to at the time. The person we see was far removed from Warner Bros' 1953 "musical extravaganza" movie, where the Doris Day movie portrayal of Calamity Jane was as a buxom blonde sharpshooting goodtime girl, who enjoyed a romance with Wild Bill Hickock.

That an extravagant musical would have been made about Calamity Jane's fictional life years after her death is somewhat fitting; hard-drinking "Jane" was no stranger to the telling of heavily embellished stories of her adventures, usually in exchange for alcohol. Her own autobiography is widely believed to have been at least exaggerated by a ghostwriter to ensure maximum sales, and by the time this image was taken by Mr Locke of her adopted town, Deadwood, Dakota, she was already participating as a storyteller in the famously entertaining and larger-than-life Buffalo Bill's *Wild West Show*. Other real-life historical figures of the Old West appeared alongside "Jane", like Buffalo Bill himself, who was a scout and bison hunter, and the famous Native American spiritual leader and resistor to the US government, Sitting Bull.

It was while Calamity Jane was still known by her real-name, Martha Jane Canary that she began to acquire notoriety in the local press. She fought several heroic actions as an army scout deployed against Native American tribes of Wyoming, the most famous of which she was reported to have single-handedly saved the life of her commanding officer, Captain Egan. However, it was for her drinking and work as a prostitute that she was initially known. Martha maintained in her book that it was Egan that gave her the name "Calamity Jane", however prostitutes were also known as "Janes" and those who used them were, "Johns". During this period, when Martha was in her early twenties, she was described as dark-eyed and beautiful.

Several local reports show the derision the press had for "Calamity Jane", who was nevertheless becoming a popular figure. The *Rocky Mountain News* reported her account of how she survived an ambush by members of the Sioux Native American tribe: *"That party of howling devils swooped down upon her and tried to capture her outfit, but she swore at them till they left...the guileless Sioux were probably awed by her profanity, or, being exceedingly superstitious they may have taken Calamity Jane for Belzebub (the Devil) himself in the disguise of a Cheyenne beer-jerker (a person, usually already inebriated, who whines when they have run out of alcohol)."*

Martha's reputation as a drinker may have proceeded her, but many hold that she played an important role as army scout under General George Crook and his battles against the iconic Lakotah war leader Crazy Horse. She was recorded as being present at the 1876 Battle of Rosebud, disguised as a man.

By the late 1870's Martha settled in Deadwood, South Dakota and fell in with brothel owner Dora DuFran. Martha and DuFran were portrayed plausibly in the acclaimed HBO television series *Deadwood* as having a lesbian relationship. Martha's devilish personality, sharp-tongue and chaotic semblance inspired a popular series of dime novels to be written about her supposed antics. She is reliably reported to have taken the reins of a stagecoach under attack from local tribesmen after the driver was shot dead, and successfully steered it and the other passengers to the safety of Deadwood. She is also said to have tended to smallpox victims during one of several outbreaks that struck South Dakota at that time.

In September 1941, a woman called Jean Hickok McCormick claimed to have been the daughter of Martha and Bill Hickock, which fuelled public speculation as to the romantic nature of the pair's relationship. Controversy exists as to the truth of this claim. However, records do show that Martha had two daughters by different men, who she eventually gave up for adoption and fostering at different times as she struggled with her alcoholism. Martha died on August 1st 1901 of inflammation of the bowels, probably brought on by excess drinking. She is remembered as a pioneering female soldier, as-well-as being an early gay female icon.

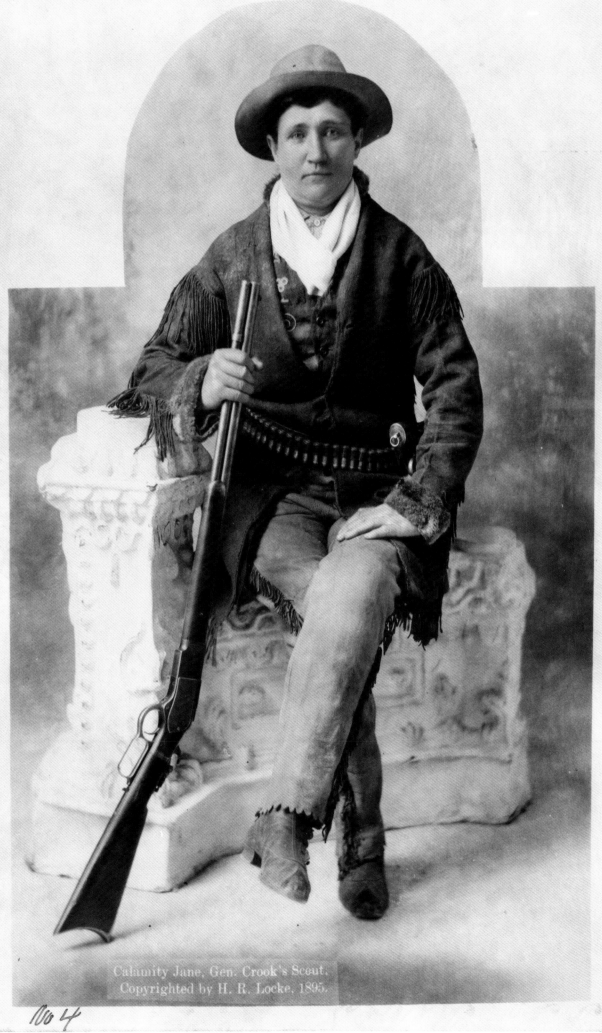

Calamity Jane, Gen. Crook's Scout.
Copyrighted by H. R. Locke, 1895.

100 4

NORTH AMERICA'S LAST HUNTER GATHERERS ARE FORCED TO LIVE IN RESERVATIONS

"Bone Necklace, Council Chief"

Photographed by Heyn Photo in 1899, Ohio, USA, image courtesy of the Library of Congress.

Colourised by Mads Madsen

This image shows a prominent member of the Lakotah Native American tribe, who represented his warrior band within the greater tribal council of the Lakotah. The proud leader looks resplendent in his traditional clothing and furs, yet his downward cast gaze gives the impression of a melancholy concentration as he handles his bow and arrows. The name of this chief's band was the Hunkpati Dacotah (of the Oglala Lakotah sub-tribe). The name, Lakotah, meant "in sympathy" or "allied" tribe. The Lakotah were a semi-matriarchal people, with property and resources managed by women. Lakotah tradition held that upon becoming married the men joining the band of their wife, with men still playing prominent roles as warriors and political leaders. The Lakotah shunned the more widely known American name, "Sioux", which was originally applied to them by their neighbours the Ojibwes, as "Nadowessi", which translated as "little snakes", or, "devils". This was mispronounced as, "Sioux" by early French explorers to the region. Throughout the Americas, horses had been hunted to extinction centuries previously, and it was these traders from France who reintroduced the animals back onto the Plains, transforming the Lakotah's lifestyle into what is now called "horse culture". This innovation allowed the tribe to rapidly expand territorially, and its members gained the freedom to hunt bison more effectively.

However, the era in which this image was taken, during the final years of the Nineteenth Century, was to be the end of serious resistance to incursions by European settlers, railroads, and US government forces into Native American territory. Before this time tribal bands had defended their lands, and the bison they depended on for food, through organised raids on both US military personnel, and civilian farmers and their families, who were targeted and killed. From the Dakota War of 1862 to the Wounded Knee Massacre of 1890, thousands of Lakotah and white Americans had died in fighting. Men such as General Custer, Crazy Horse, and Sitting Bull, had all become household names throughout the English-speaking world. The 1990 film *Dances With Wolves*, directed by and starring Kevin Costner, poignantly documents this period of tragedy for the Lakotah. After this time, the Lakotah and other tribes of the Great Plains were forced into reservations and made to raise cattle as sedentary farmers, rather than live freely as nomadic hunters.

The deer-hide artist Ambrose Keeble, whose great-grandfather was the Chief Bone Necklace we see pictured, attributed his art to the skills passed down to him through his ancestors. Keeble's background was recorded by the Akta Lakota Museum and Cultural Center, where he recounted how at the end of band's history as a free-roaming group, Chief Bone Necklace attempted to outrun the US Cavalry, before being captured on the east bank of the Missouri River. Bone Necklace's band was swiftly relocated to the Crow Creek Reservation. Once Chief Bone Necklace died, his son, White Ghost, took over as the leader of the Huŋkpati Dacotah tribe. Most of Crow Creek's population arrived on the establishment of the Reservation in 1862, therefore from the 1899 date of the image, it is possible Chief Bone Necklace's photograph was taken after this relocation of his band to Crow Creek. The revelation that Bone Necklace probably lived on the Reservation, and that he was responsible for surrendering his people's freedom to the US Government, would explain the nostalgic way he appears to handle his weapons in his portrait.

Despite their losses of territory, over the decades the native people of the Plains have expanded their population from an estimated twenty-eight thousand in the 1660's to around one hundred and seventy thousand today. From the national Native American independence movements in the 1960's and 1970's to the Standing Rock protests against the controversial Dakota oil pipeline that continue into 2017, the native people of America continue to make their presence felt on the political stage.

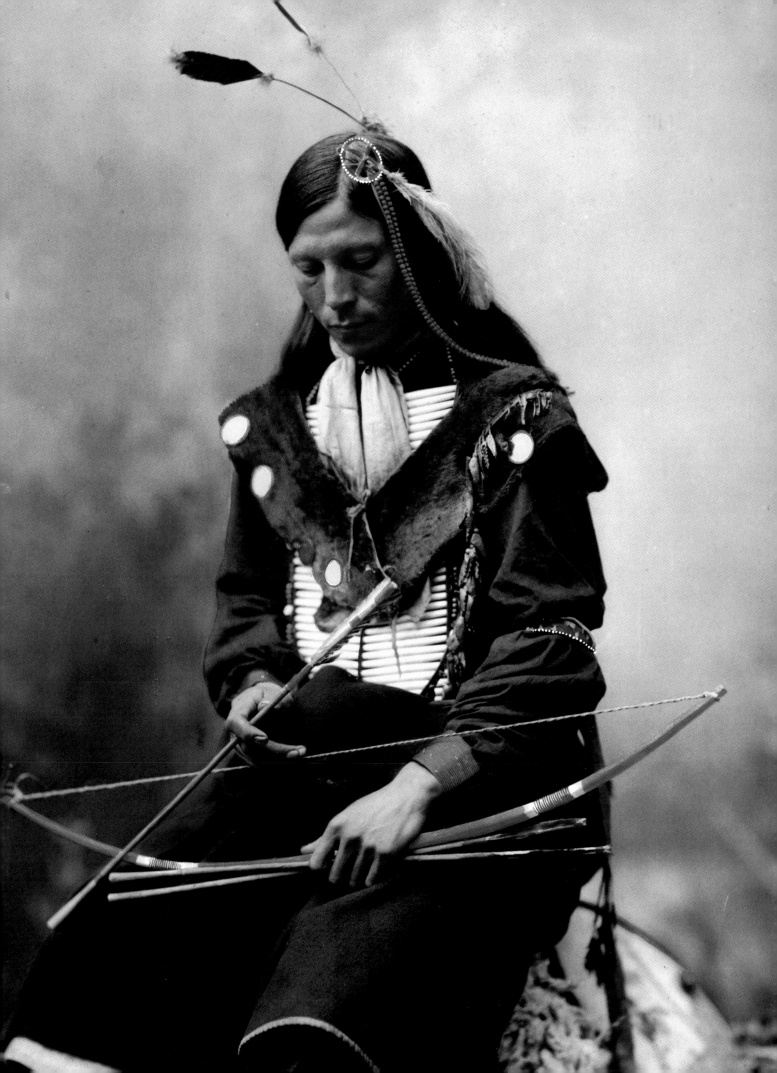

THIS IMAGE OF FEMALE STUDENTS WEARING TROUSERS SHOWS JAPAN AT THE CROSSROADS OF A TECH REVOLUTION

"Four female students dressed in the Hakama-style c.1900"

Photographed by S. Noki at Fukui, Japan

Colourised by Frederic Duriez

This image shows four beautifully dressed girls posing for their photograph with bows in their hair, while holding umbrellas, which were fashion accessories for ladies in Japan at the time. Looking earnestly into the photographer's lens, the serious demeaner of the girls is an excellent example of the disciplined yet highly aesthetic society that Japan was at the beginning of the 20th Century. However, the formal and elaborate dress they display provides a tantalizing clue as to their status and the likely reason they were gathered for this image.

The lower right section of the cabinet, the card image was affixed to is signed, "Noji + Brother" suggesting a pair of siblings owned the studio, which was located in Fuikui, a city seventy-miles north of Japan's feudal capital, Kyoto. The present keeper of the image was passed the following information by the previous owner of the original vintage photograph:

"I was told that the girls were students and dressed in Hakama style. Hakama are a type of traditional Japanese clothing. The Imperial Chinese court wore trousers during the Sui and Tang dynasties and the Japanese adopted this style in the sixth century. Hakama are tied to the waist and fall-down to near the ankles. They are worn over a kimono… The photographer of this wonderful image is S. Noji and his studio was located in Fukui, Japan. The city is located on the coast of the Sea of Japan. This photograph measures about 8 1/2 " x 6 1/2".

The photograph is a worthy example of this East-West cultural and technological transition, which allowed Japan to successfully incorporate Western innovation. We see how a European invention, the camera, was being deployed by a local business professional to record the image for his (presumably Japanese) client. The carefully composed image shows these girls wearing

clothes that were still fashionable-looking, yet originated nearly 1400 years before the image was taken. The four may have looked traditional, but their *Hakama* dress included trousers and were originally made to be worn by males. Adult women wore this type of *Hakama* if they were teachers, but younger females like the four we see pictured, most often donned them during graduation ceremonies. This suggests the picture we see is likely to have been an early example of a very modern phenomenon: the graduation photograph taken for parents to share with pride to friends and family.

During the period in which this image was taken, the Japanese were a culturally sophisticated people grappling with the dilemma of preserving the feudal traditions handed down by their ancestors, and having to adapt to the pressures of modernity brought to their society through the penetration of European technology and colonial influence in the Far East.

The image was most likely taken during the end of the Meiji period, which refers to the 1868-1912 reign of Emperor Meiji, who is chiefly remembered for having abolished the political and military power of Japan's most iconic warriors: the samurai. Meiji was a reforming Emperor who, at the time this image was taken, was in the process of implementing a radical nationwide modernisation plan. Foreigners, who until then had been largely forbidden from Japan, were allowed to trade and settle. An extraordinary state infrastructure programme saw telegraph lines, train tracks, roads and banking reform giving rise to modern factories and companies. However, industrialisation was implemented without falling under the European Imperial dominance that affected almost every other significant Asian country.

The feudal samurai clans became a threat to the Emperor's power when they rebelled against his military reforms. Under Meiji's orders, the one thousand year-long era of these warrior clans, who dominated the country in the previous Shogun (warlord) period, ended with the deaths of the final forty warriors at the hands of the modernised Japanese national army at the Battle of Shiroyama. With opposition by the samurai crushed, Shinto, the religion of Emperor-worship, was encouraged as a national religion throughout the country.

In international relations, prior to Meiji, Japan was in a position where it had been forced to end over 200-years of isolation through the humiliating 1854 Convention of Kanagawa, which opened Japanese ports to American shipping. By the end of the Meiji-era the Anglo-Japanese Alliance of 1902 was signed, a European power, Russia was defeated in the war of 1905, and by 1914 Japan entered World War One on the side of the Allies.

Soon afterwards, in a move that was a forewarning of later territorial aggression, Japan successfully annexed German colonies in China and the Pacific.

THE CORNER BOYS OF YESTERYEAR HAD NO CHOICE BUT TO WORK, LEARN AND PLAY ON CITY STREETS

"Maple Mills, Dillon, S.C. Soarbar Seris, has worked off and on in the mill for 5 years. Winds. Gets 70 cents and up. "Recon I'm about 14." Didn't look it. Has worked more nights than day time. Location: Dillon, South Carolina."

Photographed by Lewis Hine Wickes in December 1908, image courtesy of the Library of Congress

Colourised by Mads Madsen

In an age of mass communication, television, computers and wearable technology, people today no longer have to leave their homes to access entertainment, news, goods or services. In the past, before this technology was invented, this remote way of living was, of course, not possible. Prior to the Twentieth Century, for those that could read; books, newspapers and magazines offered remote entertainment and information. For people who were illiterate and wanted to entertain themselves at home; crafts, home parlour games and alcohol were alternative options. For everything else; to collect shopping, watch shows, have a conversation with a stranger, learn the news; all necessitated people leaving their homes, or for the wealthy, servants could be sent on errands. People's homes were also often in a much more impoverished state than today, families were larger and rents high as a proportion of salaries for most working people. This meant that already overcrowded homes frequently took in lodgers for additional income. Privacy, even in one's own home, was therefore a rarity for most people, who could live ten to a room in some cases. Under conditions of overcrowding it is little wonder that people spent more time in the public realm. All these conditions meant that the streets of the past appeared more crowded than they do today, even though the population of cities was often less.

The image of one of the Old Slip Piers of Lower Manhattan's East River shows how chaotic the business of getting New York City fed was. Nicknamed "Banana Docks" because of its specialisation in taking in shipments of fruit from the tropics, we can see suited wholesale traders overlooking the purchase of bananas, while dock workers throw the bunches onto carriages for market. The site, which is close to Wall Street, is today visited on most days by international tourists taking in the sites of Brooklyn Bridge and Governor's Island.

Without privacy at home and with little to do while there, children in particular grew up on the streets in a way that would be socially unacceptable in most communities within the developed world today. Children of the poor were encouraged to "go outside to play" wherever possible by their hard-pressed parents. In one fascinating but sad image, we see the children of New York play quite unselfconsciously in the gutter next to the carcass of a dead horse. One child even expresses excitement at the sight of a camera by pointing at the lens while exclaiming to his friend. No other adult bystanders seem interested or concerned by what is a quite bizarre and inappropriate scene to the modern viewer. In the picture of the fourteen-year-old boy, opposite, who according to notes taken by the photographer, had worked mainly nights in a mill, or factory, since the age of eleven, we see the face of a boy who had lost the childhood we in the modern western world have protected through compulsory education laws.

A shot of 11th Avenue, shows the neighbourhood of Hell's Kitchen just over one hundred years from the publication of this book. Known locally as "Death Avenue" because of the number of people regularly killed by the freight trains that shared the road with horse carriages and pedestrians, specially employed "cowboys" would ride in front of the engines with red handkerchiefs to warn road users of the danger. It is striking how many children were running on the streets unaccompanied during the day, and in the age of the majestic carriage, how much horse faeces had to be regularly swept from the roads.

The most recent shot was taken as the motorcar was beginning to colonise the streets, and the use of horses for transport had peaked and was just about to decline. The amusing shot shows a Boston mounted policeman galloping into action as bystanders stare in disbelief. The horse looks to be going at such a speed, and the cop leaning so far back, that the rider looks to have almost lost control of his steed, like a driver who has put his foot down too hard on the gas. We spend such little time on the byways of our cities, and we are culturally and technologically so different today, that street scenes of this richness and vibrancy are a rarity indeed.

Left: New York, N.Y.,
banana docks c1890

Photographed by Detroit
Publishing Co image
courtesy of Library of
Congress

Colourised by
Marina Amaral

Below: The close of a
career in New York
c.1900

Photographed by Detroit
Publishing Co image
courtesy of Library of
Congress

Colourised by Ryan Urban

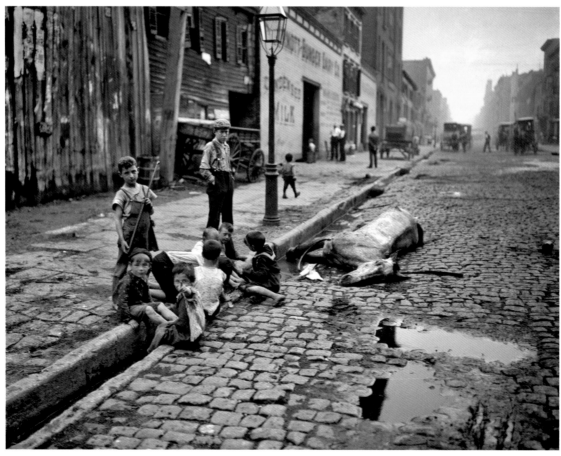

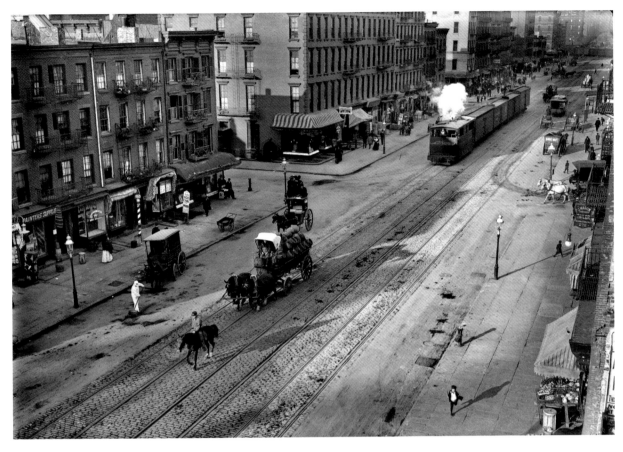

Above: Railroad cars on 11th Ave., New York City, c.1910

Photographed by Bains News Service courtesy of the Library of Congress

Colourised by Ryan Urban

Left: Mounted cop in action on Tremont Street, Boston c.1920

Photographed by Leslie Jones image courtesy of the Public Library of Boston

Colourised by Patty Allison

THE WORLD'S FIRST SUPERMODEL WAS IS THE FEMME FATALE AT THE CENTRE OF THE "TRIAL OF THE CENTURY" AFTER HER HUSBAND MURDERS HER EX-LOVER

"Evelyn Nesbit about 1900 at a time when she was brought to the studio by Stanford White"

Image taken by Gertrude Kasebier in New York 1903, courtesy of the Library of Congress

Colourised by Matt Loughrey

Nineteen-year old Florence Evelyn Nesbit was considered the first true supermodel. Her face graced the covers of magazines we are still familiar with today, including *Vanity Fair, Harper's Bazaar,* and *Cosmopolitan.* She was the first to pose for advertising as diverse as tooth paste, face creams, postcards, beer trays, sheet music, and the first pin-up girl for commercial calendars produced by Coca-Cola, Swift and Prudential Life Insurance. She was the muse for the photographer, Gertrude Kasebier, who took this image at her studio on New York's Fifth Avenue, and posed for the most renowned artist of her time, Charles Dana Gibson.

As fortunate as her circumstances must have seemed to the public, her background was one of hardship. She and her brother, Harold were children of a doting attorney, who died when she was eleven-years old, plunging the family into poverty. Her mother eventually secured employment as a sales clerk at Wanamaker's department store in Philadelphia, where a local artist discovered Nesbit.

By-the-time she was officially sixteen-years-old, but potentially just fourteen (her mother would exaggerate her age to avoid child labour laws), Nesbit met preeminent architect and notorious womaniser, the forty-seven-year-old Stanford White. He gained the trust of Mrs Nesbit by moving the family into lavish accommodation, where on an infamous night he attempted to charm the young Nesbit as she swung on a red swing. White plied her with champagne during a subsequent visit to his apartment, and sexually assaulted her as she lay unconscious. White continued to act as a benefactor, until she began associating with multimillionaire playboy and morphine-addict Harry Kendall Thaw. He was obsessed with Nesbit, having seen her on stage over forty times, and Nesbitt accepted an invitation to tour Europe with him. After she disclosed how she lost her virginity to White, Thaw locked her in a castle in Austria for two weeks, beating and sexually assaulting her.

Despite his outrageous behaviour, the persistent Thaw blamed "the beast", White for his conduct and repeatedly proposed

marriage to Nesbit, until she eventually consented. Thaw ploughed his fortune into exposing White as a pervert, and began to carry a gun to protect himself from possible reprisals. On June 26th, Thaw and Nesbit attended *Mam'zelle Champagne* on the rooftop theatre at New York's Madison Square Garden, a daily socialising spot for White. Towards the end of the show, Thaw approached White from behind, in full view of staff and patrons, produced his gun, and shot him in the back of the head. Thaw is reported to have declared, "I did it because you ruined my wife."

After it was ascertained that the shooting was not part of the show and White was actually dead, Thaw was taken into custody. Nesbit was able to leave the scene and lay low in a hotel. The press seized on the story, and the murder became a global sensation. During Thaw's murder trial, Nesbit was forced to disclose intimate details of her past relationships, including her rape by White. So outrageous was the case to church groups across America, that President Theodore Roosevelt was asked to censor reporting. Thaw pleaded not guilty on the grounds of temporary insanity and hired the best, and most expensive, psychiatric minds in the country to prove it. Nesbit was promised a life of comfort if her testimony was favourable to Thaw. On the witness stand, she would be the damsel in distress, and Thaw her protective white knight.

Thaw was tried twice, and sentenced to life imprisonment in the Matteawan Hospital for the Criminally Insane. He paid to live in comfort with minimal supervision. In 1913, he walked out of the hospital, got into his car and was chauffer driven to Canada. He was successfully extradited, but upon his return was released after being found to be "sane". Thaw had literally gotten away with murder. Nesbitt had a son, Russell, who she insisted was fathered by Thaw, despite his denials. Nesbitt divorced, remarried unsuccessfully, ran a Speakeasy during the 1920's, and became a burlesque dancer before attempting suicide in 1926. Towards the end of her life, she taught ceramics in Los Angeles, and took part as a technical advisor in the fictionalised account of her earlier life *The Girl on the Red Swing.* She died aged 82 on January 17th 1967.

BY THE BEGINNING OF THE TWENTIETH CENTURY THE CROSSROADS OF THE WORLD IS BORN

"Number One Times Square under construction 1903"

Photograph courtesy of Library of Congress

Colourised by Patty Allison

The iconic façade of the Times Square Tower is one of the planet's most easily recognisable landmarks. This image of the construction shows a tower that is in the process of transforming from what was once a humble hotel, into one of the great nexus-points of world history. The construction shows the building rising from the completed ground floor, which is already signposted "to let", into the as-yet unbuilt, but still recognisably iconic form of this famous building. The eye is drawn to the lack of safety features usually found in modern construction, the developed use of popular advertising, and the now-lost trams and horse drawn carriages.

One Times Square is one of the modern-era's most popular cultural centres, having housed the New York Times newspaper, hosted the dropping of New Year's Eve Balls, every year for over a century, witnessed rapturous celebrations at the close of WW2, and given a monumental advertising platform to America's most iconic commercial brands since the early Twentieth Century. It is above all a place for New Yorkers and their visitors to come together and celebrate great events.

What was to become a tourist hotspot which, according to Forbes Magazine hosted twenty-five million visitors in 2015, started the 1900's as a low-rise brewery hotel built on the site of a horse exchange. The area was called Longacre Square after the area of London famous for the carriage and horse trade, until Press Baron Adolph S. Ochs purchased the site. He named the building after his newspaper, the New York Times, which moved into what was to become New York's second tallest tower once it was built. Ochs remarked proudly, "(The new tower represented) the first successful effort in New York to give architectural beauty to a skyscraper.)"

The tower gave the square a strong focal point, and electrification and transport links had already made this part of Manhattan boom by the time it was finished. New York's Theatreland, Broadway, was attracting some of the greatest acts in the western world, rivalling London and Paris, if not overtaking them. However bright the lights of Times Square appeared to visitors, there was always an underbelly of poverty and danger that could rear up and surprise the unwary at any moment.

In 1910 Londoner Charlie Chaplain, who was then a comedy theatre actor on his first American tour, recorded his impression, *"When we got off the streetcar at Times Square, it was somewhat of a letdown. Newpapers were blowing about the road and pavement, and Broadway looked seedy, like a slovenly woman just out of bed."*

Because of the footfall of visitors attracted by the nearby music halls and theatres, advertising became prominent, with an eye-watering eight-five million dollars spent over the decade. It was home to what was reputably the largest electronic sign in the world, the *Wrigley Spearmint* gum sign. With money however, came crime and corruption. Gambling dens and brothels began to appear, and safety from robbers became a concern. Legendary German director Fritz Lang was inspired to base the dystopian film, *Metropolis* partly on his visit to Times Square.

During the Depression-era of the 1930's, Times Square continued to spiral downwards. However, the site yet again showed its importance as a meeting-place during the Victory in Europe and Victory in Japan celebrations, which marked the end of the Second World War. The greatest crowds ever seen gathered together during this time. The 1960's to 80's yet again saw Times Square reflect the poverty that gripped America more generally and it attracted drug addicts, criminals and prostitutes, but also musicians, writers and actors which gave rise to a seedy but creative golden-era in New York.

In the 1990's, under Mayor Giuliani, Manhattan cleaned up its act, but become sanitised, resembling other major cities more closely. According to Giuliani's critics, Times Square had become "Disneyfied", and as if to prove the point, there is prominent Disney shop at 1540 Broadway. Times Square rents became inflated, and smaller businesses were forced to close or relocate. Big business filled the space, and today twenty-two cents of every dollar spent in New York goes through Times Square.

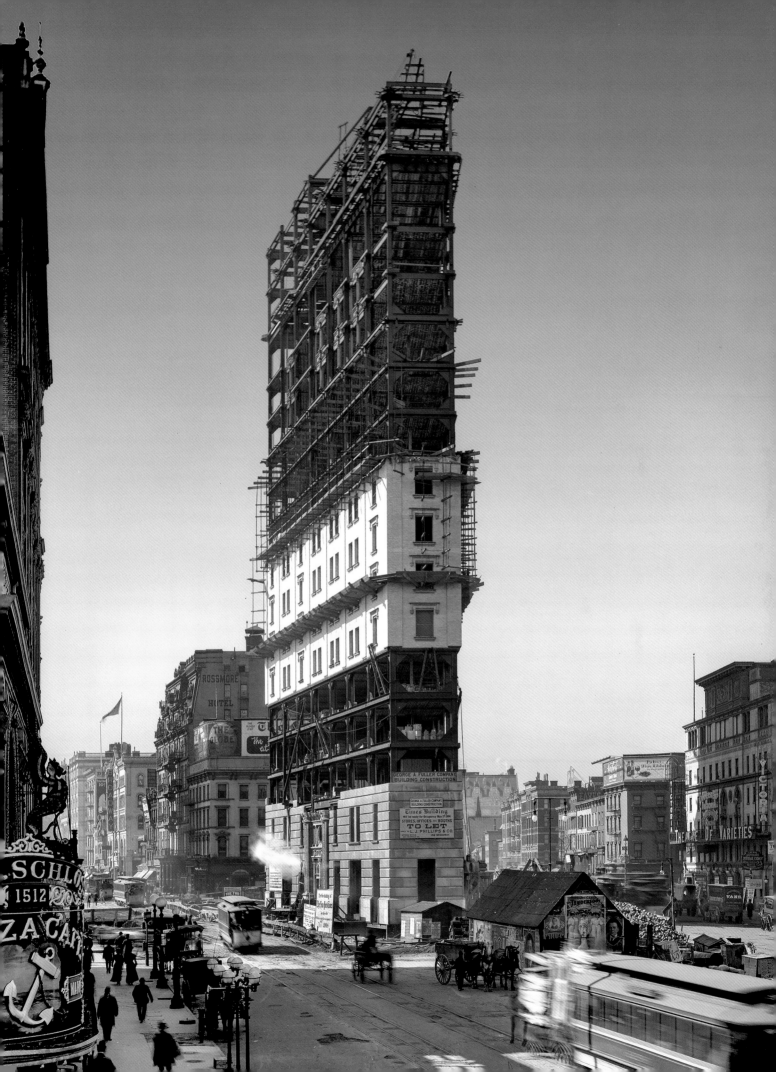

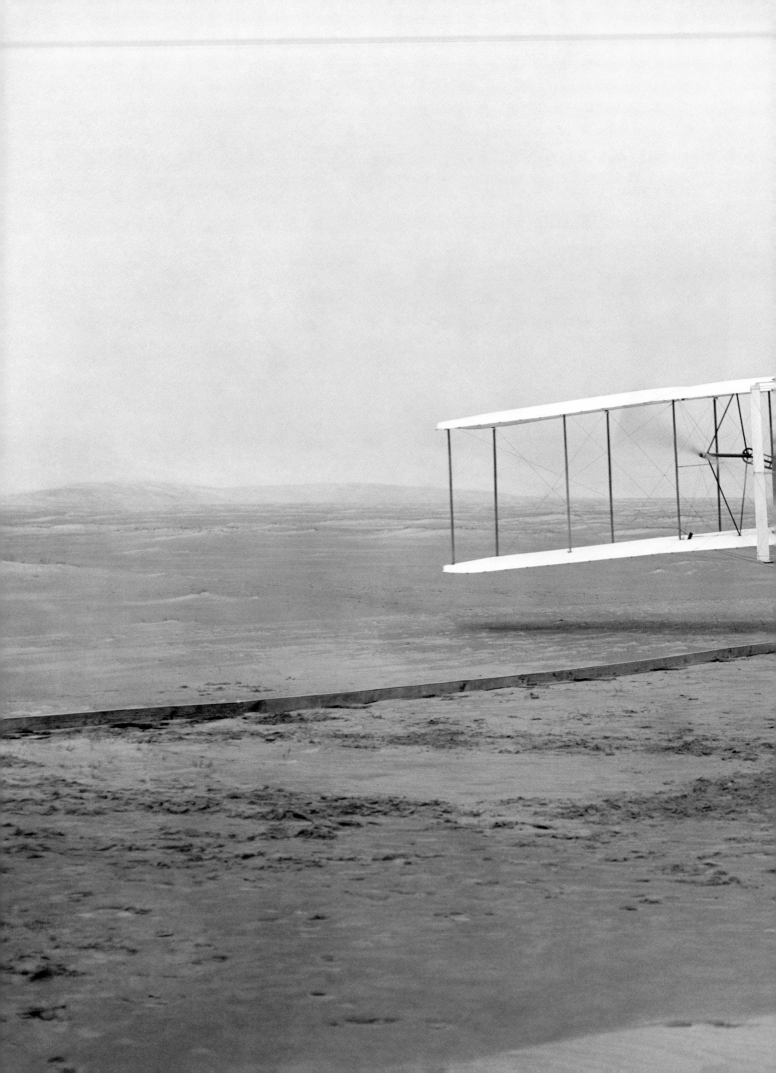

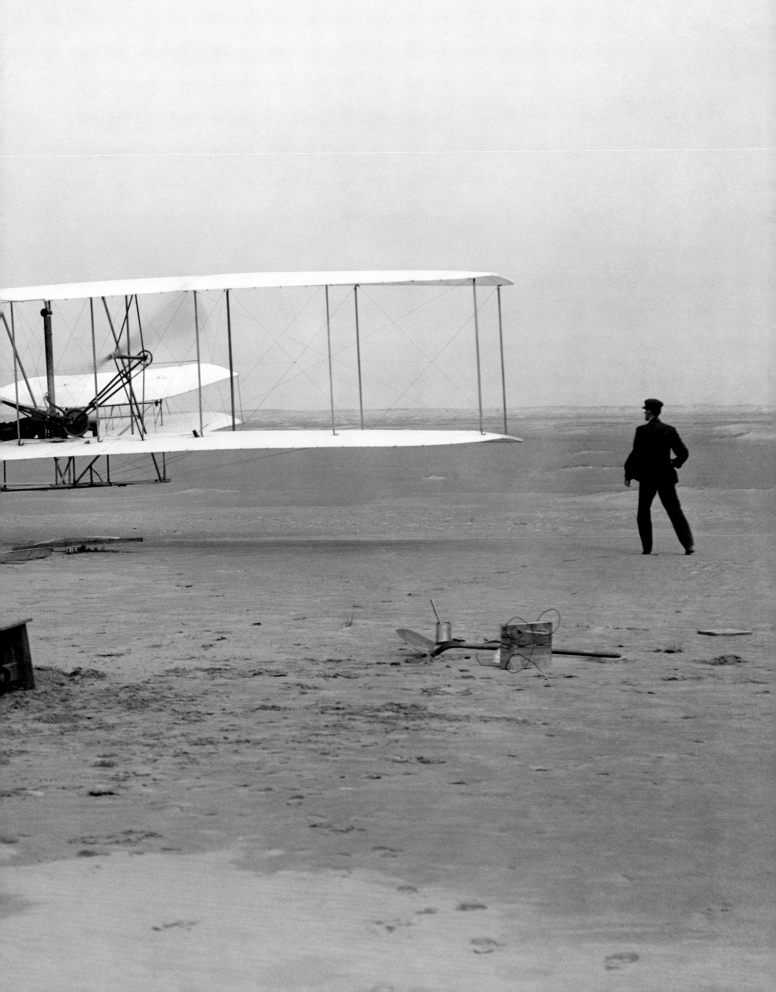

THE MOMENT HUMANITY MASTERED THE AIR

"First flight, 120 feet in 12 seconds, 10:35 a.m.; Kitty Hawk, North Carolina"

Photographed on December 17th 1903 by John T. Daniels, image courtesy of the Library of Congress

Colourised by Jared Enos

Since the time of the ancients, people have dreamed of flight. The cautionary Greek legend of *Icarus* is well-known to most people: he created wings for himself and flew too close to the sun. The heat melted the wax that fixed the feathers to his arms and he crashed into the sea. Later, medieval experimenters known as "tower jumpers" would copy Icarus' technique by attaching the feathers of various bird species to their arms and leaping from the tops of towers.

The master Fifteenth-Century polymath, Leonardo da Vinci drew sophisticated designs for fixed wing and helicopter aircraft. In China, kites were popular since ancient times. Occasionally people were affixed to giant kites and flown in the sky, both as a punishment, and for use in military surveillance. Fire was also used in China to create the hot air which propelled sky lanterns. Eventually in the West, hot air balloons which were lighter than air were built, and since the late Eighteenth Century they were used to ferry people across the sky.

The possibility of a heavier-than-air flying machine, capable of lifting a person into the air, came a monumental step further through the pioneering study of aerodynamics by Nineteenth-Century British engineer Sir George Cayley. As-well-as laying down the basic principles of flight, the Yorkshireman designed the first modern aircraft with a fixed wing, fuselage, and tail. During the Victorian-era Cayley's work spawned innovation in gliding, parachutes, and further experimentation in steam-powered flying machines, importantly in France, Britain, and America.

By the 1900's the US took the military possibilities presented by flight so seriously that the Navy provided $50,000 to astronomer Samuel Langley, who fixed an internal combustion engine to his machine. He called his invention the *Langley Aerodrome*. Sadly, for Langley, his machine was fragile in comparison to his heavy engine, and he had a fatal flaw in his design, with no means to roll the wings to control the flight. The Wright brothers were working on a flying machine to beat Langley, and there was also stiff competition from the tradition heart of aviation innovation, France, to become the first to pilot a heavier than air flying machine.

On December 17th 1903 at Kitty Hawk, North Carolina, Orville Wright won a coin toss against his brother Wilbur to mount the *Flyer I* aircraft they had built together. As a result, Orville Wright was to become the first person in the history of the world to fly a powered, heavier-than-air machine. The image shows how once the machine was activated, Orville was eventually able to rise about ten feet from the ground, travelling at just over six mile-per-hour to a total of one hundred and twenty-feet in distance, before landing without incident.

According to the brothers, before taking the image, coastguardsman John. T Daniels had never seen a camera. However, the Wrights insisted on photographic proof of their record, and wanted a picture as evidence to secure future patents. Daniels was so excited by the spectacle that he almost failed to press the plunger to take the shot. The Library of Congress summary which accompanies the image reads:

"Photograph shows the first powered, controlled, sustained flight. Orville Wright at the controls of the machine, lying prone on the lower wing with hips in the cradle which operated the wing-warping mechanism. Wilbur Wright running alongside to balance the machine, has just released his hold on the forward upright of the right wing. The starting rail, the wing-rest, a coil box, and other items needed for flight preparation are visible behind the machine. (Orville Wright preset the camera and had John T. Daniels squeeze the rubber bulb, tripping the shutter.)"

That day the two brothers took turns to fly the machine, which was based in part on bicycle design from their experience of running a bicycle shop in Dayton, Ohio. Wilbur succeeded in the record flight of eight hundred and fifty-two feet in one hundred and twenty seconds, with the highest altitude of twenty feet, before he eventually crash-landed. In his diary, Orville recorded how after removing the front rudder, the party carried the machine back to camp. They set the machine down a few feet west of the building, and while the men were stood discussing the last flight, a sudden gust of wind struck the machine and started to turn it over. Together they all rushed to stop the movement of the plane, but it was too late. John Daniels and Orville Wright seized spars at the rear, however the machine gradually turned over onto them. Daniels, who had no prior experience in handling a flying machine, hung onto it from the inside, and was knocked down. According to Orville Wright: "His escape was miraculous, as he was in with the engine and chains." Because of this incident, the engine legs of

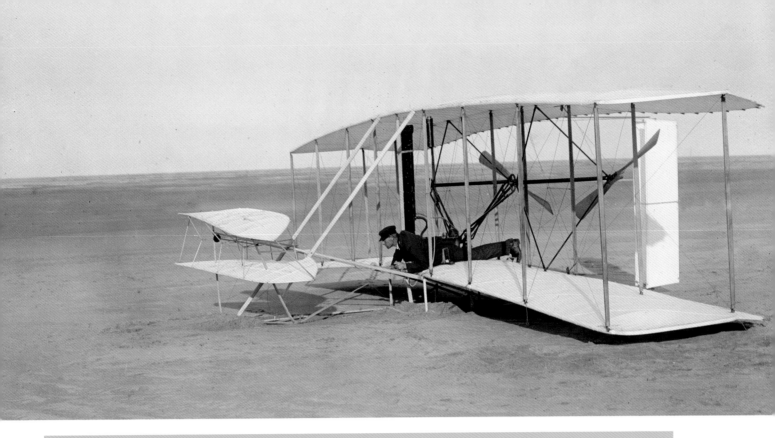

the machine were broken, the chain guides were badly bent, and nearly all the rear ends of the ribs were broken.

Daniels was unhurt, but the *Flyer I* was so seriously damaged it would never fly again. Curiously, despite the brothers signalling by telegram to immediately communicate their success, the nearest newspaper, the *Dayton Journal* considered the feat not noteworthy enough to publish. Once the story did eventually break, it created little public interest. In France, the news that the aeronautical community had failed to beat the Americans was largely met by derision. The Wrights were called *"bluffeurs"* (bluffers). The brothers themselves may have been partially responsible for the scepticism that greeted them on both sides of the Atlantic; they had no patent secured for their invention and no contracts for the manufacture of aircraft with any government. Therefore, to avoid competitors stealing their invention, it was prudent to stay under the metaphorical radar.

By 1907, the Wright's confidence was boosted by securing contracts with the US military, and a French company. They were ready to go public and decided there was no better place than the centre of the aviation world. At Le Mans, France, Wilbur Wright demonstrated his piloting skill to a captivated European public, which included notable aviation pioneers such as Louis Bleriot. Wilbur completed impressive manoeuvres, including banking turns, circles and even figure of eights. There was now

do doubt as to the brother's claims. They became instant stars.

Like Icarus, however, the brothers may have flown too close to the sun in the scale of their ambition. So-obsessed had they become with protecting the patent they eventually had approved for their design, and the subsequent legal challenges in the US and overseas, that their ability to innovate stalled, and their Wright company was overtaken by competition from aircraft manufacturers in France. The chilling effect Wright lawsuits had on the ability of rival American aeronautical companies to produce aircraft, meant that upon entering the Great War in 1916, the US had no battleworthy fighters and had to purchase an air-fleet from the French.

Neither brothers married. Wilbur died of typhoid in 1912, according to Orville, because of the strains the lawsuits had placed on his health. Orville sold the company in 1915, and for twenty-eight years served as chair of the National Advisory Committee for Aeronautics, which eventually became NASA. He was awarded the Guggenheim Medal in 1930. Orville died on April 19th 1944 of a heart attack. The man who took the image of him flying for the first time, our coastguard John T. Daniels, died the following day. According to his family, Daniels never tired of telling the story of how he survived the world's first aeroplane crash.

HOW A DEAF AND BLIND YOUNG WOMAN REVOLUTIONISED OUR PERCEPTION OF THE DISABLED

"Helen Keller, no.8", Photograph showing Helen Keller, half-length portrait, facing right, seated with hand on braille book in her lap as she smells a rose in a vase c.1904.

Image taken in Chelsea, Massachusetts, USA by the Whitman Studio. Image courtesy of the Library of Congress

Colourised by Jared Enos

On June 27th 1880, Helen Keller was born in Tuscumbia, Alabama. Her father, Arthur H. Keller, was a newspaper editor and her mother Kate Adams, the daughter of the Southern general. At the age of nineteen months, Keller contracted an illness now believed to be scarlet fever, which left her deaf and blind.

Keller grew up in a Victorian society that pitied and feared disabled people, many of whom were segregated from the rest of society by being forcibly placed into asylums. During this time the words "deaf and dumb" were synonymous, children with learning difficulties were called "defective", those with physical disabilities were described as "deformed". By 1904, in America alone, over 150,000 inmates, were incarcerated in mental institutions.

Keller was more fortunate, being from a loving and relatively wealthy family. She was also highly intelligent. Keller spent time playing games with her companion, the daughter of the family cook, Martha Washington. By the age of seven, Keller had developed dozens of signs with which to communicate. Her perception was so acute, she could recognise who was walking in her house by the strength and length of their pace. Keller described in her autobiography, *The Story of My Life* (1903), how from her infant years she was able to develop her system of signs: *"My hands felt every object and observed every motion, and in this way I learned to know many things. Soon I felt the need of some communication with others and began to make crude signs. A shake of the head meant "No" and a nod, "Yes", a pull meant "Come" and push "Go."*

Keller's mother was inspired by English author Charles Dickens' account of Laura Bridgman, the first deaf-blind person in the English-speaking world to be educated to a significant standard using the newly developed braille touch-writing. Through the inventor of the telephone, Alexander Graham Bell, who was working with deaf children at the time, the Keller family were referred to Anne Sullivan, a visually impaired student teacher, who would become Keller's lifelong companion. It was Sullivan who taught Keller the names of objects and how to read, by tracing shapes on the palm of Keller's hand.

By 1888, Keller was enrolled in the school Bridgman attended just over 50-years previously, the Perkins Institute for the Blind. By 1904, at the age of 24, Keller became the first deaf-blind person to be awarded a degree. Her circle of friends had come to include writer Mark Twain, philosopher Wilhelm Jerusalem and Boston journalist Peter Fagan, who became her private secretary. Fagan and Keller fell in love, became engaged and attempted to elope together, in defiance of Keller's family, who, like many others, believed that the disabled should be prevented from enjoying a love life.

Keller was not only able to teach herself to speak, but could lip read by placing her hand over a person's mouth. She began her lecturing career, articulating messages of hope and optimism, which astounded audiences of the 1900's. One of Keller's most famous quotes includes: "Walking with a friend in the dark is better than walking alone in the light."

A committed suffragette, social reformer, and advocate of the deaf, Keller opposed America's involvement in the Great War of 1914 and founded the American Civil Liberties Union. She raised significant funds for the American Foundation for the Blind. In 1918 she played herself in a silent movie *Deliverance* and performed on the Vaudeville stage. By 1959 playwright William Gibson wrote the Pulitzer Prize winning, *Miracle Worker* based on the relationship of Keller and Sullivan.

During her lifetime, Keller produced twelve books on subjects ranging from religion and spirituality, to politics and short fiction. She travelled the world, meeting English actor Charlie Chaplain, US politician and First Lady Eleanor Roosevelt, choreographer Martha Graham, India's first Prime Minister Jawaharlal Nehru, the Queen of England, Elizabeth II, and a total of twelve US Presidents.

On June 1st 1961, after a series of strokes, Keller died in her sleep. In 1964, she was awarded America's highest honour, the Presidential Medal of Freedom. Her college, Radcliffe, dedicated a garden to her. Internationally she received Brazil's Order of the Southern Cross, Japan's Sacred Treasure and the Philippine Golden Heart. In 1991, Keller was named the 20th Century's Most Important Person by *Time* magazine.

Her pioneering lectures, writing, political and charitable work is credited with forever transforming the way the able-bodied view the disabled. Her friend, Mark Twain said of her, *"Helen Keller is fellow to Caesar, Alexander, Napoleon, Shakespeare, and the rest of the immortals... She will be as famous a thousand years from now as she is today."*

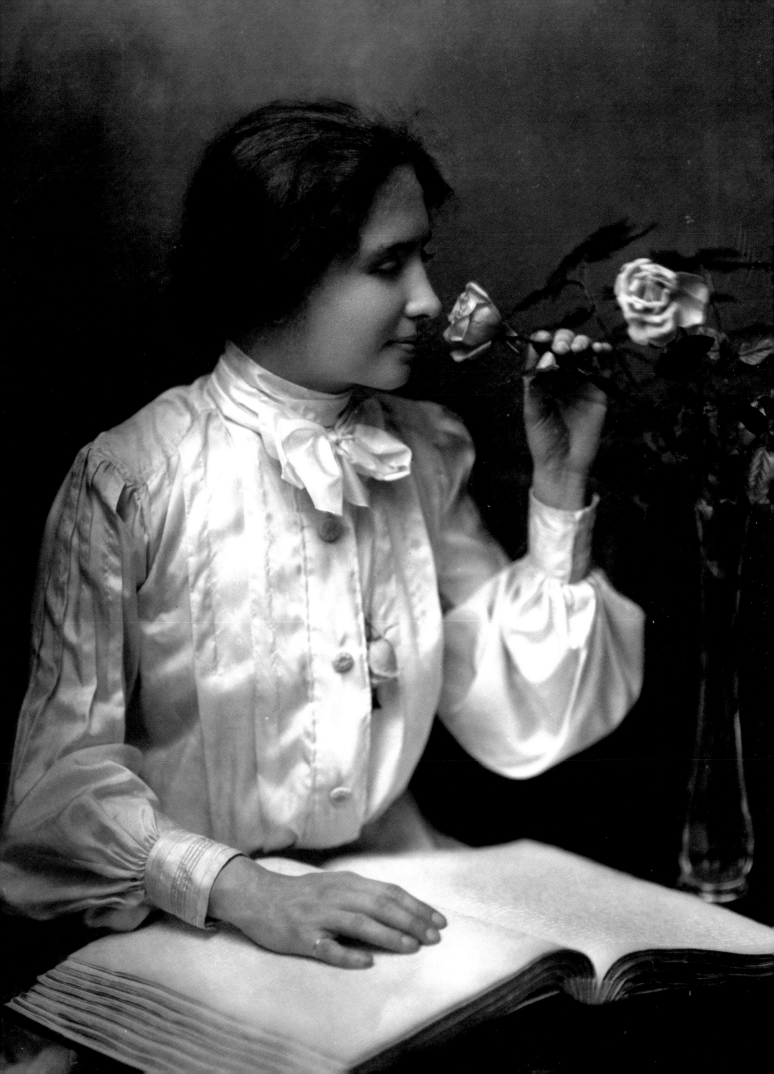

UNDERGROUND TRAVEL ADDS A NEW DIMENSION TO CITY TRANSPORTATION INFRASTRUCTURE

"City Hall Subway Station, under New York City"

Photographed in 1904 by the Detroit Publishing Company, image courtesy of the Library of Congress

Colourised by Mathew Loughrey

Underneath the entrance to New York's City Hall, lies this exquisitely built subway station. City Hall Station is a stunning example of how architecture was adapted to improve the experience of passengers travelling underground. Originally called "City Hall Loop", we see magnificent polychrome tiled arches interspaced with amethyst cut glass vaulted skylights, which radiated daylight onto the platform. The station was built in the *Romanesque Revival* style, and included luxury fittings that would normally have been the preserve of luxury hotels, such as brass fixtures and chandeliers. These touches of elegance served to impress on visitors that they were arriving at a prestigious and imposing destination, New York's City Hall. The Mayor at the time the station was built, Robert Van Wyck made personal efforts to officiate over the opening ceremony and had plaques installed to commemorate the people involved in the construction of New York's now world-famous subway system. It is ironic therefore, that what was intended to be a flagship station of NYC, now lies abandoned.

The image was taken in the same year the station opened alongside the rest of the New York Subway, 1904. From the construction equipment and material we see pictured, it is likely the photograph was taken in a period of calm, after construction was complete, but shortly before opening to the crowds that would come to alight here. The gentleman in the suit and hat is unknown, however it is pleasing to imagine he was Mayor Van Wyck, one of the chief builders, or perhaps an architect with the firm responsible for the design, Heins and LaFarge, or even Rafael Guastavino, the Italian master architect of the project and one of the leading proponents of the *Romanesque Revival* style in America. This architectural movement drew inspiration from medieval church construction of the Twelfth and Thirteenth Centuries in Normandy, France and Lombardy, Italy. The Romanesque Revivalists somewhat simplified the ancient and elegant style of utilizing arches.

Stations like City Hall were constructed to allow New York's booming population, which increased from just under seventy thousand people in 1850 to a staggering 3.4 million by 1900, to travel swiftly across the city cheaply and without hindrance. Because the granite bedrock the city was built on is so hard, tunnels were stable and therefore highly suitable for the running of an underground rail network. On the first day of opening on October 27th 1904, the New York Subway system carried one hundred and fifty thousand passengers. Today it's four hundred and seventy-two operational stations facilitate a weekday average of 5.6 million travellers. The New York Subway has been referred to in popular music throughout the decades, and has been the setting of many hit movies across the generations. These include thrillers from the 1960's and 70's, such as *Midnight Express* and *The French Connection*, Woody Allen comedies, musical dramas like *Saturday Night Fever*, as-well-as modern actions movies including *Die Hard with a Vengeance, Men in Black 2, Spiderman 2*, and sci-fi *Cloverfield*.

Sadly, City Hall Station fell victim to improvements in train construction necessitated by the influx of passengers to more popular stations. In contrast to the busier stations nearby, such as Brooklyn Bridge Station at the opposite side of City Hall Park, which connects to both local and express services, City Hall was not a popular station. At the time it's service was terminated, City Hall only served around six hundred passengers per-day, and had no night service. The tight curve on the platform and its distance from the track meant that without a complete and expensive overhaul, the station was unsuited for the new longer trains that were placed in service to cope with increased demand across the City subway system.

During World War Two the iconic skylights were tarred over to prevent light from below being visible from the air to enemy aircraft. On New Year's Eve 1945, the station joined the ranks of New York's "ghost stations" and was closed permanently. The number six train to Brooklyn Bridge still makes use of the loop to avoid the express track, however the platform itself is not visible to passengers taking this journey. Despite being covered, the three skylights still rise into City Hall Park. Now a humble park grating is the last publicly viewable part of this otherwise striking example of underground architecture.

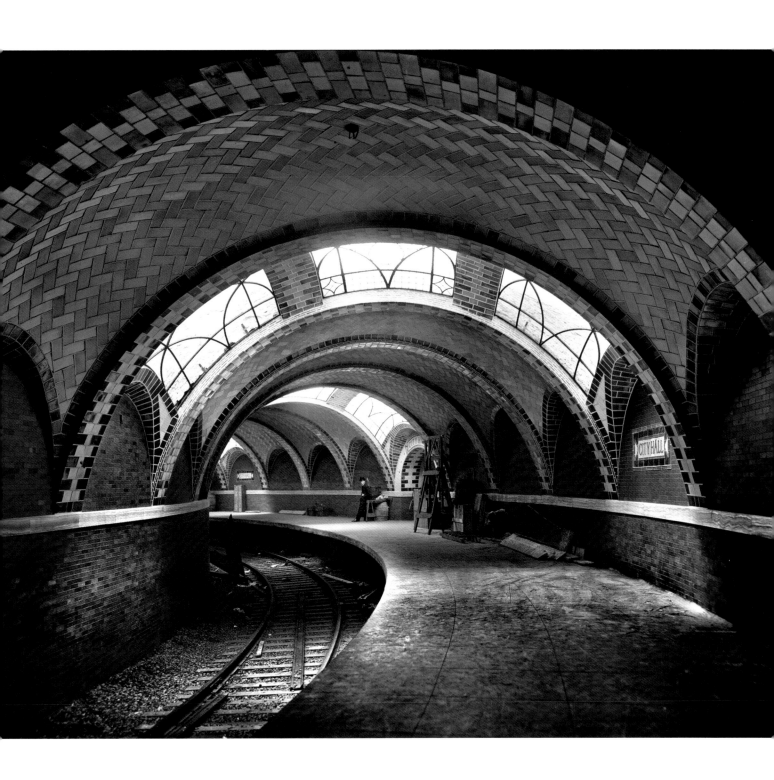

MOTHER, DANCER, WIFE, SPY: THE ORIGINAL FEMME-FATALE WAS A MISUNDERSTOOD WWI DOUBLE AGENT

"Exotic dancer Mata Hari (Magaretha "Gretha" McLeod nee Zelle) sits atop a throne"

Photographed by Unknown, probably in Paris, France c.1906

Colourised by Olga Shirnina

Accused by the French of spying for the Germans, and causing the deaths of twenty-thousand soldiers, on October 15th 1917, the world-famous dancer and courtier, Mata Hari, was executed by firing squad. Accounts of her death vary. In the most romanticised version she was brought to the spot outside Paris at dawn, and refused to be blindfolded. Instead, she chose to face her executioners. It was said, Mata Hari nonchalantly blew a kiss to the young soldiers before they shot her dead. The press in France gleefully reported the death of a principle traitor to the nation. In the popular imagination at the time, Mata Hari was the ultimate exotic seductress, whose cunning, duplicitousness, and overt sexuality had the power to confound the most intelligent and upright of men. She was believed to be from the Far East, descended from a priestly line of Hindus in what was the Dutch East Indies (now Indonesia). At the height of her career in 1910, she was the star of Paris, with her work considered to optimise the exotic femininity and mystical power of the East at a time when "The Orient" was very much in vogue.

By 1914, she was in her late thirties and she moved from dancing to acting as a private courtier to royal households throughout the continent. As a Dutch citizen, during the First World War, Mata Hari was free to move between France and Germany by way of Britain and Spain. When her Russian lover, the pilot Captain Vadim Maslov, was shot down and blinded over Germany, she was told by the German authorities that the only way she would be permitted to visit him, was if she spied on France. Ironically, she was already employed by the French to spy on one of her admirers, the German Prince Regent Wilhelm, the son of the Kaiser Wilhelm II and an army general. Mata Hari the double agent aroused the suspicions of both sides. In 1915, she was briefly arrested while in England by British counter intelligence, MI5. The French laid a trap the following year by feeding her six names of agents all working for the Germans, and one of these was suspected as a double working for both sides. When the Germans executed the double agent soon afterwards, Mata Hari was arrested and tried for espionage.

Known by the abbreviation of her first name, Magaretha, as "Gretha" to her friends, the real woman behind the Mata Hari persona reads very differently from the arch-seductress portrayed in the French popular press. She was born on August 7th 1876 to a successful businessman who lost everything, and a mother who died early in her childhood. Gretha experienced wealth in her younger years, but she also knew poverty. After a failed bid to become a teacher (she fled her position after the headmaster of the school she was working in flirted with her outrageously), Gretha secured her station in society at the age of nineteen, by marrying an aristocrat twice her age, Captain Rudolf McLeod, and giving birth to their son, Norman. The small family accompanied McLeod to his post in Java, Indonesia.

Upon arrival, she found her Captain was an alcoholic who kept a local concubine as a lover. McLeod would fall into violent rages, over the perceived attention she received from fellow-officers. Either from poisoning by an angry nanny, or from the contraction of the sexually transmitted disease of syphilis from either McLeod or Gretha, their son, Norman and their new daughter Jeanne fell seriously ill. Norman died and Jeanne only barely survived. Gretha moved in with a Dutch officer, and began to immerse herself in local Indonesian dance, very possibly as a means of escape from her unhappy life. McLeod refused to support his family, so Gretha relinquished custody of her daughter and fled to Paris. She attempted to support herself through teaching, but struggled, and resorted to nude modelling and possibly prostitution. It was her contacts from the Parisian artistic commune of Montmartre, that led to her discovery by theatre directors, and allowed her to begin performing her exotic dances on stage to enrapt audiences. "Mata Hari" was the cover she used to present herself as the confident and alluring, "man-eater", the decadent audiences of Paris had been hungry for.

Tragically it was the "otherness" that Gretha had cultivated that made her both mesmerising and expendable to the French state at the height of its wartime failures against the German invader. As a top spy for both governments, who by her own admission had accepted money from Germany (but denied passing actual secrets to them – only idle gossip), she is now largely regarded sympathetically by historians as a scapegoat. Her life and death has been dramatized on stage, on television and in cinema. Despite Gretha's own more complex life, Mata Hari remains the archetype for actresses playing mysterious, seductive, and deadly femme-fatale characters to the present day.

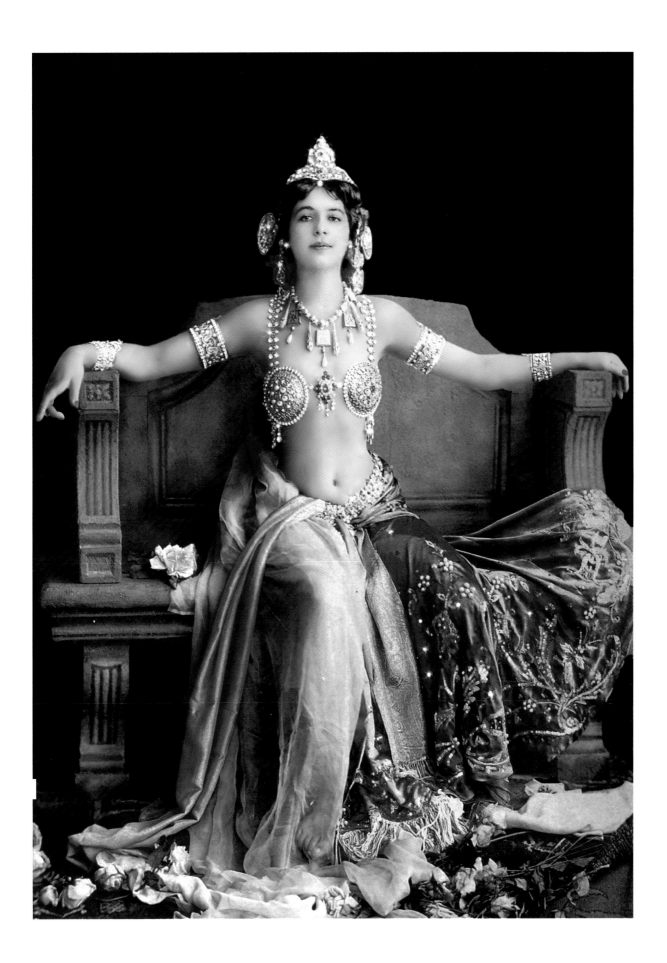

AMERICA'S FIRST PROFESSIONAL FEMALE TATTOO ARTIST TRANSFORMS OUR IDEA OF WOMANHOOD

"Portrait of a woman showing images tattooed or painted on her upper body"

Photographed at the Plaza Gallery, Los Angeles, California in 1907. Image courtesy of Library of Congress

Colourised by Matt Loughrey

With an Eve-like woman riding a lion painted prominently on her chest, a scarlet snake climbing a tree, monkeys, horses, and the American Bald Eagle with Union flag on her right arm, the vivid tattoos of Maud Wagner echoes the biblical *Fall from Paradise,* the sacred feminine and the power symbols of her day. It is therefore no wonder that the first woman to professionally tattoo is still remembered as a "historical badass".

Kansas-born Maud was raised in an Edwardian society where women could not vote, nor hold public office, and were discouraged or banned from many professions. The tattooing of Western women was virtually unknown in the mid-19th Century. The first recorded American of European origin to be tattooed was Olive Oatman, whose parents were killed by Yavapai Native Americans when she was thirteen. She and her sister were captured and sold on to the Mojave tribe, who raised her as one of her own. In keeping with the custom of the Mojave, Oatman received traditional tattoos on her face. After five years, having suffered the death of her sister, she succeeded in negotiating her freedom and was handed to authorities at Fort Yuma. At the age of nineteen, when Oatman returned to American society, her facial ink caused such a sensation she became a national icon.

"Olive Oatman, 1863"

Photographed by Benjamin F. Powelson, image courtesy of National Portrait Gallery, Smithsonian Institution

Colourised by Jecini

Victorian females were expected to raise children, service the needs of their husbands, and dress and act as directed. Tattooed women did begin to appear in the later Nineteenth Century, however they were only seen in public in travelling circuses or participating in "freak shows" alongside disabled people, exotic animal tamers and other noteworthy performers. While working as a contortionist and aerial acrobat in a travelling circus, her act was part of the 1904 *Louisiana Purchase Exposition.* This was a world fair, which showcased the latest entertainment as-well-as technological, geographical and consumer innovations, held in St. Louis, Missouri. Technological marvels such as an early fax machine, a wireless telephone, x-ray machine and infant incubator all caused a sensation amongst visitors. There she met renowned tattooist and showman Gus Wagner, who called himself the "World's Champion Hand Tattoo Artist and Tattooed Man" and purportedly having 264 tattoos, he also declared himself, "the most marked up man in America". Legend has it this exuberant man offered to teach Maud how to tattoo in exchange for a date. Two-years later the couple married and they later had a daughter, Lotteva.

As the family travelled America, a new craze for tattooing began to seize genteel middle class women. Tattooing was a sign of unconventionality and willingness to be risqué. While the fashion took hold in the major eastern cities, the Wagners are credited with bringing this trend inland to smaller towns and rural communities. As America's first female tattoo artist, Maud was a trailblazer who opened-up the tattooist community to women, and enabled women to be themselves tattooed. However, the couple were also a significant link to the traditions of the past. Together they were the last of the American tattooists to use only the ancient "hand-poking" technique, a method of piecing the skin with a needle to insert the ink used before the invention of the tattoo machine. This is still practiced by a small number of indigenous people today. Gus died in 1941, after being struck by lightning. Maud died on January 30th 1966. Her daughter, Lotteva did not tattoo her own body, however she was an accomplished tattoo artist in her own right. Before Lovetta died in 1983 she gave one last tattoo, using the hand-poking technique, taught to her by her parents. This took the form of a rose, given to artist Don Ed Hardy, of Sailor Jerry fame.

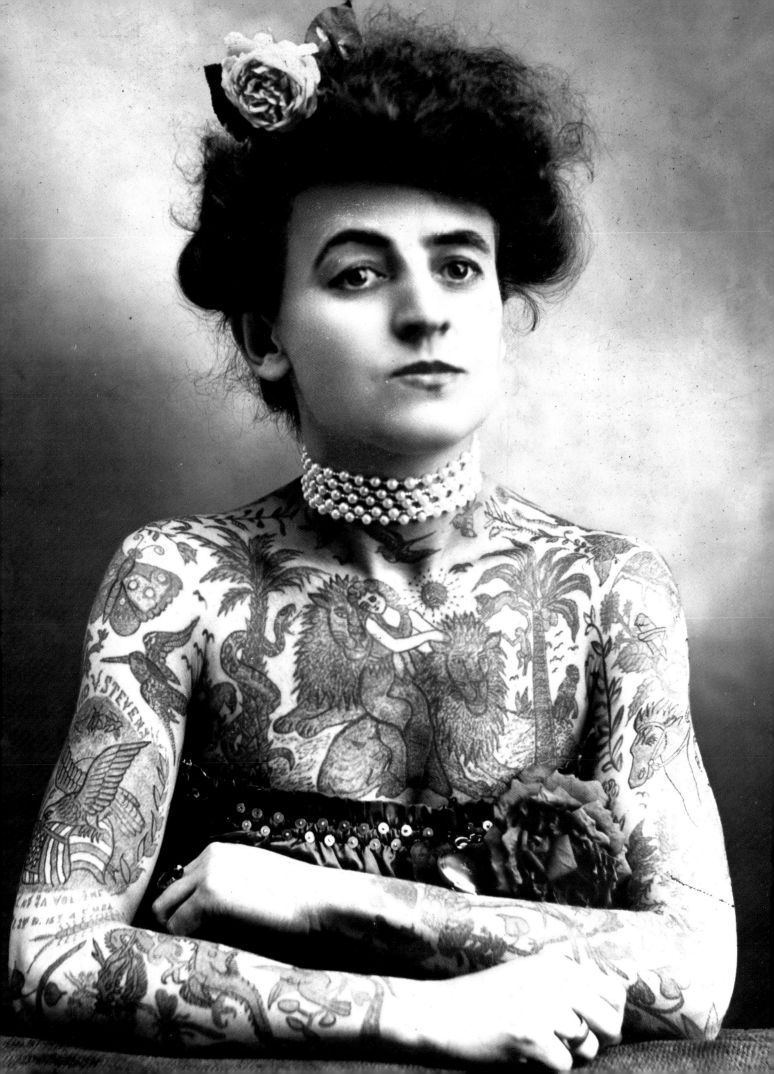

REIMAGINING THE HUNTER: HAS PHOTOGRAPHY CONTRIBUTED TO THE DECLINE OF THE NATIVE AMERICAN WAY OF LIFE BY ATTEMPTING TO RECREATE IT?

"An Ojibwe Native American spearfishing in Minnesota"

Photographed in 1908 by Roland W. Reed. Image courtesy of Library of Congress

Colourised by Jared Enos

This image of a hunter gatherer dressed in traditional clothes, sitting in a kayak with spear raised, is an iconic, picturesque capture, skilfully photographed with the intention of evoking the spirit of the America's native people and their relationship with the wilderness. However, it is unlikely to be a spontaneous composition. By the time this shot was taken by the Wisconsin photographer of Native American people, Roland W. Reed, the way of life of the tribes he depicted had almost entirely died out. Instead, the scenes he depicted were a form of reimagined memories from his childhood, when the tribal people were still free.

Reed's upbringing in a mountain cabin near an old "Indian trail" was the inspiration for his life's work. He explained in his journal how these childhood encounters with Native American neighbours shaped his adult psyche: "I longed to join them," he said, "and as I grew into manhood and left my native state, the call of those old friends of the forests and lakes never left me." In 1907, Reed described how he locked up his studio, ordered photographic material and other supplies and started his, "long deferred campaign in portraying the North American Indian." Rather than being permitted to live traditionally as nomadic hunters as they had for thousands of years, by the early Twentieth-Century, when Reed began his nomadic life as a travelling photographer, Native Americans had been forcibly moved into reservations by the government. There they survived from a combination of state food parcels and settled farming.

Reed was a self-financing photographer and hand-drawing artist who kept his business afloat by selling images as advertising for the railroad companies, and the publishers of Western-themed "dime" novels. His technique was to capture images in the pictorial fashion, which meant, rather than simply recording what he happened to see in the documentary style, he would pose his subjects or otherwise compose the scene to capture his vision as he wanted it represented. In addition, he would sometimes hand paint his images into colour for his customers.

Reed's tried-and-tested method was to approach his Native American subjects, hire them to take part, and ask them to recreate a scene from the past they will have been familiar with. So, in the image opposite we can imagine Reed asking this member of the Ojibwe Tribe to paddle out into the lake we see, request the spearman to visualise a fish in his sights, and slowly raise his weapon as if to strike. Then Reed would have pushed the shutter and captured a scene which was not documentary in the true sense of the word. Instead it was an authentic recreation of a hunting practice which will have occurred countless times in this very way by people who dressed, thought, and had the same direct experience as the subject of the photograph.

"An image of photographer Roland W. Reed"

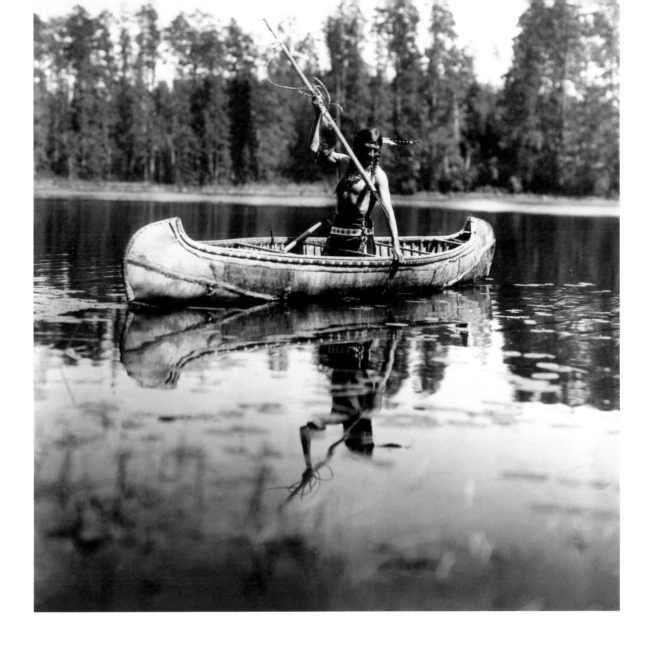

Reed's methods have been the subject of criticism for having an overly nostalgic quality. He has been accused of creating a romanticised American stereotype of how native people were expected to be and look in relation to the landscape, and having given the false impression that the Native American way of life had been preserved rather than forcibly supressed by the government.

Reed's contrived approach was in a sense born of the necessity to carry on: his images needed to be commercially sellable in some way for this solitary travelling photographer to support his work. His main competitor was the well-connected ethnographic photographer Edward Curtis. He had funds of $75,000 from the financier J.P. Morgan and the support of the Smithsonian Museum, which allowed him to record an astonishing forty thousand images of the eighty tribes he surveyed.

It's clear from Reed's portfolio that he was concerned with the education of the American public as to the way of life of the native people, and had a desire for his images to act as a bridge to a past that had disappeared by the time his shots were taken. Never widely recognised for his work, Reed was nevertheless awarded a gold medal for his exhibition at the San Diego Indian Arts Building before his accidental death on December 14th 1934.

IMAGES FROM ELLIS ISLAND REVEAL THE DIVERSE FACES OF THE MIGRANTS THAT BUILT AMERICA

"Immigrant photographs"

Photographed by Augustus Sherman, images courtesy of the Statue of Liberty National Museum and Ellis Island/National Park Service

All images colourised by ©Tom Marshall (Photografix)

In the second decade of the Twenty-First Century, many of us tend to think of racial and cultural diversity as a relatively recent phenomenon, or we may not think much about how other generations might have received people from distant places. We are sometimes tempted to imagine the questions of how we grapple with the push and pull of integration vs. multiculturalism, assimilation vs. exclusion are exclusively ours to face, without recourse to the experiences of our ancestors. In the case of America, famously known as the "Nation of Immigrants", the historical narrative of inward migration has tended to emphasise the origins of the founding English, Welsh, and Scottish settlers. After American Independence, how waves white-European migrants have contributed to the United States has been the dominant narrative. However, we can see just how diverse this voluntary immigration into the USA was even 110 years-ago through our sight of the people in the images opposite. They were just six of the estimate twelve-million immigrants who passed through the nation's busiest immigrant inspection station, Ellis Island. Despite most of them originating in Europe, in both dress and demeanour they are so exotic, they each look like they belong to another world.

We see a man in what looks like a uniform of the military or other disciplined profession recorded as coming from Denmark; a woman from Italy with an elaborate peasant's headscarf; an exotically-dressed pair, most likely to be brother and sister sweetly holding hands who were from one of Europe's most northerly and remote fringes, Lapland; a jauntily capped piper from Romania demonstrating his instrument; a young male in traditional attire simply referred to as "a Hindu boy", who would probably have travelled from the Indian Subcontinent originally; and the only person we see pictured to have their name and profession recorded by the photographer, Reverend Joseph Vasilon, who was a Greek Orthodox priest, and is seen wearing a cylindrical clerical hat called a *kalimavkion*.

These intimate portraits were captured by a clerk at Ellis Island, Augustus Sherman, who took a total of two hundred and fifty photographs of people who were briefly detained by immigration officials for a variety of reasons, before being allowed into the country. Sherman, however, was not performing an objective survey of those who found themselves

in such circumstances. He simply loved to capture people wearing traditional costumes he encountered in his daily work who were from far-flung places. The fact that these migrants were temporarily detained appears to have merely provided Sherman with the time necessary to capture their image, as compared to the fleeting visit most of the millions who passed through the Ellis Island immigration center, during its operational lifespan.

Famously, the first sight arrivals would be greeted with upon approaching the Ellis Island immigration centre by ship, was the iconic and unforgettably symbolic Statue of Liberty, which stands over three hundred-feet-tall in New York Harbor. For those who were about to arrive, seeing the raised torch of liberty raised triumphantly over the awe-inspiring cityscape, would have been a moment for rejoicing.

Designed to cope with increasing numbers of immigrants, Ellis Island itself was a former military fort opened in 1892 as the most important in a new chain of Federal arrival centres, built to replace the State reception centres formerly used to process new arrivals. First and second-class passengers were met and briefly interviewed onboard ship by officials. Those holding third-class tickets and below were sent to immigration centres such as Ellis Island, as-well-as first and second class passengers in legal, health or financial difficulties. Passengers were taken by barge to the island for health and legal inspection. Those found to be suffering from contagious disease would be forcibly held in wards until they recovered, died or had to be returned to their point of origin. Those of questionable legal status, including known criminals, enemy aliens (those from enemy countries during wartime, such as Germans during World War One) or suspected alien radicals (such as those believed to be Communists from Russia during 1920's) could all be detained and then deported.

Medical inspectors became proficient at spotting contagious disease at a glance, conducting "six second physicals" on the hundreds of people each doctor examined in a day. Nicknamed "The Island of Tears", the general experience of migrants that were processed on Ellis Island has not been recorded as positive because of the hostile manner of many, but not all, immigration officials. However, on average a new migrant spent only around

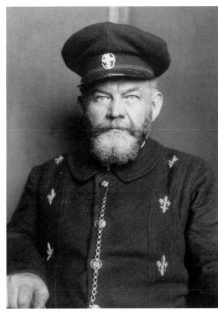 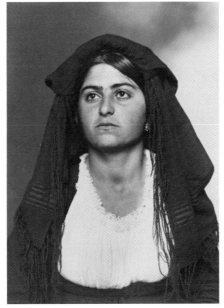

 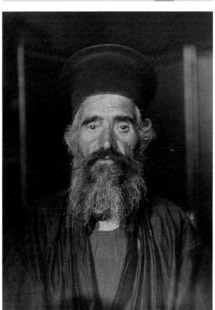

five hours at Ellis Island before being granted permanent entry into the United States, and according to official records only two-percent were rejected.

As visa applications began to be processed in the country of origin, by United States Embassies across the world, the need to finance a single large immigration centre outside New York began to diminish. During the Second World War, Ellis Island continued to function as a place to process war refugees and detain civilian enemies such as merchant seaman. By November 1954, the last detainee, a Norwegian sailor called Arne Peterssen, was released and the immigration centre closed. In 1965 it reopened as a national monument to remember the immigrants who passed through its doors. Now around two million people per-year learn of this history directly through visiting the Ellis Island National Museum of Immigration.

From top left to right: Danish man, c1909. An Italian woman, c1910. Swedish children (likely brother and sister) posing in folk costumes of Lapland c1910. A Romanian piper in a sheepskin cloak, c1910. Hindu boy, c1911. Rev. Joseph Vasilon, Greek-Orthodox Priest, c1910.

THE FORMIDABLE MILITARY LEADER WHO APPOINTED HITLER TO POWER IS VENERATED BY THE GERMAN PEOPLE

"Photograph shows Paul von Hindenburg (1847-1934), a Prussian-German field marshal and statesman."

Photographed c. 1910 by Bains News Service, image courtesy of Library of Congress

Colourised by Mads Madsen

Towering at six-foot five inches tall with a barrel chest, impeccably groomed handlebar moustache, monocle and piercing blue-eyes, the man who allowed Hitler's Nazis into power in Germany could not have been more of a colossal figure. President of the German Reich from 1925 to 1933, Field Marshall Paul von Hindenburg embodied the militaristic approach many of the German people saw as the salvation to the struggles of their nation. Yet to the modern eye, he was a man of a simpler yet more brutal era of the past. Before 1871, when the aristocratic Hindenburg was a young but rising officer, Germany was split into a patchwork of independent kingdoms and principalities, with Hindenburg's native Prussia to the east being the most dominant. Unified nations such as France and Britain had established global empires by the mid-19th Century, yet the German-speaking people looked on with envy as the wealth of Africa and Asia poured into the cities of their European competitors.

Under the leadership of their Kaiser, Wilhelm I, the Prussian *Junker* class of aristocratic soldiers organised the military into a formidable fighting force. The aim was to restore the medieval glories of the German First Reich (Holy Roman Empire of what is now mainly Italy and Germany) through territorial conquest, towards the ultimate goal: the national unification of Germany. Hindenburg's obsession with war, belief in the beauty of battles, calmness under fire, and straightforward, but simplistic way of communicating, made him the embodiment of the perfect *Junker*. In war, Prussia was startlingly successful, and Hindenburg himself took part in Prussia's victories against the Austrian Empire in 1866, and its spectacular defeat of France in 1870, to his delight he took part in the victory parade of German soldiers through Paris. To humiliate France further, in 1871 Wilhelm I proclaimed himself German Emperor from the seat of French political power, the Palace of Versailles, and thereby established the Second German Reich.

By 1914 General Hindenburg was recalled to command forces on the onset of the First World War. Hindeburg became the most respected figure in Germany, more so than even the Kaiser, who became reclusive as the war wore on. A cult of the personality formed around Hindenburg, with the public attributing him with a mythical status, and some believing he held supernatural power over his foes. Despite Germany surrendering to the Allies in 1918, Hindenburg was successful in distancing himself and the military from what was regarded as a shameful peace deal for Germany at Versailles. A fervent monarchist, he also managed to deflect blame for the forcible abdication of Kaiser Wilhelm II away from himself. Instead, like everyone else, he blamed the politicians for the humiliating terms of the peace in 1914, which led to near-crippling reparation payments to France, loss of territory, and millions of German-speakers living under foreign rule.

The Weimar Republic, which rose from the ashes of Imperial Germany, is remembered for its liberalism. However, this national free-spiritedness was to be short-lived. Hindenburg was elected President of the Republic for the first time in 1925, on the premise that he would be a stabilising force against the rising tide of extreme left-wing and right-wing political parties vying for control of the country. Hindenburg did play the part of the elder political statesman, and attempted to rise above politics. He distained politicians and the democratic process, and ultimately sought to crush Communism in Germany by whatever means possible.

After the economic chaos of the Wall Street Crash in 1929, German politics was at a knife-edge, with street fighting, killings and arson becoming commonplace. Hitler deployed his army of fascist SA "Brownshirts" to intimidate, beat and kill Jews, homosexuals, and political opponents. Using a combination of political violence, and anti-Semitism, Hitler manoeuvred the Nazis into being the second largest party by the time of the 1932 election campaign. To Hindenburg's dismay, people he considered his natural supporters, conservative protestants from his homeland in the east, overall supported the Nazis. Liberal, socialist, and urban intellectual classes, whom he despised, voted tactically for him, to keep the Nazis out of power. Hindenburg attempted to pacify Hitler by offering to make him Vice Chancellor of the country. Hitler refused and by January 1933, Hitler was appointed Chancellor of Germany. By March of that year, Hitler passed the infamous Enabling Act and became dictator of Germany. Non-Nazi parties were banned by July 1933. Just a year later, Hindenburg died of lung cancer at his home.

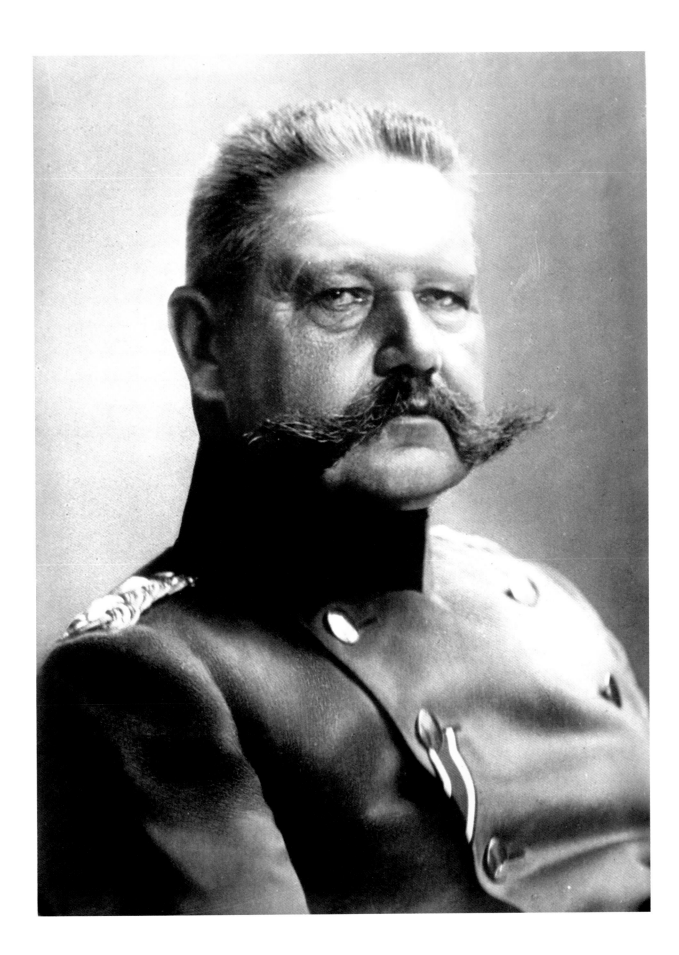

"Alphonse Bertillon demonstrating the two-part 'mug shot' method of photographing suspects that he championed"

Photograph in 1913 by Alphonse Bertillon, image courtesy of the Wellcome Library, London

Colourised by Mads Madsen

Today, mugshots, finger-printing, DNA testing, are not only familiar ways to catch criminals, but also methods for identifying each other and proving we are who we say we are. A photographic passport allows us to access services, a fingerprint swipe can unlock our mobile phone, our DNA can unlock the remote secrets of our ancestry. To some, biometric technology represents an insidious "Big Brother" technology, which in the hands of State officials, can be used to monitor and repress the freedom of the individual. Before French detective and forensic pioneer Alphonse Bertillon combined the Anthropometric method of measuring an individual's unique body parts with photographic technology, there was no reliable way to identify a suspect by his face. Criminals were able to evade identification though the simple use of aliases (acting under an invented or assumed name), failing to carry official papers on their person, and superficially changing their appearance and accents. With no knowledge of finger printing until the late 1890's, law enforcers had limited means to prove that a person was not who they said they were.

"One can only see what one observes, and one observes only things which are already in the mind." – Alphonse Bertillon

With an educational background as a physician who did not complete his training, but who retained an interest in anatomy even as a policeman, by 1879 Bertillon cemented his reputation as the grandfather of forensics by realising three key points, which he constructed into his tripartite system of identification:

1. **Measurement:** A person's key features become relatively fixed once they are an adult. The combination of size and distance of these features is fairly unique between individuals.

2. **Portait parle:** the systematic categorisation of specific features such as eye-colour, facial hair, heaviness of eyebrows, hair growth pattern, etc. The position, size and shape of the ears in relation to other features was recognised as particularly unique between individuals.

3. **Photography:** not only using photography to record the face, but to use the photograph in the context of the other two parts of the system. This meant taking a photograph as a portrait as-well-as a profile shot and placing them together to form the now iconic format of the classic mugshot.

By 1884, two hundred and forty-one repeat offenders were identified through the technique of comparing mugshots, and the system quickly spread through France to as far afield as America. The long-held belief that criminals could be identified by their skulls size and shape was buttressed through the scientific cataloguing of criminal faces by police, and criminologists began to study faces so-as-to predict what type of face a criminal would tend to have. In this way, the idea was raised of predicting criminal activity before it had been committed and the possibility of arresting a person because of their facial type was suggested. This idea of "precrime" was portrayed as a sinister force in the 2002 Steven Spielberg Hollywood blockbuster movie, *Minority Report* starring Tom Cruise. Eugenicists used mugshot photographs to racially profile groups of people, which was used as "evidence" that certain "primitive" races were more prone to criminality than other "superior" races.

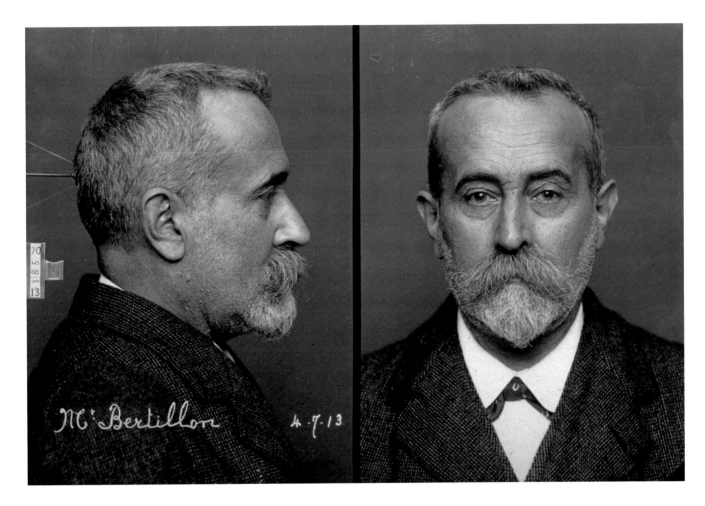

The modern-day mugshot has uses far beyond detection. It can also be disseminated to the media, as a warning to other criminals and to show justice being seen to be done. Mugshots are also published to show the public the "face of evil", as is still practiced to the present day when a notorious murderer, rapist or other public enemy is apprehended for their crimes. With the rise of the internet, the practice of taking mugshots has now become internalised. If we invert the intention of the image, the mugshot is the ancestor of the selfie: pictures of ourselves we post on social media to project ourselves as the "face of good" to the online community in which we belong. However, if one day we ourselves become newsworthy, either as victim, perpetrator, or some other human interest story, it is now our social media profile picture which is most likely to act as our modern-day mugshot.

Above: Unknown woman in neurosurgery aftercare. Baltimore in 1908

Below: Unknown 28 year old Mexican man. A mugshot taken c.1910

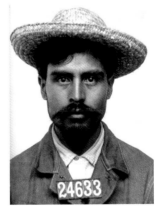

Right: Jake Vohland 1931 at Nebraska State prison. Theft of chickens and sentenced to one year in prison

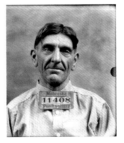

UNRECONSTRUCTED PRUSSIAN MILITARISM SURVIVES INTO THE 20TH CENTURY - CULMINATING IN THE "WAR TO END ALL WARS"

"A splendid dual portrait of a veteran of the Franco-Prussian War and his grandson, an Unteroffizier mit Portepee, dated February 9th 1913"

Photograph courtesy of the Brett Butterworth Collection

Colourised by Mads Madsen

The image of these two related men in their closely matching uniforms embodies the spirit of the military family, and in its detail and soldierly paraphernalia, this photograph shows how martial traditions were handed down from one generation to the next. The title of this image is provided by handwritten notes in German found on the reverse side of this postcard. The gentleman on the left is the grandfather in full Prussian uniform, who served on the same campaign as General Hindenburg, the Franco-Prussian War of 1870-71. Although this conflict ended over forty-years before this image was dated, we see the grandfather, who must have been approaching the age of sixty at the very least, as a barrel-chested but upright veteran who stands smartly to attention in his uniform, bayonetted rifle, and polished boots. The black sash across his shoulder was typical of the privates of the Prussian *Landwehr* infantry, or militia units, that Prussia had called up quickly in moments of war since ancient times, but by the Franco-Prussian War these had been formed into regular units. The sash itself was used prominently during the Napoleonic period.

By the time the image was taken, the grandson will have been serving in what had become the Imperial German Army. We see remarkably little difference when comparing their uniforms apart from the missing sash in the more recent uniform of the grandson, colours being changed from blue to green, and grandfather's buttons look a little more well-shined. Grandfather clearly sports an imposing dual-spiked black beard, while grandson has cultivated an upturned moustache that was fashionable among German soldiers of the time.

Of the pair, it is the grandson who holds the more antiquated weapon; because he is the *Unteroffizier mit Portepee*, which literally translates in English to, "sub-officer with swordknot" or non-commissioned officer with a knotted sword. Once the symbol of the officer-class only, the tradition in the Prussian and Imperial German Army was for non-commissioned officers to also wear swords into battle, and the swordknot was used for ceremonial purposes. It has not been possible to identify the

military badge pinned to the chest of grandson. Both men can be seen wearing wedding rings.

Through this striking image, we see how strong the continuity of Prussian military tradition was across the Nineteenth Century, culminating in the ultimate expression of her militaristic ambitions, "the war-to-end all wars" of 1914-18. Military traditions may have been preserved remarkably well across this period, however weapons technology had radically changed the way in which war would be fought during the First World War. Men like our grandson, who looks both bold and smart in his shining boots and well-oiled weapons, would face carnage in the trenches. This was a mode of war that would have been unrecognisable to grandfather, who would have been acquainted with the age-old method of charging across open fields towards the enemy. In eighteen months from the date of this image, the grandson and his generation across Europe, would be the first to face the full horror of the mechanised array of machine guns, aircraft, artillery shell and tanks. It is possible he was one of the thirty-eight million people killed in this conflict. Alternatively, he might have survived to meet his own grandchild, and taught them what he had learned of war.

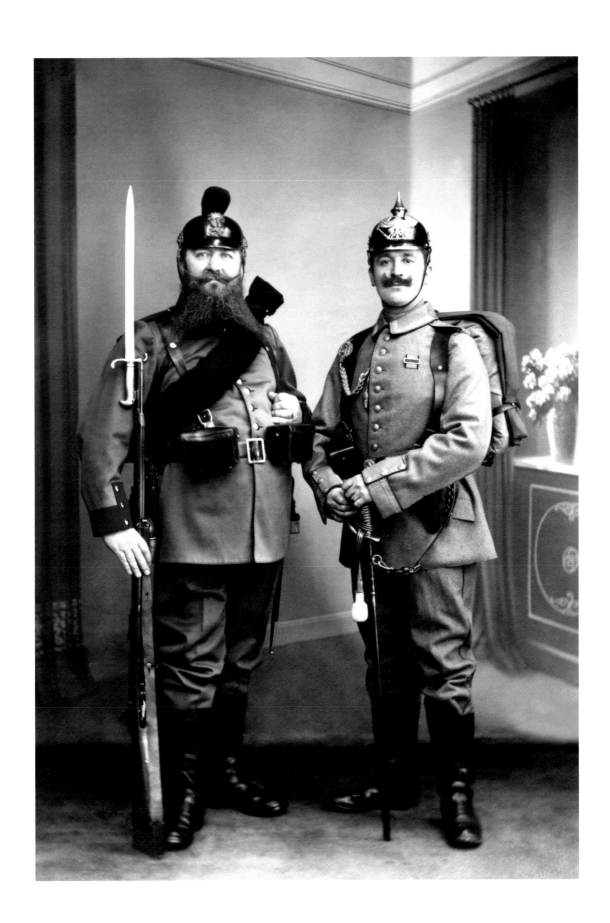

THE WORLD'S MOST ICONIC ACTOR IS MIRED IN CONTROVERSY

"A photographic portrait of Charlie Chaplin as a young man, Hollywood, taken around 1916 by an unknown photographer."

Image courtesy of the Science and Society Picture Library, London UK

Colourised by Mads Madsen

At the time this image was taken, twenty-seven-year-old Chaplin was the highest paid actor, and possibly the highest paid person, in the world. He received a yearly salary of $675,000 and had fifty silent films to his name. So great was the impact of Chaplin's iconic "Tramp" character with his cropped moustache, undersized hat, baggy pants and ill-fitting shoes that the young Londoner was hailed as a comic genius. He owned a Los Angeles studio, from where he produced a film every four-weeks under his own direction. In silent movie theatres across America, Britain and even in the trenches of Europe's Western Front, where the planet's most lethal war was being conducted, Chaplain delighted audiences with his wit, creativity, and sheer physical presence. This image shows the cocky, but sensitive Englishman during what Chaplin himself described as the happiest period of his life.

Born into extreme poverty on April 16th 1889 in Walworth, South London, Charles Spencer Chaplin's start in life could not have been more different from the success that was to come. His mother, Hannah Chaplin was an attractive and popular music hall singer, however, she suffered from poor health and Chaplin's father, celebrated singer Charles Chaplin Senior, left his family and Hannah was incarcerated in a mental asylum. By the age of nine, Chaplin had been interred in the workhouse twice. The young boy was protected by his elder brother by four-years, Sydney, who remained a paternal figure throughout the comic actor's life. If the Chaplin brothers were to stay together and earn money to bring their mother home, they had to rely on their acting and singing talents. Chaplin's first break came at the age of ten, when he joined The Eight Lancashire Lads clogdancing troupe. At the age of fourteen, he secured the role of pageboy with the first *Sherlock Holmes* actor, the American William Gillette.

The pair signed up to Karno's comedy company, and by the age of eighteen, Chaplin had his own sketch show, *Jimmy the Fearless*. By the standards of the London comedy circuits, Chaplin was now a star. He was selected to tour America, and on his second tour of 1912-13, at the age of 24, he was asked to join the Keystone film studio, part of Hollywood's embryonic film industry. By 1914 Chaplin developed his legendary alter-ego, "The Tramp", which was the comedy character Chaplin was best remembered

for. After forming his own LA film studio, First National and later helping to found United Artists, the 1920's and 30's saw Chaplin revel in the freedom he enjoyed by producing many of his own films, which included drama, romance and political commentary.

Despite his success, Chaplin's life was to be fraught with controversy. During the Great War of 1914-18, he was criticised by the British press for not joining the army. Chaplin's string of failed marriages, and very public break-ups, meant that his personal life also came to dog him in the press. During 1931 Chaplin travelled the United States for over a year. He saw the shocking labour conditions caused by the Great Depression, and perhaps reminded of his own impoverished childhood, he became increasingly political.

Through his films *Modern Times*, where he satirised modern industrialisation by positing The Tramp as a hapless cog in a mighty machine, and *The Great Dictator*, where he lampooned German Nazi leader Adolf Hitler; he found himself under political suspicion as a possible communist. After a paternity suit by his estranged lover, actress Joan Barry, in 1944 Chaplin found himself under indictment by the FBI for transporting a female across state lines for sexual purposes. If found guilty he faced twenty-three years in prison. He was acquitted, but his reputation was irreversibly tarnished. In 1952, Chaplin travelled to London for a film premier, and was banned from returning to America. He settled in Switzerland.

After years of estrangement from the US, by the 1960's attitudes towards him softened, and he received praise for his lifetime achievements. In 1972, after twenty years of exile, Chaplin returned to America to accept an honorary award from the Academy of Motion Pictures Arts and Sciences. In 1975, he was knighted by Queen Elizabeth II of England and on the morning of Christmas Day 1977 he died in his sleep at the age of eighty-eight. Having earned numerous awards for his contribution to cinema and in recognition for being the first significant big screen icon, Chaplin was featured in *Time's 100 Most Important People of the Twentieth Century*. He was survived by eleven children from his four marriages.

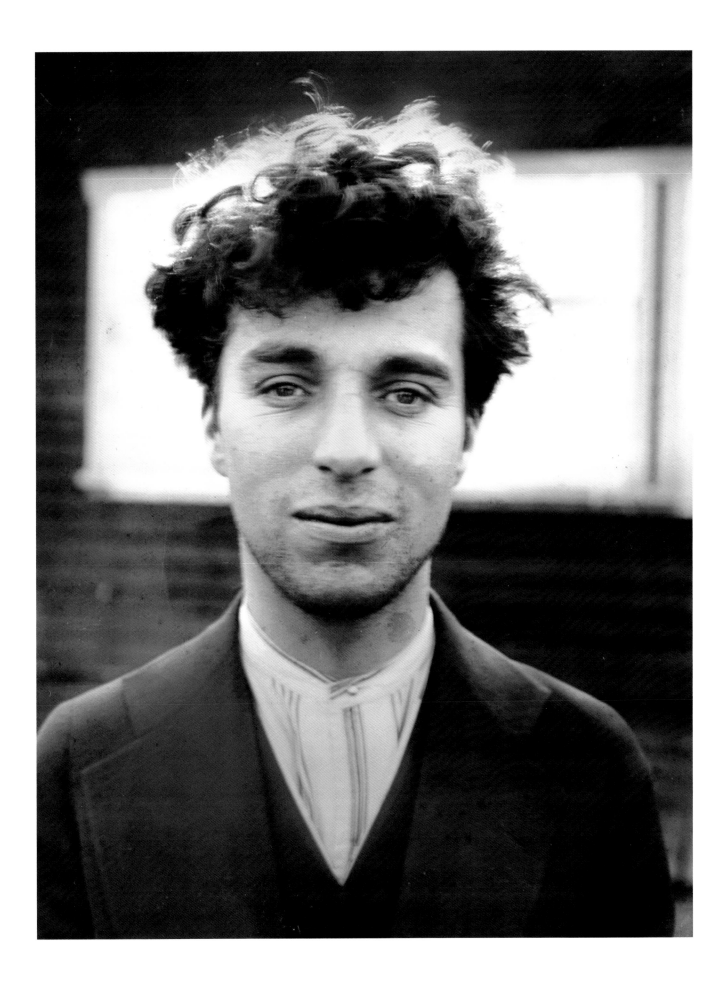

THE LAST IMAGES TAKEN OF SOLDIERS BEFORE THEY WERE SENT TO DIE IN BATTLE ARE REDISCOVERED IN A FARMHOUSE ATTIC

"The Lost Tommies of World War One"

Photographed by Louise and Antoinette Thuillier, image courtesy of the Kerry Stokes Collection

Colourised by Frederic Duriez

From 1914 to 1918 it is estimated that thirty-eight-million people died in what was known at the time as "The Great War", "The War to End All Wars" and is now simply called "The First World War". This first large-scale war of the Twentieth Century saw Britain, France, Italy, Russia, and later America, fighting Germany, the Austro-Hungarian Empire and Ottoman Turkish Empire for global supremacy. While it was the assassination of Austrian aristocrat Franz Ferdinand by Serbian nationalists that led to war being declared, historians largely agree it was European "Great Power" imperial and economic rivalries that were the underlying causes.

The Great War that ensued was one of the deadliest conflicts in human history, with new fearsome weapon technology such as machine guns, tanks, submarines, aircraft and toxic gas being deployed for the first time on a mass scale. For European armies, historically reliant on horses and manpower, with cavalry charges and infantry advances on open fields being the traditional means to win battles, the modern weaponry was devastating. A newly mechanised and dehumanising chapter in military history had been written: that of trench warfare. Mud, barbed wire, machine guns, snipers and shelling had replaced grass, lances, horses and sabres.

After opposing armies met on the battlefields of France and Belgium, they dug in for safety and formed an intricate network of trench lines which were collectively called "The Western Front". Unable to decisively break the deadlock of the trenches, generals became fixated on deploying troops in a massed assault, called a, "Big Push" to dislodge the enemy from their positions, supported by artillery bombardment from above and underground sapper explosives from below. Soldiers would then be marched towards the remaining enemy machine gun emplacements, in many cases to meet their deaths. Using these tactics, tens of thousands of men could find themselves killed in just a few hours.

The most-deadly was the Battle of the Somme, where one million casualties were caused from July to November 1916. Because being killed prior to taking part in such an action was likely, many British and Allied troops spent their final days, and wages, enjoying themselves in the French city of Vignacourt, where they gathered prior to either being sent to or returning from the front. Local amateur photographers Louis and Antoinette Thuillier offered their portrait services to these off-duty soldiers. The images were taken in a casual and candid style, in contrast to formal official regimental pictures that are more often seen, with the couple specifically encouraging the men to be relaxed and open to the photographic lens. The Thuilliers made some extra money, gave the soldiers a last photographic memento to send to their families back home, and modern observers like ourselves are provided with an important record of these final moments of respite before these men were sent forward to endure the horrors of battle.

Poignantly, the identities of nearly all the men the Thuilliers photographed is unknown. The couple preserved their images for posterity after the war, and four thousand glass plate negatives did survive. However, Louis, who was traumatised by the war, killed himself in 1931, and Antoinette locked the collection in the attic of the farmhouse they lived in. By the 1980's with a dwindling number of WWI soldiers remaining alive, the collection was nearly forgotten. A distant relative of the Thuillier family, Robert Crognier was allowed to view the collection and French historian, Laurent Mirouze was shown some of the images, and wrote an article on the collection in 1991. Curiously, there was little response in the French media and once Crognier died, the location of the collection died with him. However, Mirouze joined a Australian Channel Seven Network television production team to rediscover the *Lost Tommy Photographs*. Fortunately, they were successful, and Australian philanthropist Kerry Stokes purchased the plates, and funded their restoration and preservation. The incredible story of these plates formed the basis of Channel Seven's documentary *The Lost Diggers* focussing on the Australian troops pictured, and journalist Ross Coulthart published the

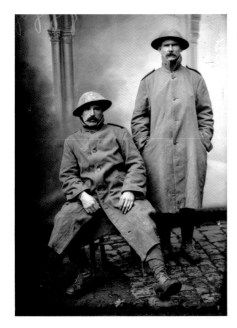

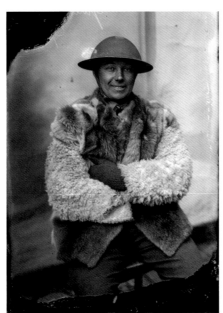
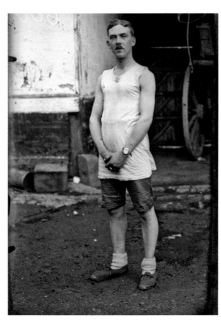

book *The Lost Tommies* based on the entire collection. A selection of the images were colourised by Tom Marshall, as part of the BBC *One Show*'s appeal to help identify the soldiers through the authentic colourisation of uniforms, badges, medals and insignia. As a result of these efforts, ancestors of the men came forward to researchers, and dozens of previously anonymous men were positively identified, contributing to both family records and national and regimental memories. Thousands more remain unidentified at present, and the search for their names continues.

From top left to right: A pair of unknown Tommies in great coats. Two unknown men of the 15th Battalion of the London Infantry Regiment, Prince of Wales Own Civil Service Rifles, wearing "Gor Blimey" winter caps. A British staff sergeant stands with an unknown sailor and a group of people in civilian dress, possibly a French family. Unknown dispatch rider of the Royal Corps of Signals. An unknown British soldier dressed in furs. An unknown soldier stands in his underwear.

GENERATION SHELLSHOCK: SURVIVORS OF THE CATASTROPHE WHICH CAUSES BRITAIN'S GREATEST MILITARY LOSS OF LIFE ARE LEFT TRAUMATISED

"A Boche prisoner, wounded and muddy, coming in on the 13th."

Photographed by unknown probably on November 13th 1916, image courtesy of the National Library of Scotland

Colourised by ©Tom Marshall (Photografix)

When we look at this image we see a powerful front full-body capture of a British soldier, escorting a wounded German from the battlefield. We know this British soldier was a military policeman from the "MP" armband we can see clearly displayed. Just behind the pair, a man in a French army uniform carries a tripod over the railway lines, which suggests this Frenchman was an official military photographer. In the background captured German prisoners of war stand and are seated, as armed British soldiers watch over them. The caption above was written by hand on the back of the original photo-print. The term "Boch" or "Bosch" was a derogatory one amongst British soldiers, which came from a synthesis of the French word for Germany, "Allemand" with that for the head, "caboche" to form "Allabosch".

If we are to indulge in speculation as to what the relationship could have been between the two enemy soldiers; the Tommy is leading his charge by the arm, and from the lack of malice on his face, he seems to have a protective attitude towards the wounded German prisoner he is helping to walk away from the horrors of the battle lines. The following caption was from a different photograph taken of the same scene at almost the same time from another angle, possibly by the French photographer in the background of our image, who could have been scrambling to reach the correct position for his shot: "Battle of Ancre. A Military Policeman with a wounded German prisoner captured at St. Pierre-Divion, France, by the 39th Division on November 13th 1916." So, the part of the first caption above which reads, "coming in on the 13th", most probably refers to the date in November.

From this photo-caption comparison, we also learn that the wounded German was one of the estimated seven thousand captured during the final British "big-push", part of what was the UK's worst loss of life in its long military history: the Battle of the Somme. Britain may have been on the cusp of claiming to have won its objectives by the middle of November 1916, however by this time the British suffered a staggering four hundred and twenty thousand casualties, with nineteen thousand men killed on the first day of fighting alone. To compound the horror on the British side, many of these men were from the Volunteer or "Pals" Divisions; men recruited from the same communities and workplaces, the survivors of which watched their friends, brothers and cousins being killed. On both sides, in one hundred and forty-one days of fighting, there were over a million casualties. By the close of the battle the Allies had won six-miles of territory from the Germans.

The most famous participants to have survived the Battle of the Somme were: Corporal Adolf Hitler, who was wounded in the battle and would go on to found the Nazi Party and lead Germany into a Second World War, Jewish holocaust victim Anne Frank's father, Lieutenant Otto Frank, who was a comrade of Hitler on the German side, Oxford Professor and author of the *Lord of the Rings* books Lieutenant J.R.R Tolkien, Grenadier Guards Captain and future British Prime Minister Harold MacMillan, British anti-war poet Captain Siegfried Sassoon and British writer, poet and scholar Captain Robert Graves.

Soldiers during the First World War expressed themselves and their experiences through painting, sketches, graffiti, but most enduringly for British soldiers, through poetry. War poets Wilfred Owen and Siegfried Sassoon famously met while recovering from the psychological damage, then called "shellshock" (now post-traumatic stress disorder or PTSD), caused by the fighting. During their convalescence at the Craiglockhart War Hospital in Edinburgh, Scotland, the pair explored the flashback memories of the action they saw, and used this as material to inform their poetry. Other soldiers were less fortunate. During the four-years of fighting three hundred and six British and Commonwealth soldiers were executed by firing squad under charges of desertion or cowardice. The shellshock phenomenon was new and poorly understood by the medical profession of the day, and it is now officially accepted that the majority of those shot were suffering what we now call PTSD.

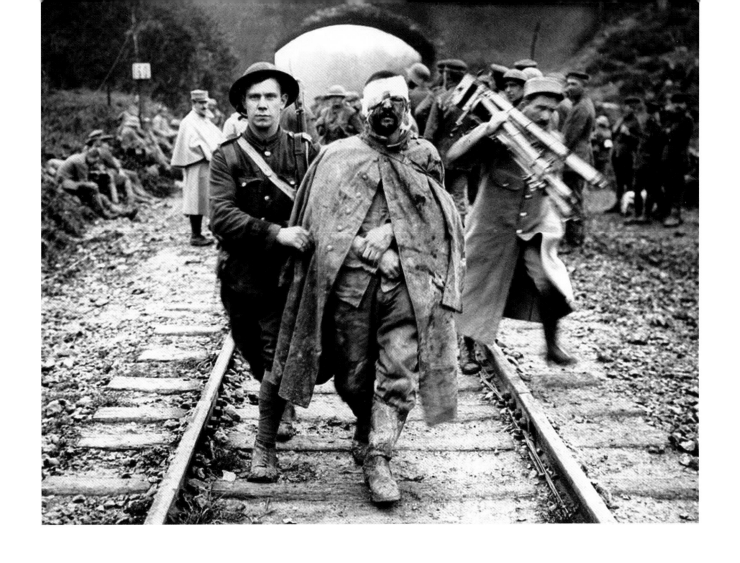

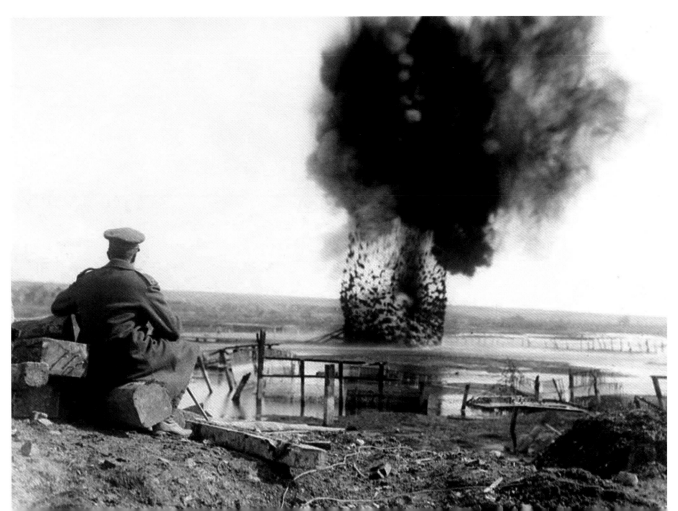

Before the Somme, British war poetry romanticised the soldier's death in patriotic terms, as Rupert Brooke so movingly penned before his death in 1915:

"If I should die, think only this of me:

"That there's some corner of a foreign field

"That is forever England."

Contrast this with the writing of veteran of the Somme Wilfred Owen, before he was killed in action a week before the war's end in 1918:

"I am the enemy you killed, my friend.

I knew you in this dark; for so you frowned

Yesterday through me as you jabbed and killed.

I parried; but my hands were loath and cold.

Let us sleep now..."

In 2006, the British Government posthumously pardoned those soldiers shot for desertion and built a memorial in honour of their memory at the National Memorial Arboretum in Staffordshire, England.

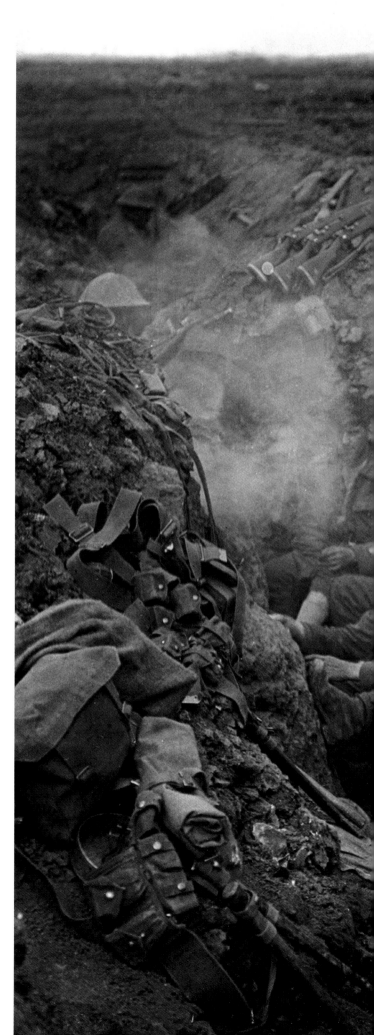

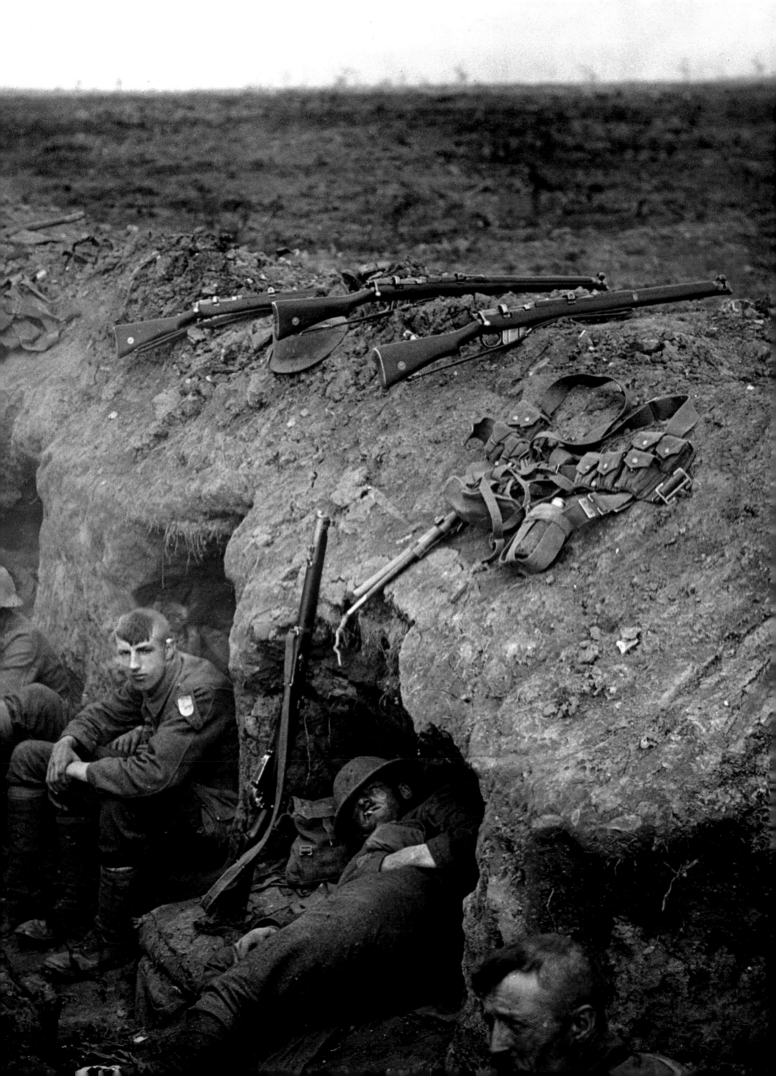

THE EXPERIENCE OF TRENCH WARFARE GIVES RISE TO A NEW SPIRIT OF INDEPENDENCE AMONGST TROOPS OF THE BRITISH EMPIRE

"A group of soldiers from the 3rd Battalion, NZ Rifle Brigade, enjoy the joke of reading a copy of the publication 'New Zealand at the Front' while seated on a captured German anti-tank gun."

Photographed by Henry Armytage Bradley Sanders, taken at 'Clapham Junction' a muddy part of the battlefield in Belgium on 20 November 1917. Image courtesy of the Alexander Turnball Library

Colourised by Frederic Duriez

Sitting on a captured German artillery piece, sharing a joke while reading the official New Zealand Division military publicatio, *New Zealand at the Front*, this image portrays the men of Britain's Empire enjoying their time in the trenches. The soldiers look healthy, in good spirits and bonded as a unit, all attributes which would have helped to boost the morale of their comrades-in-arms. Upon publication, this image will have had the effect of reassuring the New Zealand public, 11,000-miles from the front, that their husbands, sons and brothers were faring well in the trenches of Belgium and France. At this time, despite the distance of their homeland from Britain, these soldiers will most likely have had British ancestry, if they were not themselves born in Britain, and their identity would have been consciously British.

Just as soldiers were nicknamed "Tommies" in the United Kingdom, New Zealand and Australian troops were known popularly as "Diggers", because of how quickly they could complete task of "digging themselves in" for combat. The term has connotations of "mateship" and egalitarianism that is conscientiously captured in this staged shot on the part of the photographer, London-born Pathe agency cinematographer Henry Armytage Bradley Sanders. In March 1917, the New Zealand War Office commissioned Sanders, who had frontline experience of filming the initial German invasion of Belgium to become the official war photographer for the country. This Englishman had never been to New Zealand and had a wife and family at home, however he was given the rank of Lieutenant with the New Zealand Expeditionary Force and immediately travelled to the front. To this day, a total of 725 of Sanders' images have been preserved and digitised for the public.

The following rules were placed on Sanders as condition of his employment by the New Zealand Government:

1. The plates or films will be sent by the Official Photographer to General Headquarters ('I') for development. The Photographer will not be permitted to develop his own plates or films nor to superintend their development.[7]

2. The photographs will be censored at General Headquarters, France, and forwarded to the War Office (M.I.7.a.), who will dispatch them direct to the High Commissioner. The photographs will be the absolute property of the New Zealand Government, on condition that any profits derived from their sale will be devoted to such war charities as the New Zealand Government may select.[7]

3. The photographs when published will be shown as 'Official Photographs' and the name of the Official Photographer will not appear.[7]

4. The Photographer must be a commissioned officer and unconnected with the Press.

These rules show that Sanders' work was intended to be propaganda, under the strict control of the War Office. The priority of the Government was to win the war, rather than impartially document it. In fact, revealing the true horrors of war would have had a counterproductive effect on morale for both soldiers and civilians. Sanders was commissioned as an officer, and therefore found himself acting under military discipline, which will have had a significant effect on his reliability when it came to producing propaganda.

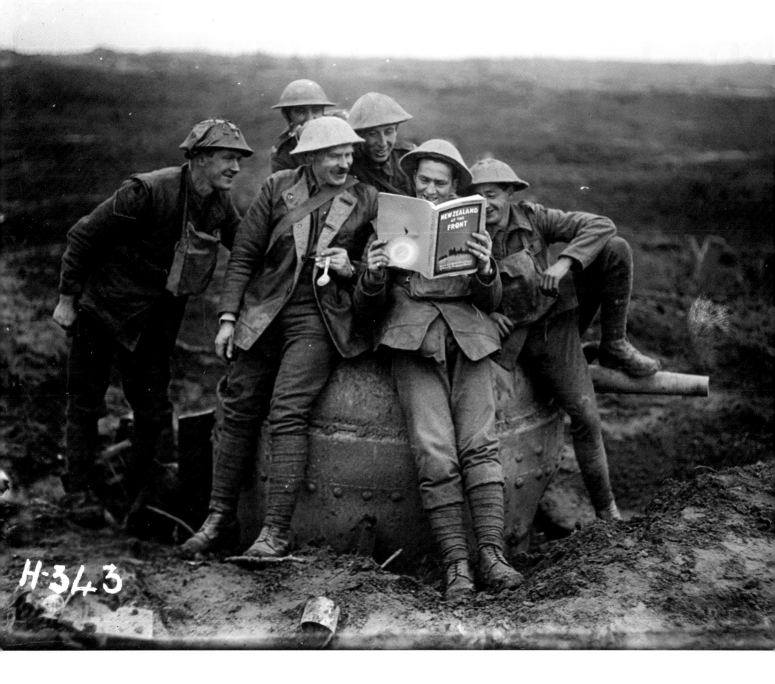

H·343

Sanders' work may have been used to manipulate public opinion, however there was an unexpected consequence of this propaganda photography and the "mateship" it embodied. The "White Dominions" (as the British Colonies with white-British majority populations were known), of New Zealand, Australia, Canada and Ireland, lost 18,000, 60,000, 61,000 and 49,000 soldiers in the Great War respectively. The involvement of the populations of these British Colonies, and the loss of life of Australian and New Zealand troops, gave rise to the "Anzac" spirit of solidarity amongst this generation of men.

Today, the Anzac Spirit is remembered as being galvanised by gruelling experiences of the Gallipoli Campaign against Ottoman Turkey, where poor leadership by British politician Winston Churchill led to terrible casualties amongst the Australian and New Zealand troops under his command. By the end of the fighting, the bitter experiences of the Great War and the comradeship necessary to survive through it, led for

the first time to the rise of a national-feeling amongst those colonies. They understood themselves as being separate from Britain and the British, which is exemplified in retrospect in this iconic image.

Sanders, the Londoner who never managed to visit New Zealand, eventually emigrated to New York with his wife Lillian Mary. He died on February 29th 1936, aged 49.

MEDIEVAL METHODS OF PUBLIC SHAMING IS PRACTICED IN AMERICA AS ANTI-GERMAN SENTIMENT GRIPS THE COUNTRY

"John Meintz, tarred and feathered during World War I for not supporting war bond drives."

Photographed by US District Court 92nd Division) of Minnesota, courtesy of National Archives Catalogue

Colourised by Mads Madsen

Total War between nations meant that conflict took place not only on the battlefield, but on the home front also. During the First World War, civilian populations were for the first time enlisted into factories and farms as active and conscious participants in the war effort, building the ships, guns and equipment necessary for their military to achieve victory overseas. In addition, people from both the Allied and Axis nations were subjected to propaganda by their governments. The enemy forces were demonised, just as friendly forces were hailed as heroes. The British, in particular, pioneered this form of manipulation of public opinion, most notoriously, releasing caricatures of German soldiers bayonetting innocent French babies, causing a public outcry when they were published in newspapers. For the first time in centuries, war was brought to British soil in the form of German aerial bombardments against major cities and ports, which further inflamed public opinion on both sides of the Atlantic against Germany and the German people.

Names for Germans such as "Bosch", "Fritz", "Hun" became used as casual terms of abuse by English-speakers. Many people of German descent changed their names to sound more English, rather than be accused of disloyalty because of their heritage. This included the British Royal Family, who traded in "Saxe-Coburg and Gotha", to become known instead as the "House of Windsor". Britain was subject to anti-German riots and looting of German shops, but Allied nations such as Australia also experienced anti-German hysteria. The German language was banned in teaching and publication, and German place-names were changed in favour of strongly patriotic alternatives. In America, four thousand Germans were imprisoned and several were lynched and killed by mobs. During this period, hamburgers were renamed "liberty sandwiches" and the German dish, sauerkraut became "liberty cabbage". As discussed previously, civilian migrants arriving to America from opposing nations were labelled "enemy aliens" by immigration officials and were routinely detained or expelled.

In the summer of 1918 the man pictured, German-American farmer John Meints from Minnesota, fell victim to this anti-

German sentiment. His crime was to have refused to buy government War Bonds. The purchasing of these by German immigrants was often insisted-upon by suspicious neighbours as a public show of loyalty to the Allies. On June 19th, Meints was kidnapped by a large group of men and driven to the state border. He was told not to return. When Meints did go home to his sons a month later, a second group forced their way into his house and took him to the border with South Dakota. According to court records this group, *"assaulted him, whipped him, threatened to shoot him, besmeared his body with tar and feathers, and told him to cross the line into South Dakota, and that if he ever returned to Minnesota he would be hanged."*

Seeking justice against his tormentors, Meints named thirty-two of the men he said were involved, and took them to court for $100,000 in compensation for false imprisonment. However, after an hour-and-a-half, the jury agreed that Meints probably was disloyal and therefore such action as was taken against him was reasonable. On November 16th, 1919 the *Star Tribune* carried the story of the complete acquittal of the accused in the "Tarred and Feathered Case". The thirty-two men left court together, as a band played and the crowd that greeted them cheered with jubilation. Notice the mispelling of Meints to "Meintz" in the headline, to presumably make the victim sound more German:

COURT VINDICATES MEN ACCUSED OF PUNISHING JOHN MEINTZ AS DISLOYALIST

The newspaper further described how, "Judge Wilbur F. Booth, in charging the jury, said that the evidence was overwhelming in support of the contention that Meintz was disloyal and that there was a strong feeling against him in the community." It took years for anti-German feeling to settle down, as this case showed. Well after the war had ended, in 1922, Meints managed to appeal the verdict and eventually settled out of court for an award of $6,000.

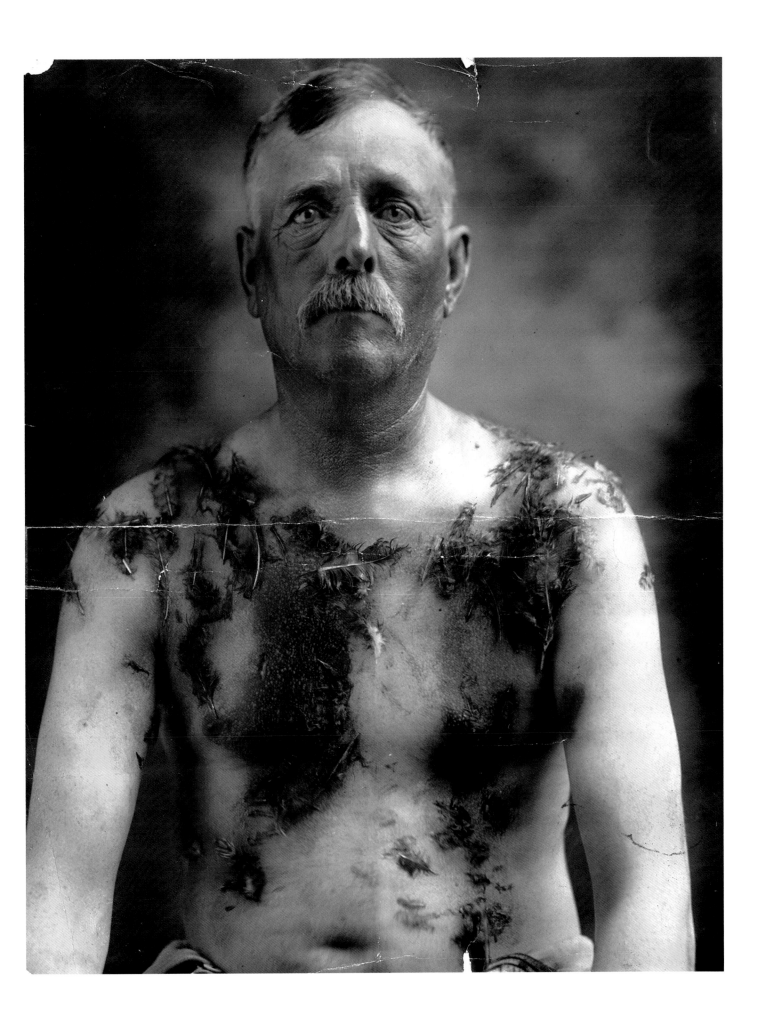

THE AUSTRALIAN UNDERWORLD "RAZOR-GANGS" ARE LED BY RUTHLESS FEMALE BOSSES

"Mugshot of Herbert Ellis."

Photographed c.1920 at the Central Police Station, Sydney by New South Wales Police, image courtesy of the Sydney Living Museums

Colourised by ©Tom Marshall (Photografix)

This is one of a series of photos taken at the Central Police Station in Sydney of men and women shortly after arrest. It shows a man called Herbert Ellis who, from his offhand demeanour and body language, which included defiantly crossed arms and spread legs, seems unconcerned by his arrest by police of New South Wales Australia. He is smartly dressed with the coolness and composed manner of a man used to being hauled in front of a magistrate. A description from the *Sydney Living Museums* website accompanies the image: *"Ellis is found in numerous police records of the 1910's, 20's and 30's. He is variously listed as a housebreaker, a shop breaker, a safe breaker, a receiver and a suspected person. (By 1934) his convictions... include 'goods in custody, indecent language, stealing, deceiving and throwing a missile.' His MO includes the entry 'seldom engages in crime in company, but possessing a most villainous character, he influences associates to commit robberies, and he arranges for the disposal of the proceeds."*

The images we see are part of a collection of two thousand five hundred "special photographs" from the New South Wales Police, taken between 1910 and 1930. Most of the images were taken while the prisoners were detained in their cells at the Sydney Central Police Station. As curator Peter Doyle explained, the pictures are of, "men and women recently plucked from the street, often still animated by the dramas surrounding their apprehension". In contrast to the subjects of prison mug shots,

the subjects of the "Special Photographs" were permitted or even encouraged to display themselves in front of the camera as they chose. Detainees sometimes adopted a spontaneous, naturalistic pose, where a particular expression took hold of their features, others composed themselves into a more contrived aspect, aware they were being documented for posterity.

At the time Ellis' image was taken, the Australia courts imposed severe penalties for those found in possession of concealed firearms. This crackdown coincided with the prohibition on the sale of cocaine, the banning of street prostitution and restrictions on gambling. In Sydney, in particular, organised criminals formed "Razor Gangs" in response. Instead of carrying guns, gang members used concealed razors to inflict grievous scars on those that crossed them. They seized the opportunities presented by the tightening of legislation, and began to control the illicit drugs, gambling and prostitution trades.

By 1929, gang warfare over territory and distribution of drugs caused two major riots. Two prominent lady-criminals were the heads of these gangs, which frequently warred against each other. The first was controller of prostitutes, Matilda "Tilly" Devine (pictured here at the age of twenty-five) and her arch-rival was "sly-grog Queen" Kate Leigh. At the time her image was taken, Devine was arrested for using a razor to slash open a man's face in a barber's shop. She was later sentenced to two-years in gaol.

The other lady we see pictured, who appears to be laughing into the camera lens, was Ellen Kreigher, who was arrested and charged for the murder of Gertrude Mabel Heaydon in a notorious case known in the press at the time as the "Coogee Trunk Mystery". Kreigher shared a flat with an illegal abortionist called "Nurse Taylor", who Heaydon had procured the services of and died upon visiting her. Police alleged that Heaydon's husband paid Nurse Taylor to kill his wife. Four accomplices, including Kreigher, were allegedly tasked with assisting Taylor in the killing and disposal of the body. According to witnesses, they transported the body through the city on a horse and cart. Despite intense press interest, and the coroner ruling that Heaydon's death was murder rather than the result of a

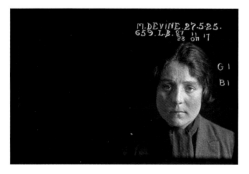

"Matilda Devine."

Photographed on May 27th 1925, Central Police Station, Sydney by New South Wales Police, image courtesy of the Sydney Living Museums

Colourised by Matthew Loughrey

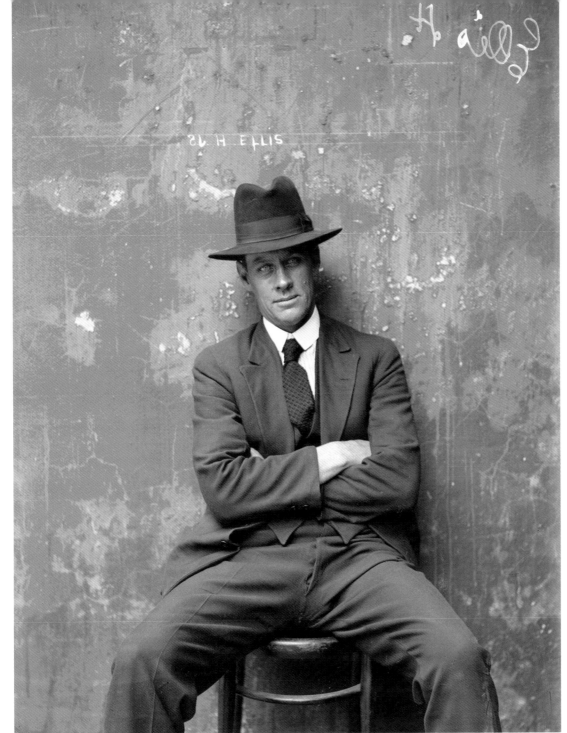

botched abortion, the prosecutor dropped charges for lack of evidence against the four. All, including Kreigher were released. Taylor had died in the interim.

Eventually the NSW Police broke-up the gangs through the enforcement of new laws prohibiting criminals from associating with each other, and on the onset of the Second World War, many of the razor gang-members were called up into the military and posted overseas. The razor gang phenomenon also struck 1920's England, amongst predominantly working class Irish communities of the city of Birmingham. They were known colloquially as the "Razor Gangs", "Razor Boys" or "Peaky Blinders". This last name was possibly given to them in reference to a technique of concealing the razors, with which they could blind their foes, in their peaked caps. This gangster-subculture of the past formed the basis for the fictional BBC television series *Peaky Blinders,* starring actor Kilian Murphy as a World War One veteran and head of one of these criminal razor gangs.

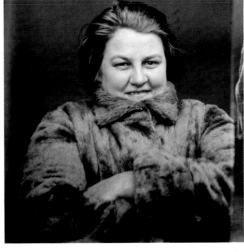

AMERICA BANS ALCOHOL FOR THIRTEEN YEARS AND ACCIDENTALLY BOOSTS CRIME

"Woman seated at a soda fountain table is pouring alcohol into a cup from a cane, during Prohibition; with a large Coca-Cola advertisement on the wall"

Photographed by National Photo Company on February 13th 1922, given to the Library of Congress in 1947 by company owner Herbert French

Colourised by Jared Enos

This lady sitting casually in a soda shop demonstrates one of the more creative ways to clandestinely enjoy a drink in public during Prohibition – carry a hollow walking cane filled with alcohol. The cheerful woman is cleverly contrasted by the photographer with the painted figures in the background and the prominent Coca-Cola sign above her head. She seems to be making a mockery of soft drinks manufacturers; the corporate giants that took commercial advantage from the opportunity to boost profits afforded to them by the nationwide ban on alcohol in America from 1920 to 1933.

The origins of the prohibition of alcohol had more earnest roots. Led by the "dry" crusaders, organisations such as the Anti-Saloon League, and the Women's Christian Temperance Movement, called for the implementation of the "Noble Experiment" to eradicate the evils they believed were caused by alcohol consumption. These included crime, domestic violence, and a lower life expectancy amongst the poor. These groups managed to campaign successfully for the 18th Amendment to the United States Constitution to be enacted, which banned the manufacture, distribution, and trade in alcoholic beverages in federal law. Certain "dry states" even went as-far-as to outright ban the possession and consumption of alcohol in public.

In addition to the perfectly reasonable arguments for banning alcohol, what are now quite amusing myths to the modern reader were circulating during this period. It was believed by some in the Temperance movement that alcohol turned blood into water, that alcoholic fumes that were merely smelt by pregnant women could result in their babies being born with disabilities, and that drinkers' brains could be so saturated with alcohol that upon death surgeons were able to hold a match to them and light the brains up like flaming torches.

The group of "dries", was of course, opposed by the faction of "wets", who sought to subvert the ban by attending the many illegal bars popularly known as, "speakeasies" that had sprung up in cities and towns nationwide. Many prominent "wets" agitated in public and were vocal in politics in a bid to overturn the ban. During a visit to the USA in 1927, German former naval officer Count Felix von Luckner recorded some of the novel ways Americans had learned to adapt to what was considered a bizarre ban by Europeans: *"I discovered…that a spare tire could be filled with substances other than air, that one must not look too deeply into certain binoculars, and that the Teddy Bears that suddenly acquired tremendous popularity among the ladies very often had hollow metal stomachs."*

Many like Luckner, who were observing US society from an outside perspective, quickly pointed to the rise of the newly respected, wealthy and public "spirited" profession of the bootlegger. Many were former liquor store and bar owners who found themselves having to adapt their business to the new commercial reality of Prohibition. Others were hardened criminals who used the fortunes they made from profiteering from the alcohol ban to support other illegal activities such as gambling, prostitution, and protection. The most famous of these was arch-mobster Al Capone. Prohibition brought what were otherwise law-abiding and respectable people into contact with criminal elements. Criminals with the wealth bootlegging brought them were eventually able to bribe police and politicians alike.

Prohibition also had an unintended corrupting influence on those ordinary people who wanted to continue drinking alcohol for various reasons, the most common of which was simply habit. Because indulging in a drink meant by necessity defying the laws of the land, it was felt that law and order in general was diminished each time a person took a swig of the bottle. Many observers at the time argued that the intention of the ban to protect the generation of young people from the negative effects of alcohol had the opposite effect. As we know today from the disproportionate number of young people who experiment in recreational drugs as compared to older people; forbidding a substance can have the effect of making it more attractive.

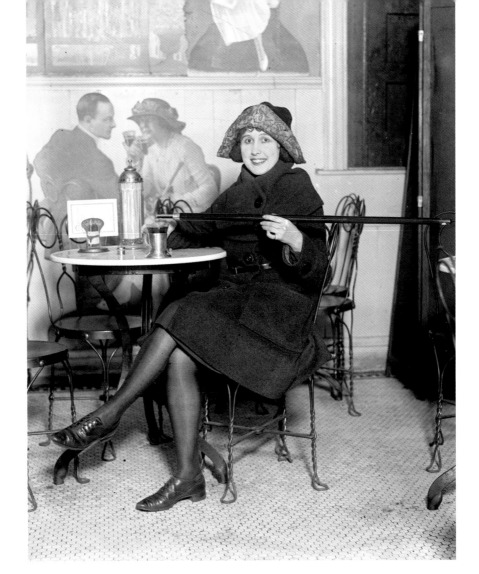

Prohibition was eventually overturned in 1933, primarily after President Roosevelt's government, which was experiencing a loss of tax revenue because of the Great Depression, accepted that huge amounts of tax could be generated by legalising drinking. Because of the amount of money involved in the flourishing black market in alcohol, it was also anticipated by law enforcement that considerable funds would be denied to organised crime.

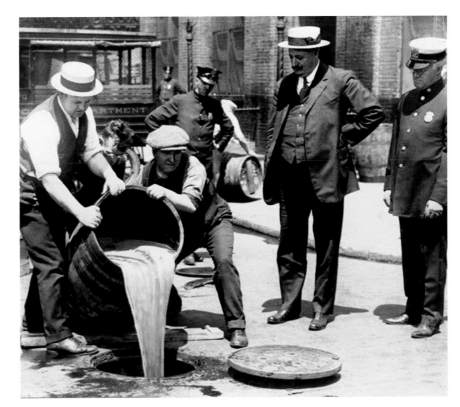

New York City Deputy Police Commissioner John A. Leach, right, watching agents pour liquor into sewer following a raid during the height of prohibition.

Photographed in New York, 1921, image courtesy of the Library of Congress

Colourised by ©Tom Marshall (Photografix)

THE LAST LINK TO THE LEGEND OF MOBY DICK IS LOST AT SEA AND WITH IT THE TRADITIONAL WHALERS' WAY OF LIFE IS GONE FOREVER

The Last Crew of The Wanderer, August 24th 1924

Image Courtesy of New Bedford Whaling National Historical Park

Colourised by Mads Madsen)

The caption for this image reads: *"On the eve of the bark Wanderer's last voyage, the crew of thirteen (plus another five unidentified men) posed for this picture. Two days later, the ship was wrecked on the island of Cuttyhunk in a hurricane and suffered a total loss. The crew survived, including captain Antone Edwards -- seen here with a red hatband. This ill-fated voyage was the last whaling expedition of a square-rigged vessel to leave New Bedford. The crew list for this voyage included: Manuel Brito, Joseph Conceicao, Pedro Cruz, Antone Edwards, Miguel Fonseca, Benjamin Freitas, J.A. Gomes, Jose Gomes, Jose Gumiares, Joao Montero, Emanuel Quiniard, Manuel Ramos, and Antonio Santos."*

New Bedford, Massachusetts had been the centre of whaling industry since the mid-19th Century, when Herman Melville sailed during the golden-era of the shipping trade, and went on to write what is regarded as the greatest seafaring tale in the English-language, *Moby Dick*. The story charts the epic hunt by Captain Ahab for revenge against his nemesis, the mighty white Sperm whale of the book's title, who bit off his leg. One of the opening scenes of opened at the *Seaman's Bethel*, the iconic white chapel that became a symbol of the whalers, and where generations of crewmen prayed before going out across the world's oceans for months at a time. Many of the whaling crews attracted to the US whaling industry were from the Azores, and other Portuguese former-colonies in Africa, hence the multiracial crewmen frequently had Latin names.

"That mortal man should feed upon the creature that feeds his lamp, and… eat him by his own light, as you may say; this seems so outlandish a thing." - Moby Dick Chapter 65: The Whale as a Dish.

Whales were hunted not so much for their meat, but for whale oil which was used as a fuel for burning, and bone as a type of ivory, until the discovery of petroleum as derived from crude oil in the late nineteenth century. After this breakthrough, the cost of oil plummeted and whales were no longer profitable to hunt. This signalled the melancholy end of the whaling-era, however, it almost certainly saved many species of whale from extinction due to overhunting by humans.

The Wanderer was the last of the great square-rigged whaling ships to be built at New Bedford, and as whaling expeditions became increasing rare into the 1920's, it was increasingly viewed as a still-working relic of a nearly-lost past. Martha's Vineyard newspaper and vanguard publication of the whaling industry, the *Vineyard Gazette*, published this story just days before this image of the last voyage was taken:

The Last Whaler

A lifetime ago New Bedford whales were numbered by the hundreds. Now the old whaler Wanderer is fitting out for what may be the last whaling cruise from New Bedford. Two or three ships returned last year, but the ventures showed small profit. The price for whalebone and oil is low. Substitution ruined the market. Science has obviated the hazards and the expenses of whaling.

The Wanderer is a suitable name for the last whaler. In their time ships from New Bedford ranged from the Arctic to the Antarctic. Some sailed from New Bedford, rounded the Americas and hunted in Bering Sea and back again in their quest for the whale. It was a hardy, adventurous, uncertain and dangerous life the whalers led. In New Bedford memorial tablets record the names of whaling-men who failed to return to port. On the quays, in the streets and on the vessels sailing from New Bedford, Melville found inspiration for some of the great sea stories of all time. Fortunately New Bedford has preserved something of the romance of the industry in a unique whaling museum, a memorial to the sturdy men who hunted the leviathan.

It was the motion picture that provided last employment for the Wanderer. If ever a shift in industry brings back a need for whaling novices of another day may be able to see how it was done. But it is fitting that the movie "prop" should go back to the sea on business bent for a last voyage - if it is a last voyage. That was the history of so many of the men who lived and died by the chase of the whale. The sea and the chase were in their blood.

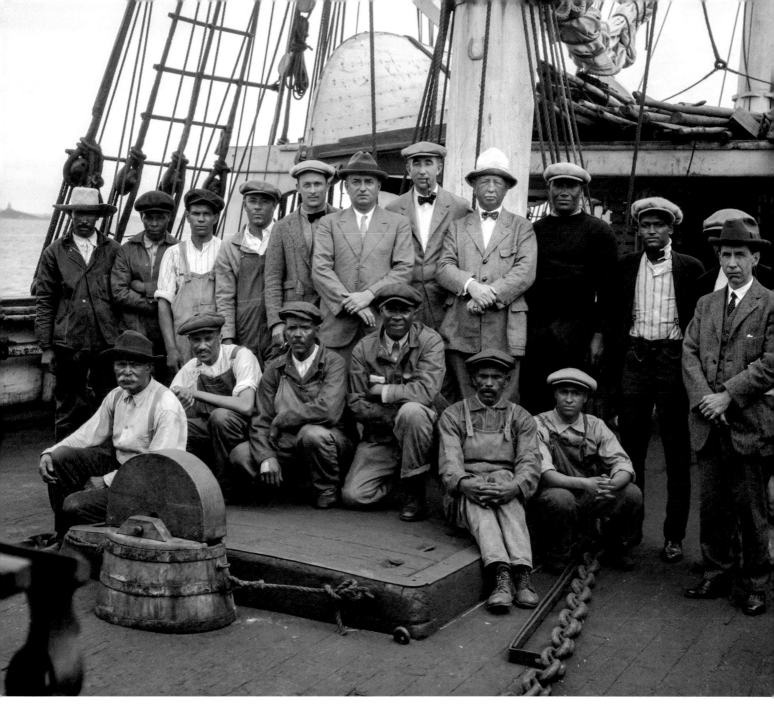

Two days after this image was taken, on Tuesday August 26th 1924, the Vineyard Gazette, carried the following story:

Bark Wanderer Lost

Twenty-four hours after she had sailed bravely from New Bedford on what was to be her "last voyage," the staunch old bark, Wanderer, last of New Bedford's once glorious fleet of square-rigged whaling vessels, came to a tragic end off Cuttyhunk island late Tuesday afternoon, when mountainous seas and a shrieking northeast gale drover her on to the jagged teeth of Middle Ground shoals.

After seven men of her crew had been picked up by the Cuttyhunk life saving station, the other boat with eight men could not be located. The boat's crew, it was afterwards learned, finally reached the Sow and Pigs lightship, from which they were taken off Wednesday morning by the life saving crew.

The Wanderer it is thought will be a complete loss.

Indeed, such was the power of the gale, the Bark Wanderer was sunk on her last voyage, without possibility of repair. Captain Ahab's final pursuit of the white whale that took his leg ends thus, echoing the loss of the ship *Wanderer* that sank rather than becoming a museum piece:

"Towards thee I roll, thou all-destroying but unconquering whale; to the last I grapple with thee; from hell's heart I stab at thee; for hate's sake I spit my last breath at thee."

AL CAPONE: THE ORIGINAL CRIMINAL MASTERMIND IS TRANSFORMED FROM FOLK HERO TO ARCH-VILLAIN NEARLY OVERNIGHT

"Scarface" Al Capone following his arrest on a vagrancy charge as Public Enemy No. 1, April 1930

Photographed by the Chicago Detective Bureau

Colourised by Marina Amaral

Sitting pensively like he is expecting unfortunate news, this wealthy underworld boss, who became the archetypal Italian-American gangster and inspired countless Hollywood movie villains, was probably the most sharply dressed vagrant the Chicago Police had arrested. The image shows a man who, until shortly before this shot was taken, had acted with violent impunity. He had corrupt senators, police chiefs and mayors in his pocket, the press celebrating his patronage of local charities and the people of the city lauding him as a modern-day Robin Hood who opened soup kitchens for the poor and gave money to orphans.

He was born Alphonse Gabriel "Al" Capone on January 17th 1899 in Brooklyn, New York to Italian parents. As a young man, Capone was considered a bright student, however he clashed with authority and was expelled after striking a female teacher in the jaw. The family had recently moved to the Park Slope neighbourhood of Brooklyn, and Capone was a member of small-time youth gangs before he graduated to the fearsome Brooklyn Rippers. It was while working as a doorman during this period that he was slashed across the face for insulting the sister of a fellow-gangster. He was then known as "Scarface", a name he hated. The prominent wound was a source of shame for him.

"I am like any other man. All I do is supply a demand."

By the age of twenty-six, Capone had moved cities and taken over as head of the Chicago Outfit, from his boss Johnny Torrio, after Torrio was shot and nearly killed in an ambush by the rival Irish-American North Side Gang. Using the ruthless technique of high-profile intimidation with the threat of extreme violence, Capone eliminated opposition within the Italian criminal community. He allowed brothels to flourish in the neighbourhoods he controlled, and contracted syphilis, which he failed to treat. He indulged in fine clothes, drinks, cigars and would hire entire train carriages to travel in and whole hotels to stay in for himself and his entourage. Yet at time this image was taken, this charismatic boss-of-bosses was staring into the face of disaster.

"You can get much farther with a kind word and a gun than you can with a kind word alone."

Capone was directly involved in the deaths of at least thirty-three of his criminal rivals, as-well-as up to one hundred innocent civilians killed by the actions of the criminal network he headed. Incredibly, for a man who enjoyed the support of the Chicago Republican establishment, many were killed by bombing campaigns against supporters of political rivals to his own allies in the City, or visitors to liquor stores that failed to buy illegal alcohol from him during the 1920's Prohibition-era. But it was the Saint Valentine's Day Massacre which turned public opinion against him. It was alleged, although never proven, that Capone had a group of his men, who were dressed in police uniform, stop seven members of the North Side Gang. The hapless rival gangsters were lined up against a wall and shot dead by a second group armed with machine guns. As a result, the press famously condemned Capone as: "Public Enemy Number One".

"Capitalism is the legitimate racket of the ruling class."

Even more incredibly than the audacious bombings and shootings, was the failure of law enforcement to prosecute him for any of the serious organised crimes he committed. Instead, he was initially persecuted under vagrancy laws in Chicago and places he visited such as Florida, until he was prosecuted for failing to pay tax on undeclared income generated by his serious crimes. Despite attempts by his lawyers to provide an illegal income to the court to pay the outstanding sums, he was nevertheless sentenced to eleven-years in prison.

By-the-time Capone was incarcerated in Atlanta Penitentiary in 1932, his syphilis had taken its toll, and he was suffering the effects of cocaine withdrawal. The once-feared arch-mobster was the victim of bullying and had to be protected by former associates. He was moved to Alcatraz where his mental decline became such that he could barely write, he was suffering from the dementia, that occurs in advanced syphilis cases, and was

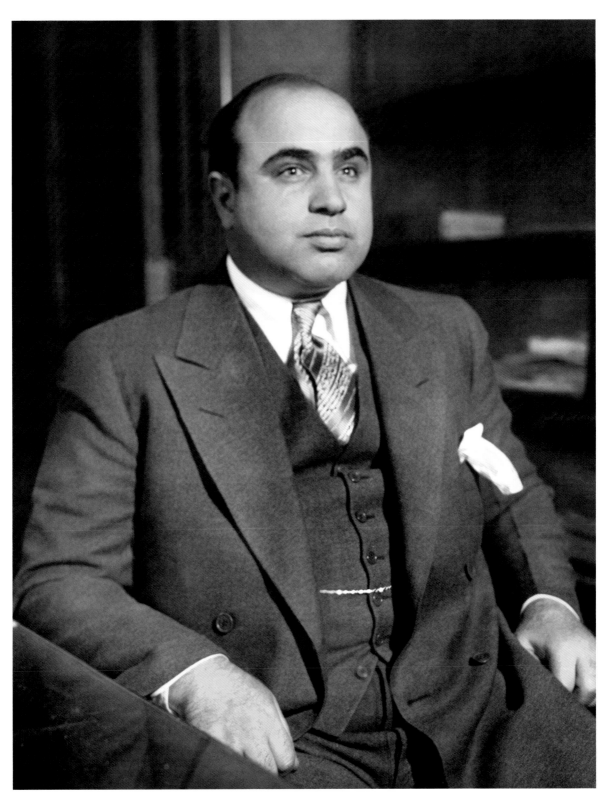

stabbed and wounded by a fellow inmate. On release on parole the nearly helpless Capone found admission for treatment difficult, but in 1939 he was admitted to Baltimore's Union Memorial Hospital. By 1946 Capone was diagnosed with having the mental age of a 12-year-old.

Accounts of his later years give an impression of a lost man living with a family in fear of the men who now ran his former-Empire "The Outfit", but who gave him $600 a month to support himself and his dependents. After suffering a stroke, heart attack and pneumonia, Capone eventually died in his Florida mansion just after his 48th birthday, on January 25th 1947.

ANTI-COLONIAL LEADER GANDHI VISITS THE HEART OF THE BRITISH EMPIRE

"Mohandas "Mahatma" Gandhi, leader of the Indian independence movement in British-ruled India, pictured during his visit to Britain in 1931."

Photographed by Harold Tomlin image courtesy of Mirropix

Colourised by Matt Loughrey

Perhaps the Twentieth Century's most important political figure, the man who was the figurehead of the struggle for freedom against Imperialism, and eventually became the founding father of the independent Indian Republic, Mahatma Gandhi, can be seen here. He was dressed in the simple and centuries-old Indian *dhoti* attire, which contrasted beautifully with the urban London street and flashy car he is getting into from his lodgings, at Kingsley Hall in Bromley-by-Bow, East London.

Born in 1869 into a Hindu merchant caste in the state of Gujarat, in what was then regarded as "The Jewel in the Crown of the Empire", British India. Gandhi may have looked out-of-place in this photograph, but in fact London was a very familiar city to him – as a young man he had been sent from India to train as a barrister in the Inner Temple. While living in the British capital, he adopted English customs, such as dancing, and founded a chapter of the Vegetarian Society. He went onto to work in an Indian law firm in Natal Colony, South Africa - then also part of the British Empire. It was here that he became politicised after being exposed to the daily discrimination practiced against non-whites. These experiences included Gandhi being beaten by a train driver for failing to make room for a European passenger, and being kicked from a public footpath by a policeman because Indians were banned from using them. The 21-years he spent in South Africa shaped his understanding of how Indian nationalism could transcend divisions of race, caste and religion. The South African treatment, propelled him onto the path of civil rights and anti-colonial activism, which he called *Satyagraha*, devotion to the truth, with the emphasis in the importance of *Ahimsa* – non-violence.

During his time in South Africa, and upon his return to India, Gandhi had grasped that it was counter-productive to take on the overwhelming might of the British military by force, and instead he used the pillars of British civilization: English law, democratic traditions, and progressive politics – against her overseas Empire. He recognised that the Empire was only able to survive by the collaboration of the peoples it subjected, so he advocated a direct way to end foreign rule: Indians would simply stop cooperating with British authority on a mass scale.

At the time this image was taken, Gandhi was in London as the sole representative of the Indian National Congress, under invitation of the British Government's representative, Viceroy of India, Lord Irwin. The resulting Gandhi-Irwin Pact was a form of political cease-fire; pro-Independence prisoners would be freed by the British, in exchange for a suspension of civil disobedience by the nationalist movement. The Pact was therefore disappointing to Congress, as it was not a move towards Dominion Status for India, which would have given the same level of autonomy within the Empire that white-majority colonies such as Canada and Australia enjoyed. Despite this setback, during his visit to London, Gandhi's natural charisma, eloquence and personal modesty turned him into a sympathetic figure for the British people and press.

By the end of his life, Gandhi would achieve far more. As he and his followers agitated and negotiated towards Indian independence, the onset of the Second World War and the possibility of Indian nationalist collaboration with the Japanese, meant that Britain was left with little option but to promise independence at the end of the war in exchange for loyalty against the enemy. Just two years after the end of WW2, on July 18th 1947, Indian Independence was declared.

Tragically, at least one million people were killed during this process, as what was formerly British India was partitioned into two separate nations, Hindu-majority India, and Muslim-dominated Pakistan. As non-Muslims fled what had become Pakistan and Muslims left or were forced to leave parts of India, intercommunal violence between Muslims, Hindus and other minority religions exploded in an orgy of killing. The former imperial-power, Britain watched from the side-lines with a national sense of horror mixed with impotence. Many from the Indian Subcontinent believed the UK deliberately allowed the two sides to weaken each other as a continuation of its "divide and rule" policy that had kept the British Raj in power for over two centuries.

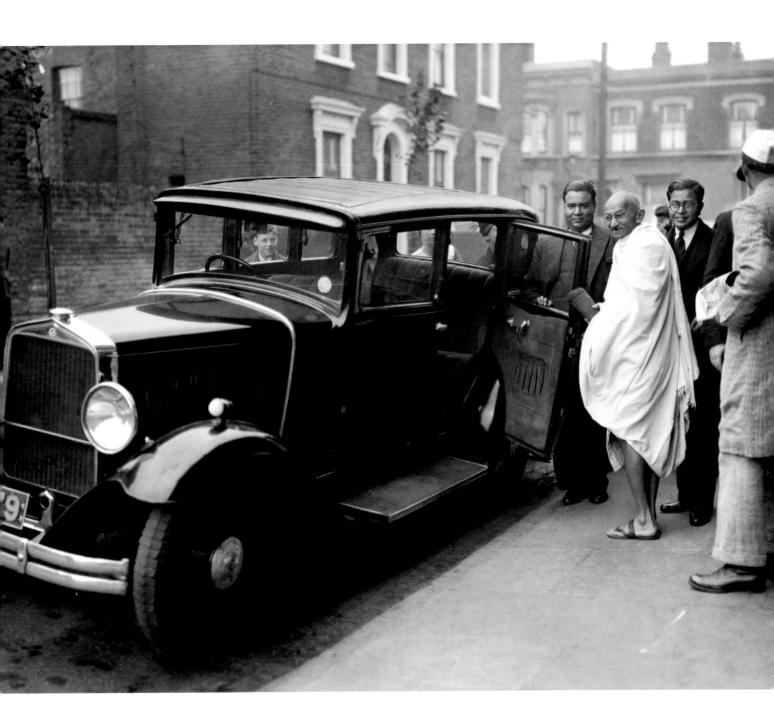

Despite his opposition to Partition, Gandhi was killed on January 30th 1949, by three bullets from a gun fired by a Hindinationalist, who believed Gandhi was too reconciling in his policy towards Pakistan. He is remembered across the world as the man who proved that even the most powerful empire on the planet could be defeated through peaceful means. Gandhi is credited with helping to usher in a post-WW2 era where colonialism was discredited and European powers began to dismantle their overseas empires. He was recognised as one of the most important political leaders in history in March 2015,

through the erecting of his statue in the seat of British democracy, London's Parliament Square.

His legacy also lives on in East London. From the building we see pictured, where he stayed during his visit of 1931, the Gandhi Foundation was established by British director, Sir Richard Attenborough, after the success of the 1982 film based on the Indian leader's life called simply, *Gandhi*. The aim of the foundation is to remember Gandhi's teachings and use them to improve multi-faith relations worldwide.

THE FIRST AVIATION PIONEERS REVOLUTIONISED LONG-RANGE TRANSPORT

"Hanno, British four-engined long-range biplane airliner of the Imperial Airways, at Samakh, British Mandate Palestine (now Israel), October 1931."

Photograph from the G. Eric and Edith Matson Photograph Collection at the Library of Congress

Colourised by Jared Enos

This image perfectly represents how early commercial airliners, combined the luxurious spirit of the time, with the devil-may-care attitude necessary among passengers willing to travel by what was, during this pioneering period, a relatively dangerous mode of transport. The picture also shows a scene that is very much an "East meets West" moment. European travellers land from the skies in a formidable silver aircraft, but must still refuel with the assistance of local Arabs who pump Shell gasoline, presumably sourced from the Middle East, into the fuel-hungry tanks of this Handley aircraft.

The aeroplane pictured was named *Hanno,* after the Carthaginian explorer, who charted the west coast of Africa in 570 BC. One of her pilots, Captain Herbert John "Horse" Horsey (possibly standing forth from left, wearing a flat cap), was a veteran of WW1, and is remembered on October 5th each year in the United Arab Emirates (UAE) for having landed *Hanno* there on that day in 1932, becoming the first aircraft to arrive in that nation.

Operated by Imperial Airways, which later became part of British Airways, the aircraft we see in this image, was the iconic Handley Page H.P.42. Its sleek art nouveau design and the overall prestige of travelling in this machine, led to this model later being described as, "the Concorde Aircraft of its day". A far cry from cramped modern air travel, the eight units that were in service allowed travellers to cross the British Empire in style. For the twenty-four passengers they could accommodate, each plane had its own smoking section, a fully stocked bar, multiple rest areas, bunk beds with luxury linen for all, and even in-flight silent movie projectors. Initially subsidised by the British Government to kickstart the air industry, the pioneering aviation

passengers that initially used the Imperial Airways service were mainly colonial officials, businessmen and academics. Eventually costs came down, and by 1939 up to fifty thousand people had travelled this way. Like Captain Horsey, who was himself a founding pilot of Imperial Airways, nearly all the original sixteen pilots recruited by the airline company were Royal Flying Corps veterans of WW1. The British Royal Flying Corps was the precursor of the Royal Air Force (RAF).

With a majestic wingspan of 130-feet, four Bristol Jupiter class engines, the Handley's top speed was 127 miles-per-hour and their range was five-hundred miles. To give an idea of the route necessitated by this range for intercontinental travel, from the UK's airbase in Croydon near London, to reach the Empire's most distant territory, Brisbane, Australia, required eleven days of travel, with twenty-four scheduled stops along the way. To land next to the capital of Empire, London, pilots had to land at night by spotting lights on the twin towers of Crystal Palace and then time themselves with a stopwatch to calculate their approach to the landing strip. Landing methods in more far-flung territories were much more risky.

However basic their technology was by modern standards, Handleys flew low and slow in comparison today's aircraft, which meant that when engine failure, weather or the occasional pilot error led to a crash, death was much less likely when compared to present-day aviation disasters. In fact, while all eight Handley's were eventually damaged beyond repair in various accidents, the model was fatality-free by the time they were removed from civilian service in 1939. Other aircraft types were not so fortunate, and Imperial Airways suffered passenger and crew fatalities throughout its service. The worst disaster

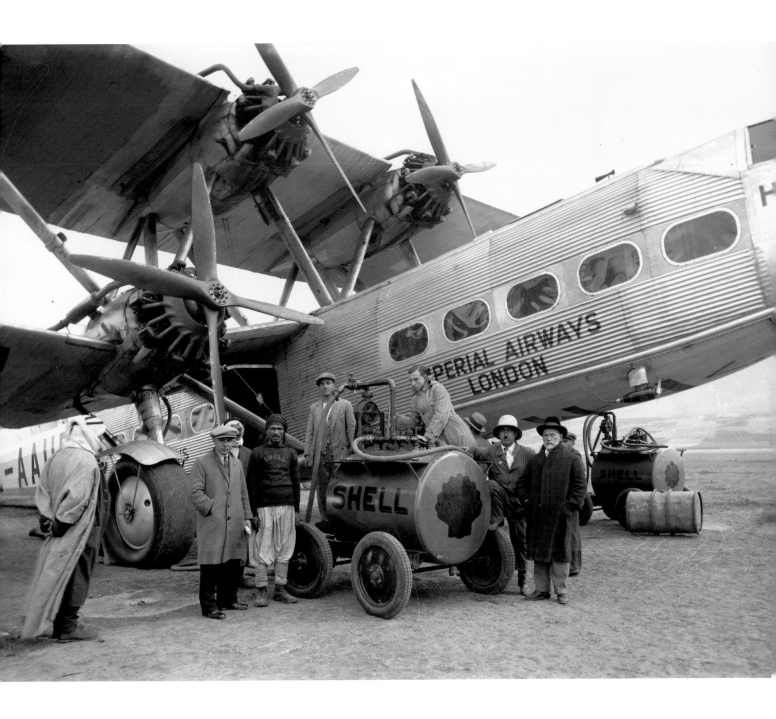

occurred on March 28th 1933 at Dixmude, Belgium when the Armstrong Whitworth Argosy II aircraft called, *City of Liverpool* was brought down by what is thought to be the first case of air-sabotage, killing all fifteen people on board.

While serving as a commander in the Air Transport Auxiliary in 1942, Captain Horsey was killed when he flew his Curtis Mohawk fighter into cables near Wroughton, England. On the onset of WW2, *Hanno* was also pressed into service for the RAF. On March 19th 1940, *Hanno* was blown into her sister-Handley, *Heracles* by a freak gale. None of the six other Handley HP42's survived the war.

While Captain Horsey may not be commemorated publicly by his home nation, the legacy of his historic piloting of *Hanno* is celebrated each year in one appreciative Gulf kingdom. Today, nearly eighty-five years since Horsey first landed there, UAE's main international airport at Dubai is the world's busiest for passengers, with over eighty-three million air travellers having passed though in 2016. Dubai International contributes twenty-six billion US dollars to the UAE economy and supports ninety thousand jobs through direct employment.

"USS Macon (ZRS-5) Flying over New York Harbor, circa Summer 1933. The southern end of Manhattan Island is visible in the lower left center."

Photographed by the US Navy, image courtesy of the Library of Congress

Colourised by Jared Enos

During the golden-era of flight in the 1930's, anything relating to the skies seemed possible. This awe-inspiring image of this 785-foot long aluminium clad Zeppelin, as it floated past the forest of Manhattan skyscrapers, perfectly embodies the futurist-vision of the transport revolution that many people anticipated was around the corner.

It seems an incredibly exotic way to protect the skies now, but so confident was the US government in ploughing resources into this technology, that the USS Macon Zeppelin we see pictured over New York, was the world's largest military war machine. Nicknamed "Queen of the Skies", this balloon was heavily armed with eight .30-calibre guns, it carried an escort of five Curtiss F9C Sparrowhark fighter aircraft, and had a flight crew of sixty Navy airmen. This helium-filled Akron-class rigid airship was powered by gas cylinders, which turned three giant steel propellers. This giant was designed for reconnaissance missions for the US Pacific Fleet and had a range of nearly six-thousand nautical miles.

A subsidiary of the Goodyear Tyre & Rubber Company built the USS Macon under the supervision of German engineering experts. After her competition in the beginning of 1933, the company was still exploring the option of building ever-larger Zeppelins for the US military. President of the Goodyear-Zeppelin Corporation Paul W. Litchfield was at pains to explain the safety record of these machines. In a December 1932 edition of Flight Magazine, he described the flight of the USS Akron from Lakehurst to Los Angeles: "The reliability of this advanced mode of transport has been thoroughly demonstrated, for, during all of these flights, there has never been an injury sustained by any passenger or any member of a crew." Despite official emphasis on the safety record of these airships, the USS

Macon was launched just one month after history's most deadly airship disaster. On April 4th 1933, an admiral and 76 crew-members were killed when her sister vessel, the USS Akron, crashed in severe weather.

Just from the beginning of her military career, the Macon fared considerably better. It operated successfully for nearly two-years, she was able to demonstrate a worthy combat role by spotting surface vessels while remaining invisible to their crew during training exercises. The Macon famously located President Roosevelt while he was on board the heavy cruiser Houston and dropped some newspapers onto the deck for him to read.

On February 12th 1935 a storm struck the Macon as she navigated Point Sur off the coast of California. The force of the wind ripped off a previously weakened and not fully repaired supporting ring to the upper tailfin, which in turn caused a massive gas leak.

Within moments a distress call was sent by radioman E.E. Dailey, "We have had a casualty. SOS falling - AS (wait a minute). We will abandon ship as soon as it lands on water. We are 20 miles off Point Sur, probably 10 miles at sea."

Lt. Commander Peck who was with the radio operator, described the efforts of Dailey to call for the rescue of his fellow crewmen, even as the sound of the waves became increasingly loud as the balloon descended towards the sea below: "The location probably saved our lives, but the sending of it cost Dailey's own life. I left him, and the boys told me later they saw him jump from a huge height, about 125 feet."

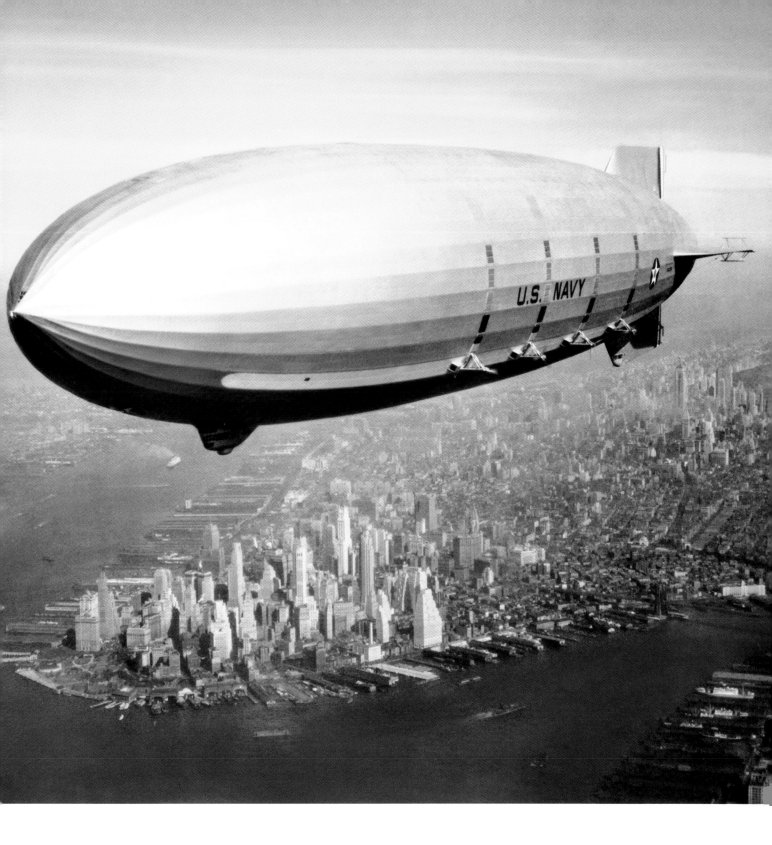

Dailey, who according to Lt Peck, had no idea how high he was from the water when he bailed out, was killed and another crewman drowned. All eighty-one of the remaining crew survived, as the *Macon* landed gently on the water and rescuers arrived promptly, further to Dailey's last signal. The crash ended the US military Zeppelin programme. This accident, combined with the infamous Hindenburg Disaster of May 1937, brought the 20th Century-era of Zeppelin flight to a final close.

THE GREAT DEPRESSION OF THE 1930'S PUSHES ORDINARY AMERICANS TO THE BRINK OF SURVIVAL

"Migrant Mother", Pea-Picker's Camp 175-miles north of Los Angeles, March 1936

Image by photographer Dorothea Lange of the US Farm Security Administration

Colourised by Mads Madsen

More than any other, this image of a fearful, but seemingly determined mother and her three hungry children came to symbolise the plight of the poor who suffered through the Twentieth Century's most cataclysmic economic period, the Great Depression. On "Black Tuesday" October 29th 1929, the capital of world finance, New York's Wall Street, suffered a devastating stock market crash. The crisis soon flattened European economies, impoverished the already poor working classes, and spread to the rest of the world. Over the following three years to 1932, international trade halved and unemployment in the US shot up to a quarter of the working population. This economic collapse was later blamed by many historians for the rise of Nazism in Germany, and the onset of the devastating Second World War. During what came to be called the, "Dirty Thirties", communities already suffering in America's rural heartlands in the Mid-West, were hit by dust storms that destroyed crops and forced desperate farmers from their land. This Dust Bowl created an extraordinary wave of migration, with an estimated 3.5 million people travelling to California in the hope of finding food, work and new homes. The US Government's Farm Security Administration (FSA) was tasked with assisting the makeshift camps that had settled across America's western coastal states. By March 1936, the FSA had commissioned a team of photographers, which included New Jersey photo-journalist Dorothea Lange, to document the impact of this assistance.

During a 1960 interview with *Popular Photography* magazine, Lange described how she was driving home after an exhausting time shooting poor communities in various locations across California, when she passed a sign for a Pea-Pickers camp 175-miles north of Los Angeles. Despite her fatigue, Lange could not shake the desire to investigate, turned her car and drove to the camp. There she saw a "hungry and desperate mother", and approached her, as if "drawn by a magnet." She made five exposures, during which time few words were spoken between the pair. The woman said she was 32 years-old, and her family had been surviving by picking frozen vegetables from the surrounding fields, and eating birds the children killed. She had sold the tires from her car to buy food. *"There she sat in that lean-to tent with her children huddled around her," said Lange, "and*

(she) seemed to know that my pictures might help her, and so she helped me...I knew I had recorded the essence of my assignment."

On publication, the image led to the FSA delivering twenty-thousand pounds of food to the Pea Pickers' Camp. Despite Lange not having recorded the name of her subject, the Migrant Mother was identified forty-years later as Oklahoma-born Florence Owens Thompson. Acting on a tip-off, *Modesto Bee* news reporter Emmett Corrigan conducted the first interview with Thompson from her mobile home in 1978. It transpired she was the mother of seven children, who had been widowed, before leaving the once-fertile Prairies for California, meeting her second partner, and having four more children. In March 1936, the family were travelling by car to find work on a lettuce farm along Highway 101, when they broke down inside the Pea-Pickers' Camp. According to the headline accompanying Corrigan's article, Thompson was, "Fighting Mad Over Famous Depression Photo". Thompson alleged she had never consented to the image being published. Despite feeling a mixture of shame in the poverty they experienced and pride in the stoicism of their mother, after her death on September 16th 1983, Thompson's family set her gravestone to read "FLORENCE LEONA THOMPSPON Migrant Mother – A Legend of the Strength of American Motherhood".

Lange's boss and founding father of the FSA's documentary movement, Roy Stryker called the image, "the ultimate photo of the depression era...she (Thompson) is immortal". Lange's work was widely believed to have inspired John Steinbeck to write one of the Twentieth Century's most acclaimed novels, *The Grapes of Wrath*. In 1998, a retouched version of the Migrant Mother became a 32-cent US postal stamp for an educational series released by the US Postal Service called *Celebrate the Century*.

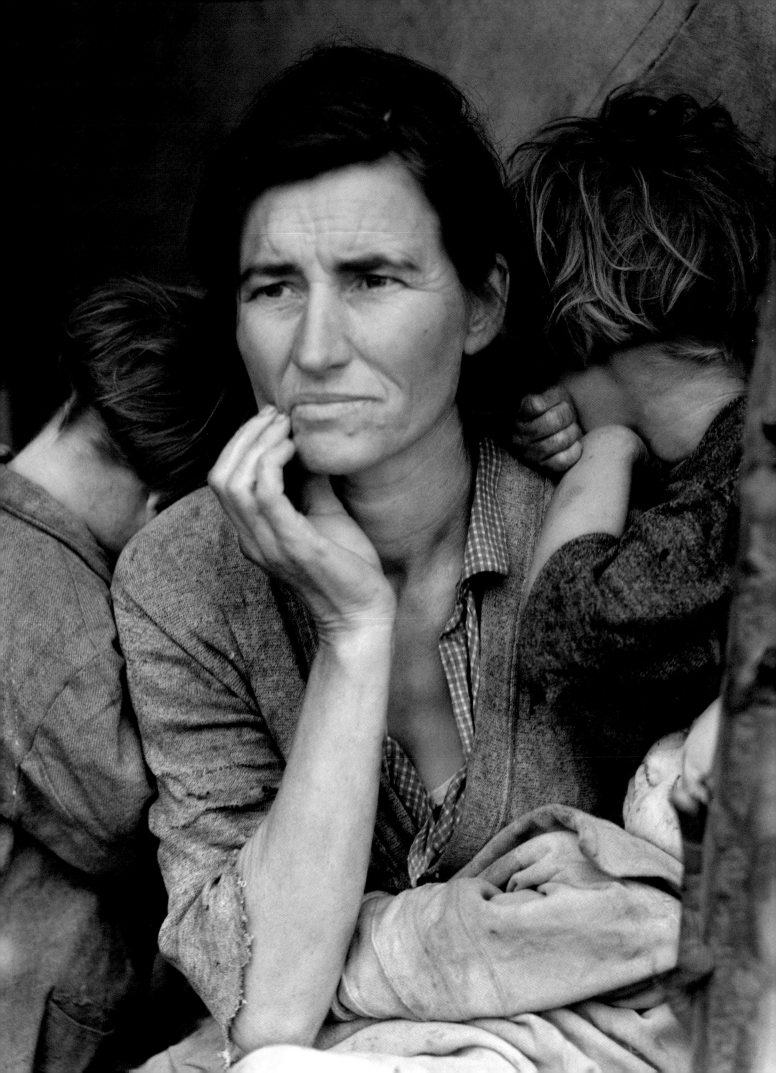

Image by photographer Dorothea Lange of the US Farm Security Administration

Colourised by Jared Enos

One of Dorothea Lange's general captions of her photographs taken in this location in August 1939, describes the pear pickers who came to the Yakima Valley during the harvest season in search of work: *"Pear growers do not provide housing or camps. The wages (season 1939) are 4c per box, and they quote $1.90 per day as average day's wage, but work is highly irregular. After the pears they work in apples, then in hops. The Yakima Valley season ends in mid-October. All local workers (season 1939) are cut off from relief in this valley when harvests start regardless of ability to work in the fields and orchards or condition of health or susceptibility to lead poisoning from sprayed trees."*

From January 1935, Lange was accompanied during some of her trips by Berkeley University economist Paul Taylor. During their summer trip surveying migrant workers in Washington State in 1939, Taylor later recalled Lange's technique for capturing her intimate images of what could often be weary and suspicious subjects. He said her method of work "was often to just saunter up to the people and look around," and when she saw something that she wanted to photograph, Lange would quietly take her camera. If she saw that they did not want their photograph taken, she would either wait for the subject to become more relaxed around her and take it at that point, or not take their image at all. According to Taylor she would talk to them sometimes, but sometimes not. *"My purpose was just to make it a natural relationship, and take as much of their attention as I conveniently could, leaving her the maximum freedom to do what she wanted....But you can see on how many great occasions she didn't need my help."*

While she did not invent the concept of the "general caption", during that summer, Lange is credited with setting the standard for the practice among photographers for producing general captions for groups of photographs of the same theme. Lange complained to her FSA boss, Roy Stryker, of the labour involved, while emphasising the importance of the work, *"I am writing captions until my fingers ache to say nothing of my head...(but) If this is not done I believe that half the value of fieldwork is lost."*

For "Migrant Mother" as well as other work including photographing interred "enemy" Japanese-Americans during WW2, Lange was hailed as being one of the pioneers of the genre of Documentary Photography. She disputed this claim, maintaining that her intention was not merely to document events, but to expose society's ills in the hope of changing it for the better. In recognition of her achievements, in 2006 the Lange (Dorothea) High School in Nipomo, California was named after her, and on 28th May 2008 State Governor Arnold Schwarzenegger announced her induction into the California Hall of Fame.

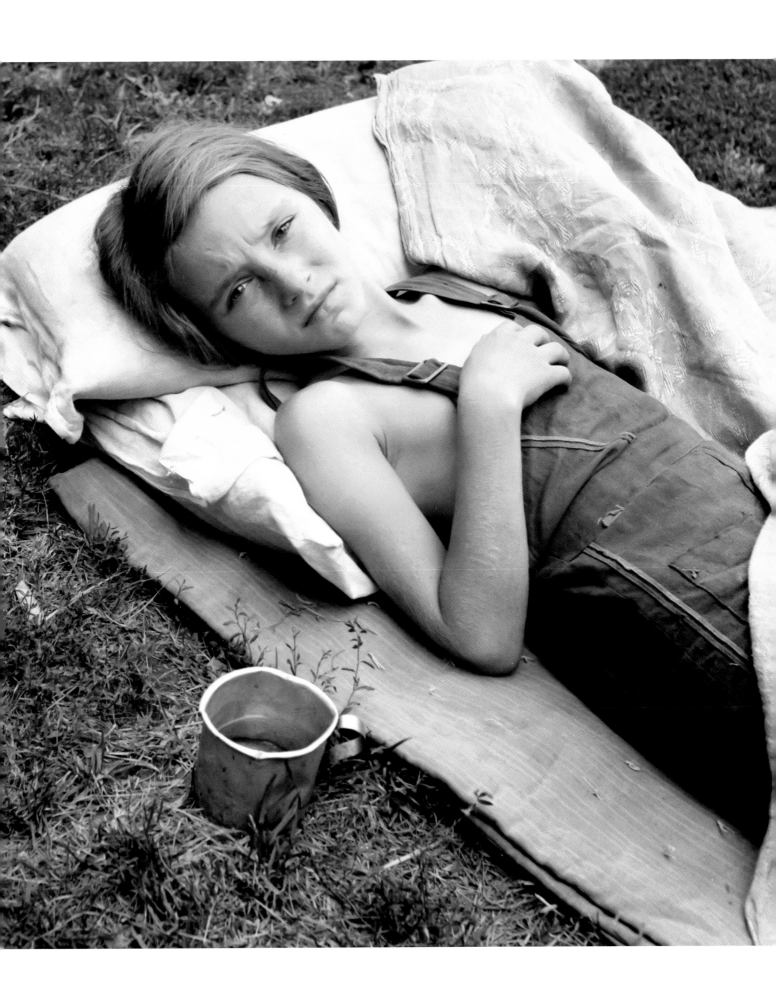

THE SPECTACULAR HINDENBURG DISASTER ENDS THE ERA OF PASSENGER TRAVEL BY AIRSHIP

The Hindenburg Explosion, May 6th 1937

Photographed by Murray Becker courtesy of Associated Press

Colourised by Matt Loughrey

Perhaps alongside the sinking of the Titanic, the Hindenburg Disaster is history's most famous transport trajedy, and the spectacular image of the fateful explosion is one which resonates to the present day. This image captured the moment the highly flammable hydrogen gas that filled its balloon caught fire, killing a total of thirty-five on board and one person on the ground. Most died in the fire, however some were killed while jumping at a great height while attempting to avoid the flames. Yet, with an air ignition temperature of around five hundred degrees Celsius, it is incredible that despite being badly burned in many cases, sixty-two passengers and crew managed to escape the hydrogen gas inferno, including its commanding officer, Captain Max Pruss. The image shows how the power of the awesome explosion utterly dwarfed the figures of the people on the ground.

American radio journalist Herb Morrison was at the scene at Lakehurst Naval Air Station, New Jersey, USA, and gave what was to become one of the most dramatic and well-known broadcasts of the 20th Century: *"It's fire and it crashing! . . . This is the worst of the worst catastrophes in the world! Oh, it's crashing . . . oh, four or five hundred feet into the sky, and it's a terrific crash, ladies and gentlemen. There's smoke, and there's flames, now, and the frame is crashing to the ground, not quite to the mooring mast. Oh, the humanity, and all the passengers screaming around here! . . . I can't talk, ladies and gentlemen. Honest, it's just laying there, a mass of smoking wreckage, and everybody can hardly breathe and talk . . . Honest, I can hardly breathe. I'm going to step inside where I cannot see it. . . ."*

Like the mighty Titanic at sea, the Hindenburg is the largest ship of its type - at 804 feet-long and capable of holding over seven million cubic feet of gas, it was the largest flying object ever built. With a top speed of 85 miles-per-hour, it was faster than travel by ship, which was the most common form of intercontinental passenger travel from the dawn of human civilization, all the way until the middle of the 20th Century. The Hindenburg provided a transatlantic service, primarily between Europe and North America, however it did also travel to Rio de Janeiro, Brazil. The interior was luxurious, with fifty-two staff attending to a maximum of seventy-two passengers, and interestingly for an airborne vessel dependent on an inflammable gas for lift, it was fitted with a famously plush smoking room.

From its maiden voyage on March 4th 1936, LZ 129 Hindenburg, named after the former Chancellor of Germany, completed sixty-three flights and carried over one thousand three-hundred passengers during its lifetime. The airship had a starring role in the controversial 1936 "Nazi" Summer Olympics in Berlin, when she flew over the crowds of spectators in Berlin while decorated with Nazi Swastikas. Despite objections by Captain Ernst Lehmann, who was considered Germany's best pilot and the officer who headed the nation's Zeppelin programme, the airship was commissioned by Hitler's Minister for Propaganda, Joseph Goebbels, to drop Nazi leaflets by parachute and broadcast political speeches by loudspeakers attached to the balloon, rather than undergo test flights as Lehmann wanted. Although he was not in command of the Zeppelin on its last flight, Lehman was the most senior officer on board the Hindenburg at the time of the disaster. Lehman was badly burned in the explosion, and his injuries were so catastrophic the internationally respected airman died the following day.

Captain Pruss, insisted that the airship had previously passed through violent thunderstorms while travelling across Brazil, and had been struck by lightning without catching fire, which challenged the official explanation that a lightning strike caused the explosion. Because of the Hindenburg's central role in the Nazi propaganda effort, as the Zeppelin travelled the world it was the frequent target of bomb threats by agents opposed to the German fascist regime. The disaster forever shattered public confidence in the airship as a reliable and safe method of transportation. After the disaster, the fact that the Hindenburg was so often threatened with destruction gave rise to the somewhat plausible explanation of sabotage as being the cause of the tragedy. One early theory was that the balloon had been shot from the ground. An initial suspect was a passenger and acrobat called Joseph Spah who survived the explosion. Spah was apparently heard making anti-Nazi jokes during the flight and made frequent unaccompanied trips to the hold to feed his German Shepherd dog, Ulla. It was thought that he had the

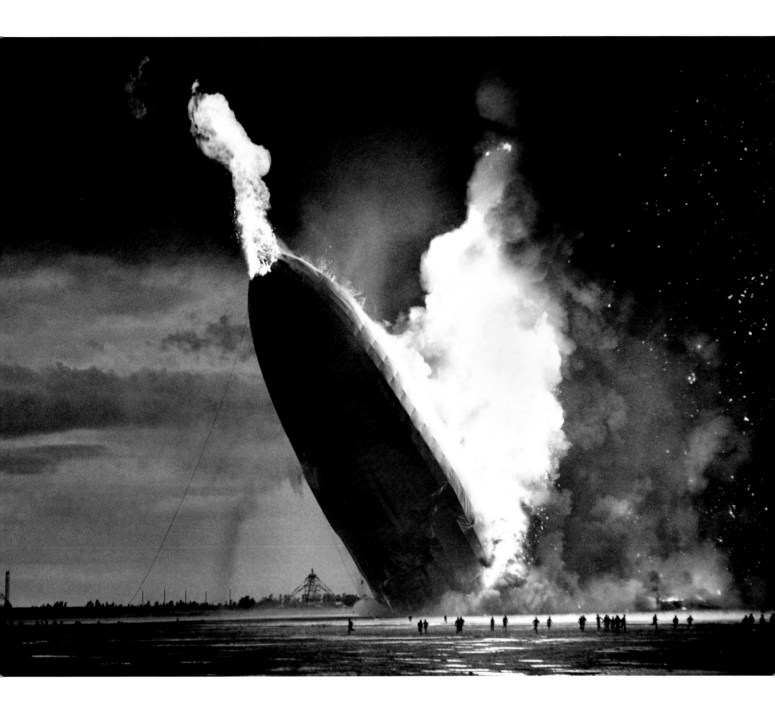

opportunity to plant a bomb during this time. A second suspect was crewman Eric Spehl, whose alleged involvement formed the plot of the 1975 Hollywood disaster movie *The Hindenburg*.

As no evidence of any bomb or bomb making material was found, historians have generally agreed that a fire was caused by a build-up of static electricity, although a more recent theory has been put forward by retired NASA scientist Addison Bain. He argued that an incendiary paint was mistakenly used to cover the balloon surface, and evidence of this was later supressed by the Nazis to avoid the embarrassment this revelation would have caused if it were made public.

THE END OF PROGRESS? THE LAST STEAM MACHINES ARE CELEBRATED AS A DARK CHAPTER IN HISTORY BEGINS

"World's Fair, railroad pageant. Final curtain, locomotives"

Photographed by Gottscho-Schleisner on May 27th 1939, New York, image courtesy of the Library of Congress

Colourised by Patty Allison

The invention of steam locomotion changed the world forever. In much of the Old World of Europe and Asia, before British engineer Richard Trevithick invented the first steam powered engine on February 21st 1804, the world's inland transport of good was carried out through networks of canals, with longboats pulled by draft horses. Land passenger transport was almost exclusively by horse in developed nations, or by camel or by foot in much of the rest of the world. Journeys from one city to the next would take days or weeks, and the danger from bandits or highwaymen was ever present. The impact of the railroad on accelerating industrialisation, and in contributing towards a globalised society cannot be exaggerated. European nations such as Britain and France spread railway technology from their home nations to the colonial territories they administered. Most famously, the British established an intricate railway network throughout its Empire in India complete with monumental railway stations, which still stand today. To the present, this Indian rail network carries a staggering twenty-three million passengers daily.

In America, the westward penetration of the railroad towards the Pacific Ocean during the mid-19th Century allowed people of European descent to start new lives by settling the Great Plains of the Midwest, and move onwards to California. For Native Americans, the new transport technology became a symbol of their loss of territory and way of life. The locomotive became a target for attack by native tribes, as-well-as the outlaw gangs who robbed them of gold and other treasures. For these reasons, the steam engines of the period are indelibly linked in the American psyche with the frontier of the "wild west".

In this picture, the two rival engines are nose-to-nose, representing how the forces of steam locomotion united the landscape of America. While the enthralled audience looked on, to the left we see the PRR K4 Pacific 3768 engine of the famous Pennsylvania line, responsible for most passenger trips in the country. This impressively streamlined version of the premier passenger-hauling locomotive was nicknamed *The Torpedo* because of its aerodynamic shape. It's counterpart on the right was a Delaware, Lackawanna and Western 1151 class Hudson, named *1939* in honour of the fair. One of the most powerful and heavy engines, at over one hundred and seventy metric tonnes in weight, plus an additional twenty-four tonnes of coal fuel, this was one of the last steam trains ordered before their replacement by the diesel-engine trains we commonly use today.

The pair were brought together during the spectacular finale of the 1939-40 New York World Fair, which with the slogan "Dawn of a New Day", showcased the most impressive technological feats, celebrated the diverse nations of the world, and gave a glimpse, to the forty-four million visitors who attended, of possibilities based on the present, but projected into the future.

The pamphlet advertising the fair read:

"The eyes of the Fair are on the future — not in the sense of peering toward the unknown nor attempting to foretell the events of tomorrow and the shape of things to come, but in the sense of presenting a new and clearer view of today in preparation for tomorrow; a view of the forces and ideas that prevail as well as the machines.

"To its visitors the Fair will say: "Here are the materials, ideas, and forces at work in our world. These are the tools with which the World of Tomorrow must be made. They are all interesting and much effort has been expended to lay them before you in an interesting way. Familiarity with today is the best preparation for the future."

The exhibition was divided into zones to reveal the latest and best experimental technology such as the transportation zone, Communication and Business Zone, Food Zone and Amusement Area. The one thousand two-hundred-acre site was populated with exhibits that portrayed the accomplishments of global civilization. However, with the onset of WW2 it was within the Government Zone where the major nations of the world held their own exhibits that the true state of international relations was played out. Nazi Germany failed to attend, the USSR had to dismantle its exhibit part way through, and the British suffered a bomb explosion, which was presumed to be German in origin.

In the centre of the image of this World Fair closing ceremony, we see a garishly dressed "woman of the future" in red, bringing together the ladies and gentlemen of the past and present as the curtain descends on the event. She represented "progress", but ironically, in just over a year from the close of the exhibition that looked to the future with bright optimism, from December 1941, America would enter the dark maelstrom that was to become history's most destructive conflict. The fighting was to become so violent, it would challenge the very survival of the global civilization the railway was so instrumental in helping to build. This terrible and costly battle for civilization would became known as: The Second World War.

BLITZ SPIRIT? EVEN THE MOST VULNERABLE BRITONS LEARN TO LIVE WITH DEATH

"Blind children in air raid shelter in London, September 3rd 1940"

Photographed by Daily Mirror, image courtesy of Mirrorpix

Colourised by Matt Loughrey

For any person living in wartime Britain, man or woman, young or old, the continuous bombing by the German air force, the Luftwaffe, was terrifying. For children who were blind, the underground shelter they were huddled inside as protection from the firestorm above, would have been a "cauldron of noise and fear", as the UK newspaper the Daily Mirror described the shot. The sense of the sheer vulnerability of these children is heightened by their upturned faces, and the way in which the youngest girl grips on to her older friend for solace.

From the time this haunting image was taken, September 1940, to May 1941, the British capital, London was targeted as a key population and industrial centre. The London Blitz killed twenty thousand people, with fifty-seven consecutive days of bombing, fifty thousand tonnes of high-explosive bombs dropped and one hundred and ten tonnes of incendiary bombs, destroying nineteen churches, two hundred and fifty thousand homes, damaging Westminster Abby, and Lambeth Palace. Each night one hundred and fifty thousand people were forced to sleep in London Underground platforms and tunnels. In addition to London, major cities such as Liverpool, Hull, Belfast, Birmingham, Newcastle, Plymouth, Portsmouth, Bristol, Sheffield, Manchester, Exeter and Nottingham each suffered their own Blitz. Hitler also attempted to obliterate British cultural centres, and the Luftwaffe famously attacked Canterbury Cathedral amongst other heritage sites.

In response, over one hundred thousand children were evacuated to live with strangers in the British countryside, three-quarters of a million domestic pets were poisoned, forty million gas masks were issued, four hundred million sandbags were deployed, a night-time blackout was imposed to prevent enemy aircraft from easily navigating towards ground targets. This blackout was enforced by 1.4 million air raid wardens or "moaning minnies" as they were known, ninety-five thousand Britons were drafted into the Auxiliary Fire Service, seventy-eight thousand women "manned" the two thousand anti-aircraft guns, over four thousand search lights and one thousand four hundred barrage balloons. One-in-ten bombs failed to explode, and as a result, seven hundred and fifty members of bomb disposal units lost their lives dealing with the forty thousand

unexploded bombs that littered the urban conurbation. Britain's Prime Minister Churchill, said of Hitler: "He hopes by killing large numbers of civilians and women and children that he will terrorise and cow the people of this mighty imperial city and make them a burden and anxiety to the government. Little does he know the spirit of the British nation."

The "Blitz Spirit" is a famous phrase used to describe the stoic, almost cheerful attitude by which Londoners and other British city-dwellers coped with the threat of death and destruction from above. It was anticipated by the German High Command that its bombing raids would completely terrorise the civilian population, and break the wartime morale of the entire nation. Remarkably, workers carried on with their tasks during the day, and fulfilled their voluntary roles in protecting their cities by night. Special psychiatric clinics that were opened to treat shell-shocked victims of the aerial bombing, were eventually closed due to lack of demand. Industrial production increased during this period, as the switch to the war economy began to outpace damage caused by the bombing, and days lost to strikes fell as the morale of workers improved with each raid. Crime, however, increased as the opportunity to commit offences such as looting and dealing in black market goods became a lucrative source of income to street gangs.

In general, despite dreadful scenes of carnage and destruction, the Blitz, which was intended to break the spirit of the people, seemed to have the opposite effect: it brought them together. As-well-as heroic tales of life-saving exploits, there are millions of unreported stories of small victories and shared moments of kindness by which Londoners helped each other get by each day. One "small victory" is poignantly shown through the togetherness of the children of the picture, who despite the terror, instinctively comforted each other, and survived at least another day.

The decisive RAF victory in the Battle of Britain for air superiority over the United Kingdom meant that the Blitz could not be sustained. Allied raids against German cities commenced, killing around six hundred thousand people in total, including seventy-six thousand German children.

AMERICA'S FIRST BLACK AIRMEN HAVE TO BATTLE THEIR OWN SIDE FOR THE RIGHT TO FIGHT

"Maj. James A. Ellison returns the salute of Mac Ross as he passes down the line during review of the first class of Tuskegee cadets."

Photographed by US Air Force, Tuskegee, Alabama, USA probably 1941

Colourised by Mads Madsen

Before the uniformed young men lined up in this image took to the air, no black man had ever fought in the skies of Europe, or anywhere else, for America. Called the Tuskagees or "Red Tails", after the distinctive red bands, on the tails of their fighters and bombers, these first ever black recruits overcame racial barriers in the US, winning the right to fight the malevolent forces of fascism and racial hatred that had overrun Europe.

During WW2, the American military was still segregated, with black and white soldiers forming wholly separate units. Black soldiers were excluded from eating, sleeping, socialising or attending parades and other public events, alongside white servicemen. Blacks were excluded from becoming officers, and were usually recruited into auxiliary roles such as cooks, janitors, and maintenance crew. Black servicemen were officially deemed "not fit for combat" by the War College of the US Army Memorandum of October 20th 1925.

Since the exclusion of black airmen during the First World War, pressure had been building amongst equal rights campaigners to allow black recruits into the Air Force. From 1939 another war looked likely and demand for recruits was on the increase. By June 1941, four hundred and twenty-nine black recruits were taken by the "Tuskagee Program", named after the airfield and university they were trained at in Alabama. Racial segregation laws required that black-only medical facilities had to be provided by the Air Force, so the program recruited the first black flight surgeons.

The first Tuskagee commanding officer, the white male pictured returning the salute, Major James Ellison, was considered as highly successful in organising and training his cadets, and was respected by them. However, he was forced from his position after refusing to implement strict Alabama State segregation laws that forbade white civilian airfield staff from being under the authority of black military policemen. His replacement, Colonel Frederick von Kimble, upheld local segregation laws, to the resentment of the black airmen under his command. Despite fierce resistance in the Air Force to the Tuskagees taking on combat roles, Kimble did succeed in making them combat ready by 1943. They were deployed as bomber escorts to the North African campaign.

The cadet seen saluting Ellison would become Flight Lieutenant Mac Ross, operational head the 100th Fighter Squadron, the first to be assigned to combat. Ross personally took part in more than fifty combat missions, many in his Curtis p-40 Warhawk fighter. He was the first black American man to parachute from a downed aircraft, therefore joining the "Caterpillar Club" of men who had survived "bailing out". Before they were disbanded towards the end of the war, the Tuskagees destroyed two hundred and sixty-two enemy aircraft, suffered one hundred and fifty of their own killed while in combat, won eight purple hearts, fourteen bronze stars and reputedly never lost a single bomber under their escort - although this exemplary record has been challenged by historians, most notably from Alabama.

When the 100th were incorporated in the 332nd Fighter Group, Ross was sidelined from combat duty and was moved to flying transport aircraft. He crashed his P-51 transport over Italy on July 10th 1944 and was killed aged thirty-two. He had won the Purple Heart, Distinguished Flying Cross, Legion of Merit.

On June 27th 1987 the US Postal Service of Ross' hometown, Dayton, Ohio dedicated the Mac Ross Memorial Philatelic Room, with a tribute, which reads:

"A young black man, one of ten children, a college graduate, becoming one of the first black pilots in the US Air Force, then a Commander of a Pursuit Squadron, manifests these three hallowed words echoed in time; obedience, integrity and courage. It is men like him that are the bricks and stones that make our country great...Mac Ross is a symbol: of what men can achieve and what they can strive for. The men and women of Tuskagee have gone down in history as true heroes of World War II. From the original five, Mac Ross, Benjamin O. Davis Jr, Charles DeBow, George "Spanky" Roberts and Lemuel Custis, grew a strong "air force" numbering 992 graduates of the Tuskagee Flying School. They have served this country well and proved what could be achieved against all odds. A salute to the Tuskagee Airmen."

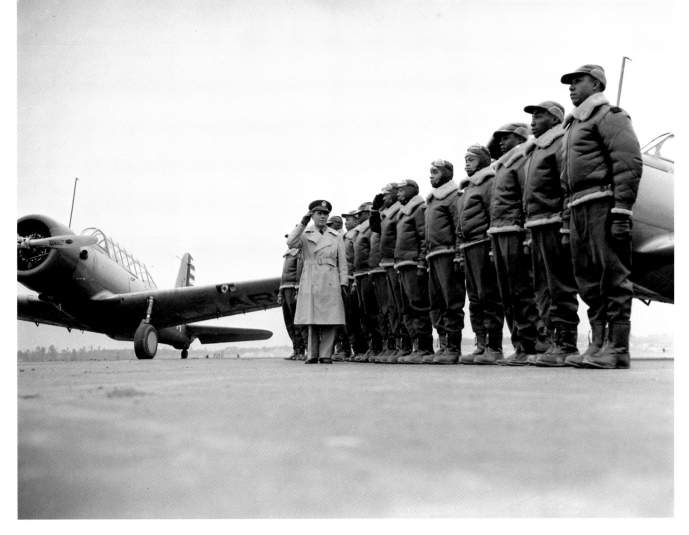

The forerunners of the Tuskagees were the WWI soldiers of the 15th New York (Coloured) Infantry Regiment, an all-black National Guard unit which became the 369th Infantry Regiment. Henry Johnson joined in June 1917 and fought alongside French troops on the Western Front. He was wounded 21 times during his single tour spent in the Argonne Forest. Such was his bravery in the face of the German army, he became one of the first Americans to be awarded France's highest award for valour, the *Croix de Guerre* (Cross of War). Unable to return to work because of his injuries, Johnson died in July 1929. He is buried alongside other US veterans in Arlington National Cemetery, and was posthumously awarded the Purple Heart in 1996, and the Distinguished Service Cross in 2002.

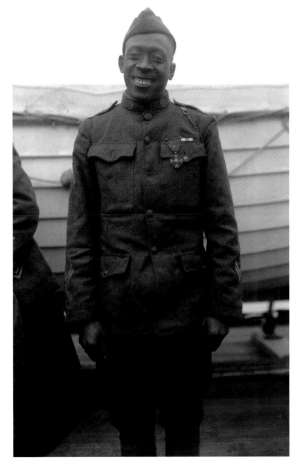

"Sgt. Henry Johnson of the 369th poses wearing the French Croix de Guerre, awarded for bravery in an outnumbered battle against German forces"

Photographed on February 12th 1919 courtesy of the US Army

Colourised by Mads Madsen

AUTOMOBILE TOURISM IN THE USA HERALDS THE END OF THE GREAT DEPRESSION

"Guests of Sarasota trailer park, Sarasota, Florida, picnicking at the beach"

Photographed by Marion Post Wolcott in January 1941, image courtesy of the Library of Congress

Colourised by Patty Allison

Blue skies over the flawless Florida sands, with an inviting turquoise ocean in the background, yet to the modern eye the holidaymakers look like they are dressed for a funeral rather than a picnic at the beach. While the average January temperature in Sarasota is a relatively temperate sixteen degrees Celsius, it is of course possible a cold spell kept the group fully bundled in clothing and close to their vehicle, rather than a conservative attitude or any lacking in the spirit of adventure.

As severe and out-of-place this group of three women and a man look in this paradise setting, the image was published to demonstrate how far American prosperity had come in the decade since the dustbowl poverty of the Dirty Thirties. Here we have what were called "Tin Can Tourists"; four average people who have driven their black 1938 Buick Series 40 (Special) from the Sarasota trailer park they were staying in. At Sarasota, social activities such as bowling, bingo, brass bands and organised bicycle rides were put on for up to three-thousand guests accommodated at any one time. This image shows that a significant number of people of modest means had excess time, fuel, food, spending money and inclination to make such an undertaking. This is a feat that may look disarmingly modest in this understated photograph, but it is one which many Florida families who were fighting for their very survival just a few years prior would never have dreamed of. They would have been too busy labouring in the hope of putting food on the table for their families.

Like Dorathea Lange, who went before her in the 1930's, the photographer responsible for this image, Marion Post Wolcott, was working for the US government Farm Security Administration. Born on June 7th 1910 in New Jersey, Wolcott trained as a teacher before taking an interest in photography. She travelled to Vienna, Austria, where she witnessed Nazi attacks on members of the local Jewish population. Upon returning to New York, she became involved in the anti-fascist movement and encountered pioneering documentary photographers Ralph Steiner and Paul Strand, who recommended her to Roy Stryker, head of the FSA. Stryker swiftly appointed her as an FSA photographer.

Wolcott explained how she felt about the significance of her work and impact it made to the condition of the working poor as part of a 1965 interview with the Smithsonian Museum conducted at her home. She said, *"Certainly a lot of people were awakened to the conditions who never would have been otherwise…it was the beginning of the recognition and governmental assumption of responsibility, for the welfare of the individual."*

Under Stryker's leadership, the FSA certainly did document the impact of the Depression on ordinary people, however, the administration also published images with the intention of showing the American people that better times were not only to come, but may already have arrived. Highlighting, as has been done in this image, the near-miracle of the health of the American automobile industry during the period of the most severe economic depression in history was certainly an obvious way to achieve this. From the 1920's when British car-making was at its pinnacle, to the 1930's when US carmakers dominated in the boldness of their designs and ability to capture the domestic market, it was during this time that key features in US design such as hydraulic brakes, gear shift in the steering column, were introduced, as-well-as the modern wrap around chassis that marks the modern car. This revolution in design, combined with innovation in engineering meant that machines of this era are still sought after classics to this day.

After marrying civil servant Leon Oliver Wolcott in 1941, Wolcott gave up professional photography to raise her family and travel the world with her husband, who was posted overseas. However, she worked extensively in the fields of women's education and family planning during her time in the Middle East and South Asia. Her photography for the FSA was rediscovered by social historians of the 1960's, her work was collected by the Smithsonian Museum and she began to exhibit her photographs. Wolcott died on November 24th 1990.

HOW THE MIGHTY FALL:
ADOLF HITLER DECLARES WAR ON THE UNITED STATES

"A devastating speech by the Fuhrer against Roosevelt. On Thursday afternoon, the Fuhrer, before the men of the German Reichstag, announced (to a) great and feverish excitement, the war in the Pacific, which had been unleashed by the war-rhetorician Roosevelt."

Photographed by unknown at the Kroll Opera House, Berlin, on December 11th 1941, image courtesy of Maritime Magason Historie / Das Bundesarchiv

Colourised by Mads Madsen

Hitler stands at the microphone addressing the top-members of the Nazi Government, the press, and the world, via radio broadcast. The image shows the National Socialist leader at the height of his military and political power, with the Imperial Eagle, the *Reichsadler* sitting atop the infamous Nazi symbol, the *Swastika*, all radiating supremacy. However, mighty this imagery may seem, the photograph in fact shows Hitler, in the moment of making what history would prove to be a fatally mistaken decision, eventually leading to his death, and the destruction of his Nazi vision for the world.

By the time this image was taken, the Germans had defeated neighbouring France, Poland, and much of Europe to the east and south. Its army, the *Wehrmacht* had engaged Russia and forced its way to within nineteen miles of the capital, Moscow. Britain and the Commonwealth stood alone, with London and the other great cities of the UK only just recovering from the Blitz by German bomber planes, which killed thirty-two thousand people, and left London with two million destroyed homes and twenty-five percent of its population evacuated.

Just three days before this speech, on December 8th 1941, Japan attacked America's Pacific Fleet in Pearl Harbour, Hawaii, bringing America into Britain's war against Japan. Against the advice of his most senior supporters, who feared a Germany already at war with Britain and Russia would overextend itself, Hitler decided nevertheless to declare war on America.

The Fuhrer was surrounded by his closest allies as he made his history-changing declaration. Directly behind him sat Chancellor Hermann Goering, acting as President of the Reichstag (German Parliament) and next to him was Foreign Minister Joachim von Ribbentrop to his right, and Propaganda chief Joseph Goebbels on his left.

Excepts from Hitler's declaration of war shows the personal animosity he had for the American President, Roosevelt:

"*National Socialism came to power in Germany in the same year as Roosevelt was elected President…While an unprecedented revival of economic life, culture and art took place in Germany under National Socialist leadership, President Roosevelt did not succeed in bringing about even the slightest improvement in his own country.*

"*I will pass over the insulting attacks made by this so-called President against me. That he calls me a gangster is uninteresting. After all, this expression was not coined in Europe but in America, no doubt because such gangsters are lacking here. Apart from this, I cannot be insulted by Roosevelt for I consider him mad just as (WWI US President) Wilson was.*

"*I don't need to mention what this man has done for years in the same way against Japan. First he incites war then falsifies the causes, then odiously wraps himself in a cloak of Christian hypocrisy and slowly but surely leads mankind to war, not without calling God to witness the honesty of his attack-in the approved manner of an old Freemason.*

"*I think you have all found it a relief that now, at last, one State has been the first to take the step of protest against his historically unique and shame less ill-treatment of truth, and of right-which protest this man has desired and about which he cannot complain. The fact that the Japanese Government, which has been negotiating for years with this man, has at last become tired of being mocked by him in such an unworthy way, fills us all, the German people, and think, all other decent people in the world, with deep satisfaction…*

"*Our enemies must not deceive themselves-in the 2,000 years of German history known to us, our people have never been more united than today. The Lord of the Universe has treated us so well*

in the past years that we bow in gratitude to a providence which has allowed us to be members of such a great nation. We thank Him that we also can be entered with honour into the ever-lasting book of German history!"

Hitler declared war on the US in part, so his submarine fleet of U-boats could attack American supply ships that were vital in keeping Britain in the war, but also in the belief that Japan would reciprocate by declaring war on his enemy, Russia. He was mistaken. Japan failed to declare war on Russia, which allowed the Soviets to throw all their forces at countering the German invaders.

RUSSIA'S ALL-FEMALE FIGHTER PILOTS, THE "NIGHT WITCHES" STRIKE TERROR INTO THE HEARTS OF THE GERMAN INVADERS

"Yevdokia Bershanskaya, commander of the 46th Taman Guards Night Bomber Aviation Regiment instructs Yevdokia Nosal and Nina Ulyanenko, crew of the Polikarpov Po-2 biplane."

Photographed in 1942 by unknown, image courtesy of the State Archive of Russia

Colourised by Olga Shirnina

These courageous ladies were the first and only all-female fighting force deployed during WW2. They came into operation, thanks in part, to the idea of all-female fighter aircraft units being bolstered by the heroic feat of Russian female aviation pioneer Valentina Grizodubova, in winning the woman's straight line record in September 1938 by crossing 3,267 miles over Russia. Building on the enormous public response to this record-breaking flying feat, upon the onset of war between Russia and Germany from June 1941, the propaganda victory presented to Soviet leader Joseph Stalin of having an all-female air combat force, was one he could not resist. From early 1942, the 588th Night Bomber Regiment was formed, with all female command to the very top in the form of Grizodubova's indomitable contemporary, Colonel Marina Raskova. Recruits were aged from 17 to 26 years and were sent to attack the enemy in converted Po-2 dust cropper biplanes made of canvas and wood. The top-speed of these machines was just 100-miles-per-hour, squeezed from their 110-break-horsepower engines. The women were armed with six bombs to drop on the enemy.

Each day at dusk the two-woman crew, pilot and navigator, would be briefed as in this picture, before taking off for the German lines. They would fly their aircraft in pairs or threes, flying low in the dark to avoid detection. Once they were close to their target, the pilots would switch their engines off, and glide quietly towards the enemy, sometimes flying so low they used treelines as cover. German soldiers described the wind cutting through the canvass wings as sounding like the whistling of a witch's broomstick, which is where the term *Nachthexen* or "Nightwitches" originates. Because of the small number of bombs each plane carried, often eight sorties per-night was required from a single flight crew, but sometimes this would extend to a relentless eighteen sorties per-night. Because of the lack of space and height, no parachutes were carried on board. The flimsy material, the Po-2 aircraft were made from, meant the crews had little protection from enemy bullets, however they used the basic capabilities of their planes to their

advantage. The Po-2 maximum flying speed was less that the 120-mile-per-hour engine stall speed of the Messerschmitt, which meant they could fly at lower altitude and out manoeuvre the much faster and better armed German fighters. Because they would fly so low and close to their target, the Night Witches could strike with much greater precision than larger bombers. The aircrews were so feared by the Germans that any soldier or airman who brought down a Night Witch was reputedly awarded an Iron Cross medal without question. As-well-as facing death from the Germans, Night Witches also had to contend with suspicion and sexual harassment from their Russian male comrades. They did not receive the resources of the regular air force, and had to fly eight hundred flight hours, rather than the usual five hundred, to qualify for a Hero of the Soviet Union Award.

First Lieutenant Yevdokiya Nosal (pictured in the pilot seat to the front of the open top cockpit), like many of the female volunteers, joined the Night Witches as a direct result of the Nazi's policy of targeting of civilians. She volunteered shortly after her new born son was killed by a German bombing raid. She decided to put the trauma of her loss behind her by, "flying and flying every night, more than the others." Nosal was killed in April 1943. Posthumously, she was the first woman of her regiment to be awarded the Hero of the Soviet Union award, Russia's highest distinction and equivalent to America's Medal of Honor, or Britain's Victoria Cross.

Sitting behind Nosal, Lieutenant Nina Ulyanenko, went on the command the 46th Taman Guard, as the regiment became known by 1944. She was active in the Battle of Stalingrad, which turned the tide against the German advance and she fought them all the way back to Berlin, flying a total of three hundred and eighty-eight combat missions. She was awarded the Hero of the Soviet Union Award, and became a teacher after the war. Ulyanenko died on August 31st 2005, aged 81.

The commander briefing them, Lieutenant Colonel Yevdokia Bershanskaya was the only woman to have been awarded Russia's medal for exceptional military leadership, the Order of Suvorov. Her military citation reads:

"The regiment under her leadership was victorious from Vorshilovgrada through Grozny, Krasnodar, Taman, Kerch, Sevastopol, Mogilev, Grodno, Bialystok, Ostroleka, contributing in supporting ground combat units to destroy enemy troops and equipment.

"By October 1, 1944, the regiment made 18,436 combat sorties with a total of 25,775 flight hours, causing heavy damage to the enemy. The regiment was awarded the title of "Guards" and awarded the Order of the Red Banner. In the ongoing battle, the regiment holds a leading position in the battle. Guard Major Bershanskaya repeatedly obeyed the orders of the great Stalin.

"Personally, comrade Bershanskaya showed the courage and bravery to defeat fascism. She has a highly developed sense of responsibility for her work. She properly coordinated combat operation with political staff, sensitive to the needs and issues of personnel. At the same time she fuelled the personnel hatred of enemies and the love for the motherland."

After the war Berchanskaya married, and had three daughters by her husband Andrey Molotov. She died in 1982 and is buried at Moscow's prestigious Novodevichy Cemetery. A statue in her memory stands in Krasnodar, south-west Russia.

In total the Night Witches numbered just forty at any one time at the height of their strength. However, on average they had each logged five hundred hours of time in flight, and in total they dropped twenty-three thousand tons of bombs during WW2. The Night Witches lost thirty women killed in combat and accidents, and twenty-three of their pilots won the Hero of the Soviet Union Award.

THE WAR OF 1939-45 SEES CONFLICT REACH EVERY CORNER OF THE PLANET INCLUDING THE ANCIENT WONDERS OF THE WORLD

"An Air Transport Command plane flies over the pyramids in Egypt."

Photographed in 1943 by US Signal Corps image courtesy of US National Archives Catalogue

Colourised by Jared Enos

War came to every corner of the planet from 1939 to 1945, and as this striking image of a US C-47 Skytrain transport aircraft flying over the 4,500-year old Egyptian Pyramids shows, the Wonders of the Ancient world were no exception. The caption that is written against this image reads: *"Loaded with urgent war supplies and materials, this plane is one of a fleet flying shipments from the U.S. across the Atlantic and the continent of Africa to strategic battle zones."*

The year this image was taken was one of a tipping point in the Allied War against Germany and the other Axis Powers. Until this point the tide had been in Germany's favour, with nearly all of Europe either neutral or under Nazi-occupation. Vast territories of Soviet Russia had been lost, Japan had been startlingly successful in the Far East and Pacific, and the involvement of the resource rich and technologically advanced USA, was yet to be felt in the Allied side.

It may almost be said, "Before Alamein we never had a victory. After Alamein we never had a defeat. - Winston Churchill

In Egypt and North Africa circumstances were different, and hope for the Allies was bolstered by the decisive victory at El Alamein in November 1942. For the first time in WW2, British forces and their allies halted the Germans, and began to push back their advance into Egypt. The North Africa Campaign, as this counterattack was called, was led by General Montgomery. Over one thousand Allied tanks, five hundred and thirty aircraft, eight hundred artillery, and one hundred and ninety-five thousand men from Britain, America, Greece, Palestine, Free France, South Africa, India, New Zealand and Australia all converged on Italian and German forces that were approximately half that strength, but were led by the formidable General Rommel. The "War in the Desert", as the Campaign also became known, was likened to a "perfect war" due to the sparse number of civilians in the region that could be killed, or otherwise obstruct fighting, and because of the desert landscape that was a blank canvass for military strategists. The Desert War, is now widely seen as being a battle of wits, between the British Bernard Montgomery, and the German Erwin Rommel.

As part of its archive "People's War", amongst others gathered from the public, the BBC published a letter from Thomas Arthur Murray to one of his grandson's. Murray was sent to Egypt as a rifleman with the 10th Armoured Division of the British Eight Army. Murray described how on the day of the battle, he was on a ridge manning a Vickers water-cooled machine gun, when he heard the heavy sound of enemy motors. Soon afterwards, Murray saw tanks coming towards his position, and from about two hundred yards away, he and his fellow machine gunner, "opened up on them". Several of the German war machines exploded into fierce flames. In the ensuing battle, when crawling back to the prepared position, Murray was hit in the leg. Now helpless, he wrote vividly how: *"All our trucks were burning and jeeps were being thrown in the air by the fire of these tanks as if a giant hand had tossed them into the air. The fire from these burning tanks was so fierce I could feel the skin being lifted from my face."*

The battle to save Egypt was seen as a sideshow by Germany, Russia, America, and Japan, but was of vital importance to the British, whose imperial lifeblood was connected to the beating heart of her Empire by the thin cord of the Suez Canal. It was only here that Britain's shipping could pass freely, without having to pass thousands of extra miles around the Horn of Africa. The Campaign was so important to Britain's wartime leader, Churchill, that he came out to Egypt personally to inspect, and stir-up, the morale of British troops shortly before the offensive against the Germans began. While he saw the obvious advantage of taking Suez from the British, Hitler had been distracted by his war against Russia on the Eastern Front. So, it was a surprise to the Nazi High Command that the defeat of Rommel at El Alamein would eventually lead to the total loss of North Africa by the Axis Powers. The region was to be used as a staging post for the Allied invasion of Italy, and the opening of a new southern front in the War against Germany in Europe.

Despite his wounds, Murray survived and was sent to Cape Town to recover. The "D-Company" to which he belonged lost about half their number. After the war, Murray went on to raise a family, and he died in 2001.

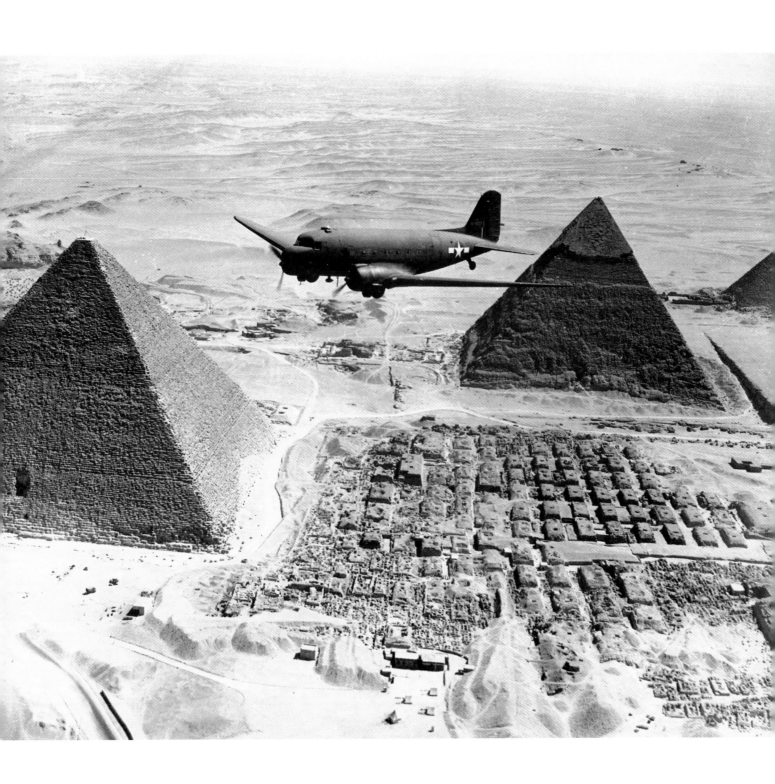

WOMEN EMPOWER THEMSELVES DURING WW2 BY RISKING THEIR LIVES FOR THEIR COUNTRY

"From left to right female pilots Frances Green Kari, Margaret (Peg) Kirchner, Ann Waldner and Blanche Osborn Bross walk away from their B-17 Flying Fortress Bomber."

Pictured at the Four Engine Training School at Lockbourne Army Air Force base, Ohio, USA c.1944 by an unknown US Army photographer

Colourised by Patty Allison

This image of four carefree female pilots striding purposefully towards the camera as they disembark from their seventy-four-foot-long aircraft, captures the *esprit de corps* of America's Women Airforce Service Pilots (WASPs). The photograph, by an unknown army photographer, was received so well by the public that it was used by America during World War Two, as propaganda to promote the war effort. It has been reproduced to this day in advertising, fashion magazines, and articles across the world which remember the achievements of the airwomen who flew for their country.

While women were permitted to fly civilian aircraft at the time, flying for the military even in a civilian capacity (which the WASPs were officially regarded as) was completely unheard of before WW2. The challenges of training in what had formerly been an all-male environment must have been great, however the women's surviving accounts paint them as stoic and good-humoured. One of the ladies pictured opposite, Blanch Osborn Bross, described the reaction she received while flying male gunner trainees in her B-17: *"One of the gunners had combat experience, and he was amazed women were flying the B-17s. "When he saw the women pilots, he said, 'I'm going to have to write home about this!'"*

The "Pistol Packin' Mama", title on the side of the aircraft referred to the Al Dexter song, which was later made famous by actor and singer Bing Crosby's version. Pin-up artist Alberto Vargas immortalised the character on the cover of *Vanity Fair* in March 1944. The Pistol Packin' Mama title and pin up was hugely popular among male flight crews of WW2, but she has a particular resonance when applied to female crews as in this iconic picture.

Over twenty-five thousand women applied to join the WASPs when war was declared with Japan in December 1941. However, less than two thousand were selected and just over half completed their training to qualify as military pilots for B-17's and the many other plane types they were responsible for flying. Typically, the ladies had between fifty and two hundred hours of flight time before piloting B-17 aircraft, which had a wingspan of one hundred and three feet, a top speed of two hundred and eighty mile-per-hour, a two thousand-mile range. They were typically armed with thirteen M2 Browning machine guns, and had a maximum bomb payload of eight thousand pounds.

From the summer of 1941 to the winter of 1944, a total of one thousand one hundred-and-two women served as WASPs in non-combat roles. Typical duties included testing and delivering aircraft, and training male crews for combat. The attempt by General Arnold to make the WASPs ready for combat stalled after opposition from male civilian pilots, and the service was disbanded after the Allied invasion of mainland Europe in the summer of 1944.

Despite being officially recognised as airwomen during the war, and thirty-eight being killed in non-combat incidents, the women of the service were not honoured as WW2 veterans until 1977, and therefore had no entitlement to veteran's medical care until this time. During the war, WASPs who were killed had to be transported home at their families' expense, and the army would not permit the American flag to be wrapped around their coffin as is traditional in military burials. In 1943 a WASP, Dora Dougherty Strother described how her friend, Mabel Virginal Rawlinson died in an incident, which was

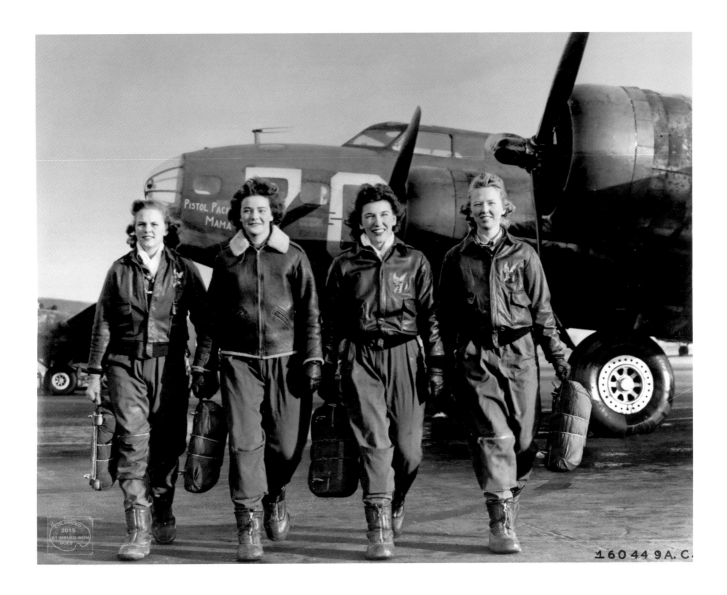

attributed to possible friendly fire or faulty equipment during a training mission: *"The fire was intense. They could not get Mabel out and she burned…This was the first time that I had seen a friend die. So it was a trauma for me and I think for all of us."*

Even in 2017, campaigners have battled for airwomen to be granted full military honours and burial space amongst their male counterparts at the Arlington National Cemetery, America's most hallowed site for military burial, which lies opposite the White House. Of the failure to fully recognise the contribution the WASPs made to the war effort, before her death in 2008, Bross said, *"We are part of World War II. For me it's not personal, but it needs to go down in history that we were there."*

Pioneers such the four women pictured paved the way for female Naval pilots to earn their wings from 1974. By 2013, there were eighty-five female pilots in the US military, or two-percent of the total. In 2016 Lieutenant Colonel Christine Mau became America's first female to pilot an F-35 Fighter. The woman pictured on the left, Frances Green Kari summed up her experience as a WW2 B-17 Flying Pilot, *"If you are determined, you can do just about anything you want to do. Anything. If you have the determination."*

BRITAIN'S PRIME MINISTER INSPECTS ONE OF THE TANKS THAT WOULD GO ON TO LIBERATE WHAT IS NOW THE CAPITAL OF EUROPE - BRUSSELS

"Winston Churchill inspects a Cromwell tank in March 1944 as the 2nd Battalion Welsh Guards prepared for D-Day."

Photographed at Pickering, Yorkshire, England by unknown, image courtesy of the Welsh Guards Archive

Colourised by ©Tom Marshall (Photografix)

As a former soldier, Britain's wartime leader knew that to maintain the respect of the troops, and boost the morale of the population, he was well served to be as hands on in military matters as possible. The propaganda value was obvious of this photograph of Churchill being briefed by the commander of Number 2 Squadron, Major John Ogilvie Spencer, on the operation of the Cromwell tank. He would be riding this machine into combat on the beaches of Normandy in a few weeks from the date this image was taken. The markings on the front of the tank, tell us a great deal about how this machine was to be used as part of its mission to cross the sea to France, land successfully, and to begin the perilous task of pushing Nazi forces back to Germany. On the left the number 45 painted in white on a green square tells us this machine belongs to an armoured reconnaissance regiment, used for scouting, and tracking enemy movements.

The number 26 surrounded by a circle means the tank is "bridge class" and therefore suitable to cross the many bridges that were in its path from France, to Belgium and Holland (those with a lower number were not permitted to use bridges). The white square means the vehicle belonged to the 2nd Squadron and the "A" inside the square informs his colleagues that this is the squadron leader's tank. On the far right, the white, "ever open eye", within the purple badge is the insignia of the Guards Armoured Division. In addition to other tank crew, and other personnel in the background and periphery, located just to the left of his hull mounted 7.92mm Besa machine gun, we see the face of tank driver, Sgt T. Dredge, looking directly into the camera lens from behind his open visor, with a sparkle of mischievous pride in his eyes.

The commanding officer we see pictured, Major Spencer was killed on September 9th 1944. However, Maj Spencer did live long enough to be part of the Guards Armoured Division's most momentous feat. From June 18th to September 3rd 1944, the Guards Armoured Division had fought through three-hundred miles of German occupied territory to reach the outskirts of the Belgium capital, Brussels. Welch Guardsman Frank William Clarke wrote to his sister, Vera, as published by the BBC's *People's War* project. He gave his account of the liberation of Brussels, which Major Spencer was also part of, *"As we progressed further in the crowds began to get out of hand for they climbed into the trucks, on the tops kissing and hugging everyone… It was the most exciting moment of my life. A moment I shall always remember. Our Division had made history."*

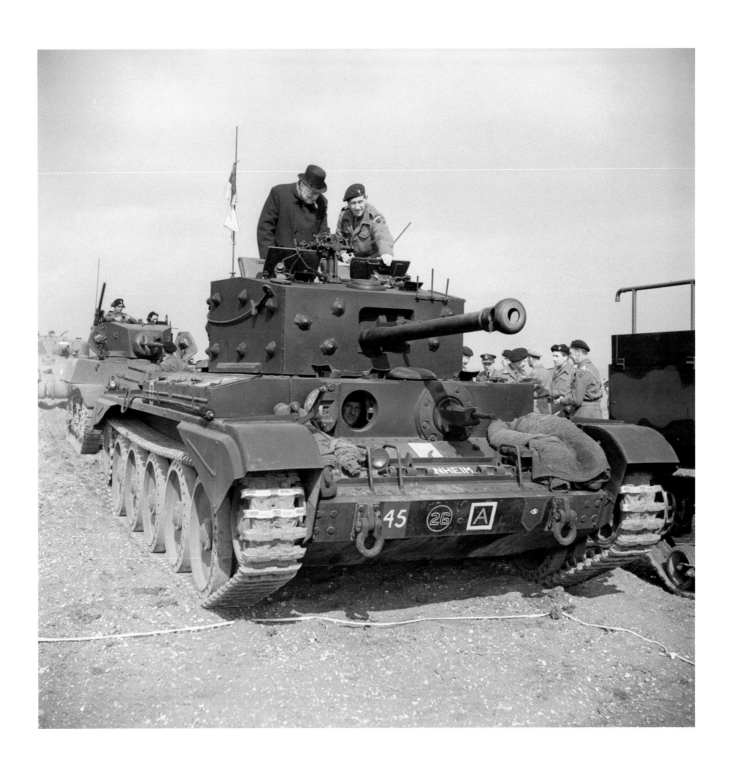

NEWS OF HISTORY'S LARGEST SEABORNE INVASION REACHES CITIZENS AT TIMES SQUARE

"New York, New York. Times Square and the vicinity on D-Day, June 6th 1944"

Photographed by Howard R. Hollem, Edward Meyer or MacKaugharie, courtesy of the Library of Congress

Colourised by Matt Loughrey

Staring anxiously upwards as at a new broadcast on the electronic new ticker known as "the Zipper", of the Allied liberation of Europe from the Nazis, this image shows how in the past people physically came together to share the experience of momentous events. While only the barest of details of the Normandy Invasion can be read on the Times Tower, people were still fixated with the words passing across the building. This now seems like a quaint practice, in contrast to news consumption today, which is increasingly experienced through looking downwards to the palm of our hand at our personal electronic devices. Rather than a a small stream of words on a single subject, now thousands of words can be read alongside high resolution images and video with sound on a range of topics chosen by any individual with a smart phone.

The Allied assault on mainland Europe was the beginning of the decisive victory of democratic nations over the forces of fascism that had swept across Europe so startlingly fast. In addition to Austrian and Czechoslovakia, which were already occupied, from the first twelve months of the Second World War, Germany had invaded Poland, France, Belgium, Netherlands, Denmark, Norway, and the British Channel Islands, placing millions of people under Nazi rule. In the following twelve months, Hitler's forces had invaded Russia and captured territory extending hundreds of miles to within a few miles of Moscow's centre by November 1941.

On December 7th 1941, Japan attacked Pearl Harbor, which brought both America and Japan as active participants into the war. Once American resources, manpower and military prowess were brought to bear against the Axis Powers, hope for an Allied victory in Europe grew substantially. In preparation for an Allied invasion of mainland Europe, America began to send troops, aircraft, tanks, and equipment to Britain. During the war, around three million American servicemen had passed through Britain on the way to fight in Europe, thirty-eight thousand aircraft were sent to British and Commonwealth forces, and nearly a million tonnes of goods were sent across the Atlantic from the USA to Britain. In total $31 billion worth of goods was sent to the United Kingdom by America through the famous Lend Lease Act of 1941. Britain managed to pay the resulting loan off with interest by December 2006.

Before the Allied Invasion of Europe commenced, an elaborate strategy of deception was enacted to distract and confuse German High Command as to the true intended location of the initial invasion. Using double agents, dummy heavy equipment (such as tanks made from cardboard to fool German aircraft reconnaissance), the Allies managed to convince the enemy that the invasion would occur at Calais. This meant more German military resources were deployed at this location, to the detriment of the real invasion point: Normandy.

In what became the largest seaborne invasion in history, from June 1944, a staggering 1.3 million British, Commonwealth, and American troops were sent across the English Channel to the beaches of Normandy. The day of the initial landing, June 6th has been known henceforth, as "D-Day". Up to this time in military terms, D-Day meant the day of attack, and because this attack was so crucial and became so famous, it is now synonymous with the Invasion of Normandy itself. Officially the invasion was given the codename, "Operation Neptune". The Allies faced three hundred and eighty thousand German troops. Despite fearsome fighting which saw one hundred and fifty six thousand Allied troops landed on the first day, with an estimated ten thousand casualties, the remainder were successfully deployed on the beach, where they established a foothold in Europe.

While the civilians shown in the image could only guess at battle being fought in their name, this account by Private Harold Baumgarten, 29th Infantry Division, 116th Infantry Regiment, B Company, who was part of the first wave of soldiers to set foot on Omaha Beach graphically illustrates the horror these men faced:

"German MG 42s were trained on our ramp opening, as I stepped forward to leave the craft. The water was bright red, from the blood of some of those who had been in front of me. Lieutenant Donaldson was killed immediately, Clarius Riggs was machine gunned on the ramp, and then fell headfirst into the bloody water.

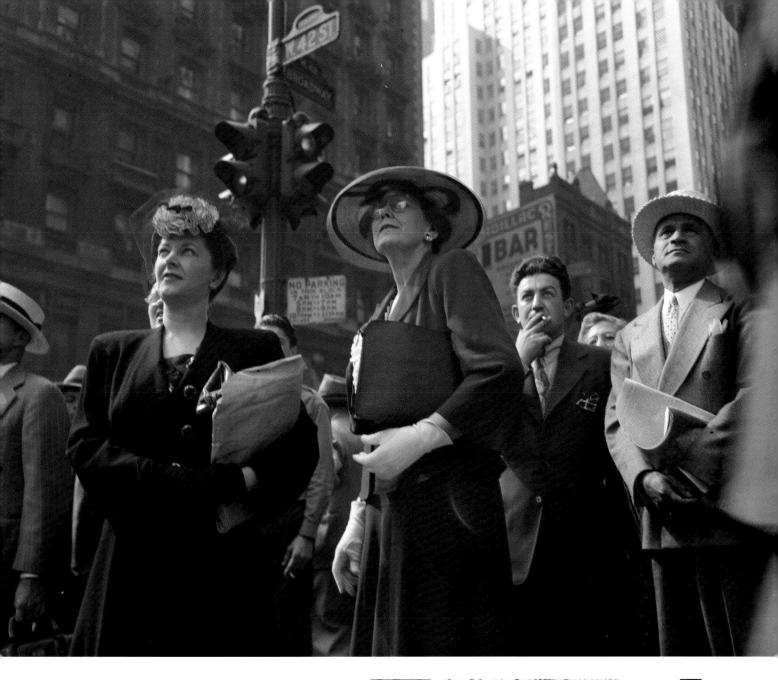

Right: "Times Square and vicinity on D-Day, June 6th 1944"

Photographed by Howard Hollem, Edward Meyer or MacLaugharie, courtesy of Library of Congress

Colourised by Jared Enos

AMERICA AVENGES PEARL HARBOUR AND THE WAR IN THE PACIFIC BECOMES WINNABLE

"B29 Waddy's Wagon and her crew, Isley Airfield, Saipan, 1944."

Photographed by unknown credit USAAF / National Archives Catalogue

Colourised by Patty Allison

At first glance, this scene of an American bomber crew seems spontaneously exuberant; the camaraderie of the men is evident by their open smiles and relaxed body language. It is only upon looking at the background that we can appreciate how carefully the photographer will have posed them to exactly mimic the comic scene represented in nose art of their B-29 aircraft. The caption, which accompanies the image in the National Archives Catalogue, reveals the name the men had given their bomber, *Waddy's Wagon*, originates from the nickname of their pilot, the American football star, wrestler, boxer, and participant in the first televised NFL game (October 22 1939, Philadelphia Eagles vs Brooklyn Dodgers), Captain Walter "Waddy" Young (holding the wagon, far left). The complete caption reads:

"The crew of the USAAF Boeing B-29-40-BW Superfortress (s/n 42-24598) "Waddy's Wagon", 20th Air Force, 73rd Bomb Wing, 497th Bomb Group, 869th Bomb Squadron, the fifth B-29 to take off on the first Tokyo mission from Saipan on 24 November 1944, and first to land back at Isley Field after bombing the target. The crew is posing to duplicate their caricatures in the nose art. The crew (l-r): Capt. Walter "Waddy" Young/pilot, Lt. Jack Vetters/copilot, Lt. John F. Ellis/bombardier , Lt. Paul Garrison/navigator, Sgt. George Avon/radio operator, Lt. Bernard Black/flight engineer, Sgt. Kenneth Mansie/flight technican, Sgt. Lawrence Lee/gunner, Sgt. Wilbur Chapman/gunner, Sgt. Corbett Carnegie/gunner, Sgt. Joseph Gatto/gunner. This aircraft was lost on 9 January 1945."

Prior to this mission against Tokyo, American bombing raids had been conducted from bases in India and China. Tokyo in particular, had already been hit by the Doolittle Raid of 1942. However, the mission Waddy's Wagon participated in was the first where the US was close enough to continuously attack the

Japanese capital city. America had been waiting to wreak vengeance on the Japanese Imperial Fleet since it decimated the US Pacific Fleet at Pearl Harbor in on December 7th 1941. Following that infamous ambush against the unsuspecting American Navy, US forces had fought fierce island-by-island battles against Japanese enemy fighters who were fanatically courageous to the point of making suicide *Kamikaze* attacks. The Battle of Saipan was won by the US on July 9th 1944 with a total of fifty-four thousand killed on both sides, including twenty thousand Japanese civilians, many of whom died by suicide, rather than face capture. American soldiers witnessed Japanese civilians throwing themselves from what are now called "Bonzai" and "Suicide" cliffs

For the first time in three years of bitter fighting, total war was now brought to the Japanese population, which until then had celebrated the victories made known to them by the military. With the loss of the Islands and the new vulnerability of Japanese cities to being bombed, the man who had ordered the original attack on Pearl Harbor, Prime Minister Hideki Tojo, was forced to resign.

French reporter Robert Guillain was in Tokyo during one of the attacks by B-29 bombers, which flew low at night and dropped incendiary bombs. He described how cylinders falling from the sky scattered a "flaming dew", which adhered to residential rooftops, setting fire to everything it splashed on. The incendiary bombs spread a rain of fire across entire neighbourhoods and because many traditional Japanese homes were made of paper and wood, the effect on these highly combustible houses was devastating. He recorded how screaming families abandoned their homes, sometimes too late; they found themselves

surrounded by the raging fires. Guillain mentioned that the response of fire crews was brave, but hopeless in the face of the onslaught. With weak water pressure and hardly any mobile fire engines, they could do little but direct people to safety and dowse them in water, so they had a better chance of survival when running through flames. Others soaked themselves in water barrels before attempting to battle though the fires. He said, *"In the dense smoke, where the wind was so hot it seared the lungs, people struggled, then burst into flames where they stood."*

The men of Waddy's Wagon were killed on January 9th 1945, while taking part in a bombing raid against the Nakajima Aircraft Engine Factory. A Kamikaze fighter pilot struck a neighbouring B-29, setting it on fire. After delivering his payload, rather than abandon his comrades, Walter Young turned his plane back to provide a protective escort to the stricken crew. Last spotted descending at twenty-seven thousand feet, both aircraft disappeared off the coast of Choshi Point, sixty-miles to the east of Tokyo. In 1986 Young was inducted in to the College Football Hall of Fame.

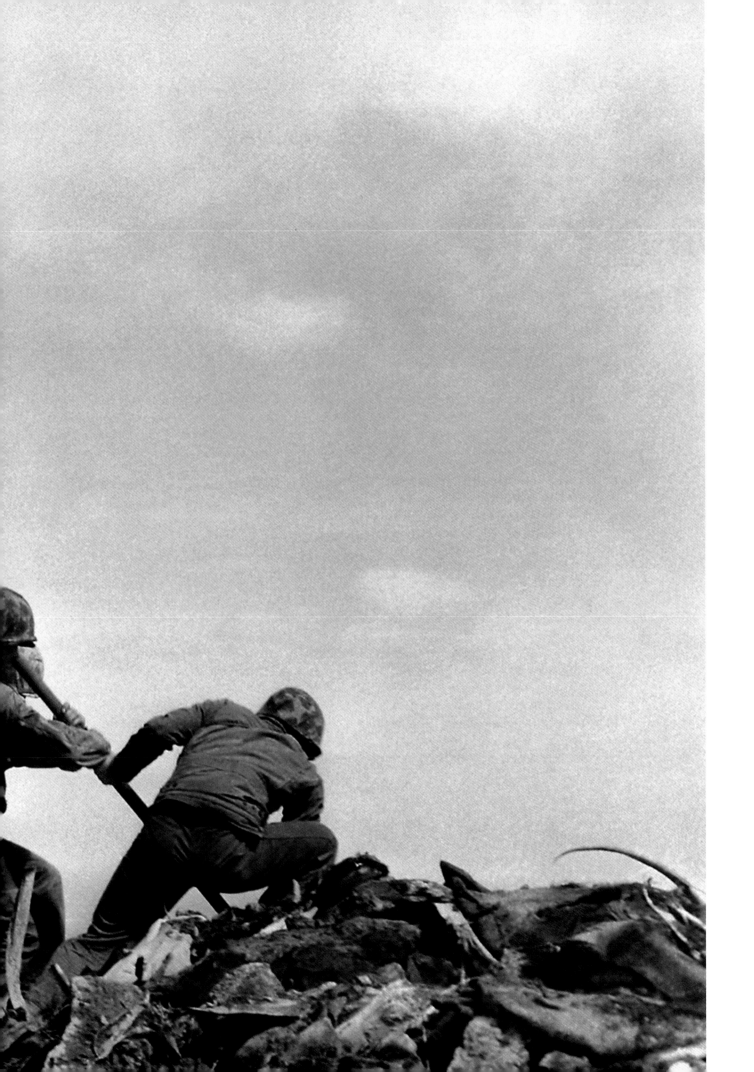

AMERICA'S MOST ICONIC IMAGE OF VICTORY IS IMMEDIATELY PLAGUED WITH CONTROVERSY

"Raising the Flag on Iwo Jima"

Photographed on February 19th 1945 by Joe Rosenthal courtesy of Associated Press

Colourised by Matt Loughrey

The image of six United States marines raising the Star and Stripes flag on Mount Suribachi, Indonesia, is regarded as one of the most significant war images in history. With the bodies of the men braced in unison to plant the flag atop the battle-scarred mountaintop, this iconic photograph skilfully depicts what is now an archetypal image of a hard-won, but triumphant victory over a ferocious enemy. It has become a worldwide symbol of American patriotism and military prowess. Rosenthal's image was the first and only to win a Pulitzer Prize for Photography on the same year as publication.

However, the true story of the photograph is not quite as straightforward as the celebrated image we see. Associated Press (AP) photographer Joe Rosenthal was assigned to the US Marine Corps in the Pacific Theatre of Operations. On February 19th 1945, he was on one of over five hundred US ships that landed a force of one hundred and ten thousand men on the Japanese-occupied, and strategically important island of Iwo Jima. This image that was later used to portray ultimate victory, was in fact taken just four days into the battle, which lasted another four weeks. In total the fighting was to cost six thousand, eight hundred and twenty-one American lives, with over eighteen thousand Japanese also killed. The image was also not of the genuinely historic and spontaneous first flag raising over the mountaintop, but a second, larger flag that was deployed so as to be more visible to US naval ships stationed off the coast of the island.

On the morning of February 23rd, Rosenthal was walking the coastline when he heard from Marine photographer Sergeant Louis Lowery that he had already captured images of a US flag being raised atop the highest point on the island, Mount Suribachi at 10.40am that day. It transpired that a forty-man combat patrol led by First Lieutenant Harold Schrier had succeeded in occupying the summit in just over an hour, after only a brief firefight with Japanese troops. Alongside Marine photographer Private Bob Campbell and camera operator Sergeant Bill Genaust (who was killed shortly afterwards) Rosenthal ascended the mountain and arrived just in time for the smaller first flag to be replaced by the second. He attempted to capture both flags in the same frame, but was unable to do so from his position, so he decided to focus on the raising of the larger second flag. Describing the shot ten years later, he said: *"Out of the corner of my eye, I had seen the men start the flag up. I swung my camera and shot the scene."*

Within days of the image being distributed, *Raising the Flag on Iwo Jima* made a sensational impact in the US and overseas. It was published within a matter of hours of being taken, which was highly unusual for the time. The Raising the Flag image was also immediately controversial. Rosenthal had taken what he thought was a more memorable shot at the time, the "Gung Ho" image of members of the patrol posing with the flag on the mountaintop. When Time-Life reporter Robert Sherrod congratulated him for his shot and asked whether it was posed, Rosenthal replied, "Thanks. Sure." Because of this misunderstanding over whcih shot Sherrod was referring to, Rosenthal was never able to fully shake accusations that he had arranged the shot. This is despite colour footage that Genaust had taken at the same time, showing his account to be correct. At this point, there were even calls for him to be stripped of his Pulitzer Prize.

Of the six men pictured, Private Franklin Sousley (second from the left, in the first line visible), Corporal Halon Block (far right on the first line) and Sergeant Michael Strank (in the second line of men, behind Sousley) were all killed in fighting against the Japanese over the following days. The three men believed to be the surviving flag raisers were all corporals: John Bradley (third on the left in the first line), Rene Gagnon (behind "Bradley" in the second line) and Ira Hayes (far left, in the first line).

Gagnon, Hayes and John Bradley became national heroes within weeks of the image being captured. They were redeployed back to the USA, where they toured the nation, and helped to raise $26.3billion in war bonds. The Marine Corps War Memorial in Arlington, Virginia hosts a sculpture built as a replica of the image. It was opened on November 10th 1954 by President Eisenhower and Vice President Richard Nixon, in the presence of the three surviving second flag raisers. Such was the publicity around the memorial built on the image of these second flag raisers, that members of the first flag raising Marines complained they had not been recognised for their role in securing the mountaintop, and had even been branded liars by those who were only aware of Rosenthal's image.

On June 23rd 2016 the Marine Corp surprisingly announced that Bradley was not the marine pictured third from the left. He was in fact not present at all during the second flag raising. Bradley, who was a Navy Cross recipient, died in 1994, so could not be asked to explain the misidentification, but he was pictured by Lowery in the first flag raising image, which could explain the confusion. Bradley was so secretive about his war experiences, that after his death, his son James Bradley, began a quest to learn about the Battle for Iwo Jima himself by interviewing the families of the flag raisers. James Bradley's research was published as a book *Flags of Our Fathers* and then made into a 2006 movie of the same name directed by legendary actor Clint Eastwood.

It was established that Corporal Harold Schultz was the true third surviving flag raiser, however he died in 1995 and took the secret of his participation to the grave. The reasons for Schultz's secrecy remain a perplexing mystery to historians, however he is not the only flag raiser to have sought privacy.

After the image was sent on the newswires, Rene Gagnon identified five of the flag raisers, including himself, but declined to identify Ira Hayes because Hayes had asked him not to. Gagnon only complied with the command once he was informed it came from the President himself and it was a serious crime to disobey. Hayes, who was of Native American decent, suffered from alcoholism probably brought on by survivor's guilt for having lived through a bloody conflict during which he lost many friends. Gagnon also misidentified Corporal Harlon Block as Sergeant Henry Hansen. As both men were killed shortly after the flag was raised, there was no-one to clear up the initial confusion over which man had taken part.

Hayes was redeployed to his unit in Hawaii, however he was never comfortable with the fame his wartime exploits attracted; following the war he suffered from depression. He died on February 2nd 1954 of exposure to the elements and alcohol poisoning at the reservation he lived in near Sacaton, Arizona. His life and tragic death became the inspiration for the 1961 Tony Curtis film *The Outsider*. In 1964 singer Johnny Cash described how this hero ended his life, in the Ballad of Ira Hayes, which concluded: "Two inches of water in a lonely ditch, Was a grave for Ira Hayes."

THE STORMING OF THE REICHSTAG BUILDING COMES TO SYMBOLISE THE DRAMATIC DEFEAT OF NAZI GERMANY

Victory Banner Over the Reichstag, Berlin, Germany May 2nd 1945

Photograph courtesy of Multimedia Art Museum Moscow / Moscow House of Photography

Colourised by Olga Shirninay

On this day, six years of devastating conflict in Europe came to a symbolic close as troops of the USSR dramatically stormed Nazi Germany's centre of Government, the world-famous Reichstag Building. It was the climax of the Great Patriotic War as the Second World War is known in Russia, to halt the German blitzkrieg and push the invading forces back into the Nazi homeland. After four-years of bitter fighting and destruction, Russia eventually succeeded in stopping the German advance at Stalingrad, and striking back to eventually take Berlin. It was a struggle against a disciplined and well-equipped Nazi enemy that wreaked havoc against the civilian population. So relentless was the fighting and how very extreme were the Nazi atrocities, that twenty million soviet lives were lost.

During the Battle of Berlin from April 23rd to May 2nd 1945, over one million Soviet military personnel descended on the city and its surrounding area, to attack the last remaining forty-thousand German regular troops, policemen, children of the Hitler Youth, and *Volkssturm* irregular militia, all making their last stand in the ruins of the German capital. In just nine days of fighting, three hundred and fifty thousand lives were lost on both sides. The majority, at least one hundred and seventy-five thousand were German civilians, many of whom committed suicide.

Hitler spent his final days in his Fuhrerbunker, near the Reich Chancellery, where from January 16th 1945, he furiously issued baffling commands to his increasingly perplexed general staff for the defence of Berlin, by forces that often no longer existed. His female companion, Eva Braun reportedly continued to entertain guests and staff by throwing debauched parties for Hitler's inner circle. As the Russians crossed into Berlin, by April 28th it became obvious even to Hitler that defeat was certain. He married Braun on Midnight that day, and within forty hours the pair had killed themselves, Braun by taking a cyanide pill, and Hitler by shooting himself in the head. In accordance with Hitler's wishes the bodies were taken outside and set on fire.

Despite the death of their leader on April 30th, many Germans were either unaware of his death, had resigned themselves to their own fate, or were simply so fanatical that they continued to fight and die. The Soviets wished to score a propaganda coup at home by aiming to declare the symbol of German Government, the Reichstag, had been captured on International Worker's Day, May 1st (May Day). This meant that Soviet Commissars rushed members of the Soviet 3rd Shock Army into the building, where one thousand, heavily dug in and well-supplied German soldiers waited for them. The windows had been bricked up by the defenders, so the front entrance was the only viable way for the Russians to enter the building. As the 3rd Shock Army stormed in, the main hall became a killing ground with piles of Russian dead littering the rubble-choked ground. Nevertheless, the troops managed to break through and fought room-to-room, up to the top of the building where, it is claimed by Russia, the Red Soviet flag was hoisted by Georgian Sergeant Meliton Kantaria and Russian Red Army Scout Mikhail Yegorov at ten minutes to eleven on the evening of May 1st.

In his memoirs, Russian military correspondent Vassili Subbotin recorded what he saw of the pair that day:

"Fighting was still going on inside the Reichstag above them and also below them. It was difficult to orientate themselves in the gloom. They did not know where the passages led to. And where should they raise the flag? Nobody had told them. Certainly as high as possible, so that it could be seen from far off.

"Then they reached the frame of the dome. The iron ribs were far apart. All the glass had gone, but they took care not to look down, where the assembly room yawned. They hung as over an abyss. Their hearts were gripped by the cold.

"From the dome they climbed up to the platform. They were dizzy, they weren't used to this they weren't structural engineers. Just don't look down! Silently they fastened the flag with a strap. Then they went back down again as quickly as they could."

Fighting continued from the basement level into the following day, until some German soldiers managed to break out, three hundred surrendered, five hundred that were already incapacitated were taken prisoner and two hundred were killed in the final fighting. Within six days of The Reichstag's capture the end of war in Europe was officially declared. Victory in Europe, VE Day, has been commemorated on May 8th each year since this time, by the generations who have come afterwards.

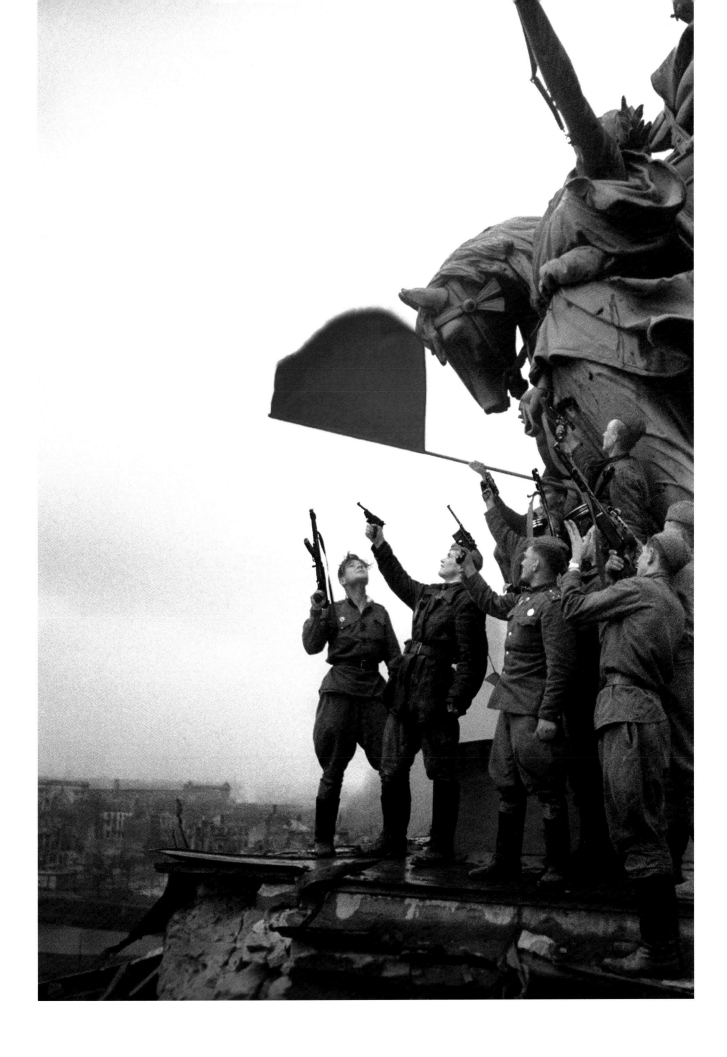

AMERICA'S GREATEST SOLDIER RETURNS HOME AFTER THE ALLIES VANQUISH THE FASCIST THREAT TO HUMAN CIVILIZATION

"General George S. Patton acknowledging the cheers of the welcoming crowds in Los Angeles, California, during his visit on June 9, 1945."

Photographed by Office of War Information credit National Archives Catalogue

Colourised by Marina Amaral

General George S. Patton, also known as "The Old Man", "Old Blood and Guts", "Bandito", "America's Fightingest General", was responsible for leading the Allies, from the coast of England to the beaches of Normandy, then advancing 800 miles through the heavily entrenched enemy, into the heart of Nazi Germany. There, once he met friendly Soviet forces, and the German High Command had unconditionally surrendered, there was Victory in Europe. Patton had a reputation for speaking his mind, and making very public faux pas, but he inspired his men with his straightforward if bluntly humorous attitude. Amongst the Germans he was the most feared Allied commander.

The image shows Patton returning to his home state, California, after playing a key role in liberating the vast territories previously under Nazi occupation and bringing lasting peace to a troubled continent. It's little wonder so many showed up to greet him with such enthusiasm; his actions had a direct and lasting impact on their lives. Each person in the crowd, would have had a friend or relative serving in the theatre of war, who would be able to come home, thanks in no small part to Patton's leadership.

In this image, we can see the backdrop of the iconic lifting of the flag at Iwo Jima with the invitation to "Buy Bonds Here" and the statement "We Salute You" above. The Stars and Stripes bunting adds to the raw emotional patriotism of the scene. It was a moment when America cemented its undeniable position as the world's new superpower.

Los Angeles Times reporter Walter Cochrane, described the heroes' welcome for the two senior soldiers George Patton and Jimmy Doolittle when they came home to Los Angeles: *"From the split second that their C-54 Skymaster planes—three of them—roared over the Municipal Airport, they were given thunderous*

welcomes in the style to which only conquerors are accustomed."

As Patton's plane rolled to a stop at the airport, Cochrane described how civic officials led by Mayor Bowron, Army generals and the enlisted men all flocked to the side of his aircraft, to welcome him home. He wore a shiny steel helmet on his head, polished boots and a studded pistol. He saluted, and according to Cochrane: "On his face was the grim grin of the conqueror." As Patton drove into the city with his military entourage along the highway to City Hall, it was estimated that one million people had left their homes to greet and cheer the men who had fought, and won a great victory in their name.

As-well-as his military victories, Patton is remembered for his colourful quotes. Here are some of his most famous words of advice for his men:

1. On the importance of not dying: *"Now I want you to remember that no bastard ever won a war by dying for his country. You won it by making the other poor dumb bastard die for his country."*

2. On being brave: *"Death must not be feared. Death, in time, comes to all men. Yes, every man is scared in his first battle. If he says he's not, he's a liar. Some men are cowards but they fight the same as the brave men or they get the hell slammed out of them watching men fight who are just as scared as they are. The real hero is the man who fights even though he is scared. Some men get over their fright in a minute under fire. For some, it takes an hour. For some, it takes days. But a real man will never let his fear of death overpower his honor, his sense of duty to his country, and his innate manhood."*

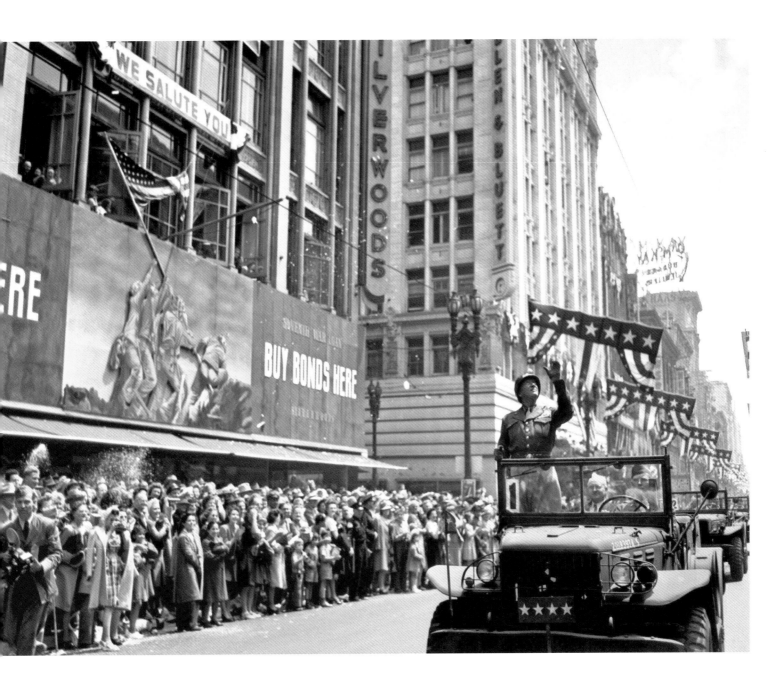

3. On the important of advancing: "*I don't want to get any messages saying, "I am holding my position." We are not holding a Goddamned thing. Let the Germans do that. We are advancing constantly and we are not interested in holding onto anything, except the enemy's balls. We are going to twist his balls and kick the living shit out of him all of the time. Our basic plan of operation is to advance and to keep on advancing regardless of whether we have to go over, under, or through the enemy.*"

Despite his Victory in Europe, war continued in the Pacific against Japan until September 2nd 1945. True to form, Patton applied for service on that theatre of war, but was officially discouraged from doing so. Six months after this photo was taken, Patton broke his neck in a mysterious car accident near Speyer, in Germany. He died in hospital twelve days later.

THE END OF WW2 IS COMMEMORATED TO THIS DAY IN ONE OF THE WORLD'S MOST ICONIC IMAGES

"V-J Day in Times Square"

Photographed by Albert Eisenstaedt on August 14th 1945, image courtesy of Getty

Colourised by Sanna Dullaway

In this image, which is regarded as the most iconic of the Twentieth Century, we see a sailor reaching forward to embrace a nurse, who arches her back and tips her right foot back as if to steady herself. From the smiles on the faces of the bystanders behind the couple, it appears that the atmosphere is one of unrestrained joy. The composition of the spontaneous shot skilfully includes the iconic Times Square Tower in the background.

Just before this image was taken, rumours had begun to spread across the world that Japan was soon to surrender to the Allies, bringing WW2 to an end. Thousands of people converged on Times Square to await the official announcement. LIFE magazine photographer, Alfred Eisenstaedt was assigned to cover the reaction of the crowd to the news of total victory. While he explored the scene of drunken revelry, his interest was immediately drawn to a sailor who was running towards him and kissing any woman he could grab hold of, young or old. According to Eisenstaedt's account, he spotted a white-clad nurse in the path of the sailor, and to his delight, almost on cue, this sailor planted a kiss firmly on the lips of the nurse. In a few seconds, Eisenstaedt captured four photographs, one of which was just right. It was taken at one minute past five in the afternoon with a Leica IIIa camera. The photograph was published a week later in *LIFE*, becoming an immediate cultural icon.

Because of the chaotic nature of the celebrations, Eisenstaedt did not have time to record the names of the subjects of the photographs. As such, over the decades, as the cultural legacy of the image became ever more important, there was controversy as to the identity of the sailor and nurse, with several rival candidates coming forward. To settle the matter, in 1980, the editors of *LIFE* appealed for the subjects to come forward. Three women and eleven men did so. Eventually, after expert analysis of the height, weight, complexion, and movement of the candidates, it has been agreed that the nurse was Greta Zimmer Friedman.

Friedman was born into a Jewish family in Austria, and emigrated from the Nazi-controlled nation to the United States at the age of fifteen. Her parents both died in concentration camps during the Holocaust. At the time the image was taken, Friedman was employed as a dental assistant, and was still in her uniform when she joined the crowds celebrating at Times Square. In an interview with the Library of Congress Veterans History Project, Friedman described the moment the stranger approached her from behind, grabbed her and kissed her. "It wasn't my choice to be kissed," she said. "The man just came over and grabbed!" After a 2012 interview with CBS News, the debate around the image took a more sinister tone, with commentators inferring that Friedman had endured a form of violation. Friedman seems to have not made this claim herself, simply stating, "It wasn't much of a kiss...It was just somebody celebrating. It wasn't a romantic event."

Of the men who came forward claiming to be the sailor, it was for decades generally accepted that George Mendonsa was most likely the man in question. According to Mendonsa he was at the Radio City Music Hall with his future wife, Rita, when suddenly the doors were thrown open and crowds of people entered, while shouting "the war is over!" The couple walked into the street to join the revelling. Mendonsa spotted Friedman in white and kissed her in celebration, because he considered her as a nurse, to be, "one of the troops." According to analysis by the Naval War College, Mendonsa's scars and tattoos match those of the sailor pictured, although his timeline, which places him at the scene at 2pm, rather than 5pm, has brought his version of events into question. Other contenders, for the sailor image include retired policeman Carl Muscarello, who was also a drunk sailor kissing women that day, and postman Glenn McDuffie who remembered enjoying a long kiss with a nurse while being photographed at Times Square. McDuffie was a naval gunner who alighted in New York to celebrate after finding out his brother, who was a Japanese-held prisoner of war, was now likely to be released. McDuffie's account of the circumstances of the kiss seem to be at odds with Eisenstaedt's, however McDuffie was identified as the true sailor in 2007 by Houston Police Department.

McDuffie died at the age of 86 in March 2014 after being acknowledged in the press as the sailor. Friedman met Mendonsa in 2012 and agreed they had kissed each other, before Friedman died in September 2016. Eisenstaedt died in 1995 without confirming who had kissed whom. The controversy surrounding the image seems only to be enhanced it's longevity, and it lives on as one of the most enduring cultural symbols of joy in the world.

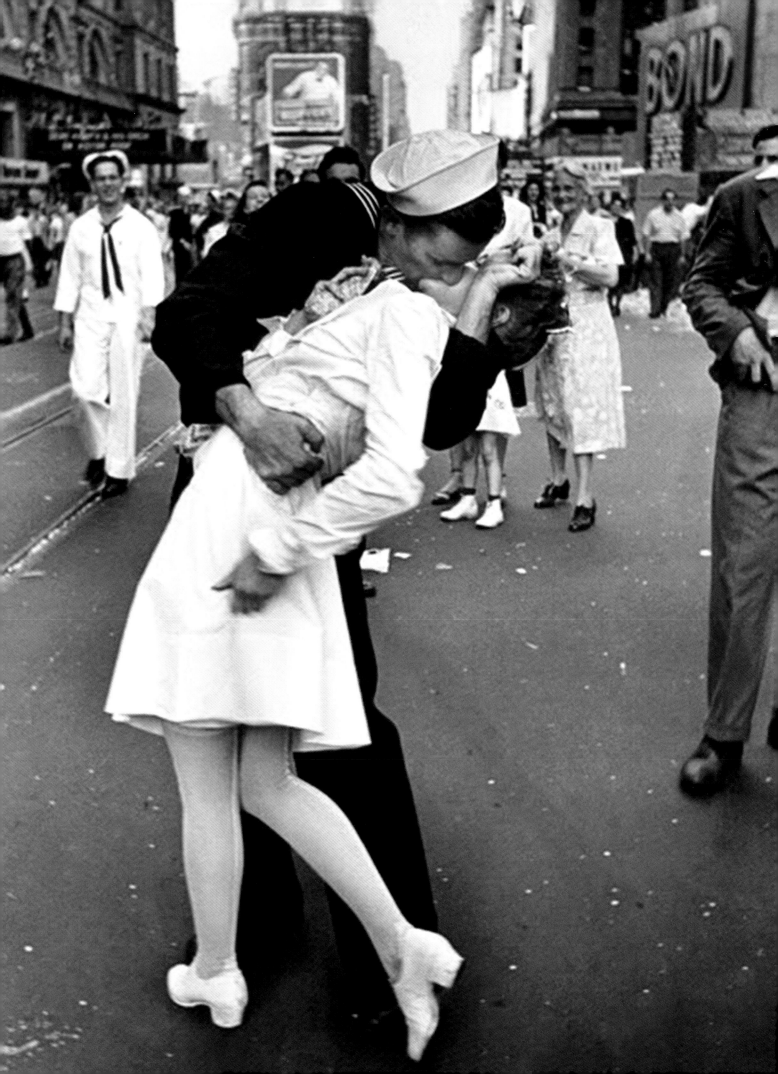

THE COLD WAR USHERS IN A GLOBAL ARMS RACE FOR NUCLEAR SUPREMECY BETWEEN THE US AND USSR

"Operation Crossroads "Baker" nuclear explosion, Bikini Atoll, Micronesia July 25th 1946"

Photograph courtesy of the United States Department of Defence

Colourised by Sanna Dullaway

The devastating power of just one nuclear explosion can be seen in the image opposite. Here, in the first US round of nuclear explosions since the bombing of Nagasaki, Japan, which ended WW2, we see a photograph taken 3.5 miles away from the underwater explosion called, "Baker". This test was designed to study the effect of a nuclear weapon on warships, and surrounding the column of the nuclear cloud, some of the former WW2 ships the bomb was detonated against can be seen. As two-million tonnes of sand and water were lifted into the air by the supersonic shockwave of the explosion, ten ships and submarines were sunk by the blast, which rose six thousand feet into the air. A resulting ninety-four-foot-high tsunami rolled over the surviving ships, reaching the beach of Bikini island and coating it in radiation.

In the new post-Second World War order, nuclear weaponry like that we see pictured, would have a crucial and dark role to play. With the British, French and German nations crippled by the devastating impact of war in Europe, from 1945 the new superpowers of America and the Russian Soviet Union dominated the planet. The two former WW2 Allies were by this time, rival power blocs with starkly opposing visions for humanity: America had a capitalist democratic system, which promoted the interests of the individual, and the Soviets had a Communist ideology that promoted communal solidarity over that of the private citizen.

These opposing systems competed for global influence over the post-war and post-colonial countries of the world. Winston Churchill described the effect of this rivalry in Europe, in his famous speech of March 5th 1946, "From Stettin in the Baltic to Trieste in the Adriatic, an iron curtain has descended across the continent." This description of an iron curtain across Europe is regarded as the point at which the new, Cold War, began.

America and her allies in Western Europe were now enemies of Russia and the East. However, the invention of nuclear technology meant that, were either side to directly fight a total war with the other, the complete annihilation of human civilization as we know it would have been caused, along with the deaths of countless billions of people across the world. This stalemate raised the stakes of war to such a high level that, "mutually assured destruction" had the effect of reducing the chances of all-out war. However, generations of people had to live with the possibility of a nuclear holocaust, which became likely during certain flashpoints in the Cold War. In particular, the destruction of the human race came close during the Cuban Missile Crisis of 1962, where a confrontation in the Caribbean between Russia, her Communist ally Cuba, and the United States, almost led to nuclear missiles being fired.

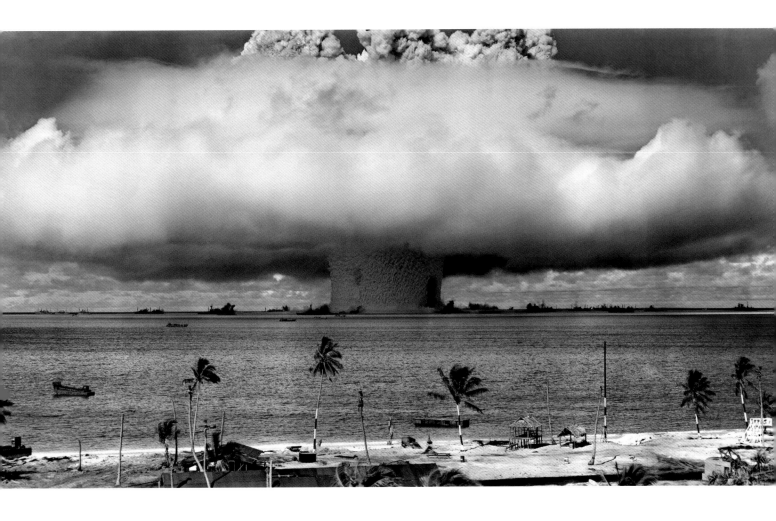

The lasting effects of radioactive contamination were poorly understood at the time of the Baker explosion we see pictured. The post-explosion clean-up effort by naval officers and men had to be aborted after it was realised that they were being exposed to dangerous levels of radioactivity and were contaminating their ships. The inhabitants of this tiny Polynesian atoll had agreed to leave their homeland during the Crossroads nuclear tests, however they could not have known the lasting environmental effects would leave the island uninhabitable to the present day. A US government study on the mortality of Operation Crossroads veterans concluded that on average of 200 excess deaths had been caused in a test sample of over twelve thousand men, caused by a higher instance of leukaemia and other cancers. Life expectancy across the sample group was reduced by an average of three months.

In popular culture, the name of the atoll would live on through the word *bikini*, which French swimwear designer Louis Réard adopted for his new two-piece swimwear which exposed the wearer's naval region. He said: "like the bomb, the bikini is small and devastating."

THE MOMENT AMERICA'S FIRST RACIALLY INTEGRATED NIGHTCLUB GIVES RISE TO THE WORLD'S BEST VOICE

"Portrait of Sarah Vaughan, Café Society (Downtown) (?), New York Aug 1946"

Photographed by William R. Gottlieb, courtesy of the Library of Congress

Colourised by Jared Enos

During the mid-1930's a New Jersey born shoe-buyer, called Barney Josephson was invited to Harlem's famous Cotton Club. During America's segregation-era, this celebrated establishment was for white-only audiences, but featured many legendary black performers, such as Louis Armstrong, Billie Holiday and Fats Waller. Josephson fell in love with the Cotton Club acts, but the injustice of disallowing black people from enjoying music from their own community, repelled him.

Determined to end the colour bar in the entertainment industry, Josephson opened Café Society in 1938 to provide a space for black and white people to mix on equal terms, and where racially integrated bands could perform freely. The name "Café Society" satirised the uptown businesses that catered for New York's wealthy. Josephson's advertisements called it, "The Right Place for the Wrong People" and the place for, "Celebs, Debs and Plebs". It was also an overtly political place, with comedy acts, decoration and adverts that lampooned racism, anti-Semitism, and anti-trade unionism. Celebrity actors such as Orson Wells, Charlie Chaplin and the glamorous Lauren Bacall, would rub shoulders with down-on-the-heel local bohemians.

Young African-American, Sarah Lois Vaughan was a fellow-New Jersey born jazz fanatic. This impressive singer was steeped in the Baptist choir tradition handed to her by her deeply religious parents. As a teenager she had cut her teeth in black jazz music halls, like the Apollo. She then went on to tour the US, with jazz legend Miles Davis, famed trumpeter Dizzy Gillespie, and swing bandleader Billy Eckstine, from whom it is said she picked up her nickname "Sassy".

Café Society was so popular Josephson founded a second establishment called Café Society Uptown, located between Lexington and Park Avenue. It was around this time in 1946, that the 22-year old Sarah Vaughan performed at the venue we see her pictured in. From the image title "…Café Society (Downtown) (?)", it would seem that the person who captioned the image believed it was the original club she was singing at. Renowned music critic Leonard Feather, who lived in an apartment above Downtown Café Society, described what impressed him about Vaugh's performances: *"It isn't only one thing, but a combination of qualities; the ethereally pure tone, her instrumentlike sense of phrasing…by spreading one syllable over*

several notes and suggesting passing chords with these subtle variations on the melody."

During one of her performances, such as the one we see pictured, Josephson's trumpeter, George Treadwell found himself enchanted by Vaughan. He gave up his own musical career to manage hers. In just a few months of their partnership forming, Vaughan produced the hit record *It's Magic,* which was heard "on all the jukeboxes", according to Josephson. Vaughan was immediately catapulted to stardom; the pair fell in love and eventually married. Josephson, however, was not to be so lucky. Just a year after Vaughan sang at Café Society, his brother and business partner, Leon Josephson found himself subpoenaed by the House of Un-American Activities, for his membership of the Communist Party. The club began to received hostile reviews, business dried up and Josephson was forced to close its door for the last time in 1948.

Vaughan's most well-known songs included *Summertime, Someone to Watch Over Me, Send in the Clowns, Broken-Hearted Melody* and *Black Coffee.* She signed with Colombia, then Mercury and Roulette Records. Vaughan's career was hugely influenced by her rocky personal life. Her marriage and business partnership with Treadwell broke down in 1958 and she remarried in 1959. Her new husband Clyde Atkins was outside the music industry, yet Vaughan ask him to manage her. This marriage too ended after allegations of violence. She was to marry and divorce four-times. Nevertheless, Vaughan remained highly productive and over her lifetime, she toured the world, sang for presidents, won a Grammy Award four-times and the National Endowment of the Arts gave her its Jazz Masters Award.

The secret to her success, lay in her operatic voice, which was applied to the jazz genre like a musical instrument. The Queen of Jazz, Ella Fitzgerald called her the world's greatest singing voice. Even during the last months of her life, until her death on April 3rd 1990 at the age of 66 of lung cancer, Vaughan's voice was regarded to have maintained peak performance and even become richer and more sophisticated over time. Upon hearing of her death Leonard Feather said, *"She just kept becoming greater and greater as the years went on. In the last few years she was just astonishing. She was the idol and envy of virtually all singers."*

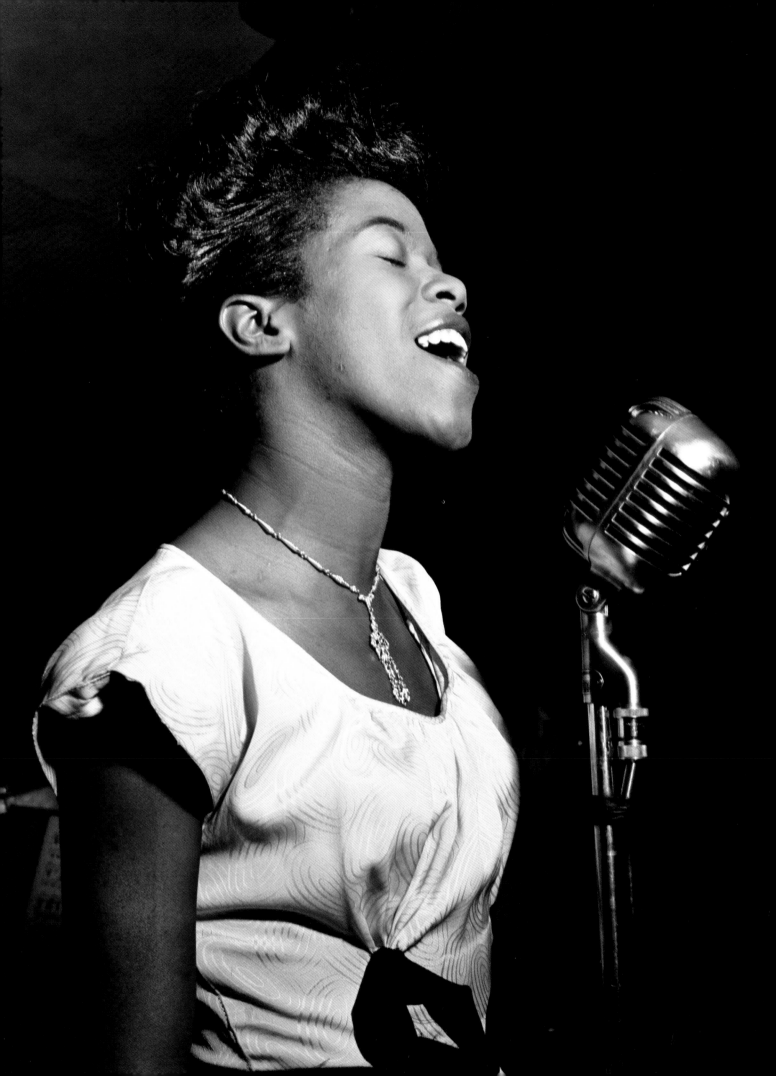

THE NEW ELIZABETHAN AGE BEGINS WITH THE TELEVISATION OF AN ANCIENT ROYAL CEREMONY

"The Coronation of Queen Elizabeth II at Westminster Abbey, London UK"

Photographed by the Daily Mirror on June 2nd 1953, image courtesy of Mirrorpix

Colourised by Matt Loughrey

Elizabeth Windsor had just been passed the Sword of State before she was invested with the Robe Royal and Sovereign's Orb, the Queen's Ring, the Sovereign's Sceptre with Cross and the Sovereign's Sceptre of Dove, before the Archbishop of Canterbury crowned her Queen Elizabeth II of England. By taking part in the Coronation at Westminster Abby, Elizabeth was continuing nine-hundred years of tradition, becoming the thirty-ninth monarch crowned there. The moment the nearly three-hundred-year-old St. Edward's Crown touched Elizabeth's head, three cheers of "God Save the Queen" were shouted by the crowd. From the Tower of London, a twenty-one-gun salute told the rest of that London a new monarch reigned from the Capital. In the image opposite, we see the moment the Bishops offered their fealty to the new Queen, as Head of the Church of England. From the angle of the shot the Royal Crown seems large and sits heavily on her head, her face looks small, young, and stern.

Through the crowning of twenty-five-year-old eldest daughter, of King George VI as Queen, hopes for the future as-well-as faith in the preservation of the traditions of the past, were invested in a single person by the people of Britain and the Commonwealth nations. The pomp and ceremony by which the British, and the Royal Family in particular, are known, was deployed by the British Crown at a time when the country was still recovering from the devastation wreaked on her people, cities and infrastructure through the struggle to defeat Nazi Germany during the Second World War. Thousands of building destroyed in the Blitz were still in ruins, trains ran late, London was depopulated in comparison to pre-war levels, the rationing of certain foodstuffs such as meat and sugar was still in force., Britain was paying back American "Lend Lease" and other loans made during and immediately following WW2. It was difficult for many outside Great Britain to realise that what was once the world's preeminent empire, which sprawled so far across the globe from East to West that the sun never set on it, was now crumbling and close to bankruptcy.

Elizabeth's father, King George VI, who suffered a stammer and could be nervous in public, was obliged to take on the role after his elder brother, Edward, was forced to abdicate because of the scandal of his marriage proposal to divorced American, Wallis Simpson. George VI had nevertheless overcome his initial reluctance to appear in public, and helped Britain and the Commonwealth through the darkness of the war years. So, upon his death in February 1952, the continuation of the spectacular, and spectacularly expensive, ceremony to crown his daughter as the new Queen, was just as much a statement about the resilience of the institution of monarchy, as it was a message to the international community that Britain, was still an important force in the world. Despite economic problems, the UK Government was prepared to foot the bill of what was to be the most expensive royal ceremony in history, at a cost of £1.57 million at the time, or what would be £41.5 million in 2017. By way of comparison, the Royal Wedding of Prince William and Kate Middleton on April 29th 2011, was a far more modest, with £20 million spent on the occasion.

However expensive the ceremony was, it reached an unprecedented number of royal subjects by virtue of it being the first coronation to have ever been televised. Because, at the time, television transmitters had only been built near population-centres, a drive to build more so the signal could reach the fringes of the country was implemented. On the day of the Coronation, 20.4 million people watched the ceremony on television, in a nation that owned only 2.7 million TV sets. This meant in each UK household, at least seven people watched on average, excluding children who were not included in BBC statistics. In an age where radio was the dominant broadcast medium, it was said that through the Queen's Coronation, television was transformed from a minority pursuit to a tool for mass communication. In the press, the now television-hungry British people were being called, "The New Elizabethans".

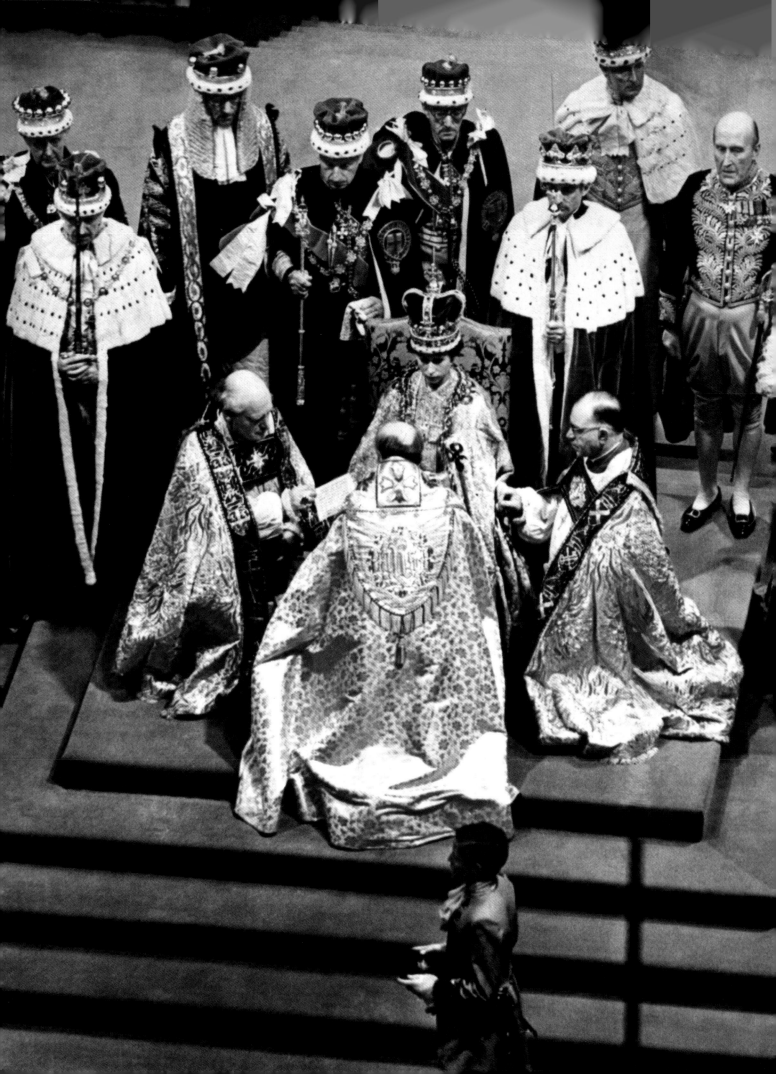

For an institution traditionally wary of the press and broadcasting, the boost in popularity gained by sharing the ceremony with millions in Britain and across the world, radically changed the attitude of the Royal Family to the media. The change ushered in the era of celebrity royals that we are familiar with today, and began a new chapter in Royal history, which is beautifully embodied in this relaxed shot of the Windsors as they wave to the crowds that gathered outside from the balcony of Buckingham Palace. Here we see Queen Elizabeth smiling, looking glamorous and confident on the left, with her son, the four-year-old Prince Charles to the right, and a two-year-old Princess Anne next to him. Her consort, Prince Phillip, the Duke of Edinburgh, appears to be looking at his wife with admiration. The contrast with the first coronation shot, is remarkably refreshing.

In addition to her role of preserving the British monarchy into the future by securing the goodwill of her people, Elizabeth II had a crucial role in Britain's relationships with overseas nations, particularly those of the British Empire and Commonwealth. As-well-as being the monarch of the United Kingdom of Great Britain and Northern Ireland, Elizabeth was crowned Queen of Canada, Australia, New Zealand, South Africa, Ceylon (now Sri Lanka), Pakistan, Jamaica, Barbados, the Bahamas, Grenada, Papua New Guinea, Solomon Islands, Tuvalu, Saint Lucia, Saint Vincent and the Grenadines, Belize, Antigua and Barbuda and Saint Kitts and Nevis. To symbolise the importance of her realms across the world, Elizabeth's coronation gown was embroidered with the floral emblems of prominent Commonwealth nations: the English rose, Scottish thistle, Welsh leek, Irish shamrock, Australian wattle, Canadian maple leaf, New Zealand silver fern, South Africa protea, the lotus flower for India and Ceylon and cotton for Pakistan.

To replace the Empire, which was to be dismantled, in the 1950's British foreign policy centred around the establishment of a Commonwealth "family of nations", with self-government, and equality, assured for former-colonial nations that opted to become members. Along with Prince Phillip, Elizabeth performed the role of binding these nations through a forty-thousand-mile tour across thirteen countries just months after she became Queen. She was the first reigning monarch to visit Australia and New Zealand, and in 1957 was the first to open the Canadian Parliament.

While the role of the Queen as Head of State in Britain is supposed to be strictly ceremonial, she has powers to intervene in politics and has had cause to use these powers in the past. Just three years into Elizabeth's reign, in 1956, the humiliating attempt by Britain and France to invade and capture the Suez Canal from Egypt in defiance of the United States and United Nations, caused the Conservative government of Prime Minister Anthony Eden to collapse. With no Conservative Party mechanism then in place for a successor to be chosen, the Queen was forced to consult her ministers, and chose a replacement in the form of Harold Macmillan. In 1974, Conservative Prime Minister Edward "Ted" Health failed to form a government after the general election of that year resulting in a "hung parliament", with no overall majority for any party. After attempts to form a coalition with the Liberal Party failed, Heath resigned and the Queen appointed the Labour Party leader, Harold Wilson as Prime Minister. During the 1975 Australian Constitutional Crisis, Elizabeth's representative, the Governor General Sir John Kerr dismissed Australian Prime Minister Gough Whitlam, and the Queen declined to reverse Sir John's decision.

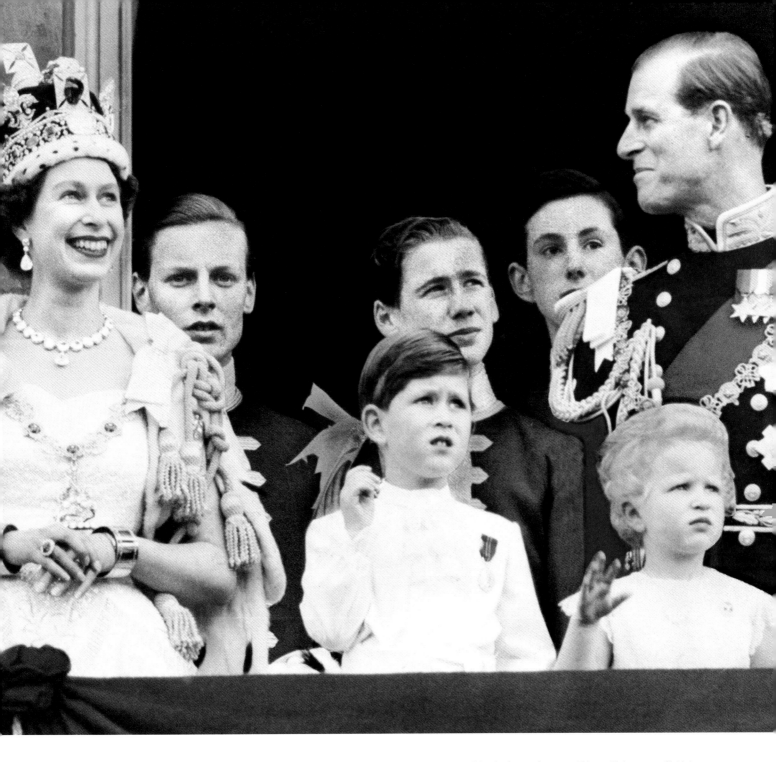

As-well-as becoming unwillingly involved in politics, the Queen's family life has been touched by tragedy. Scandal erupted close to her from 1976 to 1978 when her only sister, Princess Margaret, who was already rumoured to have had numerous affairs, eventually divorced her husband Anthony Armstrong-Jones, the Earl of Snowdon. A year later, her cousin and Prince Charles' favourite great uncle, Lord Mountbatten and his fourteen-year-old grandson Nicholas were both assassinated in an Irish Republican bomb attack in Mullaghmore, County Sligo, Republic of Ireland. The 1980's brought various controversies in the press, however it was 1992 that was to be her *annus horribilis*, or horrible year. Her son, Prince Andrew divorced the Duchess of York, Sarah Ferguson, she had eggs thrown at her while in Germany, and Windsor Castle suffered a damaging fire.

In 1993 Prince Charles' marriage to Diana Princess of Wales began to break down and in 1997, a year after the divorce, Diana was killed in a car accident in Paris. Diana "The People's Princess" was a hugely popular figure, and there was an outcry over the failure of the Royal Family to acknowledge her death by flying the Union Jack flag at half-mast over Buckingham Palace. However difficult these trials may have been, the Queen in 2017 is the world's longest serving monarch, having celebrated her 60th year on the throne with the Diamond Jubilee of 2012. By 2017, Prince Charles' marriage to the Duchess of Cornwall has been largely accepted by the public, the marriage of her eldest grandson Prince William to Kate Middleton and the birth of her great-grandchildren, has meant the Queen herself and the institution of monarchy is at its most

A GUST OF WIND ALLOWS US TO VIEW HOLLYWOOD'S MOST CELEBRATED ACTRESS IN HER MOST ICONIC POSE

"Marilyn Monroe poses over the updraft of New York subway grating while in character for the filming of "The Seven Year Itch" in Manhattan on September 15, 1954."

Photographed by Matty Zimmerman, image courtesy of Associated Press

Colourised by Matt Loughrey

Sex-symbol of the Twentieth Century, goddess of the big screen, Hollywood's famously seductive and tragic actress, Marilyn Monroe, is captured in this image in one of her most iconic and memorable poses. While the image looks spontaneous, and was intended to seem so, the jovial filmmaker holding the handheld film camera in the background gives us a clue as to the staged-nature of this famous photograph. It was taken as a publicity shot for the film Monroe was starring in, *The Seven Year Itch*. Along with around two-thousand spectators, a press pack had gathered on the corner of Manhattan's 52nd Street and Lexington Avenue, to watch the recreation of the scene in the movie where actor Tom Ewell and Monroe exit a movie-theatre after sharing a date, and the obliging gust of wind allowed Ewell to catch a glimpse of Monroe's figure. Instead of expressing embarrassment at the "wardrobe malfunction", as most women of the time would have been expected to do so, Monroe surprised audiences by declaring, "Isn't it delicious?"

Monroe's ability to shock, yet delight audiences was refreshingly seductive to 1950's moviegoers, who were used to much more conservative portrayals of female sexuality. Born Norma Jeane Mortenson in Los Angeles on June 1st 1926, and with much of her childhood spent in foster homes and orphanages, Monroe's story was one of rags to riches. While working in a munitions factory during WW2, she was discovered at the age of eighteen by a photographer from the US Army First Motion Picture Unit. Monroe soon began work as a pinup model, whose image was used to inspire the troops while they were fighting overseas. By 1946, she had signed as an actress with Twentieth Century Fox and Columbia Pictures, and began with comedy roles in films such as *Monkey Business* alongside actor Cary Grant, the Fritz Lang drama *Clash by Night* and the film noir *Don't Bother to Knock*. A brief scandal over a nude photo-shoot Monroe participated in only served to enhance her sex-appeal and the popularity of her movies. During the mid-1950's her movies *Gentlemen Prefer Blondes*, *Niagra*, and *The Seven Year Itch*, cemented her status as Hollywood's most appealing actress.

However, Monroe clashed with the studios over being typecast as a "dumb blonde" in musical comedies, and objected to not being given the income she felt she deserved. She married baseball star Joe DiMaggio in January 1954, however the marriage did not survive the publicity generated by the picture we see opposite. Once the image was reproduced worldwide along with Monroe's tongue in cheek comment, DiMaggio was outraged and the marriage soon collapsed. Seemingly unperturbed, Monroe renegotiated her contract and began training as a serious method actor. She married the acclaimed writer Arthur Miller, and after starring and being involved in the production of the Western drama, *Bus Stop*, Monroe began to be treated as a serious actor. Sadly, she was not consistent in her success. Her behaviour on set became erratic as her health deteriorated and her drug use escalated. The difficulties in shooting her 1959 movie *Some Like It Hot* were an open secret in Hollywood, with Monroe apparently unable to remember her lines and suffering stage fright. However, her charismatic performance was such a hit, it earned her a Golden Globe for Best Actress.

By the time she completed her final complete movie, *The Misfits*, Monroe was addicted to barbiturates and her marriage to Miller was left in tatters after he started another relationship. Filming was halted for a week while Monroe detoxed in Los Angeles. Despite these setbacks, after a pause, she continued to be a productive yet-still drug addicted and tempestuous artist. Tragically, she was found dead by her psychiatrist Dr Ralph Greenson on August 5th 1962. The cause of death was barbiturate poisoning.

A large number of photographers were present for the photo-shoot that propelled Monroe to global stardom. However, it was AP photographer Matty Zimmerman who had the skill and luck that day. This enabled him to file the image that is considered the most iconic and has therefore come to optimise the image of Monroe as the 20th Century's most revered female star.

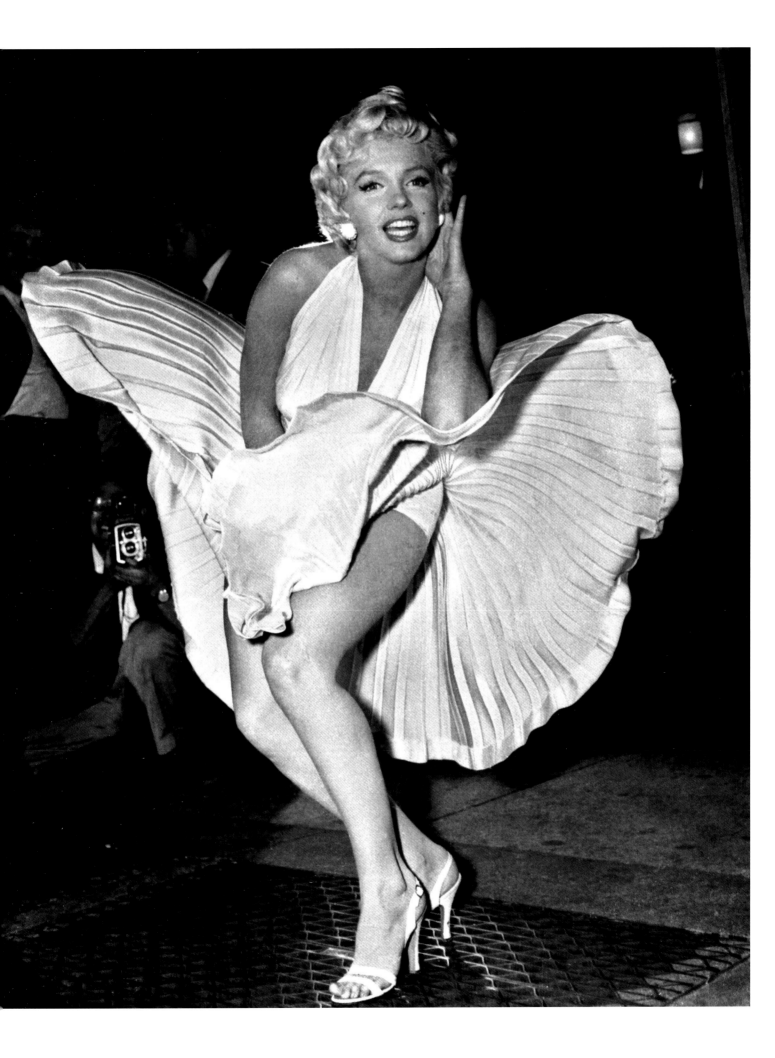

"Clarence Anglin police photograph after a failed bank robbery."

Photographed by Leavenworth Police Department in April 1958, image courtesy of Anglin's nephew K. Widner

Colourised by Matt Loughrey

The most ingenious and mysterious prison escape in history, was from America's most secure and notorious jail, Alcatraz. Located on a rocky island one-and-a-quarter miles from San Francisco, the total of three hundred and thirty-six regular cells were occupied by around three hundred of the country's most high-risk prisoners. Special measures were put in place to make the facility "escape proof", with metal detectors, tool-proof grills, fitted remoted control tear gas canisters, gun galleries for armed guards to patrol along, solid steel doors, numerous watch towers and a recreation yard surrounded by a twenty-five-foot fence topped with barbed wire. The water surrounding the island was said to be shark infested, and so cold any prisoner who managed to get past these measures and try to swim to shore would die in the attempt.

In the 29-years the prison operated, fourteen escape attempts were made by thirty-six prisoners, of which twenty-three were apprehended, two drowned, six were shot and killed while escaping and five are listed as missing, presumed drowned. It is widely believed that the three men pictured opposite, bank robber brothers Clarence and John Anglin, along with fellow-prisoner Frank Morris, did survive. However, the authorities have refused to accept this narrative and they are officially listed as drowned.

Born into Depression Era America, the Anglin brothers were two of thirteen siblings born into a family of poor migrant farm workers who settled near Tampa in Florida. As children the brothers were described as wild, but also fiercely protective of their family and were remembered as being incredible swimmers. By-the-time they became teenagers in the 1950's, the Anglins had launched their careers in crime by robbing banks, mainly at night to apparently avoid having to resort to violence. In 1958, the pair were arrested on a heist and sentenced to up-to 20 years in prison. After attempting to escape from Atalanta Penitentiary, they were both transferred to the top-security facility at Alcatraz in October 1960. They claimed the only "weapon" they ever used was a toy gun.

There the Anglins met the highly-intelligent armed robber, Frank Morris, who was sent to Alcatraz in the same year, following his

recapture after having escaped Louisiana State Penitentiary. The brothers also fell in with former car thief and fellow escapee from Louisiana Penitentiary, Allen West. Finding conditions decent in terms of food and privacy compared to other prisons, but grim in terms of the strictness of the regime, the four prisoners hatched an audacious and intricate plan to escape.

After six months of planning and preparation on June 11th 1962, the four inmates put their escape plan into action. The published FBI report details the facts federal officers that took part in the manhunt gathered at the time:

ESCAPED FEDERAL PRISONERS CONSPIRACY

On June 12, 1962, at 7:15 a.m., FRANK LEE MORRIS,

Alcatraz No. 1441; JOHN WILLIAM ANGLIN, Alcatraz No. i476j (1476) and CLARENCE ANGLIN, Alcatraz No. 1485, all inmates of the United States Penitentiary, Alcatraz Island, California, were discovered missing from their cells by officers of the Penitentiary. Dummy faces were found in their beds.

Their exit had been accomplished by digging holes through the back walls in the ventilator areas of their cells.

Crawling through these holes into the utility corridor, they then used the plumbing pipes to crawl on top of the third tier of cells. Hence (sic), they broke out onto the roof of the cell house through bars and a ventilator lid. They climbed down from the roof on the large pipe at the rear of the cell house and went over the fence, proceeding down steep embankments to the northeast shore of the island in the vicinity of the power plant.

A similar hole was discovered in Alcatraz No. 1335 (Allen West's) cell, as well as a dummy as sTated (sic) they (Algin brothers, Morris, West) were to escape together, but the hole in his (West's)cell was not quite completed. At 9:37 p.m. on June. .11, 19^2 (1962), MORRIS went to get one of the ANGLINs (brothers)to assist…but they never returned.

USP LK 75456 4-14-58

Later that night (West) completed the hole in his cell- and proceeded to the roof but they were gone. Also, a six foot by four-teen foot raft made from- rubberized raincoats and three yoke life preservers similarly made were gone. These articles had been stored on top of the third cell tier under the cell house roof where Escapees had worked (on the same) in the evenings after breaking out of their cells, (West) returned to his cell and went to bed.

... The subjects made two rafts. They took only the larger one with them. The small one left behind showed the same ingenuity in (construction) as did the life Jackets.

SAC (Special Agent in Charge) Price stated the work which the subjects performed in - preparation for the escape is fantastic. Examination of the Mae West life preserver jacket which was left behind shows great ingenuity in its preparation. Using raincoats as material, the subjects not (only) sewed the seams but apparently used hot steam pipes to vulcanize these seams to make them air tight. They used a hollow plastic tube, such as is ordinarily contained

in small spray devices in bottles, as a means of inflating the jacket...(A) paddle, obviously made at Alcatraz, was found between 100 and 200 yards off the shoreline at Angel Island which is in the Bay. The water there is about 12 feet deep. This is the only evidence which might support the conclusion the convicts reached Angel Island but this is no way conclusive.

This evidence was for the most part all that was initially found of the three successful escapees, the Algins and Morris. The man left behind, West, cooperated fully with the investigators and was not charged with his part in the conspiracy. Apart from a short spell of freedom in 1967, he spent the rest of his life in prison after murdering another prisoner. He died on December 21st 1978 aged 49.

The surviving relatives of the Anglin brothers have consistently held onto the belief they survived, and have been able to produce Christmas cards in their handwriting, as-well-as photographs they believe show the brothers as much older men, together in Brazil in 1975. Several family members confessed on their deathbeds they had maintained regular contact with the brothers up to 1987, which they could not reveal previously for fear of risking the brothers' recapture. If they do survive, the brothers will now be well into their eighties.

Originally settled by Native Americans, on November 20th 1969 the island of Alcatraz was occupied by up to four hundred *Indians of All Tribes* activists and supporters, until the government forcibly removed them nineteen months later. In 1979, the hit movie *Escape from Alcatraz* was released, with legendary actor Clint Eastwood playing the brains behind the plan, Frank Morris. Now a museum occupies the remaining Alcatraz buildings, dedicated to the three hundred staff and their families who lived on the island at any one time, as-well-as the escapees, and other famous inmates such as the Robert Stroud "Birdman of Alcatraz" (whose story was also made into a film, in 1962 starring Burt Lancaster as Stroud), the gangster Al Capone and others. Each year, several hundred people participate in the "Escape from Alcatraz" triathlon to swim just over a mile from the island to the shore.

Main photo right: John Anglin at Alcatraz prison island in November 1960.

Left: Frank Morris at Alcatraz prison island in January 1960.

Below: Picture Anglin relatives believe shows the brothers in Brazil 1975.

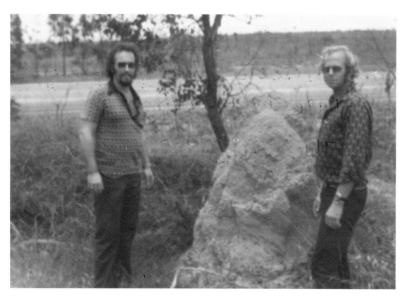

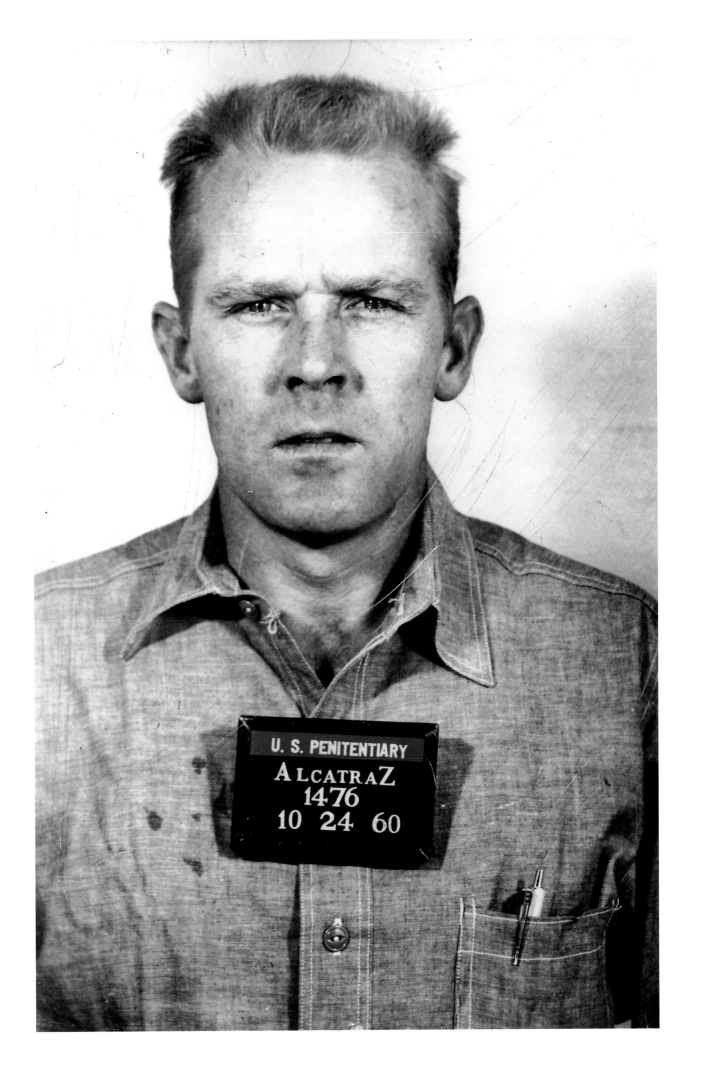

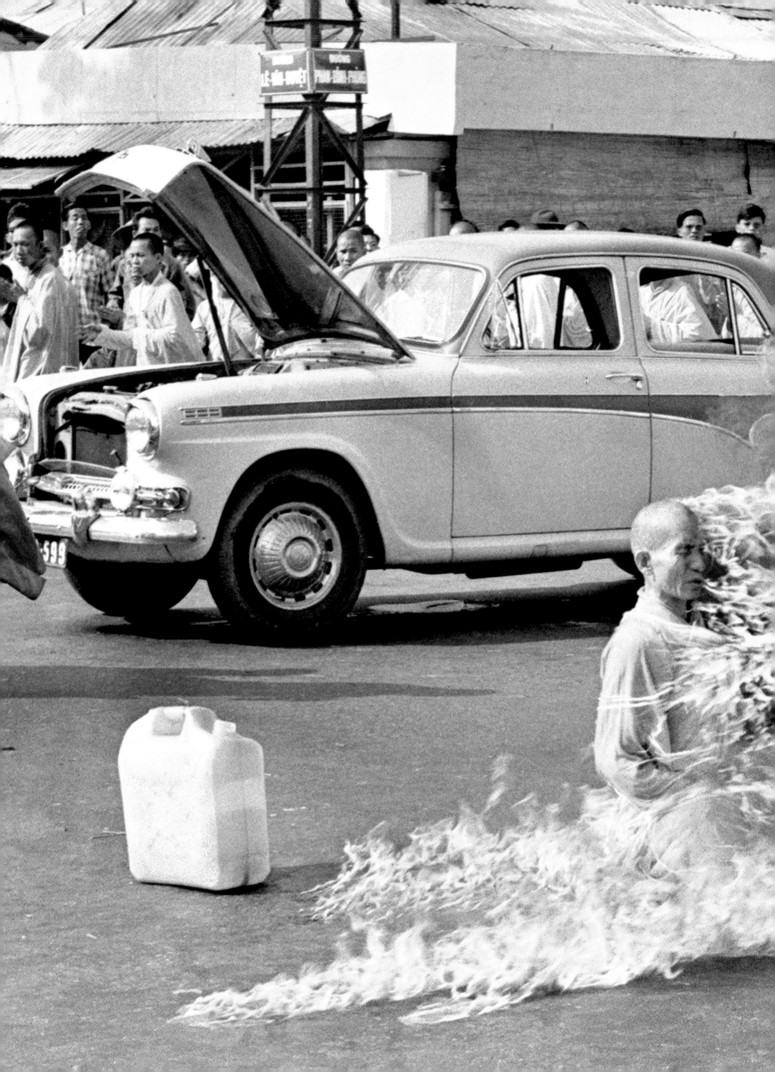

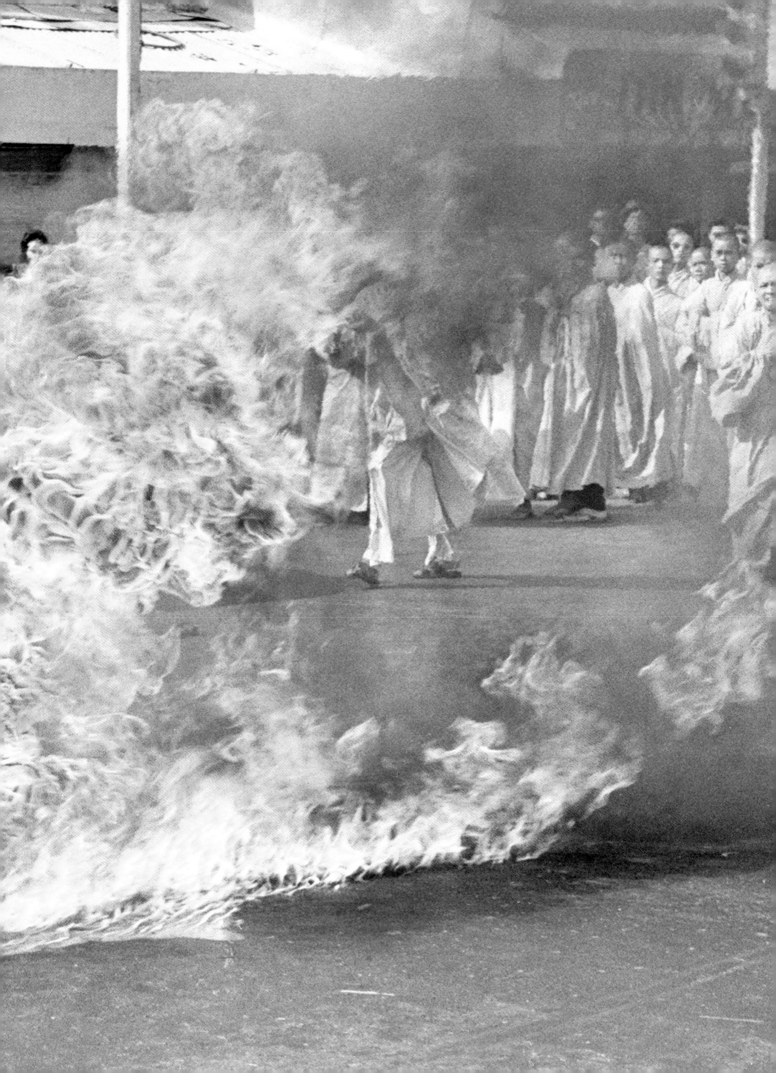

NON-VIOLENT PROTEST IS TAKEN TO ITS MOST EXTREME BY THIS MONK WHO BURNED HIMSELF TO DEATH

"Vietnam Monk Protest"

Photographed by Malcolm Browne in Saigon, Vietnam on June 11th 1963, image courtesy of Associated Press

Colourised by Matt Loughrey

One of the Twentieth Century's most famously shocking images embodies incredible self-sacrifice, endurance and total unwavering commitment to a cause on the part of the individual. As 73-year-old Reverend Thich Quang Duc set himself on fire through the practice known as "self-immolation", he was performing the ultimate and most spectacular form of non-violent protest. During the summer of 1963, photographer Malcolm Browne was covering events in Saigon for AP. Browne was friendly with many of the politicised monks of Vietnam's capital Saigan (now Ho Chi Minh City), and he was made aware that anti-government Buddhist demonstrators were planning a dramatic public display of protest on June 11th. In an interview with *Time* magazine, during the procession through the streets of Saigon, he described seeing a car pull up and three monks getting out: *"Two young monks brought up a plastic jerry can, which proved to be gasoline. As soon as (the older monk) seated himself, they poured the liquid all over him. He got out a matchbook, lighted it, and dropped it in his lap and was immediately engulfed in flames."*

According to Browne, who was the only Western photographer present, Reverend Duc neither cried out, nor moved his facial expression or body once the flames were lit. He sat cross-legged, so impeccably still that it was impossible to know at what

point he died. Nearby monks repeatedly chanted in Vietnamese and English, "A Buddhist priest burns himself to death. A Buddhist priest becomes a martyr." The crowd of around a thousand onlookers that had gathered at the scene were left stunned, some began to take photographs, while others, including some policemen, prostrated themselves around the burning man. After about ten-minutes the charred body fell backwards, and was placed in a small wooden coffin by his fellow monks. Browne filed the picture, which was published in multiple publications worldwide. Duc was successful in his mission to bring global attention to the repressive policies of Vietnamese President Diem; upon seeing the image, American President John F. Kennedy said, "No news picture in history has generated so much emotion around the world as this one." Browne was awarded a Pullitzer Prize for this photograph.

What is not reported widely in reference to the image, is the fact that Duc was a senior and highly respected abbot, who was responsible for the construction of thirty-one Buddhist temples across Vietnam, before he burned himself to death. The reason for his drastic protest was rooted in the history of his people. Formerly a colonial territory ruled by France, Catholicism had been established in Vietnam by the French settlers. Vietnamese Catholic converts had been given trusted positions over

Buddhists, until France granted the nation independence in September 1945. However, well into the 1960's Catholic President Ngo Dinh Diem continued the French policy of discrimination against Buddhists. The policies Duc sacrificed his life to protest against included: the demolition of temples, seizure of land, forced conversions to Catholicism, organised looting, and shelling of Buddhist communities by the army. After a wave of protests in response to the banning of the practice of flying Buddhist flags from temples, nine people were shot dead by government forces. After this massacre, Reverend Duc formed a suicide pact with other senior monks to publicly burn himself to death. Shortly before the act, another monk stepped forward to replace him, however it appears that Duc pulled rank, and his seniority meant that he was the one to make the fateful and final sacrifice.

A note the Reverend Duc left with his colleagues documents his last message: *"Before closing my eyes and moving towards the vision of the Buddha, I respectfully plead to President Ngô Đình Diệm to take a mind of compassion towards the people of the nation and implement religious equality to maintain the strength of the homeland eternally. I call the venerables, reverends, members of the sangha and the lay Buddhists to organize in solidarity to make sacrifices to protect Buddhism"*

President Diem did not heed Duc's call for compassion towards Buddhists. Following his self-immolation, the American government put pressure on him to restart negotiations with the protestors, and relax his policies towards Buddhism. He complied, however his reputation was irrefutably tarnished and public opinion in the US was so far against him that even CIA officials admitted that they could no longer work with him against their mutual enemy: the Communist insurgents of North Vietnam. Eventually the crisis was so severe, the army stepped in and removed Diem from power. He attempted to escape, but was captured. Diem was shot and stabbed to death by an army captain in the back of an armoured personnel carrier on November 2nd 1963.

Duc was re-cremated during his funeral service, yet his heart survived intact. After being confiscated by the government, the heart was eventually recovered. It is now considered a holy relic, presently stored in the Reserve Bank of Vietnam. Because of his sacrifice, Thich Quang Duc is regarded in Vietnamese Buddhist tradition as having reached a pinnacle of human spiritual evolution. He is deemed a *Bodhisattva* or "Enlightened Being".

THE MAN AT THE CENTRE OF THE 20TH CENTURY'S MOST FAMOUS AND MYSTERIOUS ASSASSINATION IS HIMSELF KILLED WHILE IN POLICE CUSTODY

"Mugshot of Lee Harvey Oswald taken at the Dallas Police Department on November 23, 1963. There is a cut on the left side of his forehead and his right eye is bruised. He has stubble on his face and wears a white shirt."

Photograph taken by Dallas Police Department

Colourised by Matt Loughrey

The day before the image opposite was taken, this former US marine was arrested for shooting dead John F. Kennedy, the President of the United States of America. Wounds to his neck and face sustained during his arrest are visible in the picture. As Kennedy rode on a motorcade through downtown Dallas on November 22nd 1963, Oswald allegedly fired an Italian Carcano .38 rifle from his place of employment, the Texas School Book Depository, and struck the President in the head. The bullet Oswald fired also passed into the side of Texas Governor Connally. The official Warren Report into the assassination concluded that Oswald fired three rounds from his 1940 bolt-action rifle in up to 7.9 seconds, hitting his target twice at a maximum range of two hundred and sixty-five feet. It was found that Oswald had purchased the rifle by mail order from a sporting goods shop in Chicago for $19.95, plus $7 for a Japanese telescopic sight.

Kennedy's bodyguard assigned to the motorcade, Special Agent Clinton J. Hill, gave the following statement of the shooting: *"I jumped onto the left rear step of the Presidential automobile. Mrs. Kennedy shouted, "They've shot his head off,"...I forced her back into her seat and placed my body above President and Mrs. Kennedy...As I lay over the top of the back seat I noticed a portion of the President's head on the right rear side was missing and he was bleeding profusely. Part of his brain was gone. I saw a part of his skull with hair on it lying in the seat."*

While Oswald attempted to escape, he shot a policeman, Officer Tippit, who had tried to arrest him. Oswald was quickly reported as missing from the depository store and he was captured while attempting to hide in a nearby theatre. When questioned by police, he vehemently denied having shot anyone. Oswald instead insisted he was being made a "patsy" because he had previously lived in the Soviet Union. This denial implied that it was the authorities who were covering for the true assassins by framing Oswald, an accusation that has since given rise to controversy between the official version of events and credible alternative theories, as-well-as wilder conspiracy theories.

Oliver Stone's 1992 movie *JFK*, thoroughly explored the contradictions in the ballistic evidence and concluded that Kennedy was killed by multiple gunmen. The movie supports the most widely held alternative theory that the assassination was carried out by members of the Mafia under the direction of America's foreign secret service, the CIA, which feared Kennedy was about to disband it and pull American troops out of the conflict in Vietnam.

There are certainly contradictions in Oswald's early life that are curious and add fuel to the burning mystery of his involvement. He appears to have been a socialist-Marxist during his teenage years, but he enrolled in the US marines. He had a politically left-wing background, which during the height of the Cold War against Communist Russia would have been suspicious, yet he was given security clearance to operate radar and handle classified material. Even his fellow-marines called him "Oswaldskovich" because of his Marxism and desire to learn Russian. After his discharge, Oswald fled to Russia where he attempted to defect, but was rejected by confused Russian officials. After he attempted to slit his wrists in response, he was placed under observation and allowed to stay. Oswald was given a factory job and his own apartment, which made him very comfortable by Soviet standards. However, he tired of the "drab" factory work and applied to return to the US with his new Russian wife, Marina Prusakova.

The day after this mugshot image was taken, Oswald, while being escorted out of the police department to the car that would take him to country jail, was shot dead at close range by local nightclub owner Jack Ruby. This ended Oswald's role in the mystery and elevated Ruby to co-conspirator in the alleged CIA cover up of the assassination. Ruby said he was motivated out of a desire to spare Jackie Kennedy the distress of a trial. Ruby died of lung cancer on January 3rd 1967 at the Parkland Memorial Hospital, the same medical facility where both Kennedy and Oswald also died.

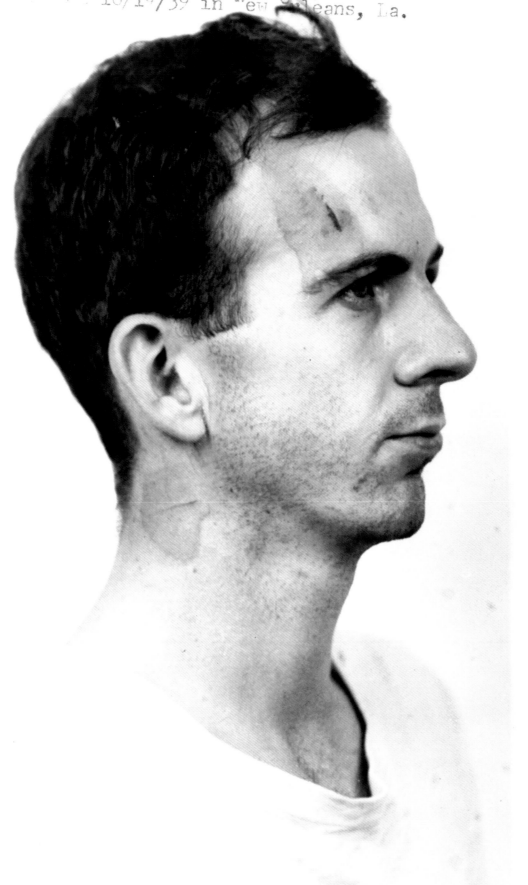

THE FAB-PAW: TWO VERY DIFFERENT WORLDS COLLIDE - JUST AS THEY ARE ABOUT TO BECOME GLOBAL MEGA-STARS

"The day Ali met the Beatles"

Photographed on February 18th 1964 at Miami Beach, Florida, USA, courtesy of Associated Press

Colourised by Matt Loughrey

This light-hearted, but historic, meeting between "The Fab Four", and boxing-legend Mohammed Ali, or Cassius Clay as he was then known, was also one of those happy accidents that produced an image that is photographic gold. From left to right, we see Beatles band members, Paul McCartney, John Lennon, Ringo Starr, and George Harrisson taking a fake blow from heavyweight boxer Cassius Clay, who stands a full head above the "Mop Tops" from Liverpool. As part of the shoot, Clay pretended to throw a punch at Harrison's head, with the remaining three band members acting as if they were being knocked to the floor like dominoes. The image captures both the band and the boxer as they all unknowingly stand on the cusp of global fame.

The Beatles were already Britain's heavyweight champions when it came to pop-music. Formed in 1960 in their home city of Liverpool, England, these working-class young men started their careers beside other local bands, many of whom also enjoyed success during the golden-era of Liverpudlian music, centred around the now-legendary Cavern Club. By 1963 their debut LP, Please Please Me was the first Beatles number one album chart hit, and was the first of seventeen number one records to 1970. Their tour of the UK, which began in February 1963, translated their commercial success into what became a popular phenomenon. Unforgettable scenes outside music venues, saw frenzied fans weeping and fainting as perplexed police offices attempted to control mobs of teenage girls who were determined to get as close as possible to their idols. This "Beatlemania" that had struck the UK, was migrating across the Atlantic.

As part of the famous "British Invasion" of America, the image we see was the part of the beginning of the Beatles' US tour,

intended to win the hearts and minds of teenagers across the nation. They were in Miami to take part in the filming of an appearance in America's most popular variety show, The Ed Sullivan Show, when they found themselves being ushered into Miami Beach's 5th Street Gym for the shoot with Cassius Clay. At the time, he was training for his heavyweight title fight against the then-champion Sonny Liston. The Beatles' first choice for the photoshoot was in fact Liston (Clay was the 7-1 underdog), but the champion was so focussed on the fight, which was in less than a week's time, that he declined to meet them. According to Rolling Stone magazine, John Lennon would rather not have met Clay, describing him as, "that loudmouth who's going to lose". Upon meeting the band, Clay did not disappoint. "Hello there Beatles", he said upon seeing them, "We oughta do some roadshows together, we'll get rich." Clay further lived up to his larger-than-life reputation by lifting Ringo Starr, and posing for a picture with a Beatle under each of his arms.

The Beatles' US tour was a monumental success. During their first Ed Sullivan Show broadcast, they were watched by a record-breaking seventy-three million people, with a further seventy million tuning in for the second broadcast. Their first US concert at Washington Coliseum was a huge success. The Beatles became, and remain to this day, the bestselling band of all time in both Great Britain and the United States. By the time they broke up in 1970, as they moved from the rock-n-roll sound they were initially known for, to their ground-breaking psychedelic rock, the Beatles are credited with having made more contribution to popular music than any other band.

Clay's rise to stardom was to be just as spectacular. Prior to his fight with Liston on February 25th 1964, Clay attempted to

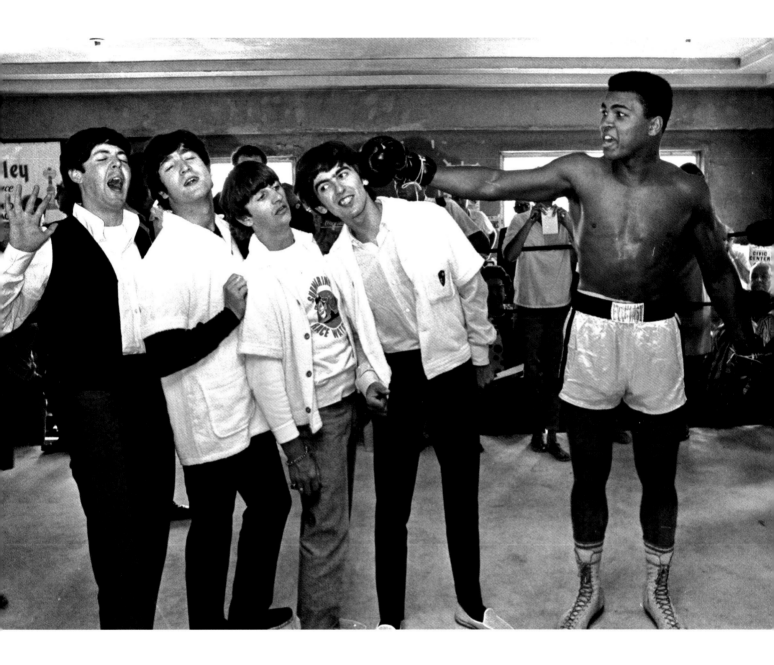

intimidate his opponent by likening him to a "bear" that he would "donate to a zoo" after he had finished with him. During the weigh-in he declared, "someone is gonna die tonight". The fight lasted seven rounds, with Clay defying the bookmakers by defeating Liston on a technical knock-out. He was champion, and shouted from the ringside, "I am the greatest! I shook up the world. I am the prettiest thing that ever lived."

Within a month of being declared the heavyweight champion of the world, Clay converted to Islam and changed his name to Mohammed Ali. He was involved with the Nation of Islam movement, led by African-American activist Malcolm X. Ali famously, and controversially, refused to serve in Vietnam, yet such was the recognition for his commitment to civil rights, he

was awarded the President Citizens Medal by Bill Clinton in 2001, and the Presidential Media of Freedom by George Bush in 2005. Throughout his spectacular boxing career, Ali remained committed to political activism, and upon being diagnosed with Parkinson's Disease, he fought to raise awareness of the condition until his death on June 3rd 2016, aged 74.

THE SUPERHERO BLOCKBUSTER MOVIE PHENOMENON IS MADE POSSIBLE BY A SLAP-STICK 1960'S TV SERIES

"Adam West as Batman helps out with road safety campaign May 1967 which is being sponsored by the Ministry of Transport"

Photographed by Bob Hope, image courtesy of Mirrorpix

Colourised by Matt Loughrey

Comic book characters, and more specifically the film versions of comics superheroes, have become a ubiquitous staple of Hollywood blockbuster movies for the past two decades. Primarily from Marvel and DC Comics, superhero names known across the world include Superman, Spider-man, Wolverine and the other X-Men, Captain America, Judge Dredd, Ironman, The Incredible Hulk, Thor, the Avengers, Teenage Mutant Ninja Turtles, Hellboy, and of course the superhero we see pictured, Batman. From the top one hundred superhero movies, it is estimated that over $17 billion, has been grossed by the film studios over the past two decades, from the US box offices alone. With the comic universes so in depth, having in some cases, such as Superman, been written for almost eight decades (the first Superman comic was published in the summer of 1939), there is a ready-body of material, plotlines and themes for studio writers to mine and shape into sensational blockbuster movies, with highly sophisticated special effects. This development has led to solid performance for the biggest superhero movie franchises, with Iron Man alone collecting $1.66 billion over four movies, and Spider-Man $1.37 billion, after the same number. In short, the superhero has become a commercial and cultural phenomenon, with all manner of merchandise, clothing, and toys, sold to adults and children alike. Some particularly devout fans even continue to consume their superhero stories via the medium they were originally written for: they pick up comic books in their hands, and read them.

How did this mass industry become such a mighty force? The success of the big screen superheroes owes no small debt to the popularity of the most iconic, and well-loved crimefighter of the small screen, Batman. In contrast to actor, Christian Bale's stern, and angst-ridden Dark Knight of the more recent Batman movie franchise, the 1960's television series was camp and comical. Actor Adam West was chosen to play the caped-crusader after being spotted by producer William Dozier in a Nesle Quik chocolate milk advert, playing a spy character called Captain Q. The style of the show was to be one of tongue-in-cheek simplistic humour with a moral message at the end; directed mainly towards teenage viewers.

From 1966 to 1968, one hundred and twenty episodes were aired over three seasons. The format of the show was standardised, with a sinister plot by a villain such as the Joker, Penguin, Riddler or Poison Ivy, to kidnap a notable person, take over the city Batman was set in, Gotham, or release inmates from Arkam Asylum. Batman and his alter-ego Bruce Wayne, were played by actor Adam West, and his sidekick Robin, played by former child ice-skater Burt Ward. The Caped Crusaders would learn of the dastardly plot, and seek to thwart the villain and bring them to justice. Along the way, viewers would be treated to the unveiling of the simple mystery, as-well-as unforgettable punch-ups against the villain's hapless henchmen, with satisfaction at the end of the show when the villain was eventually caught. During the story, which was usually split into two episodes with a cliff-hanger at the end of the first part, there could be a cameo performance by a celebrity who would pop their head out of a window while Batman and Robin were climbing the wall of a building. Celebrity cameos included actor Jerry Lewis, broadcasting personality Dick Clark and entertainer Sammy Davis Jnr. The show was hailed as the biggest TV phenomenon of the mid-1960's.

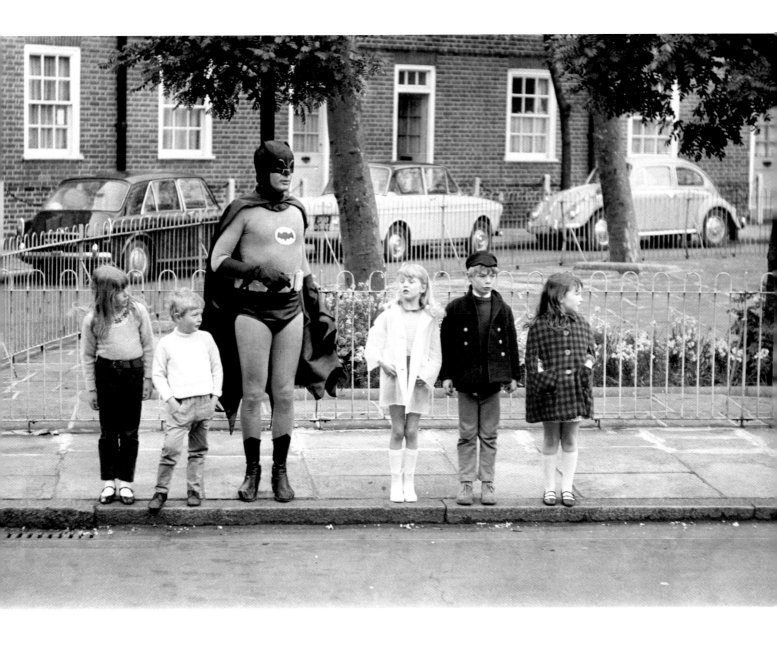

The humorous, but clean-cut style of the show, was further reinforced by the public awareness messages that went alongside the storylines, such as the importance of drinking milk, not drinking alcohol, saving money, and as in this image of a trip Adam West took to England on behalf of the UK Ministry of Transport, of how to cross the road safely. In this capacity of being a public figure, while dressed as Batman, Adam West appeared in a public service announcement in the US, which encouraged children to purchase US Saving Bonds in aid of the Vietnam War.

West and Ward were victims of Batman's mass popularity, and after the show was cancelled, the pair found themselves severely typecast because of their portrayal of the Dynamic Duo. Adam West was reportedly offered the role of James Bond in 1970, but declined on the ground he believed the actor who played the superspy should have been British. Outside Batman, he was able to secure work as minor characters in both film and television, and did continue to make appearances as Batman occasionally. During the 1990's and 2000's, reruns of the original Batman series led to West being rediscovered as a cult-icon, and he regularly appeared as a television personality in films, and talk shows. West died of leukaemia in Los Angeles in June 2017, aged 88. He is survived by three wives, and six children.

A POOR INDUSTRIAL CITY IN THE NORTH OF ENGLAND BECOMES THE WORLD CENTRE OF POPULAR MUSIC

"Pop stars from Liverpool"

Photographed on June 18th 1963 by Howard Walker, image courtesy of Mirrorpix

Colourised by Matt Loughrey

During the early 1960's something incredible happened in the English industrial city of Liverpool. It was the crucible for an extraordinary cultural explosion that saw young people from this traditional working-class community thrust into the world spotlight through the music they performed. Since the Nineteenth Century, Liverpudlian songs were sung across the world through famous sea shanties such as *Maggie May* and *Heave Away*, with the city's Irish and seafaring roots influencing the music the city of Liverpool produced. By the 1960's, *Merseybeat* became established both as a musical genre and a magazine, which was sold at one time by one man who was to be instrumental in shaping the sound of his city: band manager Brian Epstein. The caption which accompanies this joyous image shows the impact and excitement generated by this influential former furniture salesman, seen standing on the far right as his acts jump from a wall in unison: *"Manager Brian Epstein, pictured with some of the groups he manages. These include, The Beatles, Gerry & The Pacemakers, Billy J Kramer & The Dakotas, Tuesday 18th June 1963. John Lennon, Paul McCartney, Ringo Starr and George Harrison, Gerry and the Pacemakers, Gerry Marsden, Freddie Marsden, Les Chadwick and Les McGuire, Brian Epstein and Billy J Kramer and the Dokotas Robin McDonald, Mike Maxfield, Billy J Kramer, Ray Jones and Tony Mansfield".*

Epstein was born in September 1934 into a Jewish family who lived in Liverpool's Anfield Road. After a schooling that saw him sent to several boarding schools, one of which dismissed him for laziness, he was drafted into the army as part of his National Service in 1952. After being caught impersonating an officer while cruising London bars, Epstein was deemed to be psychologically unfit to serve, and was conscripted instead by his father into the family furniture firm, which had expanded to the adjacent shops. It was now the North End Music Store (NEMS), selling musical instruments and other home goods to local people, which included a piano to Paul McCartney's father, James, who lived nearby. Epstein's homosexuality came out while he attended sessions with a psychiatrist, and his father allowed him to leave Liverpool to train as an actor at London's famous RADA. Declaring himself too much of a businessman to be an actor, he dropped out after the third semester.

Upon returning to Liverpool, his father made him director of NEMS, personally in charge of the new store in Great Charlotte Street and Whitechapel, where he met right hand-man and fellow salesman Peter Brown. To a man with disparate interests, it was the burgeoning Liverpool music scene that most held Epstein's attention. After seeing rising local talent, The Beatles at the legendary Merseyside venue, The Cavern Club, on September 9th 1961, he was immediately struck by their sound, but also their humour while on stage and personal charm once he met them in person after the show. Despite being warned-off the group, by their former-manager Allan Williams, who was annoyed that they had failed to pay him an agreed percentage from a concert the band played in Hamburg, Epstein was smitten with the Beatles. He saw them each day before eventually convincing them to let him manage them, which he did from January 1962. Once in charge, Epstein immediately convinced them to drop their Teddy-boy image of blue jeans and leather jackets for the cleaner look of wearing identical suits and ties, and not smoking, drinking, eating and swearing on stage. He had them perform their signature synchronised bow at the end of each performance, as actors at RADA did upon completing a performance. Once he had established the Beatles' new identity, Epstein fell back on his salesmanship, and started

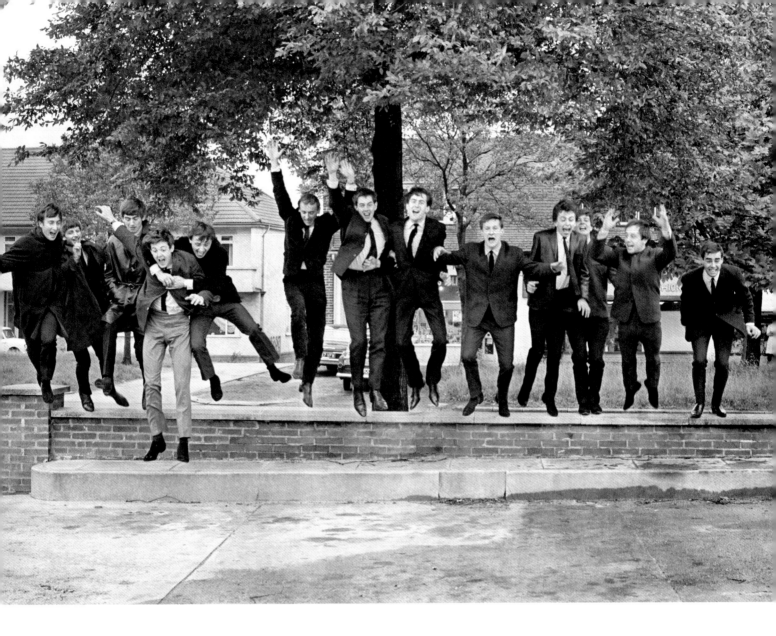

a campaign of introducing the band to all the major record labels in London, eventually succeeding with EMI's Parlophone label. Drummer Pete Best was sacked, and eventually replaced with Ringo Starr, after the studios requested a more experienced drummer for the recording sessions. Epstein was also highly successful in marketing the band in areas outside the selling of records, such as merchandising and publishing. He hosted his own television show in America called *Hullabaloo*.

Epstein's personal life, however was one of tragedy. He was addicted gambling, drugs and had closeted homosexual life, which was an open secret to his friends. However, sex between people of the same gender was a criminal offence in England during his lifetime, and public revelations about his sexuality would have led to public disgrace. His addiction to barbiturates, combined with alcohol intake led to his death on August 24th 1967. After this trauma, the Beatles were a changed band. They continued to produce ground-breaking music, however the end was now in sight, and two-years later they split-up. Homosexual sex was legalised in England just four weeks after Epstein's death.

Thanks to Epstein's careful management, the Beatles became the world's greatest band, his other bands were highly successful in their day, and Liverpool's position as a centre for musical excellence was cemented into cultural history. Post-Beatles, the city continued to produce talented bands into the 1980's, 1990's, and 2000's. Significant names include, Echo and the Bunnyman, Frankie Goes to Hollywood, The Boo Radleys, The La's, Cast, The Zhutons, and Ladytron. In 2001, the Guinness Book of Records declared Liverpool, "The City of Pop".

TRANS-ATLANTIC CULTURAL CROSS-POLLINATION AT ITS MOST PROLIFIC: AN AMERICAN TV COMEDY ACT TAKES BRITAIN BY STORM BY LAMPOONING THE UK'S MOST SUCCESSFUL POP GROUP

"Members of the 1960's pop group The Monkees at a press conference."

Photographed by Daily Mirror in London, June 1967, courtesy of Mirrorpix

Colourised by Matt Loughrey

In a wonderful example of life imitating art, Los Angeles spoof-band the Monkees began their career on television pretending to be an unsuccessful Beatles-inspired pop group – until they found success as musicians in their own right. The Monkees, which were named in a similar way to the Beatles, by deliberately misspelling a commonly used noun, aired on television from 1966 to 1968. The global popularity of the Beatles, combined with the light parody of the group's happy-go-lucky persona by the Monkees, meant that the show was wildly successful on both sides of the Atlantic for several decades – despite only being recorded over such a short time.

From left-to-right we see Peter Tork, Michael Nesmith, Davy Jones, Micky Doletz. The premise of the television show was that the Monkees were Beatles-wannabees, but try-as-they-might, they never could quite get their lucky break. The concept was developed by filmmaker Bob Rafelson, who went on to produce the sixties movie cult classic *Easy Rider*. British actor Davy Jones, who played the Artful Dodger in the musical *Oliver!*, was swiftly recruited as the chirpy-cheeky Paul McCartney-esque central bandmember. During the casting for the remaining three in September 1965, out of 437 applicants, guitarist and songwriter Michael Nesmith was chosen because of his nonchalant-attitude and memorable woolly hat, Micky Delenz became the drummer, but needed lessons to be able to mime credibly, and Peter Tork was chosen because of his Nordic looks.

The dynamic of the band was a close one, filled with the practical joking and exuberance music-lovers had come to expect from their pop-stars, even pretend ones. However, the brilliance behind Rafelson's idea was to create a popular fanbase through the television show, and record songs while the band

caught up on their musical skills. Some members, like Tork and Nesmith, were musicians and songwriters already. Even Dolentz, once he was taught how, contributed through his rich voice, that other band members eventually agreed, gave the Monkees their distinctive sound. The training came together in August 1966, when the first single *Last Train to Clarksville* was released only a few weeks before the television debut. Their first album, *The Monkees* was a number one hit for thirteen-weeks. The way the series was shot at the same time as the music was recorded, meant that the Monkees were one of the first bands to produce what would today be regarded as music videos. Once they came on tour to the UK in the summer of 1967, as we see in the picture opposite, the band were greeted by adoring fans in the hysterical "Beatlemania" fashion that the UK newspapers loved to make great play of. The Beatles were part of the sixties musical phenomenon, known as the "British Invasion", where American rhythm and blues music was perfected by British bands and made popular once again in America. British music journalists and producers have enjoyed making great play of this success; the absurdity of selling American culture to the Americans was likened to, "selling ice to the Eskimos." However, the example of the Monkees shows the interplay of back-and-forth cultural exchange between Britain and America was much deeper. Instead both nations, primarily because of their shared history and language, could instead be viewed as a pair of Eskimos continuously selling ice to each other.

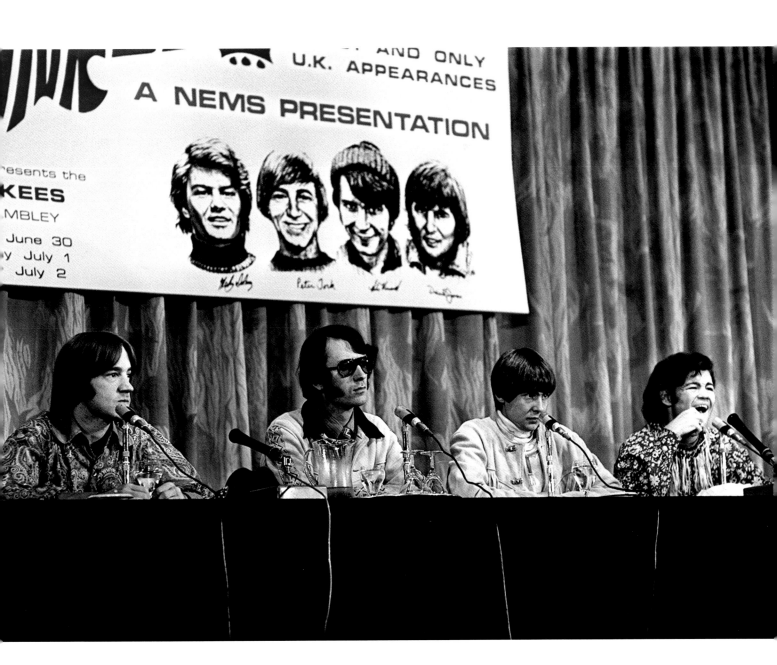

Despite their difficulty in taking control of their music from their producers, as-well-as the long road they each had to take to be taken seriously as musicians after the show was not renewed after the second season, the band stayed together and released new music, which made the charts. They starred in the film *Head* and stayed together until Tork bought out his contract in 1969, and Nesmith resigned in 1970. In just four years the band had produced nine albums. The music of the Monkees found a resurgence of interest in the late 1980's, once the children's television network Nickelodeon began to re-run the shows to a new generation, and MTV aired the music videos at the same time. The members reunited to tour and record together for a further two decades. Frontman Davy Jones died in 2012 from heart attack at the age of 66. However, the remaining bandmembers celebrated their 50th year in September 2016.

In May that year they launched an album *Good Times!* with songs written by Oasis lead guitarist Noel Gallagher, The Jam lead singer Paul Weller, and Weezer's Rivers Cuomo. At the age of 74, Michael Nesmith announced his last gig with the two-other remaining Monkees, Peter Tork and Micky Dolenz on September 16th 2016.

THE FACE OF '66: SUPERMODEL TWIGGY MAKES "THE SKINNY-LOOK" FASHIONABLE FOR DECADES TO COME

"Model Twiggy seen here modelling a mini dress with her Swedish "double" Kerstin Lindberg."

Photographed by the Daily Herald at Little Portland Street, London on July 3rd 1967, image courtesy of Mirrorpix

Colourised by Matt Loughrey

The image we see opposite shows supermodel Twiggy on the right, swinging around a lamppost with her lookalike, competition winner Kerstin Lingberg, who was chosen from eight hundred contestants all competing for the chance to meet their idol in London. At the time this image was taken, Twiggy, real name Lesley Hornby, was the most iconic face of the era. Aged just seventeen, Twiggy's androgynous looks optimised the mini-girl in a mini-skirt look, that became representative of the 1960's Swinging-London fashion scene.

From a working class-background in the London suburb of Neasdon, the young Hornby learnt to sew from her mother and made her own clothing. There is some disagreement over how Twiggy was discovered. Her ex-boyfriend and manager, Justin de Villeneuve, credited himself with having helped make Twiggy famous, while in subsequent years, Twiggy laid more emphasis on how she was discovered by chance. In her account, Twiggy agreed to have her hair cut in a new cropped style by celebrity hairdresser Leonard, who placed a picture of the new haircut on the wall of his Mayfair salon. London *Daily Express* fashion journalist Deidre McSharry spotted the photograph and was immediately struck with her look. She asked to meet Twiggy, who took part in a photoshoot arranged by the *Express,* and soon her images were published with the headline, "The Face of '66".

Both de Villeneuve and Twiggy agree that de Villeneuve advised her to use the name Twiggy, based on her childhood nickname "Twig", and that he did steer her modelling career through its meteoric rise. It was her youthfully boyish looks, tiny five-foot six-inch-tall eight stone body, and lavish eye-lashes, which made her so strikingly different from female models that had come before her. Twiggy arrived just at the moment the androgynous look was to become popular, although her participation contributed to this trend.

While she cited her greatest inspiration, early 1960's model Jean Shrimpton, as being the world's first supermodel, many at the time credited the fashion phenomenon that became Twiggy as being the first true instance of a globally recognisable fashion icon that could be referred to as such. Who exactly can be crowned "history's first supermodel" is hotly contested, as we

see from our earlier example from the Nineteenth Century, Evelyn Nesbitt. Despite competition in this regard, Twiggy was undeniably influential in Britain throughout 1966, and just months before this image was taken, in March 1967, Twiggy took Paris, New York and Tokyo by storm. She was featured on the cover of fashion-bible *Vogue* half-a-dozen times that year in various international editions of the magazine, which described her as the, "extravaganza that makes the look of the sixties."

During this time, the powerful force of 1960's youth counterculture included what academics now call, *Second Wave Feminism.* Unlike the first wave of feminist, where groups such as the Suffragettes campaigned for the legal rights such as the right to vote, this second wave focussed on the cultural impact of asymmetric gender-relations. Many feminist thinkers were, and still are, outspoken in their condemnation of Twiggy's role in shaping the way models are still expected to look today: underweight. They were concerned by the objectification of women by the fashion industry in general, but as the most-skinny looking and popular model, Twiggy became a controversial figure for many during the late 1960's and early 70's.

It is perhaps at least partly for this reason that Twiggy turned her back on modelling after just three-years in the industry. Instead she chose to build on her friendship with cult film director Ken Russell, and she starred in several of his films, in particular, his 1971 musical *The Boyfriend* won her two Golden Globe Awards, including Best Actress. She performed in London's West End theatres, appeared in David Bowie's seventh album cover *Pin Ups,* released her own albums *Twiggy* and *Get My Name Right.* She hosted *Twiggy's Jukebox* for several American television networks. Twiggy married American actor Michael Witney in 1977, and gave birth to her daughter Carly in 1978. She found herself bereaved after Witney died of a sudden heart attack in November 1983. She was remarried in 1988 to British actor Leigh Lawson, and they continue to live together in West London. Throughout the 1980's to the present, Twiggy has continued to appear on television, in the charts and in public through her charitable work. She supports breast cancer research, and has campaigned against animal cruelty and the use of fur in the fashion industry.

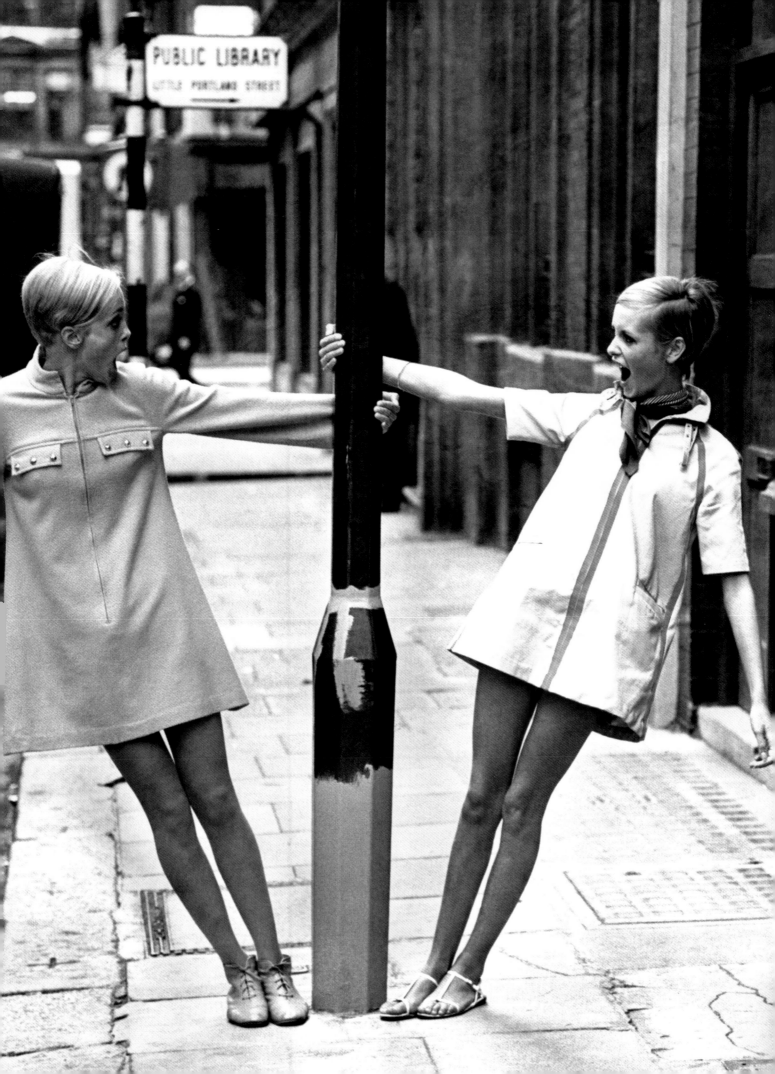

THE GREATEST AFRICAN-AMERICAN ROCK STAR IS MADE … IN BRITAIN

"The Jimi Hendrix Experience arriving at Heathrow Airport August 1967 airplane guitar luggage sunglasses"

Photographed by Victor Crawshaw, image courtesy of Mirrorpix

Colourised by Matt Loughrey

The day after this image was taken, Jimi Hendrix released the US-version of what became one of the greatest debut albums in the history of rock music, *Are You Experienced*. It was the moment Hendrix was transformed into a global psychedelic rock phenomenon. Recorded from October 1966 to April 1967 in studios across London, England, the American LP included hit-songs such as, *Purple Haze, Hey Joe*, and *The Wind Cries Mary*. Within seven months the album sold over one million copies and critics hailed Hendrix's performance as ground-breaking, in that he changed forever what musicians understood a guitar could be used for. Hendrix revolutionised the way people perceived black musicians, and he blazed the trail for later hit rock performers of colour.

Born on November 27th 1942 in Seattle, Hendrix grew up in a deprived home, with a father who was a violent alcoholic. He taught himself the guitar at the age of fifteen, and joined the military for a year to avoid prison, before being honourably discharged. In 1963, he formed the band King Kasuals with his friend and fellow ex-serviceman Billy Cox. It was during this time Hendrix began what became his signature trick, to play the guitar with his teeth.

Despite being active in the R&B scene across America, Hendrix was never able to rise above a supporting role, or "sideman" for other acts. His chaotic on-stage antics were considered an annoyance and caused him to be sacked. While playing with Curtis and Squires at New York's Cheetah Club in May 1966, Hendrix was spotted by Linda Keith, wife of British Rolling Stones guitarists Keith Richards. Linda Keith introduced Hendrix to British startup producer, Chas Chandler, who immediately recognised Hendrix's potential. Chandler flew Hendrix to London and began to audition for a band called the Jimi Hendrix Experience. Hendrix liked both the musical-style and the haircut of Kent-born Noel Redding (pictured on the left of Hendrix in the image opposite) and asked him to play the bass guitar. Redding agreed, found London-based drummer Mitch Mitchell (to the right of Hendrix) through a friend, and asked Mitchell to audition to join them.

London at this time was a crucible of pop-rock talent. Hendrix performed with rock supergroup Cream, and impressed lead singer Eric Clapton so much he said Hendrix, "changed his life" that day. He quickly signed with the label owned by The Who managers, Kit Lambert and Chris Stamp. During a legendary performance at the Bag O'Nails club in London, Hendrix astonished the audience, which included Erica Clapton, Paul McCartney, John Lennon, Pete Townsend, Brian Jones, Mick Jagger. Hendrix had stormed the UK music scene and was to appear on television throughout the year.

After the US release of *Are You Experienced* Hendrix returned to the US, which was itself experiencing the 1967 social phenomenon that encompassed travel, sex and drugs now known as, "The Summer of Love". It was during his explosive performance at the Monterey Pop Festival that Hendrix famously set fire to his guitar on stage.

Hendrix was to record two further albums, *Axis: Bold as Love*, and *Electric Ladyland,* which were both successes, however there was friction between Hendrix and Redding over Hendrix's poor work ethic. Hendrix became violent when he combined drugs and alcohol, in contrast to his calm personality when sober. By the summer of 1969, Redding had quit the band. Nevertheless, Hendrix continued and by this time was the world's highest paid rock star. During what was perhaps his peak performance, Hendrix was watched by an estimated four-hundred thousand people while headlining at the legendary Woodstock Festival, where he famously played a psychedelic version of America's national anthem, *The Star Spangled Banner.*

Hendrix burned brightly, but briefly. On September 18th 1970, the superstar was found prone in his London hotel, was rushed to a nearby hospital, but died that day. He was found to have choked on his own vomit while intoxicated with barbiturates. Through his death, Hendrix joined the infamous and tragic "27 Club" of celebrities who died at the age of 27, which includes, among many other talents, Jim Morrison, Kurt Cobain, Janis Joplin, Brian Jones, and Amy Winehouse.

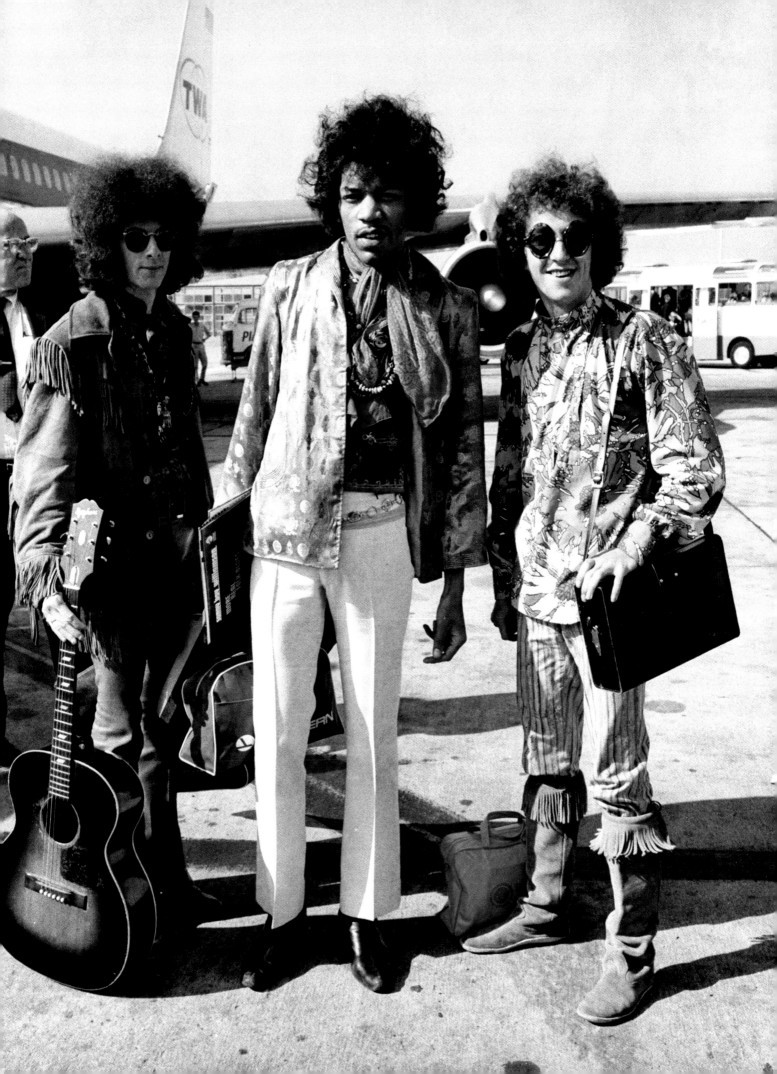

"Deke Slayton (in black shirt, left of center) director of flight crew operations, and Chester M. Lee shake hands in Mission Control, while Rocco Petrone watches Apollo 13 commander Jim Lovell on the screen."

Photographed by NASA at the Christopher C. Kraft Jnr. "Houston" Mission Control Centre, Texas on April 17th 1970

Colourised by Matt Loughrey

One of Hollywood's most powerful and uplifting scenes, is the portrayal of NASA Mission Control staff, to news of the Apollo 13 crew splashing down to safety, as depicted in the Oscar-winning *Apollo 13* movie. While the reaction on the part of senior NASA executives Slayton and Lee are exuberant, Apollo Flight Director Eugene Kranz (to the right in the picture, smoking a cigar), broke down in tears when he heard the announcement by Commander Jim Lovell (played by actor and space-enthusiast Tom Hanks) that all three crew members had survived. The sense of relief by Krantz was depicted movingly by actor Ed Harris, who had heard how the former Korean War fighter pilot was overcome with emotion. During filming, Harris also developed the line that was to become widely-used management mantra: "failure is not an option". The moment this image was taken, Mission Control Staff were celebrating Commander Lovell's television interview (as seen on the screen, in black and white as it was originally broadcast) after being recovered by the USS Iwo Jima from the command module the space crew had used for Earth re-entry.

The *Apollo 13* launch was towards the end of the golden-era of the Space Race, where Soviet Russia and Capitalist America peacefully competed against each other for scientific and symbolic supremacy in the vacuum outside the confines of our planet. With each successive mission of the 1950's and 60's, millions were glued to their television sets, at the same time, to share in the collective experience of witnessing their space-heroes putting their lives on the line in the name of human progress, and national prestige.

Like *Apollo 11* and *Apollo 12* before, *Apollo 13's* mission was for American astronauts to land successfully on the moon for the third time, explore and bring back data and samples from the moon and return safely to Earth. Instead, after a smooth launch from the Kennedy Space Centre in Florida, fifty-six hours into the mission, *Apollo 13* suffered an oxygen tank explosion which released gas in a twenty-five mile radius around the module in just a few seconds. This is when Lovell reported to Mission Control, with famous understatement: "Houston, we have a problem." In a 2016 interview with Forbes magazine, Lovell described the feelings of the crew immediately after the disaster: *"We were all apprehensive. But you have to have a positive attitude, number one. And number two, we were all from test pilot backgrounds, so naturally, this was an adventure."*

The mission to the moon was immediately aborted by Kranz, and the plan to return the crew safely to Earth was put into place. This involved burning the remaining fuel at precisely the right moment to utilize the gravitational pull of the moon and slingshot *Apollo 13* home to Earth. By using the lunar module as a life boat during their hazardous return journey, the crew were able to ration the little oxygen they had remaining. The live television broadcasts to the public at home had to be discontinued in a bid to conserve electricity. Despite minimal odds of survival, with the help of thousands of NASA ground staff, the *Apollo 13* command module survived re-entry into the Earth's atmosphere and all three crewmembers survived.

The crew of *Apollo 13* did not complete their mission to the moon, which is why Ron Howard was so honoured by the praise he received for his directing of the movie, which many remember as his finest. Howard felt it was extraordinary that a film about a man, Lovell, whose dream was thwarted by events outside his control would be so lauded by critics and audiences

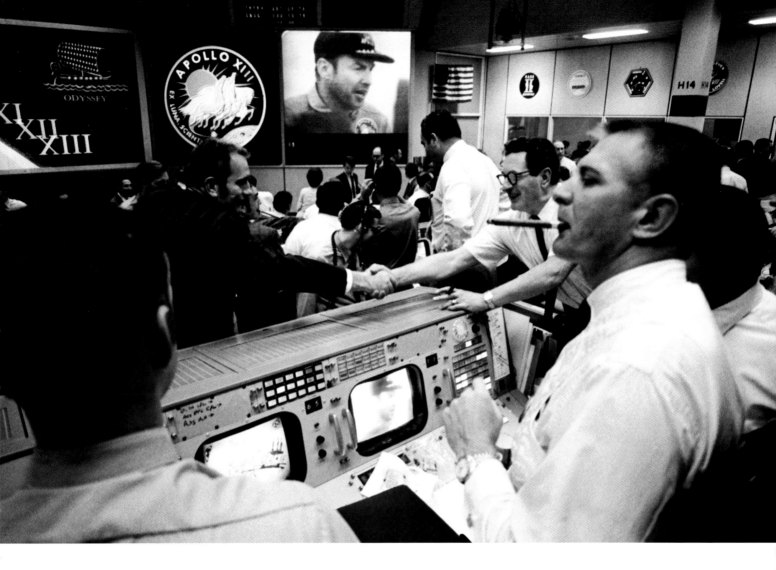

alike. Lovell explained: *"When the explosion occurred, it brought out the true value of leadership, teamwork, and initiative at Mission Control and turned an almost certain catastrophe for NASA into a successful recovery."*

While the official mission may not have been a success, a fact sometimes overlooked by historians, is the extraordinary exploration record the *Apollo 13* flight crew still hold. In their bid to survive the disaster, on April 15th 1970, *Apollo 13* travelled 248,655 miles from Earth to the far side of the moon. As such, on this day, Lovell, Mattingly and Haise unwittingly fulfilled a different, but perhaps more momentous feat: they became the three humans in history to have travelled the furthest distance from our home planet into the void of space.

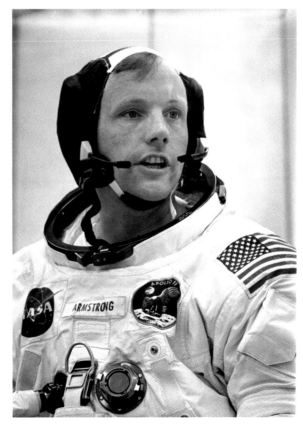

Armstrong suits up for the Apollo II launch.

Photographed by NASA on July 16th 1969

Colourised by Mads Madsen

THE "MAN WHO FELL TO EARTH" TRANSFORMS OUR UNDERSTANDING OF MANHOOD

"David Bowie, the pop star and song writer, whose wife Angie three weeks ago presented him with a baby boy, which they have called Zowie, June 29th 1971

Photographed by Ron Burton courtesy of Mirropix

Colourised by Matt Loughrey

Singer, song-writer and performer, David Bowie's influence on music cannot be underestimated. Born David Jones on January 6th 1947, in Brixton, South London, for the five-decades Bowie contributed to global popular music, he constantly reinvented himself, and remained not only relevant, but hugely influential on other great musicians during his lifetime, and no doubt beyond it.

At the time this image was taken, Bowie and his American wife Angie Bowie, were showing off their three-week old first son to the press. He was called, Duncan Zowie Haywood Jones, or simply "Zowie" from the Greek "Zoe", meaning "life". Dressing femininely, Bowie looks to be deliberately turning the patriarchal idea of fatherhood on its head. Similarly, his wife Angie has her hair straightened in a similar style to that of Bowie in his earlier years, making her image of motherhood just as ambiguous. Indeed, as parents they are suggesting they may have swapped traditional roles – anticipating 21st Century trends of new parenting strategies, and transgenderism. Soon after this image was taken, Bowie wrote the song, *Kooks*, about his feelings on becoming a parent. He directly referenced how families can develop a unique way of living, when he said in the song, "if you stay with us you're gonna be pretty kookie too".

Like many photos in the book, this image captures Bowie, well-known for his ability to change himself, at the cusp of his greatest transition: from his feminine art rock image presented in his 1970 *Man Who Sold the World* and 1971 *Hunky Dory* albums, to the glam-rock explosion that was his most famous alter-ego, Ziggy Stardust. His relationship with Angie was hugely influential in the development of Ziggy and his band, the *Spiders from Mars*. At the time this image was taken the pair were collaborating on the name, look and personality of the character of Ziggy, however it was his proto-punk musical collaborators Iggy Pop and Lou Reed who would have the most impact: Bowie intended Ziggy to be a combination of the two. The "Man from Mars" was to have Iggy Pop's flare combined with Lou Reed's alienlike presence. The red shock of hair, translucent skin, Bowie's naturally duel-coloured eyes, and the otherworldly way in which Ziggy acted and dressed all combined to give him an almost cult-leader-like status to many of his fans.

The irrepressible personality of Ziggy was so strong that it almost overshadowed Bowie's own identity. He increasingly failed to stop being Ziggy offstage or during interviews, and Bowie confessed that he seriously questioned his own sanity during the Ziggy-era. The star fought within himself and eventually succeeded in retiring Ziggy. He replaced him with the, "Thin White Duke" persona, based on the lead extra-terrestrial character of the cult 1976 Bowie movie, *The Man Who Fell to Earth*. Musically, Bowie again reinvented himself, moving from glam-rock to black soul and blues inspired "plastic soul" with the album *Young Americans*. His addiction to cocaine and total submersion into his Thin White Duke character led him to publicly giving, what many considered to have been, a Nazi-salute. However, Bowie denied this at the time, and later qualified the gesture by blaming drugs and his reading of far-right mythology, which made him "deranged".

Despite his personal struggles with drugs and fame, Bowie continued to absorb and reinterpret the successive waves of popular music that echoed across the decades of his life, from Berlin's *Krautrock*, to the 1980's *New Romantics*, to *electronica* of the 1990's and *neoclassicism* of the noughties. Bowie's final years were taken up with painting and living a quiet family-centred life in New York. However, it was during the final weeks of his life as he was dying of terminal lung cancer, that he once again astonished the world. His candid track *Blackstar* released to coincide with his 69th birthday, directly addressed how he was facing the end of his life. Two days later he died.

The year of this death, 2016, was one filled with an unusually high rate of mortality in the celebrity world. Following Bowie on January 10th, the world then lost forty-four major figures, including actor Alan Rickman, novelist Harper Lee, Beatles producer Sir George Martin, musician Prince, boxer Muhammad Ali, comedy actor Gene Wilder, Israeli politician Shimon Peres, singer Pete Burns, poet Leonard Cohen, actor Robert Vaughn, dictator Fidel Castro, socialite Zsa Zsa Gabor, singer George Michael and actress Cary Fisher.

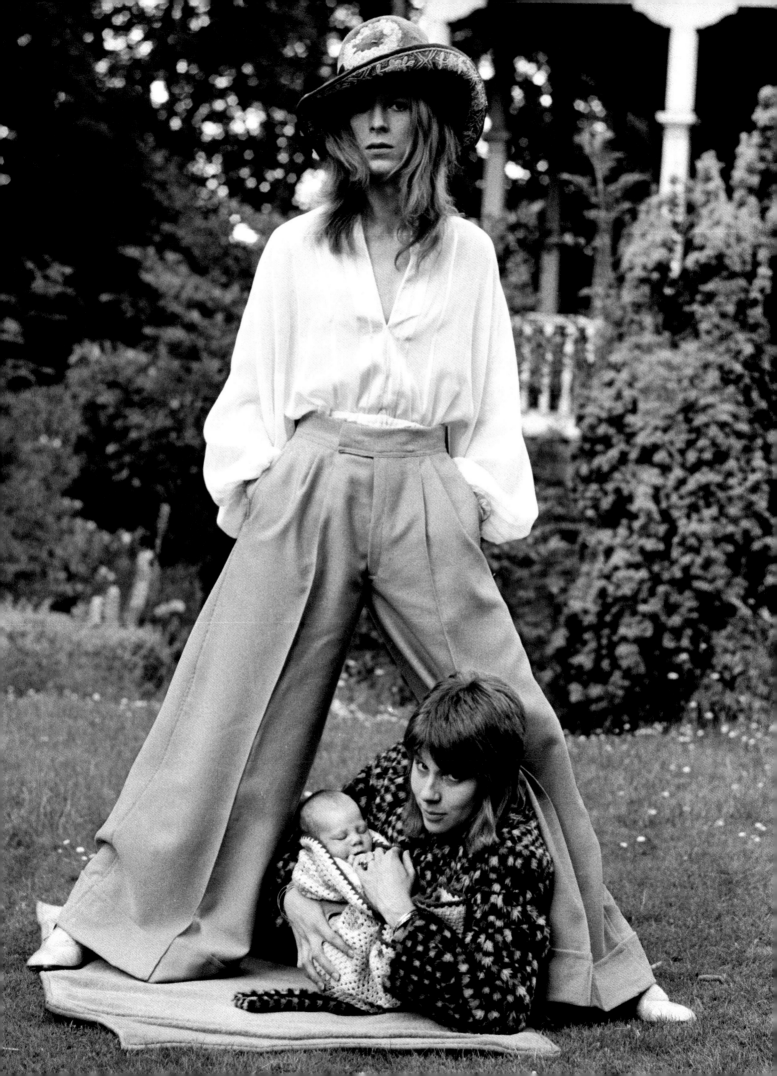

A COURAGEOUS CATHOLIC PRIEST TAKES ON THE BRITISH MILITARY DURING A MASSACRE BUT REFUSES TO BOW TO THE IRA

Priest Edward Daly waves a handkerchief during the Bloody Sunday massacre of January 30th 1972

Photograph courtesy of Mirrorpix

Colourised by Matt Loughrey

This is the image that shocked and horrified people across the world, becoming symbolic of the massacre of unarmed civilians at the hands of British troops in Northern Ireland. More than any other, this is the photograph remembered from the time of the Troubles between Catholics and Protestants in this part of the UK and was replicated in political posters and street murals throughout the conflict.

During the strife-filled year of 1971, thirty British soldiers were killed by the IRA, barricades had been constructed in what was known as "Free Derry" a majority-Catholic Bogside area, which had become an IRA stronghold and no-go area for the British Army and Royal Ulster Police. An estimated four million pounds-worth of damage had been caused by Irish Nationalist protestors at a spot known as "aggro corner". British paratroopers responded with rubber bullets and baton charges, beating protestors so badly the troops had to be restrained by their own officers. On January 30th 1972, the Northern Ireland Civil Rights Association organised a protest in Derry against the internment without trial of Irish Republican Army (IRA) terror-suspects. An estimated ten thousand demonstrators gathered, who were prevented by British troops from reaching their planned rally point at the city centre's Guildhall. The official march changed route to meet at Free Derry Corner, however some protestors broke free and began throwing stones at soldiers who were manning barriers. Two alleged stone-throwers were shot and wounded by paratroopers, before a company of troopers were ordered to advance past the barriers and arrest rioters. Two people were run over and injured by riot vans. The soldiers began seizing peaceful protestors and rioters alike, allegedly shooting them at close range with rubber bullets, beating and verbally abusing them. Soldiers took aim at people close to a barrier where stones were being thrown and fired live rounds, killing six people and wounding one. The crowd began to flee, including Father Daly, who we see pictured. Several dozen were cornered in a car park, before soldiers again opened fire and struck seven people, wounding six. Teenager John "Jackie" Duddy was shot in the back

as he ran. The courage showed by Father Daly as he gave the last rites to Duddy, was an inspirational show of humanity during the midst of the massacre. What he did next reverberated across the planet. Still under fire, Father Daly calmly formed a party of six civilians to carry Duddy back towards the hostile lines of British troops, where he hoped some medical assistance could be found for him. In this photograph we see Daly, with a bloody handkerchief in his hand, spread his arms widely to protect those who were carrying Duddy behind him, as troops from the 1st Battalion Parachute Regiment looked on. Tragically by the time the group crossed the lines, Duddy was mortally wounded and had already joined the twelve others killed that day.

British troops were originally sent into Derry to protect Catholics from attacks by their Protestant neighbours. However, after Bloody Sunday they were seen not as a neutral force, but a hostile one towards Catholics. The immediate effect of the massacre on the wider conflict was that the IRA increased its recruitment of disaffected and radicalised young people. International opinion turned against Britain, and public support for the presence of troops in Northern Ireland fell in the British mainland. Fourteen people eventually died in total and twenty-six were injured. The initial British Inquiry into the events of the day accepted that some troops had acted recklessly, but ruled that overall, reasonable force was used in the light of the nail bombs and gunfire soldiers alleged were used against them by rioters.

Edward Daly went on to became a bishop and a campaigner for peace in Northern Ireland. While he condemned the British use of the military to occupy the province, he was outspoken in criticising the brutal tactics of the IRA. This extended particularly to the kidnapping of victims for use as "proxy bombs", where civilians were forced to drive bomb-laden vehicles towards a target and were killed in the detonation. In respect of proxy-bombing, Daly described IRA members as having demonstrating that, "their lives and their works proclaim

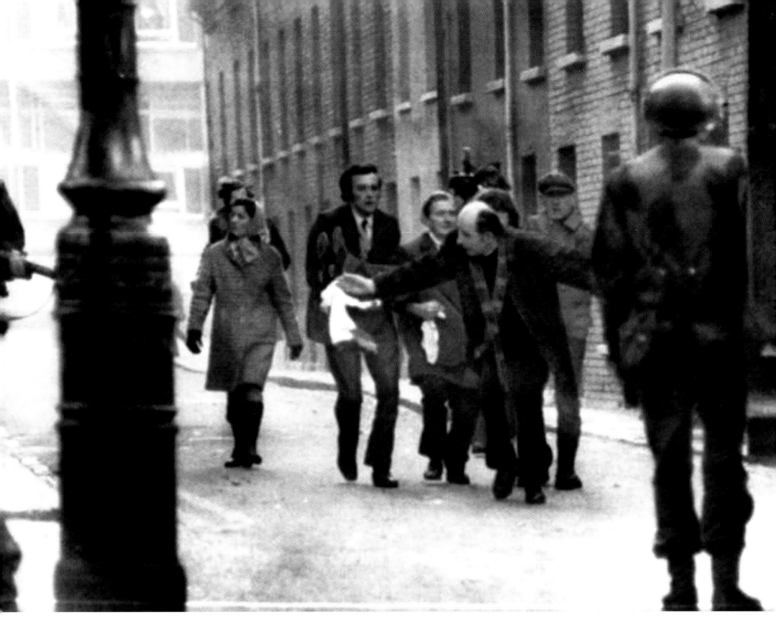

clearly that they follow Satan." He was also defiant in his dealing
with them over matters of religion, refusing dead IRA members
military-style funerals with gunshot salutes. He played an
important part in the Northern Ireland peace process, helping
to negotiate a cease fire between the two sides in the 1990's.
Upon his death on August 8th 2016, he was described as "a
fearless peacebuilder" by the Primate of All Ireland, Archbishop
Eamon Martin.

Under public pressure, the British Government launched a fresh
inquiry into the massacre led by Lord Saville, which found that
protestors were unarmed and their killings were unlawful. In
June 2010, Prime Minister David Cameron apologised for the
massacre on behalf of the British Government. After decades
of civil strife that left thousand dead on both sides of the
conflict, as of 2017 peace still largely holds in Northern Ireland.
Bloody Sunday is remembered in popular culture through the
famous song by Irish band U2, *Sunday Bloody Sunday*, and
through the songs of British musicians of Irish decent, such as
Beatles members, Paul McCartney and John Lennon, and heavy
metal band Black Sabbath's Geezer Butler.

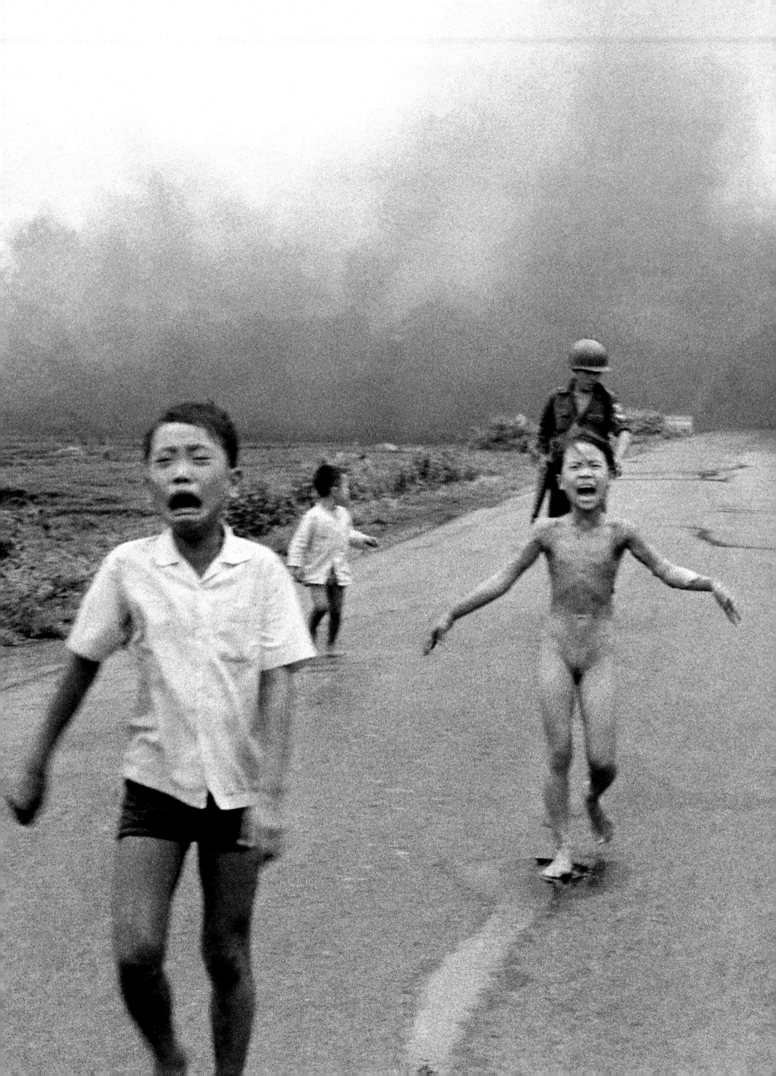

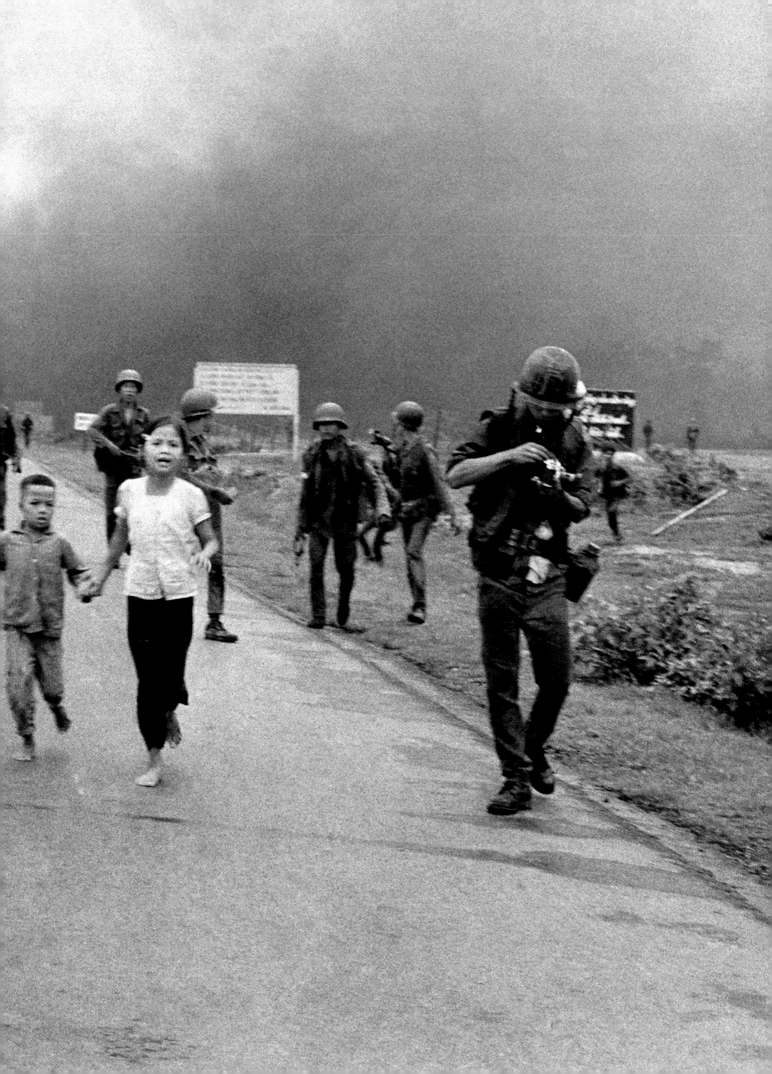

NOT IN OUR NAME: THE ANTI-WAR IMAGE IS BORN IN THE MOMENT THIS BADLY BURNED GIRL CRIES OUT IN PAIN

"Napalm Girl"

Photographed by Nick Ut outside Trang Bang village, Vietnam June 8th 1972, image courtesy of Associated Press

Colourised by Matt Loughrey

Just moments before this unforgettable image was taken, deadly American-produced bombs containing napalm mixed with phosphorus jelly were dropped towards the children we see pictured. They had apparently been mistaken by the American-backed South Vietnam Air Force for enemy North Vietnamese communist fighters. Upon impact this incendiary bomb rained a 1,000 degree Celsius chemical fire over outskirts of their village. The naked, screaming girl pictured third from the left was nine-year old Phan Thi Kim Phuc. Seconds before AP photographer Huynh Cong "Nick" Ut pressed his shutter to take the image, Kim Phuc had torn the clothes, and a considerable amount of skin, from her torso. She had been struck by the napalm blast, and was enduring the resulting damage which caused third degree burns. The quick-thinking act of removing her chemical-coated clothes, which makes her look so vulnerable in the image, may have saved her life. Two of Kim Phuc's cousins and two other villagers burned to death in the attack. The children pictured from left to right are Phan Thanh Tam, Kim Phuc's younger brother who lost an eye in the attack, Phan Thanh Phouc, the youngest brother of Kim Phuc, Kim Phuc, her cousins Ho Van Bon and Ho Thi Ting. Members of the Vietnam Army 25th Division are behind them.

In a radio interview Nick Ut described the horror of what he saw. Ut explained how he resolved the conflict between his professional role as a war photographer to document the event, and his instinctive desire to help the children: "*I keep shooting, shooting pictures of Kim running…She just said, 'I'm dying, I'm dying, I'm dying,' and, 'I need some water, bring water.' Right away, [I] run and put water on her body. I want to help her. I say no more pictures, I want to help Kim Phuc right away.*"

Napalm, was developed by chemist Louis Fieser, in a secret science lab at Harvard University in 1942, during the height of WW2. It was initially used in bombing raids against Japanese cities, but also in handheld flamethrowers and tanks. Most people are killed if napalm covers ten percent of their body; in this picture Kim Phuc is thirty-percent covered. As well as having a sticky jellylike composition that makes it nearly impossible to remove once it strikes a person, building, or other surface, it also reaches such an extreme temperature that in enclosed spaces a deadly firestorm can be caused. During the period of American involvement in the Vietnam conflict from 1965 to 1972, seven-million tonnes of bombs were dropped on the country, approximately three-times the amount dropped during the Second World War. The conflict cost the US an estimated $200billion, with 58,220 US lives lost. The Vietnamese lost over two million people.

This image, which in the years before the identification of Kim Phuc, was simply entitled "Napalm Girl". Upon being published, it was quickly circulated worldwide, and became the most easily recognised image of the Vietnam War, and one of history's most iconic anti-war photographs. It was instrumental in bolstering support for the campaign to hasten the removal of American forces from the region, to the extent that the President in office at the time the photograph was published, Richard Nixon, believed it could have been staged for this purpose, according to White House transcripts of his conversation on the matter. Nick Ut won a Pullitzer Prize for the photograph and later moved from his home in Vietnam to live in America.

According to Ut, the South Vietnamese soldiers that were present exhibited no interest in helping to save the children, so it was left to the journalists and photographers on the scene to offer respite in the form of water to drink and pour on the wounds. Once Ut had taken the children safely to Barksy Hospital in Saigan, doctors believed Kim Phuc would probably die from her injuries. However, she survived and had to undergo surgery seventeen times in fourteen months. For the rest of her lifetime, Kim Phuc has endured the pain of her injuries, coped with the severe scarring and undergone treatment as recently as last year. As a teenager and young-adult she was used by the victorious Communist government of Vietnam for propaganda

purposes, and was granted permission to study in the allied Communist nation of Cuba. There she met her future husband Bui Huy Toan. For their honeymoon, the couple took a flight to Moscow, and claimed asylum in Canada while the aircraft was refuelling. Their application was granted, the couple settled in Toronto where they raised two children. Ut stayed in regular contact with Kim Phuc througout her life. Together they built on the moment of horror they shared, Ut though the exhibition of the war photography he dedicated a lifetime to compiling, and Kim Phuc through her public speaking and the establishment of the Kim Phuc Foundation for the medical and psychological treatment of children affected by war. In 1994 Kim Phuc was named a UNESCO Goodwill Ambassador. During a 2008 National Public Radio interview Kim Phuc said: *"Napalm is very powerful, but faith, forgiveness, and love are much more powerful. We would not have war at all if everyone could learn how to live with true love, hope, and forgiveness. If that little girl in the picture can do it, ask yourself: Can you?"*

WATERGATE: THE LEADER OF THE FREE WORLD IS FORCED TO RESIGN AMID THE MOST NOTORIOUS POLITICAL CONTROVERSY IN HISTORY

"Richard Nixon Farewell"

Photographed by Bob Daugherty outside the White House, Washington DC, on August 9th 1974

Colourised by Matt Loughrey

This is the moment Richard Nixon became the first and only American President to resign before completing his term in office. Despite facing accusations that he was part of a conspiracy to suppress the world's most famous political scandal, Watergate, Nixon can be seen with both hands raised in his famous, double "V for Victory" sign as he boarded the *Army One* helicopter that had been ordered to transport him from the White House for the last time. It would be an understatement to describe him as putting a brave face on what was probably the lowest point in the history of American democracy.

The extraordinary story behind this history-making scene, began with five arrests for the infamous burglary of the Watergate Complex, specifically the National Committee headquarters of his political rivals, the Democratic Party on Saturday June 17th 1972. The five burglars were men who had worked for the FBI or CIA in the past, and were caught with cash provided to them by Nixon's official political campaign group, the Republican Party's Campaign for the Re-Election of the President. They were part of a covert investigations unit that came to be known as "The White House Plumbers", a tongue-in-cheek reference to their primary task of containing and minimising the effects of potentially harmful political leaks. The group was led by former FBI agent G. Gordon Liddy, ex-CIA officer E. Howard Hunt and Special Counsel to President Nixon, Charles Colson. The Plumbers hatched a plan to break into the Democratic Party HQ, place wiretaps in the office telephones and photograph sensitive documents. The men they recruited were successful in installing listening devices, however it was decided repairs to these machines were needed, so a second burglary was made. Police were called on the night of the second break-in, after suspicious tape was found by a security guard on the locks of doors.

While the money trail pointed towards the President's campaign, it is possible Nixon did not himself know of the illegal operation, and this is the position he maintained throughout what is now called the Watergate Scandal. Upon hearing of the disastrous operation, a secret taping system Nixon had installed himself in the White House recorded him as saying to his Chief of Staff H.R.

Halderman "Who was the asshole who ordered this?" The Whitehouse Tapes, as they came to be known, were made public during the Senate Committee Investigation into Watergate, and were to be the nail in the coffin of Nixon's political life. Nixon publicly proclaimed his support for any investigation into alleged illegal activities by the Plumbers, when he famously said, "There can be no whitewash at the White House."

However, sensational work by Washington Post reporters Bob Woodward and Carl Berstein to publish material provided by a mysterious FBI insider known only as "Deepthroat", suggested the cover-up reached to the top of the FBI, CIA and Republican Party. Evidence was revealed, which suggested Nixon had knowledge that the Watergate burglars were bribed and threatened into committing perjury as part of the cover-up. This involvement, combined with Nixon's profanities and casual use of racists terms revealed in the Whitehouse Tapes, turned public opinion against him. As impeachment became likely, Nixon was advised by his legal and political team that he had no choice but to resign.

Within a month of taking office, Nixon's successor President Ford, who was unelected at the time, gave him a full Presidential pardon. Uttered minutes before this image was taken, in what is remembered as a bitterly sad speech, the last words of Richard Nixon as the 37th President of the United States might give us a clue to his state of mind, or at least the one he wanted to project to the world:

"I am confident that the world is a safer place today, not only for the people of America but for the people of all nations, and that all of our children have a better chance than before of living in peace rather than dying in war.

"This, more than anything, is what I hoped to achieve when I sought the Presidency. This, more than anything, is what I hope will be my legacy to you, to our country, as I leave the Presidency.

"To have served in this office is to have felt a very personal sense of kinship with each and every American. In leaving it, I do so with this prayer: May God's grace be with you in all the days ahead."

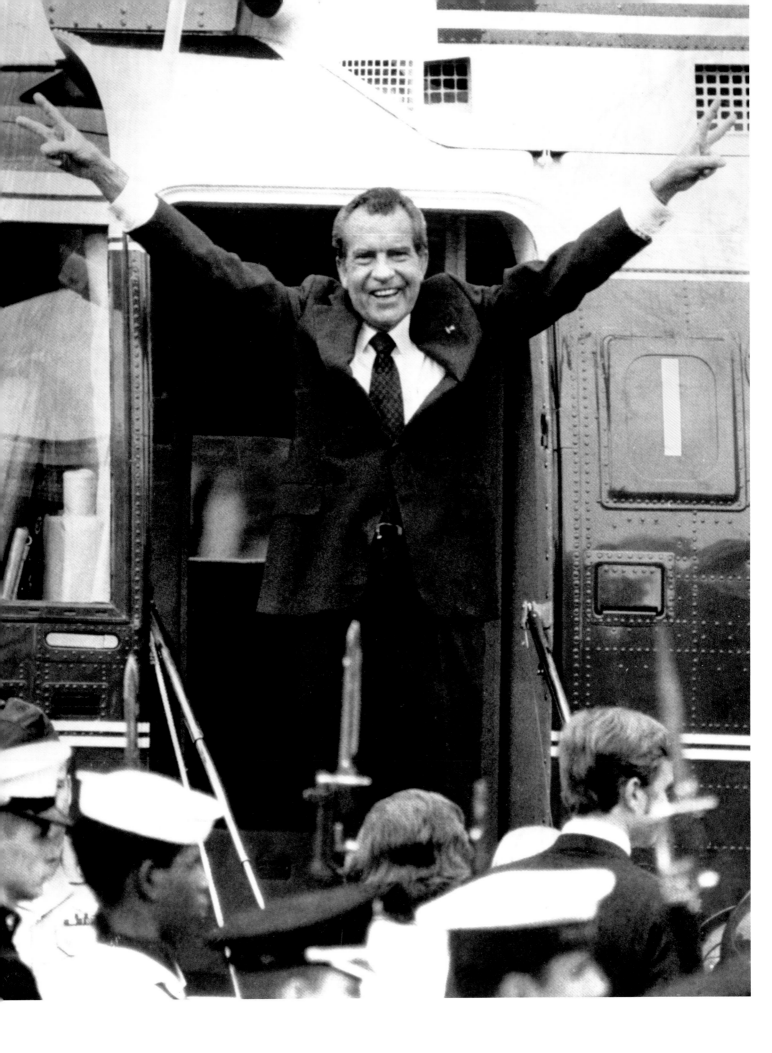

BIOGRAPHIES

Frederic Duriez

Frederic Duriez is 51 years old and lives in the village of Angres in Northern France -in the heart of what, during the First World War, was the Western Front. His passion for colourisation was sparked while running in the battlefields between Vimy Hill and Notre Dame de Lorette, home to some of the fiercest fighting of WWI, and to near what is now the French National War Cemetery. Frederic started to collect black and white images showing the men who fought and died in the conflict, and began to colourise them. Two years later he has colourised hundreds of images, branching from war to portraits of people from the past. He tries to give soul, part of himself to the photograph, so each one remains a testament to the future. Frederic is married with one child.

For more of Frederic's work visit: http://histoire.de.couleurs.free.fr/

Jecinci

Paul Kerestes, known by his online handle, "Jecinci", is a professional architect and 3D Artist from Romania. He began as a colourisation artist two years-ago after spotting, by chance, a colourisation tutorial on You Tube and started working on a black and white image of his great grandparents. He took inspiration and help from other colourisers in the community, like Olga Shirnina, Doug Banks, Dragos Andreescu, Florin Rostariu, Patty Alison and Jared Enos, many of which are featured in *Retrographic*. He concentrated on portrait images to improve his technical skills, until he gained the courage to tackle complex images such as landscapes, war scenes, cars and city life. Jecinci is drawn to images which fire his imagination, and which he is curious to see brought to life in colour. His mission is to set the viewer on a path to discovery, to bring them a slice of knowledge, to make them smile, and remember a piece of history. Paul thanks his community of followers for their support, and hopes to continue to inform their interest in history, through images he is yet to colourise.

Jared Enos

Jared Enos is a 20-year-old hailing from North Kingstown, Rhode Island, in the USA. He is a full-time radiography student, an Emergency Medical Technician, and a skilful colourist. He discovered colorization entirely by accident, but was hooked after his first attempt. That was four years ago, and since then he has breathed new life into over two hundred photographs of subjects ranging from World War II to Victorian Ireland. Through his work, he attempts to develop a stronger connection to the past via vivid, well-researched colours. Jared's style is continuously evolving, most notably in the area of nature colorizations. His colorizations "*A Soldier on patrol,*" "*At the Gap of Dunloe,*" and "*Finnish Tanks on the Move*" blur the line between colorization and reality. Jared enjoys developing his colorisation to explore new techniques, and tools that will bring the viewer even closer to the past.

Marina Amaral

Marina Amaral is a self-taught digital colorist with an incredible gift for breathing life into the past. She was an international relations student before deciding to take up her art full-time. She takes monochrome photos and gives them colour, using rigorous historical research and a natural artist's gift to produce rich, immediate, incredibly moving images of the most important events in world history. She describes her colourised versions as her "second perspective", providing us with insight into what the contemporaneous witness would have seen. Marina is chiefly interested in the moments that have made history. She was considered by *Wired Magazine* the master of photo colorization. Her work has been widely reproduced in the most important media outlets around the globe, such as the *BBC, London Evening Standard,* and *The Verge.*

Marina's professional website can be found here: www.marinamaral.com

Matt Loughrey

Matt Loughrey has been actively involved in photography from a young age. He turned his passion into a profession in early 2010, and for five years he documented the West of Ireland; in particular, the people and surrounds of Co Mayo. Matt received positive publicity from his professional photography, and he soon recognised that as technology progressed, there would room to realise an idea for breathing life into the historical imagery of photographers who had gone before him. Through dedicated practice, Matt discovered he had the patience, and skill, to concentrate on advanced colorization. Soon, he had put down his camera to work on colourisation full time. Over the past three years, Matt has seen his creations travel the world, educating and entertaining thousands of people weekly. Several of Matt's works have been published in National Geographic Magazine, and his colourisations were featured in a recent global advertising campaign for Dell Computers. Matt's love for colorization is borne from the chance at self-reflection it offers, and the power of the craft to enthuse young minds.

Mads Madsen

Professional Danish colouriser Mads Madsen began exploring photography at the age of twelve, and fell in love with images of the American Civil War in particular. After stumbling upon a website featuring colourised images in 2009, Mads decided to try his hand at the art. His approach to colourisation rests on diligent research, he will spend hours looking at diaries, and field records to date and apply the correct season to the images he works on. Mads approaches specialist military historians to verify uniforms, signals and flags. His method for colourisation is wedded in his passion for bringing a previously lost world to life; what was once made alien and distant by the march of time is brought into the realm of the present. Mads' work has appeared in the *History Channel, National Geographic, Australia's ABC television network, Business Insider, the Huffington Post,* and a plethora of UK newspapers, including the *Times of London, Daily Telegraph,* and *Daily Mail.*

For more of Mads' work visit Colorizedhistroy https://www.facebook.com/MadsMadsen.CH/

Olga Shirnina

Olga Shirnina is a translator from Moscow. Her journey into the world of colourising historical images began with her own experimentation in photo-collages. She was drawn to black and white images, and started to explore the possibility of colourising them, before discovering the online community of colourisors. She believes that while black and white images remain important historical records, adding colour to them removes barriers between "then and now", and allows historical experts, witnesses to history, and relatives of those featured to participate in the colourisation process. Olga's passion is for photography concerning the cataclysmic and dramatic events that shaped Twentieth Century Russian history. She hopes through her work, she can help the people of Russia and the West to understand each other better.

Olga is known online by her handle, "klimbims". Her work can be found here: www.flickr.com/photos/22155693@N04/

Patty Allison

Patty has been colourising for the past four-years, usually producing at least one colourised image per day. Her journey into colourisation began through her exploration of one of America's most valuable and comprehensive photographic resources, the website of the Library of Congress. She discovered images taken by the Detroit Publishing Company, which in the early 1900's deployed a troupe of photographers to document America with huge cameras fitted with 8 X 10 glass negatives. The resulting images were highly detailed, which inspired Patty to spend hours colourising a selection of them. Rarely devoting herself to famous historical images, Patty is instead concerned with city and transport scenes from the past. In particular vehicles such as cars, trains, buses, taxis and trains are the stars of her imagery. She enjoys working with reflections to explore the way lights hits a highly-polished surface.

Patty's website is: www.imbuedwithhues.wordpress.com

Tom Marshall B.A. (Hons) (PhotograFix)

Tom Marshall has been professionally colourising photos since 2014, when he decided to try and make a career out of my hobby. Trading as 'PhotograFix', Tom has been fortunate to work with some of the world's leading museums, photo archives and publishers, including The Open University, The National Museum of Ireland, The Welsh Guards Archives, Uniform Press and the BBC, alongside hundreds of private clients who have allowed him to colourise their personal family photographs.

Tom's projects have gained worldwide attention, including the *Lost Tommies* and *The Somme in Colour,* which both focused on the First World War, and *A Chaplain at Belsen* which was a personal homage to his Great Grandad, CMK Parsons and the photos of *Hell on Earth* he took at Bergen-Belsen during the final months of World War Two.

You can find out more about Tom's work at www.photogra-fix.com and www.facebook.com/PhotograFixUK

Michael D. Carroll

Michael D. Carroll is the director of Britain's most exciting press agency, Media Drum World. From the agency's newsroom in Birmingham, England, he manages a team of staff journalists specialising in the curation of offbeat digital content, particularly historical photography, for national newspapers and international media outlets. He lives with his wife and two daughters.

The author would like to thank his wife, Amrita Carroll, for her love and support, without which this project would not have been possible. To Freya and Anoushka for being patient with their father, colleagues Rebecca Drew and Mark McConville for holding the fort, Jeff Vickers of RPS, my publisher Gary Shove, colourisers Matthew Loughrey, Tom Marshall, Jared Enos, Mads Madsen, Frederic Duriez, Olga Shirnina, Marina Amaral, Patty Allison, Paul Kerestes, Ryan Urban, Sarah E. Yukich of the Kerry Stokes Collection, author Joe Bauman, Colin Panter at Press Association, Bruce Brown of Astonisher, Andrew Motion trustee of the Brooke Estate, author Jon Stallworthy of Wilfred Owen: The War Poems, Getty Images, Olessia Islamova of Rosphoto for her help and advice, Flickr members Blue Ruin and Drakegoodman, Associated Press, Library of Congress, Moscow Museum of Modern Art, University of Chicago Press, Bundesarchiv, US National Portrait Gallery, Wellcome Trust, Library of Ireland, Hilary Wall of the Vineyard Gazette, National Parks Service, The Society of Authors, Kate Bamforth.

The magic of Retrographic
is that it transforms the greyscale past
into the colourful present